Mastering Digital Black and White

A Photographer's Guide to High Quality Black-and-White Imaging and Printing

Amadou Diallo

THOMSON

™

COURSE TECHNOLOGY

Professional ■ Technical ■ Reference

ISBN-10: 1-59863-375-9

ISBN-13: 978-1-59863-375-7

Library of Congress Catalog Card Number: 2006910289

Printed in the United States of America

07 08 09 10 11 BU 10 9 8 7 6 5 4 3 2

Publisher and General Manager, Thomson Course Technology PTR:
Stacy L. Hiquet

Associate Director of Marketing:
Sarah O'Donnell

Manager of Editorial Services:
Heather Talbot

Marketing Manager:
Heather Hurley

Executive Editor:
Kevin Harreld

Series Editor:
Harald Johnson

Marketing Assistant:
Adena Flitt

Project Editor and Copy Editor:
Marta Justak

Technical Reviewer:
Tyler Boley

PTR Editorial Services Coordinator:
Erin Johnson

Interior Layout Tech:
William Hartman

Cover Designer:
Mike Tanamachi

Indexer:
Katherine Stimson

Proofreader:
Karen Gill

THOMSON
COURSE TECHNOLOGY
Professional ■ Technical ■ Reference

Thomson Course Technology PTR, a division of Thomson Learning Inc.
25 Thomson Place ■ Boston, MA 02210 ■ http://www.courseptr.com

This book is humbly dedicated to the memory of Bruce Fraser (1954-2006), whose writings and lectures combined a deep understanding of complex subjects with the willingness and ability to communicate in an accessible manner. His body of work stands as a touchstone for all of us who write about digital imaging.

Foreword

I spent my youth and college days buried deep in photography—not so much shooting images, but spending days and nights in the darkroom. Processing film, making silver prints, and toning with selenium. It really made me happy. I had become a darkroom guy. At some point, others started coming to me to make prints or to ask advice. It seems that all that time in the darkroom had made me a craftsman of sorts. After college, I went on to other photography-related jobs, and earned the title of "Custom Black-and-White Printer" along the way.

Fast forward to the digital age. Now, we could scan our film or shoot with a digital camera, manipulate the images in the computer, then off to the printer and presto, an inkjet print! Suddenly, everyone could make "good" prints. This is about the time I migrated to Vermont and joined Cone Editions Press. I learned about inkjet printing first on an Iris printer and then eventually moved to the Epson platform. We began making black-and-white images with color ink and then the seas parted and the wonder of quad black printing arrived.

I learned that printing—even with an inkjet printer—is still printing, and being the person I was, I wasn't happy to just click and print. I wanted to learn how the printer worked and what I could do to it to make prints that looked better. I just couldn't accept that all our output would look the same. I listened and learned from my master printmaker, and once again found myself becoming a "specialist" in black-and-white printing. That's when I started noticing something. If I took someone else's file and printed it, mine looked better. Why? Foundation: a basic knowledge of my craft. That's right, *craft*. I went from doing output to making prints. It is a process, from input, to manipulation, to making a print. I was a craftsman again.

This book will help with building that foundation and provide you with a thorough understanding of the black-and-white inkjet printing process. When I was asked to write this foreword, I figured I would just skim through the book, then write something really quickly. I was wrong. I read it from beginning to end. Then I read it again. "Wow!" I thought to myself, "This is good stuff!"

I recommend this book to beginners and experienced photographers alike for gaining the knowledge necessary to give you an edge in the creation of black-and-white images and prints. *Mastering Digital Black and White* covers all the basics from equipment, to file handling, to printing and beyond. Even if you've been involved with digital black and white for a while, this book introduces new ideas and technologies of which you may have not been totally aware. It has inspired me to recommit myself to my chosen career.

In our printing studio and at our workshops, one of my favorite sayings is, "Make a print and let's see." I'm heading for my printer; what are you doing?

Larry Danque
Studio Manager
Cone Editions Press, LTD
East Topsham, Vermont

Acknowledgments

It's a crime that this book has only one name on the spine. The number of people who have made this endeavor possible is staggering. But my first and most heartfelt thanks go to my wife, Mishi Faruqee, whose intelligence, compassion, and unwavering support for my creative endeavors have made me a better person than I could have become without her in my life.

Harald Johnson, my series editor, was the first to believe that my idea for this book could, and should, become a reality, and he enthusiastically convinced others of the same. Tyler Boley, in addition to a thorough job as technical editor, graciously allowed himself to be my sounding board, never tired of explaining ideas and concepts (often more than once), and most importantly for my sanity, seemed to always be in the office when I called.

A good chunk of the information in this book would not have been possible without the generous sharing of technical information, hardware, and software from numerous vendors. I'd like to especially thank Shari Becker at Porter Novelli, Johan Lammens at HP, Leonard Musmeci and Felix Ruiz at Canon USA, Evan Phillip Lippincott at Aztec Inc., Derrick Brown at Integrated Color Corp., C. David Tobie at Colorvision, Mike Collette at Better Light, John Nack and all the CS3 engineers at Adobe Systems Inc., Mark Duhaime and Greg Hollmann at Hasselblad USA, Kari Kroeger at Hahnemühle USA, Wayne Connelly at Innova Art USA, Mark J. Rowe and Peter Supry at ErgoSoft USA, John Pannazzo at ColorByte Software, and Josh Lubbers at CSE, Inc.

I'd like to thank the entire editorial, design, and production team at Course Technology PTR, particularly Kevin Harreld for championing the concept, Marta Justak for turning my manuscript into an actual book, and Mike Tanamachi for designing the perfect cover.

About the Author

Amadou Diallo is a New York City-based photographer, writer, digital imaging consultant, and teacher. He owns and operates Diallo Photography, a studio that offers fine art printmaking and digital imaging workshops to a client base from Brazil to Brooklyn. Amadou's words and images have been featured in national magazines and graced some of the most popular photography-related sites on the Web. His fine art photography has been exhibited in galleries nationwide and is in a growing number of private collections. For information about his photography or the services he offers, please visit: www.diallophotography.com. Amadou lives in Fort Greene, Brooklyn with his wife and son.

If you'd like to share comments about the book, please e-mail Amadou at amadou@masteringdigitalbwbook.com.

About the Series Editor

Harald Johnson has been immersed in the world of commercial and fine art imaging and printing for more than 30 years. A former professional photographer, designer, and creative director, Harald is an imaging consultant, the creator of the Web site DP&I.com (www.dpandi.com), and the author of the groundbreaking books, *Mastering Digital Printing: The Photographer's and Artist's Guide to High-Quality Digital Output* (2003), *Mastering Digital Printing, Second Edition* (2005), and *Digital Printing Start-Up Guide* (2005). Harald is also the founder of YahooGroup's *digital-fineart*, the world's largest online discussion group on the subject of digital fine art and digital printing.

Contents

Chapter 4
Digital Capture 123

Chapter 5
Photoshop in Black and White 167

Chapter 6
Black-and-White Inkjet Printing 219

Chapter 7
The Imaging Workflow 263

Chapter 8
The Limited Edition 291

Chapter 9
The Portfolio 323

Appendix A
Resource Guide 351

Appendix B
New York State Law 355

Index 359

Introduction

Anyone who tells you that writing a book is hard work isn't being truthful. It's a *lot* of hard work. In the years of exhilaration and struggle that I have experienced in my quest to create my own personal vision in the digital darkroom, I've often wished for a comprehensive reference geared toward high quality black-and-white techniques and materials. Being involved with monochrome imaging and printing in the digital age has often meant riding on the bleeding edge of technology with few out-of-the-box solutions. This book is written precisely so that you don't have to face the same hurdles that I did. This is a great time to be producing black-and-white images. We've never had such a wide selection of tools at our disposal. It seems the digital revolution is finally beginning to acknowledge our needs as photographers and printmakers. If the contents of this book aid you in migrating your photographic vision onto paper in a way that resonates with your audience, I will consider the hard work to be more than worthwhile.

Who Should Buy This Book?

While my accountant would probably answer, "everyone should," this book makes a fair number of assumptions about your skill level and ambition. To get the most out of this book, you will need to own a relatively recent version of Photoshop, have at least a moderate level of confidence in your camera exposure technique, and above all be committed to translating your photographic vision to the printed image. Today's imaging and printing tools make it quite easy to produce work of mediocre quality. You don't need to buy a book to do that. *Mastering Digital Black and White* is written for photographers who want to take their imaging and inkjet printing to the next level. Instead of just telling you what to do, I'll focus on explaining why you should do it.

In the pages to come, we will explore equipment, techniques, and methodologies that enable you to maximize the quality of your images as they pass from capture to edit to print. As is evident from the title, the primary focus of this book centers on black-and-white photography. But many of the foundations of digital photography that we'll be exploring are relevant even to those with only a passing interest in monochrome images.

If you are a serious amateur or working photographer and want to indulge your passion for gallery-quality black-and-white photography in the digital darkroom, this book is for you.

How This Book Is Organized

While the information in this book is presented in a logical order, each chapter is self-contained, and you can jump around if reading a book cover to cover is not your thing. The opening chapter is an image gallery of my work, meant to emphasize the very reason for buying this book—to produce high quality black-and-white images. In Chapters 2 and 3, I explore the equipment needs of the serious photographer and the foundations of color management upon which rest our hopes for consistent and pleasing output. Chapters 4 through 7 are dedicated to the nuts and bolts of a capture, edit, and print workflow. The final two chapters address the post-printing phase, focusing on the concept and practice of limited editions, long-term image stability, and the task of preparing your work for a public audience. Sprinkled throughout these chapters are five case studies that highlight some of the work I've printed for other photographers. You get to see their images and read interviews in which they talk about their process and inspirations.

Companion Web Site

I've created a companion Web site for this book at www.masteringdigitalbwbook.com that not only offers additional content, but also includes a discussion forum with a community of photographers who share a passion for digital black-and-white imaging and printing. Readers are also eligible for discounts on consulting, workshops, and printing services offered by Diallo Photography.

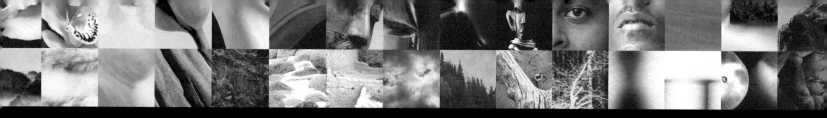

1

Image Gallery

I have always found that the path to mastering any new technique involves viewing as many examples of the process as possible. You can learn things from reading images—good ones as well as bad—that are nearly impossible to absorb from any text or teacher. In that vein, I humbly begin this book with a selection of my own fine art photographs. These reproductions are scans of actual printed editions. I created the original images using the tools, techniques, and methodologies that we will explore in the chapters ahead.

Looking at finished images *before* talking about technique may seem a bit like having dessert before dinner. But the nature of the digital darkroom makes it all too easy to get lost in a sea of specs and upgrade features. At the end of the day, it's all about the print. This is the medium through which viewers will connect most intimately with your work. So it's important that all of our tools and techniques have as their aim the creation of an expressive print.

It is my hope that these images will excite you about the possibilities that today's editing and printing tools provide for black-and-white output and will inspire you in bringing your unique vision to the world. I consider myself fortunate to be practicing photography in an era of such flexible and precise imaging. We have access to a wider range of tools and techniques than at any other point in history. My wish is for you to enjoy viewing these images as much as I have enjoyed creating them.

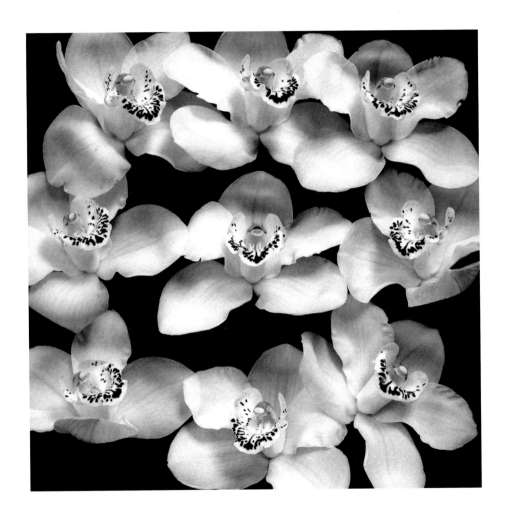

Title Orchid No. 2, 2005
Dimensions 30 × 29 in.
Paper Innova Cold Press Art
Camera Format 4 × 5
Location Studio

Title Orchid No. 4, 2005
Dimensions 20 × 25 ½ in.
Paper Innova Cold Press Art
Camera Format 4 × 5
Location Studio

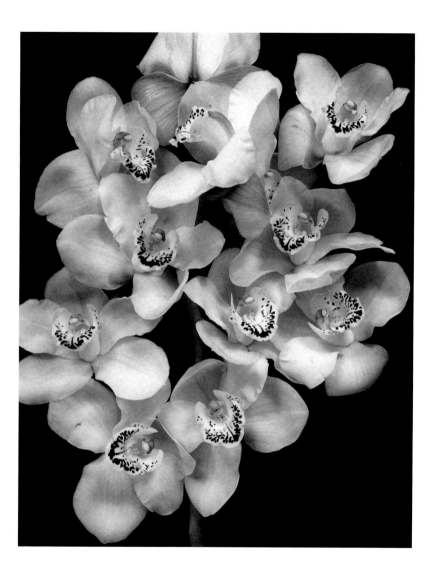

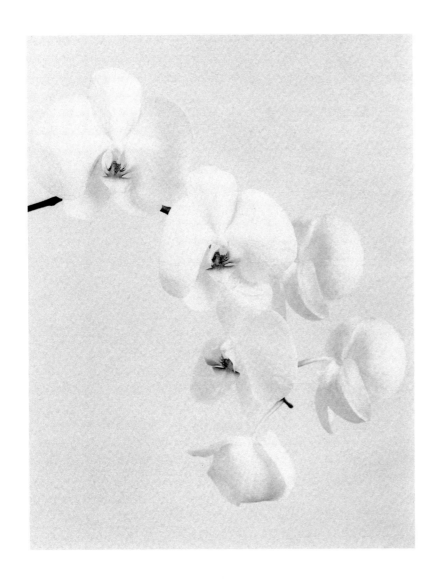

Title Orchid No. 1, 2002
Dimensions 16 × 20 ⁵/₈ in.
Paper Innova Cold Press Art
Camera Format 4 × 5
Location Studio

Title Tulip No. 1, 2002
Dimensions 12 1/2 × 16 1/8 in.
Paper Innova Cold Press Art
Camera Format 4 × 5
Location Studio

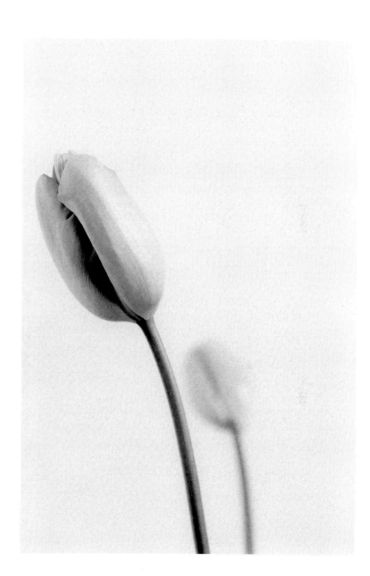

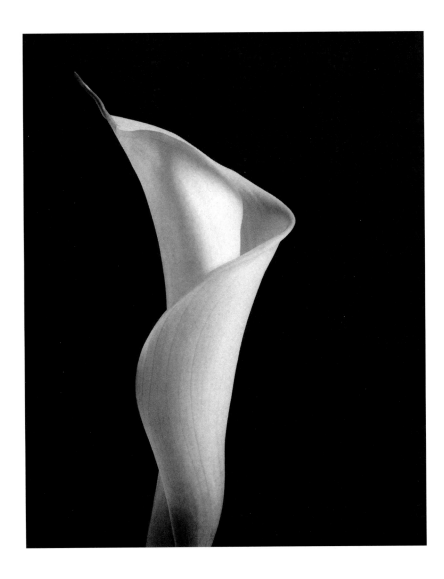

Title Calla Lily No. 4, 2004
Dimensions 20 × 25 in.
Paper Innova Cold Press Art
Camera Format 4 × 5
Location Studio

Title Lily No. 2, 2001
Dimensions 12 ¹/₂ × 16 in.
Paper Innova Cold Press Art
Camera Format 4 × 5
Location Studio

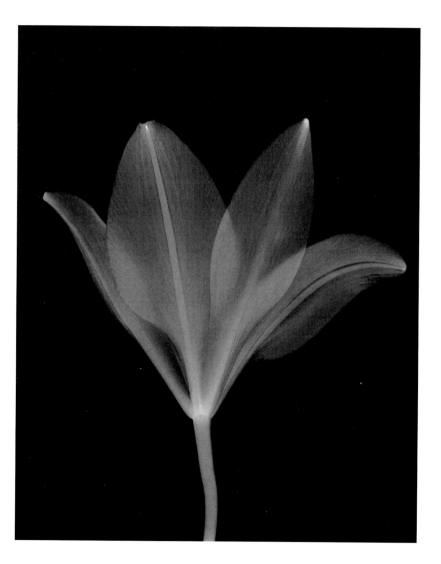

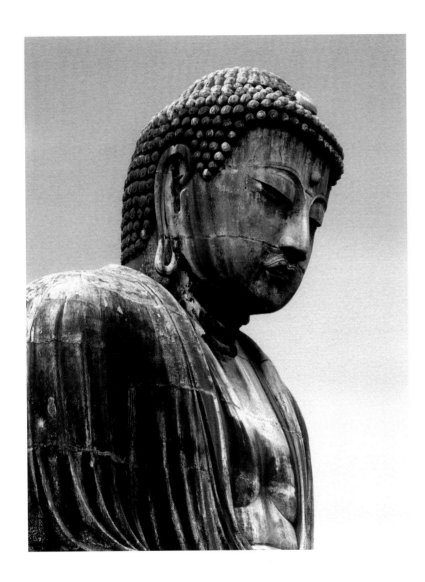

Title Daibutsu No. 2, 2004
Dimensions 16 × 21 in.
Paper Hahnemühle William Turner
Camera Format 4 × 5
Location Kamakura, Japan

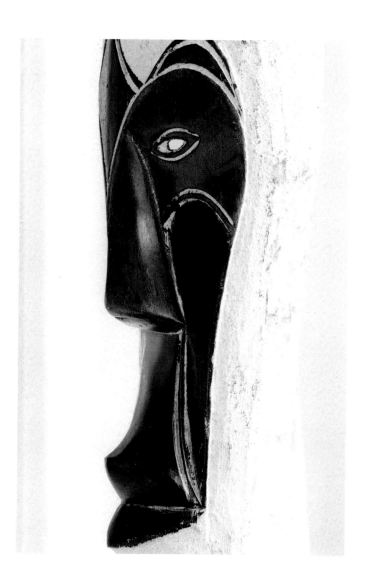

Title Delineation No. 4, 2005
Dimensions 30 × 45 ³/₄ in.
Paper Innova Cold Press Art
Camera Format 4 × 5
Location Studio

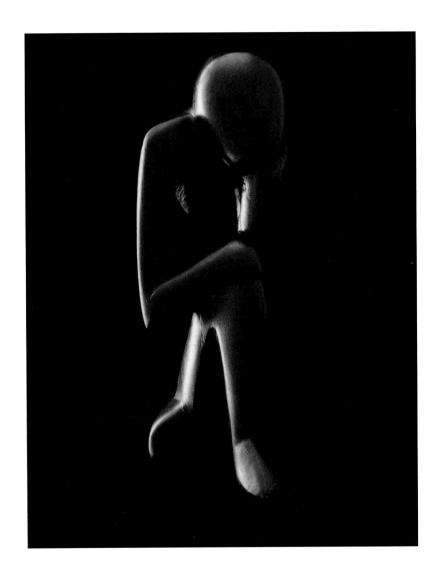

Title Delineation No. 1, 2005
Dimensions 30 × 38 ½ in.
Paper Innova Cold Press Art
Camera Format 4 × 5
Location Studio

Title Delineation No. 2, 2005
Dimensions 30 × 37 ⅛ in.
Paper Innova Cold Press Art
Camera Format 4 × 5

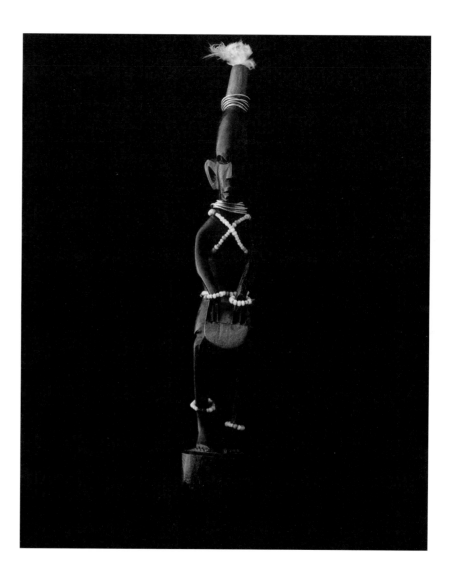

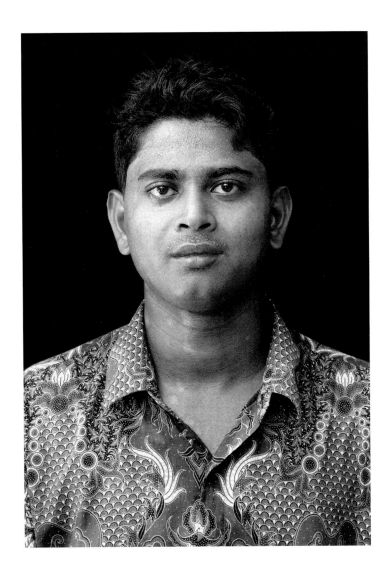

Title Nuruh, 2002
Dimensions 23 ⅝ × 34 ¼ in.
Paper Innova Soft Textured Art
Camera Format 4 × 5
Location Dhaka, Bangladesh

Title Rajaque, 2002
Dimensions 23 ¹/₂ × 28 in.
Paper Innova Soft Textured Art
Camera Format 4 × 5
Location Dhaka, Bangladesh

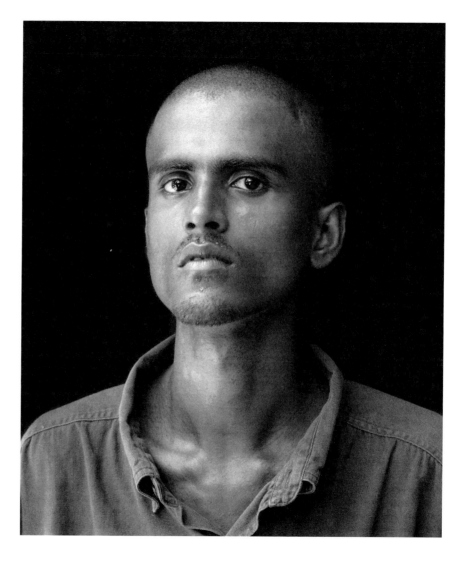

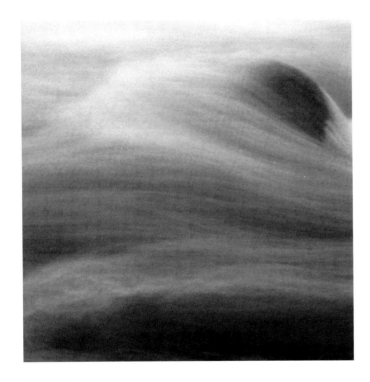

Title Motion I, 2002
Dimensions 30 × 30 in.
Paper Japanese Mulberry
Camera Format 4 × 5
Location Yosemite National Park, California

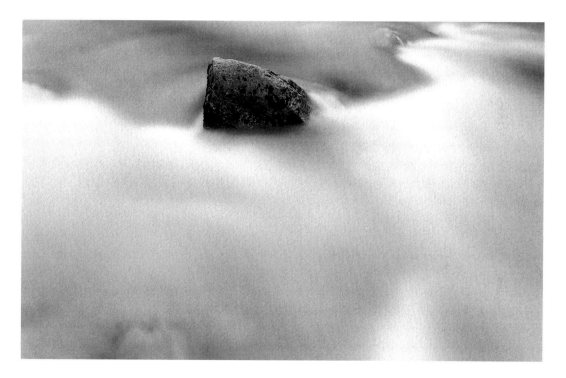

Title Rock and Water No. 1, 2002
Dimensions 31 7/8 × 20 in.
Paper Hahnemühle William Turner
Camera Format 4 × 5
Location Yosemite National Park, California

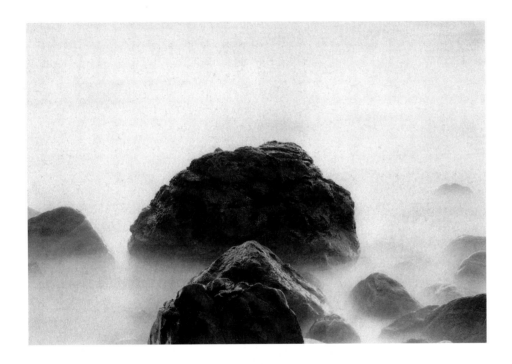

Title Rock and Water No. 12, 2006
Dimensions 30 × 20 ½
Paper Japanese Mulberry
Camera Format 4 × 5
Location Cape Breton National Park, Nova Scotia

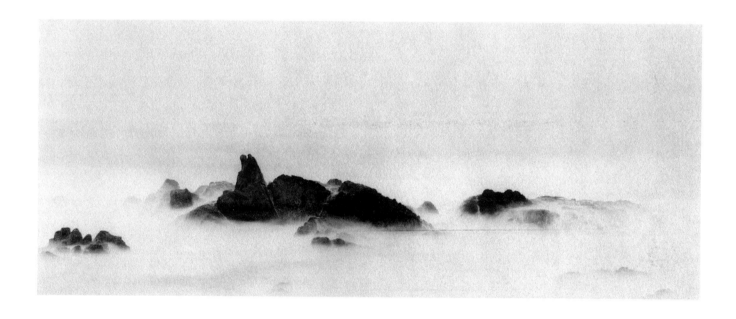

Title Rock and Water No. 4, 2002
Dimensions 35 × 14 in.
Paper Japanese Mulberry
Camera Format 4 × 5
Location Big Sur, California

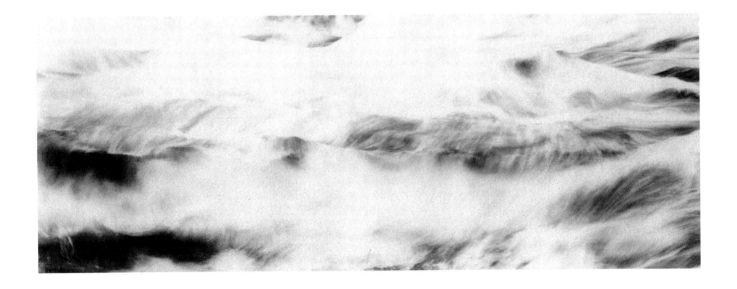

Title Motion XII, 2002
Dimensions 35 × 13 in.
Paper Japanese Mulberry
Camera Format 4 × 5
Location Acadia National Park, Maine

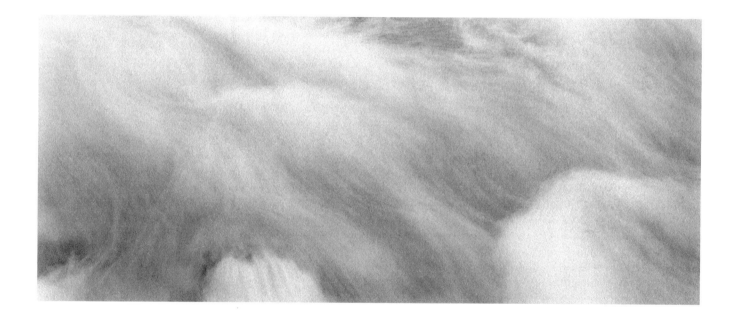

Title Motion III, 2002
Dimensions 35 × 14 ½ in.
Paper Japanese Mulberry
Camera Format 4 × 5
Location Yosemite National Park, California

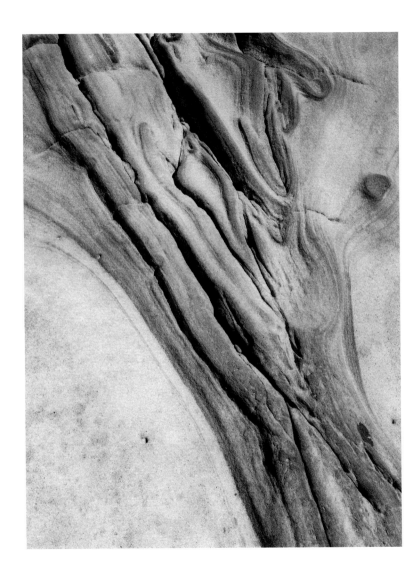

Title Rock Forms I, 2002
Dimensions 20 × 26 ⁵/₈ in.
Paper Hahnemühle William Turner
Camera Format 4 × 5
Location Point Lobos State Park, California

Title Rock Forms II, 2006
Dimensions 20 × 26 ⅝ in.
Paper Hahnemühle William Turner
Camera Format 4 × 5
Location Gros Morne National Park, Newfoundland

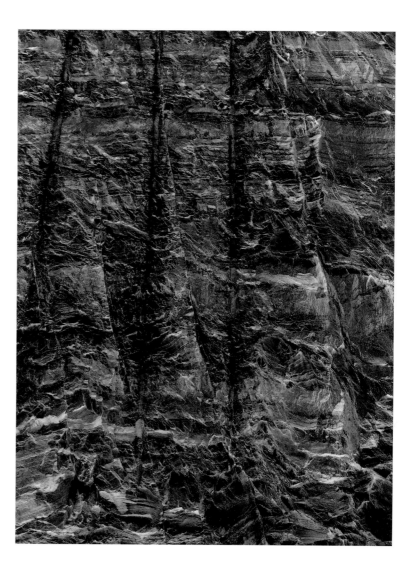

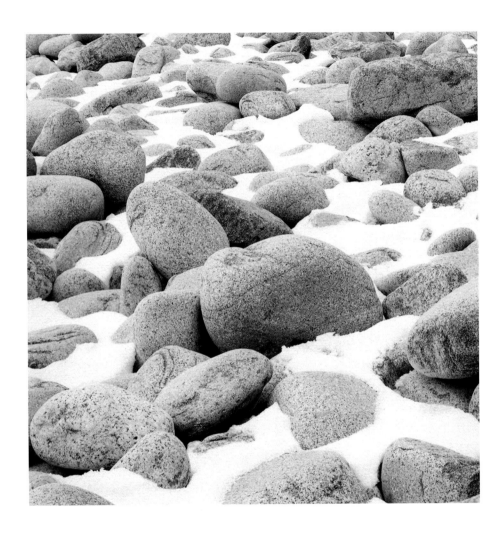

Title Otter Cliff Beach, 2002
Dimensions 18 × 18 in.
Paper Hahnemühle William Turner
Camera Format 4 × 5
Location Acadia National Park, Maine

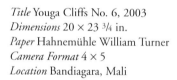

Title Youga Cliffs No. 6, 2003
Dimensions 20 × 23 ³/₄ in.
Paper Hahnemühle William Turner
Camera Format 4 × 5
Location Bandiagara, Mali

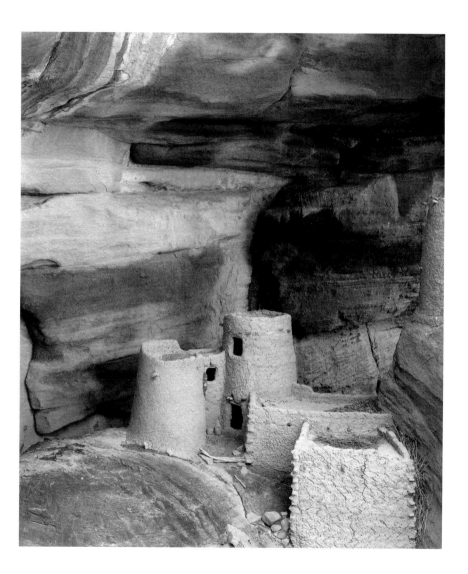

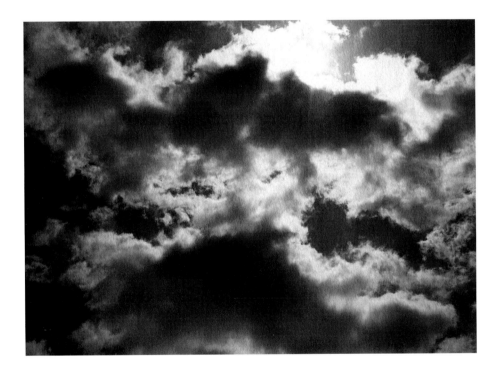

Title Clouds I, 2004
Dimensions 7 × 5 in.
Paper Hahnemühle William Turner
Camera Format 6 × 9
Location Shimoda, Japan

Title Forest Clouds, 2006
Dimensions 7 × 4 ⁵/₈ in.
Paper Hahnemühle William Turner
Camera Format 35mm
Location Gros Morne National Park,
 Newfoundland

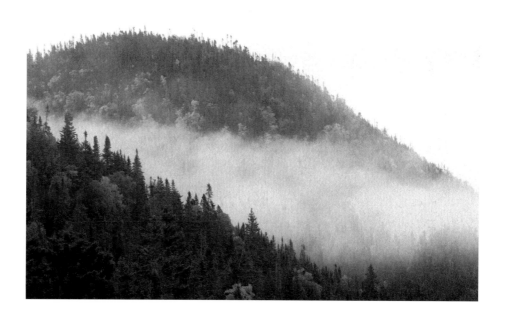

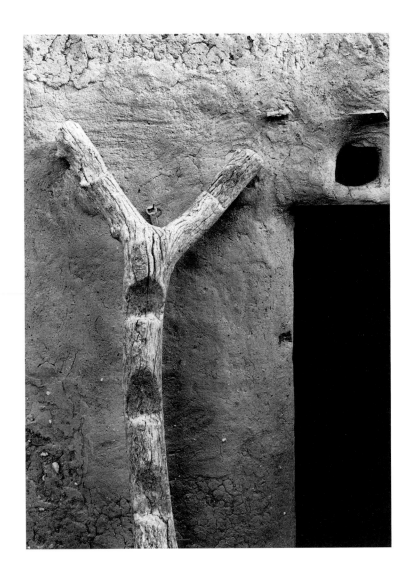

Title Ladder, 2003
Dimensions 16 × 22 in.
Paper Hahnemühle William Turner
Camera Format 6 × 9
Location Bandiagara, Mali

Title Winter Forest, 2002
Dimensions 30 × 40 ³/₄ in.
Paper Japanese Mulberry
Camera Format 4 × 5
Location Tillamook, Oregon

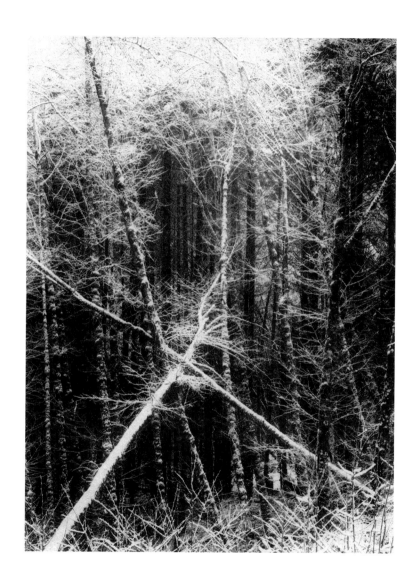

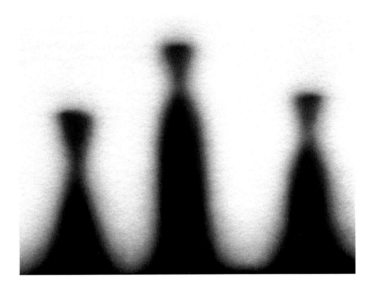

Title Shadow Series III, 2002
Dimensions 3 ¹/₂ × 2 ⁵/₈ in.
Paper Hahnemühle William Turner
Camera Format 35mm
Location Studio

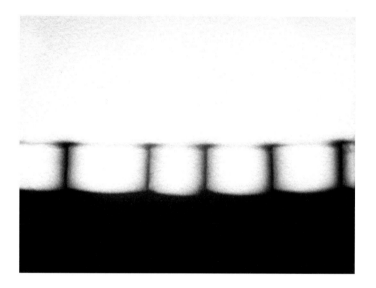

Title Shadow Series I, 2002
Dimensions 3 ⁵/₈ × 2 ³/₄ in.
Paper Hahnemühle William Turner
Camera Format 35mm
Location Studio

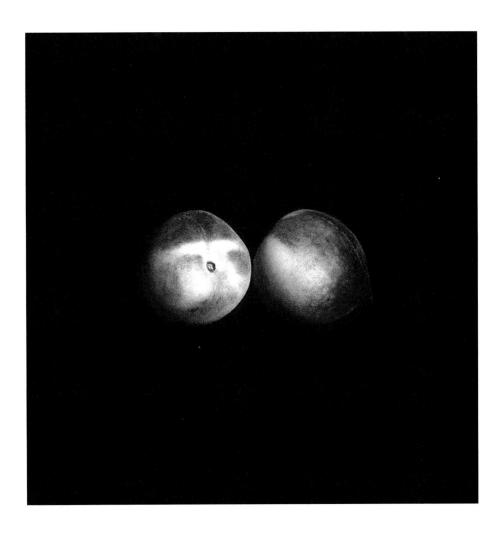

Title Peaches No. 2, 2001
Dimensions 10 $\frac{1}{4}$ × 10 $\frac{1}{4}$ in.
Paper Innova Cold Press Art
Camera Format 35mm
Location Studio

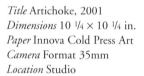

Title Artichoke, 2001
Dimensions 10 ¼ × 10 ¼ in.
Paper Innova Cold Press Art
Camera Format 35mm
Location Studio

2

Building the Digital Darkroom

One of the more daunting tasks confronting any digital photographer is choosing among the large number of hardware and software options. In this chapter, I'll take an in-depth look at the tools you need to outfit your digital darkroom.

A credit card and a quick trip to any big box retailer will allow you to generate a print from a digital file. But producing the highest caliber of digital output requires identifying tools that will complement, if not enhance, your creative vision. The digital workflow is a cumulative process. Each component must work in concert, maintaining the integrity of the image file. Within your digital darkroom, there are likely to be items that vary significantly in quality—for example, a powerful computer paired with an aging monitor. I believe that creativity flourishes best when your tools are consistent in performance. I do recognize, however, that most of us must work within a budget, so I will discuss equipment in order of its relative importance to fine art digital imaging. With these priorities in mind, you can allocate resources in a way that addresses your most pressing equipment needs.

While this book is obviously written with black-and-white output as its focus, the information in this chapter is relevant to the needs of any serious photographer. I'll highlight important technology features and discuss ways to optimize tools for the most efficient use. I'll begin each equipment section with a look at what I've chosen to use in my own studio. At the end of this chapter, you'll find a brief *Savvy Shopper* guide with a recap of features to consider when outfitting the digital darkroom. By necessity, this chapter is sprinkled with some computer geek terminology and acronyms. I promise that it won't hurt too much. And by understanding some basic technology concepts, you will be better prepared to see beyond the marketing hype and make informed decisions when shopping for equipment.

Surviving the Technology Treadmill

Digital photography has many benefits when compared to the traditional darkroom. Sadly, cost is not one of them. Yes, you can eliminate film and development expenses, but many of the digital tools are on the cutting edge of technology and priced accordingly. On

top of that, rapid development cycles mean you will end up replacing equipment much more frequently than you ever did in the wet darkroom. In the never-ending effort to make hardware and software tools more powerful and easier to use, compatibility with older equipment is often sacrificed. There is simply no digital equivalent to the 20-year-old darkroom enlarger that still works seamlessly with current lenses, films, and papers.

Let me be very clear: In the digital darkroom, equipment upgrades are simply unavoidable. But you can limit their occurrences by clearly identifying your needs, purchasing the appropriate tools, and closely evaluating the benefits, if any, that new versions provide. Just because a product is new does not mean it is better suited to your needs. In my studio, for example, I have been producing fine art black-and-white prints for years using RIP (Raster Image Processor) software that is now two full versions behind the current release. While the upgrades I resisted included improvements in many areas, the features I care about and use the most perform just as well in my original version.

The lure of the upgrade is hard to resist. But remember that replacing equipment requires not only an investment of money, but of time. Adapting to a new user interface, understanding new features, and working around new bugs that may have cropped up are all things that take time away from producing images. So in the following sections, I'll look specifically at the features relevant to consistent production of high quality images. And when the next "must-have" product is announced, you can more easily determine whether it warrants a place in your toolbox.

IN THE STUDIO...

When the Eizo ColorEdge CG21 was announced in 2003 (see Figure 2.1), it signaled a breakthrough in LCD performance, rivaling many of the top CRT displays in color accuracy and shadow detail. Other important features were DDC (Display Data Channel) communication and a 10-bit internal LUT (lookup table) for precise and accurate calibration.

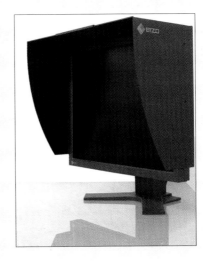

Figure 2.1 My switch to LCD monitors came in the form of an Eizo ColorEdge CG21. It has a smaller footprint but a larger viewable area than the CRT it replaced.

Monitors

Yes, that's right, I'm putting the monitor ahead of the computer. Why? Because the monitor is the lens of your digital darkroom. It is the primary interface you have with your image. Simply put, you can't edit what you can't see.

Photographers are notorious for choosing their particular camera brand based on the quality of its "glass." In this vein, I strongly recommend that the addition of a high quality monitor be your top

equipment priority. It's that important. Make no mistake—the price tags of monitors developed for critical imaging represent a large investment in your art, rather than an impulse buy. But without an accurate visual representation of your on-screen images, it is very difficult to achieve consistent results. It may seem obvious that color images require accurate renditions of hue and saturation, but grayscale images also benefit from a display that can distinguish subtle shadow details and provide a uniform and neutral tone across the entire screen.

A Laptop Limitation

The relatively poor performance of laptop screens makes them uniquely unsuited for critical evaluation or editing tasks. Small screen size, uneven illumination, and a limited viewing angle are just a few of their shortcomings.

Are LCDs Ready for Prime Time?

Just a couple of years ago, one of the livelier debates was whether or not LCD screens were on a par with CRT displays for critical image evaluation. Display manufacturers have since rendered that discussion moot. High-quality CRTs are no longer in production. The industry has shifted to flat screen LCD monitors. You may find some high-end refurbished CRTs here and there if you look hard enough, but any new models on the shelves of retailers are of low quality and best avoided for image evaluation. The good news is that the best LCD displays now compare favorably with the CRTs they have replaced.

The space-saving appeal of LCDs is undeniable. They also consume a fraction of the energy of a CRT and give off much less heat—a consideration when you have lots of computer equipment in the same room. And LCDs provide for much more comfortable view-

ing. While a CRT must constantly redraw the screen image—that's what makes the screen flicker—to compensate for phosphor decay, the pixels on an LCD simply remain in an on or off state. The benefit? No more eye fatigue, even after a long day in front of the screen.

One of the first things that photographers notice when moving to an LCD is how much sharper the on-screen image appears. A good LCD can show intricate detail that was often lost to fuzziness on a CRT. This is, without doubt, a good thing, but it can be disheartening because you can easily spot flaws and defects in some of your prized images!

The backlights illuminating LCDs produce significantly higher brightness levels than CRTs were capable of achieving. Monitor brightness is measured in candelas per square meter (cd/m2). Today, it is not uncommon to see specs of 300 to 400cd/m2. And while there is no practical image editing use for such a high setting—you'd need to wear sunglasses—you can comfortably work at 120cdm/2. CRTs were typically run between 85–95cd/m2 in order to retain optimal contrast. Since the monitor's light source should be among the brightest elements in the room, CRTs required very dim lighting conditions. Anyone who's spent hours hunched over a screen in the dark can certainly appreciate the benefit of higher ambient light levels. Note, though, that the ability to work in a brighter room does not eliminate the need to control ambient light, a topic I will discuss in "Color Management Concepts" later in this chapter.

From Screen to Print

Improvements to screen brightness and contrast should not obscure the fact that fine art images are ultimately destined for print. And no reflective material (print) will achieve the gamut, brightness, or contrast range of its transmissive (on-screen) counterpart. LCD technology further exaggerates this difference and must be accounted for through color management controls like device profiling and soft proofing.

Given the premium prices charged for LCD displays, it seems a fair question to ask about their longevity. Unfortunately, as a newer technology without a long track record, it is hard to give a definitive answer. We know from experience that the light source in a CRT could provide anywhere from three to five years of color critical performance. The backlights that illuminate LCD screens are thought to have a useable lifespan of perhaps 30,000 hours. Powered on eight hours a day, seven days a week, that translates to about 10 years—in theory. The more cynical among us will note that most LCD vendors offer either three or five year warranties. Where does the truth lie? We'll simply have to wait and see.

Screen Real Estate

As a rule, displays optimized for critical imaging begin at 19 inches in size. Unlike CRT displays, when an LCD is advertised as 21 inches, you actually get 21 inches—measured diagonally—of viewable screen area. For LCDs larger than 21 inches, the trend is now toward a widescreen format ratio, with widths 1.6 times that of the height. The extra horizontal real estate allows you to keep tool palettes open in applications like Adobe Photoshop, while retaining a sizeable image window.

Before you plunk down for the largest display you can find, be aware that LCDs have fixed, or native, resolutions. The more resolution (pixels) you cram into a given space, the smaller the screen text and icons. While you can change the resolution through software trickery, this leads to a noticeably degraded image. I suggest that you visit a retail store and make sure that on-screen items, particularly text, are easy to read on the screen size you are considering.

If your eyesight, spouse, or both balk at a 30-inch behemoth, a dual display setup, seen in Figure 2.2, is an attractive option. On both Macs and PCs, the appropriate video card allows for an extended display desktop. You can designate the larger monitor as your main display and use a smaller cheap display to hold tool palettes and dialog boxes. Using the mouse, you can seamlessly scroll between monitors, mimicking their physical relationship on your desk. A dual display configuration of a 21- and 15-inch monitor will result in more horizontal screen area than a single 30-inch display. A final benefit of this approach is that the inexpensive "palette monitor" can be used to preview your Web images as they may appear to an audience without calibrated displays.

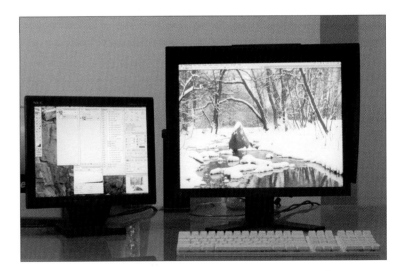

Figure 2.2 In a dual display configuration, the larger, calibrated screen is used for evaluation and edits, while the inexpensive monitor keeps Photoshop's numerous palettes and dialog boxes from obscuring views of the full screen image.

Judging Screen Quality

Monitor specs are notoriously poor indicators of image quality. After all, the actual screens are made by a small handful of manufacturers. Each monitor vendor adds its own color processing circuitry, video lookup tables, and other features aimed at optimizing image display. Quality control tolerances can also vary from one company to the next. It is quite common for identical screens appearing under different brand names to result in monitors with significantly different real-world performances. Furthermore, a degree of variation from unit to unit can exist even within the same make and model. Given that you can't unpack a monitor and test it in the store, it's a good idea to ask about exchange policies when deciding where to shop.

Once you get the monitor home, though, there are some observable qualities that set a top-tier display apart from a lesser one. A display must exhibit uniform and neutral illumination throughout the entire screen. A grayscale image should be just that, gray with no colorcast. A quick test for screen uniformity is shown in Figure 2.3.

You also want to be able to see a smooth gradation of tones from white to black. Figures 2.4 through 2.6 show you how to create a simple gradient test. For a meaningful evaluation, you should first calibrate and profile the monitor.

Figure 2.3 Duplicate an image in Photoshop and move the copies to various locations on the screen. If you detect shifts in color or brightness, your display has issues that are not likely to be solved, even with calibration and profiling.

Figure 2.4 Make a full-screen RGB gradient in Photoshop by going to File> New and entering the pixel dimensions of your monitor. Photoshop CS3 (seen here) offers a convenient drop-down menu of Web presets that lists common monitor resolutions.

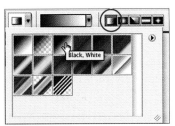

Figure 2.5 Select the Gradient tool (G). Under the Gradient picker fly-out menu select the Black, White gradient. Make sure that the Linear Gradient icon (circled) is also selected.

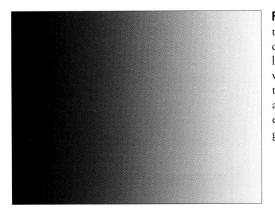

Figure 2.6 Holding the Shift key down, draw a horizontal line across the image window. Set the view to full screen mode at 100% and examine the resulting gradient, shown here.

Figure 2.7 Again in Photoshop, create a new file, this time with pixel dimensions of 1024 by 768, a resolution of 72ppi, an image mode of 8-bit, a white background, and a working space of sRGB, so our numbers will match.

Figure 2.8 Draw a marquee that selects the bottom half of the image area. Fill it with an RGB value of 0, 0, 0.

Figure 2.9 In the top half of the image, draw a smaller marquee and fill it with RGB values of 250, 250, 250. In the bottom half of the image, draw a similar-sized marquee and fill it with RGB values of 6, 6, 6.

While examining the gradient, keep in mind that this is a brutal test, and few monitors will be completely free of slight vertical bands. But if you see abrupt breaks in tone or color shifts in the shadows, this display may not be the best choice for image editing.

A quick way to find the usable endpoints of your display is to compare neighboring tones in both deep shadow and bright highlight regions. In Figures 2.7 to 2.9, we will create a test of a monitor's ability to separate detail.

The patch overlays in Figure 2.9 represent print values of 2 percent ink over paper white and 98 percent ink over 100 percent. If you can see all four tones on your screen, rest assured you can see well into highlights and shadows of whatever you can print on paper. On high-quality and well-calibrated monitors, you can distinguish

even subtler differences, like an RGB value of 3, 3, 3, which equals 99 percent ink over 100.

Due to the extreme contrast in this image, it may be easier to distinguish the dark patch by zooming in and eliminating the white area from view. If it is still not visible, try again, this time increasing the RGB values. But if you end up at values of 11, 11, 11 or higher before you can distinguish between the shadow tones, your monitor, calibration, or both need some attention.

One of the more publicized complaints with LCDs centers on the issue of either dead or stuck pixels. Although production quality continually improves, manufacturers find it challenging to produce a display without a single defect in any of the millions of pixels that fill the screen. A dead pixel will not "open up" to allow light to pass through. It will show up as a constant black speck on the screen. A stuck pixel, on the other hand, cannot completely seal off the backlight. It can be white, red, blue, or green, depending on whether all or just some of its underlying subpixels are defective.

To check for defective pixels, use Photoshop to create a white image matching the dimensions of your monitor and look for a dark speck. To check for stuck pixels, simply create a black image at the same size and look for a white or colored spot. I should warn you that there is no uniform policy among monitor companies regarding the number of defective pixels they consider to merit a replacement. I wouldn't bet much on your chances for replacement due to a single defective pixel wedged in the corner of the screen. But I would certainly hope for a quick remedy for a group of dead pixels sitting smack dab in the middle of the display.

Low quality LCDs are plagued by such narrow viewing angles that if you tilt your head even slightly, colors and contrast will noticeably shift. Try watching a video clip on a laptop with two other people, and you'll see what I mean. A viewing angle of 170 degrees is typical among higher-end displays. Whatever the spec, you should

be able to view the screen from normal angles and see a consistent image with no shifts.

A monitor hood, seen in Figure 2.10, is a great way to prevent ambient light from spilling onto your monitor. This device can improve visual perception of subtle shadow detail. And perhaps just as importantly, it signals to visitors that you are an image editor to be reckoned with!

Figure 2.10 Many vendors of high-end displays sell custom-fit monitor hoods as an accessory. If you balk at having to pay $150 for such a device, some black foam core and double-sided tape can provide sufficient—if decidedly less stylish—protection.

Alphabet Soup: DVI, DDC, and LUTs

At the risk of stating the obvious, both your computer and LCD monitor are digital devices that understand your images as collections of ones and zeros. It is important that the connection between these two be digital as well. Enabling a digital signal to pass from the video card to the monitor without analog degradation ensures that the highest quality image is transmitted to the ultimate viewing device—your eyes. An all-digital connection requires that both the video card and monitor have a DVI (Digital Visual Interface) port. Fortunately, this is now a standard option on all but the least expensive equipment. Still, for the sake of compatibility, monitors

often come with two sets of cables, DVI and VGA, as seen in Figure 2.11. The latter is analog-only, so always use the DVI cable.

Figure 2.11 A DVI cable (left) allows for the transmission of either digital or analog signals, depending on the capabilities of the connected hardware. The VGA cable on the right transmits only analog signals.

DDC is a technology standard that predates the widespread emergence of LCDs, but it plays a crucial role in their proper calibration, which I will demonstrate in "Calibration and Profiling: Kissing Cousins" in Chapter 3.

DDC protocols allow for two-way communication between the video card and monitor. Software engineers have leveraged this technology to make monitor calibration significantly easier for the end user. Often referred to as "push button" or "DDC enabled" calibration, you no longer have to fiddle with buttons adjusting brightness or contrast to match on-screen prompts. You simply choose white point, luminance, and gamma settings and let the video card and monitor automatically determine optimum values. Aside from convenience, this method produces much more accurate results. Subtle refinements, impossible to achieve with buttons on the monitor, can be made to a much more objective reference than is possible by eye.

This enhancement in communication between the video card and monitor has paid dividends in the on-board processing that occurs

inside the monitor itself. Commercial video cards are 8-bit processors, capable of showing 256 distinct tones from white to black. The gamma adjustments necessary for monitor calibration unfortunately reduce the number of available tones to a level below 256. This can lead to visually noticeable banding in what should be a continuous grayscale. To address this shortcoming of video cards, the better monitors incorporate an internal 10- or 12-bit LUT and perform the gamma adjustments internally. Because the internal LUT starts with a much higher number of grays—1,021 for 10-bit and 4,081 for 12-bit—the monitor can always return a full 256 shades of gray to the video card after calibration. The result is a smoother rendition of tones and improved shadow detail.

IN THE STUDIO...

From left to right (see Figure 2.12), my studio setup includes a PC to run Windows-only scanning and printing software; a PowerMac G4 that functions as a print and backup server; a network attached storage device for client backups; a four-drive external scratch disk for Photoshop; an uninterrupted power supply (UPS); and my editing workstation, a Mac Pro. A gigabit Ethernet router is underneath the stand.

Figure 2.12 Computer hardware can pile up quickly in the digital darkroom.

Computers

Okay, so it's a no-brainer that you need a computer for digital imaging. But a system optimized for digital photography looks much different and costs significantly more than one intended for spreadsheets and e-mailing. Even among high priced models, there are configuration options that make digital imaging a more efficient and reliable experience. The goal here is not to buy the most expensive computer on the market, but to purchase a system that is flexible enough to meet your current needs while providing expansion options that allow you to take advantage of upcoming technologies. Having said that, computer purchases are decidedly short-term investments. It's been my experience that every four to five years, the increased power and processing demands of new hardware and software require the purchase of a new computer if you want to work at anything other than glacial speeds.

Platform

Mac or PC? Which is better for digital imaging? Let's see, on a Mac you can create stunning images that convey your artistic vision. With a PC, you can create stunning images that convey your artistic vision. Gaps in performance and price are virtually nonexistent. Intel, a longtime developer of the microprocessors that drive most PCs, now supplies these same chips for Macs. The same monitors, hard drives, FireWire, USB, and networking devices can run on either type of system. While there are software titles that only run on a single platform, these are much more the exception than the rule in digital photography. It's worth mentioning that the feature set of Photoshop remains identical on both platforms.

The only significant differences revolve around the current operating system (OS) for each platform. Apple's OS X has undergone several major upgrades since its launch in 2001, providing user interface enhancements, increased metadata support, and enhanced memory allocation for Photoshop. This year Microsoft responded with its long-awaited new OS called Windows Vista. In addition to a new user interface, this release offers built-in importing, organizational, and sharing capabilities specifically targeted for digital image files.

I'll come clean. I have always preferred using Macs. Almost all of the screenshots you'll see in this book are from OS X. I find color management to be a more seamless experience than on Windows. And Macs are simply what I am used to working on. I know my way around the neighborhood, if you will. But with well over 90% of the OS market, Microsoft must be doing something right. I would, however, lose my Mac aficionado membership if I didn't point out one benefit of Apple's tiny market share—OS X is not yet an attractive target for Internet worms and viruses.

At the end of the day, the choice is one of personal preference. It's not as if you can walk into a gallery, look at a photograph, and say, "Oh, that was made using a Mac." Unless you have other compelling reasons to switch from a Windows or Mac system, it's a far better use of your time to build a system around the OS with which you're already comfortable.

Hardware

If it's been a few years since you shopped for a computer, the good news is that anything you buy is going to be many times faster than what you are replacing. In the brief sections that follow, I'll highlight components that play the biggest role in meeting the demands of digital photography.

Processor

Photoshop, like most other image editing software programs, is built to take advantage of multiple processors. We've grown so accustomed to the manipulation of pixels that it's easy to forget these tasks

actually require that a lot of complex calculations be performed and then visually rendered on-screen. For quite some time now, it has been possible for a single computer to house two processors. When large calculations are required in a dual processor machine, the instructions are split between each processor, allowing both of them to work on the task simultaneously. As you can imagine, this drastically reduces the time needed to complete the request.

More recently, the quest for greater processing speed and reduced power consumption has led chipmakers to fabricate multiple processors onto a single piece of silicon. Stick two quad-core chips in a computer, and you've got a total of eight processors, ready and waiting to crunch data. Just how many processors can you fit on a single chip? Well, computer geeks are already salivating over the prospects of 16-core chipsets. But I digress. The point is that you want a computer with at least two processors. Apple makes it easy. It has eliminated single processor machines from its entire lineup. Multiple processor offerings from PC vendors are also readily available.

Memory

The surest way to slow down a powerful computer is to run it with the recommended minimum amount of RAM (Random Access Memory). A computer's memory acts as a temporary storage space for data that the OS and other software applications can access at very high speeds. With an abundant supply of RAM, a single application will run faster, and you can keep multiple applications open at the same time.

The speed of virtually every task in Photoshop is related to the amount of RAM available. More RAM means less time watching progress bars. The need for RAM is dictated largely by image sizes. Larger images simply use up more memory. So when eyeing that new higher resolution digital camera, be sure to consider whether you'll need a RAM upgrade as well.

When you launch Photoshop, the program sets aside a chunk of memory for its use, even before an image file is created or opened. The amount will vary depending on how much RAM is installed and your Photoshop preference settings. On my Mac, it is usually around 75MB. Of course, Photoshop's not very useful with no images open, so RAM allocation quickly increases. Some of the more common memory hogs in Photoshop are layers, filters, plug-ins, and masks. Working in16-bit mode also greatly increases file size and thus memory usage. I recommend 3GB of RAM on a PC and 4GB of RAM on a Mac as sensible targets for those working with high-resolution image files. This may sound a bit excessive, but if a significant portion of your image editing is spent waiting for a RAM-starved computer to complete tasks, you will be amazed at the speed benefits that additional memory can provide.

Storage

According to a recent study, most people underestimate their weight. I'm sure they didn't mean you, but I bet most photographers do underestimate their storage needs. Why? For starters, many of us are still in the process of digitizing our film archives. Even if we stopped creating new images, working through years' or decades' worth of work will require increases in storage capacity.

Remember how digital cameras are supposed to allow us to shoot fewer images, because we can check results on the spot? The reality is that freed from film constraints, most of us now shoot with impunity. And each new generation of cameras produces larger and larger files. Furthermore, in a sound workflow, multiple versions of every image exist—a raw file, master file, and print-ready file, for example. After all of this, we then need the space to back up these images. So for many photographers, storage quickly becomes one of the most pressing concerns.

It's useful to consider storage in two broad categories: internal and external. Today's internal drives use a SATA (Serial Advanced

Technology Attachment) interface, seen in Figure 2.13, that is capable of very fast transfer speeds. To take full advantage of these speed benefits, look for SATA drives with a 7200rpm spindle speed and 8MB or higher disk cache.

Figure 2.13 The physical dimensions remain the same, but a hard drive with a SATA interface allows for faster data transfers. The SATA spec also uses thinner cables and smaller connectors, making drive replacement much easier. *Image courtesy of Western Digital*

Because of its optimized pathway or bus to the computer, internal drives are generally faster performers than external drives. Look for a computer that allows for at least one additional internal drive. This is a good place to house your working files—images you need to access on a regular basis. They will open and save faster than if stored on an external drive. Once the files are no longer needed for editing, they can be moved to an external drive, creating space for the next batch of working files.

The beauty of external drives is that there is virtually no limit to the number you can connect to a single computer. FireWire has proved to be the most popular way to add external storage. A FireWire enclosure still contains a hard drive—in this case, the slower ATA version. It derives its name from the interface it uses to communicate with the computer. FireWire drives can be disconnected without shutting down the drive or computer, making them an easy way to move data between locations. FireWire drives can also be daisy-chained, as explained in Figure 2.14. Although they are not as speedy as an internal SATA hard drive, FireWire provides faster performance than USB, at only a nominally higher price.

Figure 2.14 Ever wonder why FireWire drive enclosures come with two ports? Because multiple units can be daisy-chained or piggybacked with only a single enclosure actually plugged into the computer or hub. The FireWire spec allows for up to 64 devices to be connected in this manner. *Image courtesy of LaCie*

PCI Expansion

No matter how well you choose a computer system, there will inevitably emerge useful technologies and unforeseen needs not directly supported by your machine. One of the allies in the fight against obsolescence comes in the form of PCI expansions slots. These are empty bays in the back of the computer that can be fitted with industry standard cards to provide either new or expanded functionality.

FireWire and USB ports, wireless networking, faster storage interfaces, and support for higher resolution monitors are among today's many upgrades available for older computers through the use of PCI cards. Cards like the one shown in Figure 2.15 allow a new computer to continue using legacy equipment. Over time, a few PCI slots on your machine are bound to go a long way.

Figure 2.15 The majority of computers sold today do not include a SCSI interface. If you need this capability—to drive a drum scanner, for example—a PCI card can add SCSI ports to your computer quickly and easily.

Video Card

A robust video card allows for large displays to be connected, as well as dual-display configurations. A must for any video card is a DVI port for connecting the display. This port provides an all-digital signal from the computer to the monitor, ensuring the highest on-screen image quality. Support for 30-inch displays, DVI connectivity, and dual display support are common features on all but the lowest end of video cards. A card that is capable of dual-display support will be obvious. It will have two DVI ports on the back. A telltale sign of whether or not a card can support the larger displays is the amount of video memory or VRAM it contains. Most any card with 256MB of VRAM will allow you to drive a 30-inch LCD.

Until recently, photographers did not need to seek out particularly powerful video cards, leaving that domain to the gaming crowd. But more and more applications are now offloading complex imaging tasks to the video card's on-board processor, or GPU (Graphics Processing Unit). The advantage of manipulating data directly in the video card is that the computer's processors are then free to work on complementary tasks simultaneously. It's like hiring more workers to take on a bigger job and finish it faster. We can now apply filters and effects in real time. The drawback is that applications that are making substantial use of GPU processing power will not work with older, less powerful video cards. And you didn't believe me when I said upgrades are unavoidable.

Video Card Compatibility

When shopping for a new video card, make sure you purchase one designated for your operating system and computer model. Cards built for Windows generally will not work on a Mac, for example. And within each computing platform exists different and incompatible types of video card slots that can vary from model to model.

Input Devices

A big boost in both comfort and productivity can be achieved when you replace your standard mouse with an input device suited for precise editing and easy navigation of a large screen. Wacom makes a range of pen tablets that are *de rigueur* for many professional photographers, retouchers, and designers (see Figure 2.16). The tablets come in a variety of sizes and allow you to draw shapes and selections as if you were using a pen and paper. Photoshop automatically recognizes the presence of a pen tablet and provides a number of customizable options. You can vary opacity settings on the fly, simply by adjusting pen pressure as you draw. Flip the pen over to its "eraser," and Photoshop temporarily switches to its Eraser tool.

A tablet can help in general screen navigation as well. Each point on the tablet has a corresponding point on the screen. Place the pen in the upper-right corner of the drawing area, for example, and your cursor automatically appears in the upper-right corner of your screen. With a little practice, you can avoid scrolling by simply pointing the pen over the appropriate area of the drawing surface.

Of course, there are times when holding a pen in your hand is not practical—writing this chapter, for instance. But instead of reaching for a traditional mouse, I have become quite fond of trackball devices in which the unit remains stationary while you swivel a large ball that rests on top. With a large ball, seen in Figure 2.17, you have a surprisingly fine degree of control over cursor movement. If a pen tablet seems a bit extravagant for your taste or budget, a good trackball is a vast improvement over a standard mouse.

Whether you upgrade to a pen tablet or a trackball, you'll soon wonder how you ever managed all this time with the mouse that came bundled with your computer.

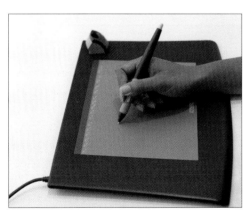

Figure 2.16 A Wacom pen tablet, such as this Intuos 6 × 8 model, allows you to create and modify masks and selections in a very intuitive manner. There is even a customizable strip along the top with menu shortcuts.

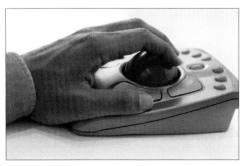

Figure 2.17 This wireless trackball has a large ball that I find much more comfortable to use than a standard mouse. The scroll wheel and four click buttons can be customized for any number of keyboard shortcuts.

Photoshop Speed Boosts

Photoshop, while not the only piece of software in your digital toolbox, does place more overall demands on your computer than any other program you are likely to run. Following the system recommendations I've outlined will give you a machine well suited to digital imaging. The following section is devoted to those on a mission to eke every last bit of performance out of Photoshop. You are by no means compelled to take these steps and can certainly have a fulfilling Photoshop experience without implementing any of them. But if you lie awake at night tormented by the feeling that Photoshop *could* be running faster, consider the options discussed below.

Scratch Disk

Photoshop requires the use of a scratch disk. This is free space on a hard drive used to store temporary data when the available supply of RAM is exhausted. By default, Photoshop designates your startup drive as the scratch disk. This presents a few performance issues. Transferring data to and from a hard drive is much slower than using RAM, as illustrated in Figure 2.18. A full drive transfers data even slower than an empty one. If the OS, Photoshop, and scratch disk all reside on the same physical hard drive, they all must wait in line to read and write data. That's very inefficient.

You can mitigate each of these factors by designating a separate hard drive exclusively to the role of scratch disk. See Figure 2.19 to change the default scratch disk in Photoshop CS3. The drive does not need to be huge. An 80–120GB model should be plenty. Speed is what you're after here. An internal SATA drive with a 16MB cache and 7200rpm or greater spindle speed is just the ticket. Resist the temptation to use this drive for file storage, however. Hard drive transfer speeds decrease as the drive fills up with data.

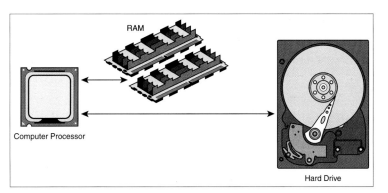

Figure 2.18 The data path between your computer's processor and RAM is much shorter than the one between the processor and a hard drive. RAM uses electrical signals to transmit data, while a hard drive controller must physically locate each bit of data among a series of spinning platters.

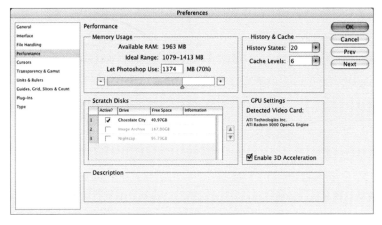

Figure 2.19 To change your current scratch disk, go to Photoshop>Preferences>Performance. The default choice is your startup drive. Check any available drive to designate it as the scratch volume.

RAID 0 Scratch Disk

For the ultimate scratch disk, consider using a RAID (Redundant Array of Independent Disks) configuration. This technology allows you to harness the speed and capacity of two or more hard drives into what your computer recognizes as a single large volume. In a RAID 0 there are other numbered flavors, all of which are beyond the scope of this book, you can have, say, two 80GB drives that are "bundled" together to form 160GB of storage.

The speed benefit comes when Photoshop transfers data to this volume. If 10MB of data are sent to a single drive, that drive must read 10MB of data. But, as shown in Figure 2.20, when 10MB of data are sent to a two-drive RAID 0 configuration, the data is automatically divided between each hard drive. A single drive then has to read only 5MB of data. The benefit is that both drives are processing data simultaneously. So a two-drive setup takes exactly half the time to complete a given task.

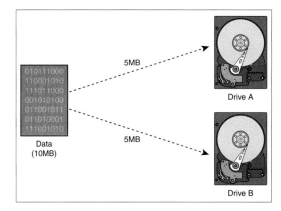

Figure 2.20 In a RAID 0 configuration, the task of reading and writing data is split equally between each available hard drive. In this example, two drives are used in the RAID, so each drive has to process only 5MB instead of 10MB of data. Increasing the number of drives in a RAID decreases the overall time needed to perform the task.

Segregate Working Files

So now you've got both a startup disk and a separate volume dedicated as the scratch disk. If your computer can accommodate a third internal drive, you can achieve further speed boosts by designating a hard drive exclusively for your working files. These are images that you are still editing on a regular basis. Placing them on a fast internal drive, apart from system files, software applications, and other digital clutter will reduce the open and save times for these images. This three-drive approach helps overall system efficiency, as illustrated in Figure 2.21. After image files have completed the editing stage of your workflow and no longer need to be accessed on a regular basis, they can be moved to slower external drives for longer-term storage.

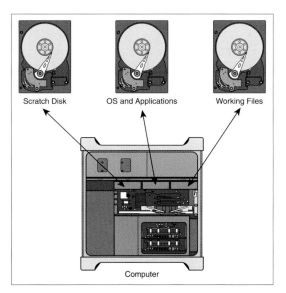

Figure 2.21 You can take advantage of your OS's multithreading capabilities by designating specific tasks to individual hard drives. The computer's processor can simultaneously process data to the scratch disk, manage OS and application prompts, and open and save image files to a working files drive. This is like assigning separate traffic lanes to reduce data bottlenecks.

External SATA

Earlier, I mentioned that external drives usually don't match the speed of internal drives. Here I'll discuss an exception. It is possible to reap the speed benefits of the SATA interface using an external drive enclosure. External SATA technology, commonly referred to as eSATA, provides for the same high performance storage as SATA, but in an external enclosure. The enclosures themselves are available in multidrive configurations. If you are looking to build a RAID for use as a scratch disk, or need a faster storage alternative to FireWire, eSATA is well worth a look.

Configuring such a setup requires an eSATA-compatible PCI controller card, cables, and an external enclosure, seen in Figure 2.22, which will house the actual drives. You use the same type of SATA hard drives normally installed inside the computer. If you've never before purchased an internal drive, these "bare" units omit the case, cable, and power supply, none of which you will need.

Figure 2.22 This SATA enclosure allows for three external hard drives to be accessed just as quickly as if they were housed inside the computer. The enclosure itself contains the power supply and cables necessary to operate the drives.

Back It Up

Without a backup plan in place, your images are about as safe as a budget surplus in an election year. An ugly truth about working digitally is that sooner or later you will lose an image. A hard drive can malfunction. A file can become corrupted. A virus can wipe out entire directories. And who among us has never deleted a file by accident? At some point, you will lose data. That's a given. The question is whether you will be able to recover it. A thorough discussion of available backup options and strategies is beyond the scope of this book, but I do want to highlight a few key areas to consider when choosing among the available backup solutions.

Automated Scheduling

Your backup solution must run automatically on a defined schedule. A backup plan that relies on you to 1) remember to do it and 2) take time out of your day to do it is guaranteed to fail. Data protection depends on regular backups that happen without fail. Each time you forget to run a backup or get too busy to do it, your data is compromised. And, if you believe in Murphy's Law, the day the backup doesn't get done will be the same day you actually need it.

Creating an automated schedule requires that you consider carefully the frequency of backups. If you shoot images every day, it is clear that backing up once a month does not offer much protection. You also want to protect the investment of time you have committed to editing your images. How much time are you willing to lose repeating work on an image that gets lost, corrupted, or accidentally deleted?

Verification

You also need a way to verify that the backup actually took place and copied all the files you were expecting to be copied. Of course, you don't want to have to spend time poring through backup logs, so some form of error message should display if things don't go according to plan. Even better is an e-mail alert that you can access from anyplace with an Internet connection. The main idea here is that

you have the confidence that your backup data is ready and waiting should you need it.

Recovery

In the event of data loss, you don't want to have to read through a manual or call tech support just to figure out how to restore your data. Data recovery should be a simple and relatively quick procedure that can be done with a minimum of effort. The easiest method of recovery is to drag-and-drop files between hard drives or folders. While arguments can be made for compressed backup files located in password protected directories, make sure that you actually know how to restore using these files. Performing a practice restore before any actual data loss occurs will increase your chances for a successful recovery in the real event.

Backup Types

In backup jargon, you'll invariably come across two common terms. A *source* can be an entire hard drive or just a single folder. It contains the data you want to back up. A *destination* can also be an entire drive or a single folder. It will contain the backup of the source data.

Full backups erase a destination and then copy files from the source. This is the simplest form of backup and ensures that the destination contains only the current source files.

Incremental backups also copy files from the source to the destination. But since the destination is not erased, the existing files on the destination are first compared to the current files on the source. Only the source files that have changed since the last backup are copied to the destination. There are two inherent benefits. By copying only files that have been modified, subsequent backup times are reduced to minutes instead of hours. A less obvious factor is that a file that has been deleted from the source will remain available on the destination. An incremental backup will only delete destination files when an identically named source file with a newer modification date exists. So if you trash a file on Tuesday that was backed up on Monday, you can still recover it. Over time, the destination can

grow significantly larger than the source since it holds onto copies of source files you have deleted.

Archive backups treat updated files much differently. Imagine that file A exists on both the source and the destination. If file A is modified on the source, an archive backup will not write over the old version of file A. Instead, it will store both versions of file A on the destination. This means you can go back in time and retrieve earlier versions of any current file. Be aware, though, that maintaining all these versions will make the destination grow significantly larger than the source.

IN THE STUDIO...

While a drum scanner has well-documented image quality advantages (see Figure 2.23), I still find uses for my flatbed scanner. With its 8.5 × 11-inch transparency adapter, I can quickly scan an entire sleeve of negatives to make a digital contact sheet.

Figure 2.23 My Howtek drum scanner (left) takes up a lot of space, requires careful film preparation, and is much slower than my Epson 1680Pro flatbed scanner (right). The quality of capture, however, greatly outweighs the inconveniences.

Scanners

Even if you're now shooting exclusively with digital cameras, chances are that you've got a substantial library of film negatives and slides. The quality of your scanner is going to have significant ramifications for these images throughout their digital life, from preservation of image detail to maximum print size. Photoshop may indeed allow you to take lemons and make lemonade, but you still can't make a silk purse from a sow's ear.

Unfortunately, the enormous popularity of DSLRs has shifted the industry's focus away from scanner development. New models appear at a fraction of the clip they did just a few years ago. The good news is that current scanners are capable of very good results. And the model you buy today won't be obsolete next month. Let's take a look at some of the areas in which scanner performance impacts your images.

Film Format

The first thing to determine when considering a particular scanner is whether it will accept your chosen film format(s). Desktop scanners come in two broad classes. Flatbed models are the most readily available and have letter-sized scan beds. Only the more expensive flatbeds, though, can actually scan transparent media of that size. The lower-priced units typically have 4 × 5-inch transparency windows within which to scan film. Flatbeds do double duty and scan reflective media like prints as well. Some photographers even use these scanners as "cameras," placing three-dimensional objects on the scan bed. I'll demonstrate this technique later in Chapter 7.

Dedicated film scanners are generally more compact machines and are optimized exclusively for film. All of these models handle 35mm, and a few can accommodate 120/220 film as well. Scan times are

significantly slower than flatbeds, but film scanners tend to produce larger files with cleaner shadow detail and greater sharpness.

With either type of scanner, the ability of the film holder to keep your film flat is crucial for achieving the sharpest possible scans. A scanner's lens has a very shallow depth of field. Most flatbed scanners have just two focus settings: one for items resting directly on the glass; the other for objects mounted in film holders that raise them a few mm above the glass. While some film scanners boast an autofocus feature, they are still limited to focusing at a single distance with a shallow depth of field. Since many holders simply grasp a thin piece of the film's edges, the center of the film can bow. This occurs most often with 120 film, which may be curled to begin with, and large format film in which a greater mass of film area is without support. When the edges and center of the film are at two different distances from the scanner lens, it is simply not possible for both of them to be in identical focus. And in the resulting scan, one of these areas will be noticeably soft.

Some dedicated film scanners offer glass mount accessories that sandwich the film between two pieces of specially treated glass. While this ensures that the film lays flat from edge to edge, it can exacerbate the presence of dust, simply trapping it between the glass and the film. It is therefore important to keep your scanner in a relatively dust-free environment and give extra attention to cleaning your film just before you scan.

Wet Mounting

Unless you own a drum scanner, you may not be familiar with the technique of wet mounting film. One of the great benefits of a drum scan is that the film is mounted directly to an acrylic drum and wrapped tightly, ensuring a consistent plane of focus over the entire area of the film, as shown in Figures 2.24 and 2.25. But in high-resolution scans, placing film in direct contact with an acrylic

Figure 2.24 Wet mounting on a drum requires a specialized mounting station on which to lay out and position the film on the drum.

Figure 2.25 The roller handle is used to apply even pressure over the surface of the drum as the film is wound tightly around it. Mounting fluid forms a seal between the surface of the drum and the film. Tape is used on all four sides of the Mylar to keep the fluid from leaking as the drum rotates during the actual scan.

or glass surface produces a series of concentric circles known as Newton rings. To eliminate this effect, a specially formulated mounting fluid is used to create a liquid barrier between the film, scanning surface, and a transparent overlay that holds everything in place as the drum spins.

Wet mounting has other optical benefits. The fluid barrier provides a smoother film surface by filling in small scratches and other imperfections. The application of mounting fluid also helps to slide dust off of the film's surface, eliminating hours of post-scan image spotting in Photoshop. High-speed emulsions and overdevelopment can each lead to overly prominent film grain. For my taste, digitized film grain does not have quite the same appeal as its analog counterpart. Wet mounting can help minimize grain in the resulting scan.

Wet mounting certainly adds additional steps and time to the scanning process, and its benefits really come into play only at significant enlargements. But these benefits have drawn considerable interest among fine art photographers. As a result, wet mounting techniques are being used with more frequency on CCD scanners. There are third-party fluid mount film holders available for the popular Nikon Super Coolscan 9000 film scanner. A growing number of photographers are wet mounting with flatbed scanners, as seen in Figure 2.26. When Epson introduced its Perfection V750 flatbed scanner, it drew attention largely because it shipped with its own fluid mount holder, seen in Figure 2.27.

Is wet mounting worth the additional time and learning curve? Figure 2.28 shows one of the primary benefits of this technique. If you have film that bows noticeably in your scanner's holders, you are certainly going to end up with an image that is soft either in the center or toward the edges. You may have numerous post-scan sharpening techniques at your disposal, but they are all edge contrast adjustments meant to trick the eye into perceiving contrast as sharpness. The only way to make a scan optically sharper

is to make sure the film lies flat within the scanner lens' plane of focus. If you shoot with a tripod and capture images with fine detail, it may be well worth it for you to preserve as much optical sharpness as possible.

Figure 2.26 Because the film remains stationary during a scan, wet mounting on a flatbed is fairly straightforward. The film is laid directly on the scan bed, with mounting fluid applied to both sides. A sheet of Mylar holds everything in place.

Figure 2.27 In a first for consumer-level scanners, a fluid mount accessory is included with the Epson Perfection V750 Pro flatbed scanner. *Images courtesy of Epson America*

Figure 2.28 This sheet of 4 × 5 film was scanned twice: once in the flatbed's film holder (top) and a second time wet mounted directly onto the scanner glass (bottom). Wet mounting provided a consistent focus distance across the entire film area, resulting in a sharper scan.

Bit Depth

The tonal range that your image is capable of exhibiting is dependent upon the bit depth of your scanner. Virtually all scanners aimed at the photography market today can capture data beyond 8 bits per channel. The bit number determines how many shades between pure black and pure white can be distinguished. An 8-bit image can display 256 levels, or steps, between black and white. Not bad, until we consider that increasing the rate to 16 bits allows for over 65,000 levels, or steps.

Humans, of course, can't distinguish 65,000 steps between black and white. Even with perfect vision, it's more like 256 steps. But having such ample headroom becomes important once an image is brought into Photoshop. As we'll explore in Chapter 5, Photoshop at its core is a contrast adjustment tool. We are either pulling neighboring tones apart from each other or pushing distant tones closer to each other. In either case, distinct pixel values are lost. If we only have 256 separate tones to begin with, it doesn't take much editing before we can visually detect gaps where a smooth gradation of tone should occur. Starting with a higher bit depth allows for much more substantial image editing without degrading pixel information to the point that it becomes visually apparent. Figure 2.29 shows the advantage of maintaining a large number of levels.

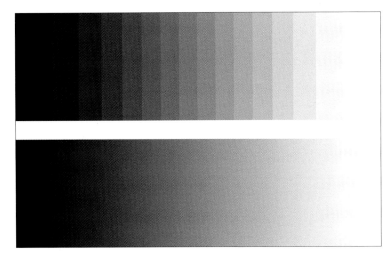

Figure 2.29 Both images start with black and end with white. But the top gradient has only 16 levels with which to distinguish tones. The gradient on the bottom, however, has 256 levels available to describe the range from black to white. It contains sufficient tonalities to create a continuous tone gradient.

Resolution

Photographers have been conditioned to look for ever higher resolution numbers in scanners, but numbers alone tell only part of the story. For one thing, manufacturers often quote both optical and interpolated pixels per inch (ppi). We're concerned only with the smaller optical, or native resolution. This number is a direct result of the actual number of sensors on the scanning head. In the case of flatbed models, you usually are confronted with two numbers even for optical resolution, i.e., 1600 × 3200 ppi. Again, it is the smaller number, in this case 1600 ppi, that reflects the actual sensor count of the scanning chip. The greater the number of sensors, the more detail that can be captured—in theory. In practice, not all scanner chips and methods of collecting and converting analog data are equal. In Figure 2.30, you'll see a drum scan compared to a flatbed scan at identical optical resolutions. This example makes clear that the only thing resolution can absolutely guarantee among different capture devices is identical file size.

Resolution does determine the maximum enlargement percentage and, accordingly, the maximum size of an acceptable print. Just like

in the darkroom, a larger negative requires a lower enlargement factor for a given print size. A photographer shooting 4 × 5 film only needs a resolution a bit over 1400 ppi to print a 16 × 20 inch image at 360 ppi. A 35mm shooter, however, would have to scan film at a resolution of nearly 6000 ppi to reach similar print dimensions.

Capturing film at your scanner's optical resolution involves the least amount of manipulation to the pixel data during the scanning process. When you scan above the optical resolution, pixels are created through interpolation to reach the desired file size. In some cases, scanning below the optical resolution may require the scanner to capture pixels at a higher resolution first and then downsample the image to match your desired resolution. For critical work, I recommend that you always scan at your hardware's optical resolution, whether you're making an 8 × 10 print or a 5-foot mural. The first benefit is that you avoid any software interpolation—up or down—in the scanning software. Photoshop almost always offers higher quality options in this regard. As a practical issue, scanning at the optical resolution allows for a scan-once-use-many approach. If you need to print that 8 × 10 image at 30 × 40 one day, you may already have a file that contains a sufficient number of pixels, eliminating the need to rescan at a higher resolution and then duplicate your original edits.

Dynamic Range

Density is the logarithmic value of the lightness or darkness of an object. The brightest possible white has a density of 0, while a pure black has a density of 4.0. Dynamic range is the amount of this area that a scanner can record. It is often expressed in terms of the scanner's end points. Dmin is the brightest point at which a scanner can no longer see differences, and Dmax is the darkest value that a scanner can distinguish. So a scanner that can accurately read a density of 0.2 as well as one of 3.2 has a dynamic range of 3.

Figure 2.30 Both the drum scan (left) and the flatbed scan were captured at a resolution of1600 ppi with no sharpening applied. It is obvious that the drum scan has resolved more detail, has greater shadow information, and has rendered a sharper image.

Scanners have little problem reading very low densities. By contrast, the interference of digital noise—inherent as the sensor increases sensitivity to accurately read dark values—is where scanner technologies differ. A scanner with a wider dynamic range can be assumed to be reading further into darker areas than a unit with a narrower range. As a rule, drum scanners distinguish higher densities than desktop film scanners, which perform better than consumer flatbed models. While it's easy to be depressed because your scanner doesn't have a dynamic range of 4.0, realize that density end points are absolute. A bright white paper stock may have a density of 0.3 and the maximum density of slide film is under 4.0—unless perhaps you're photographing a pitch black room. In terms of printing, even dye-based inks, popular for their higher density, max out well below 3.0. Finally, beware that there are no independent standards for measuring a scanner's dynamic range. Manufacturers' dynamic range numbers have to be taken with a grain of salt...maybe two.

Capturing Pixels: CCD Versus PMT

The overwhelming majority of today's scanners share a common technology, illustrated in Figure 2.31. The film image is recorded onto a CCD (Charge Coupled Device) chip. Drum scanners, by contrast, rely on the older but optically superior method of PMT (Photo Multiplier Tube) capture. At the most basic level, both CCD and PMT scanners work by illuminating the original image, recording analog color values, and then converting the information to ones and zeros. Virtually everything else about their operation is different.

A CCD scanner captures image data for an entire row of pixels at a time. Both the CCD and light source are designed to cover a fixed width and simply scroll line by line down the length of the original image to complete the scan. Light passing through the original hits the CCD, which has a color filter array to separate red, green, and

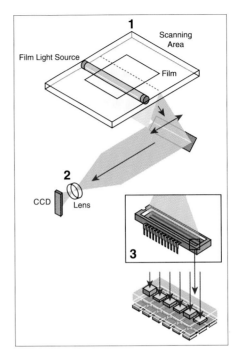

Figure 2.31 In a CCD scanner, the light source passes through the transparency (1). It is then directed through a lens, which focuses the light onto a fixed-width CCD sensor (2). The sensor reads one row of pixels at a time and records them onto red, green, and blue photosites on its surface element (3).

blue light waves. The CCD measures the light's intensity and converts it into electrons. An analog-to-digital (A/D) converter then translates the information to the ones and zeros that your computer understands.

Compact scanner design allows for a small footprint but packs a great number of heat generating components, as well as a power supply, in close proximity to the sensor chip. As a CCD's sensitivity is amplified to read lower light levels, electrical heat from these various components, including the CCD itself, is often recorded, showing up as random noise in shadow areas.

PMT scanners capture data one pixel at a time. In this scenario, shown in Figure 2.32, it is the original image that moves, wrapped around a rapidly spinning cylindrical drum. A highly concentrated

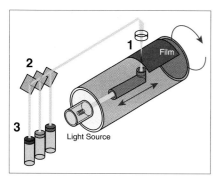

Figure 2.32 A highly concentrated light source illuminates the transparency as it rotates atop the spinning drum (1). Each spot of captured light is then split into individual wavelengths (2) that are directed to a set of red, green, and blue photo multiplier tubes (3). The intensities of light are converted into an electrical signal and sent to an A/D converter (not shown), which converts these signals to digital data.

beam of light travels perpendicular to the drum's rotation, illuminating a single spot at its apex on the drum, where the film lies perfectly flat, ensuring sharp, edge-to-edge focus. This spot on the image is split and directed to three very precise photomultiplier tubes (one red, green, and blue) based on wavelength. In these tubes, the light intensity is measured and converted to electrons. The information is passed through an analog to digital (A/D) converter on its way to the host computer. Native resolutions of 4000 ppi and higher are the norm. For even greater precision, PMT scanners allow manual adjustment of the aperture or spot size of incoming light. An aperture matched to the size of a particular film grain lets you capture faithful image detail right down to the film's grain structure. With some scanners, the A/D converter can be optimized on the fly for each and every film/exposure/development combination that is scanned. The large physical size of drum scanners has inherent cooling advantages. Electrical heat is kept well away from the optical components. The analog tubes also have a much greater ability to read low light values without signal amplification.

Hasselblad—after acquiring Imacon—markets virtual drum scanners. The Flextight models borrow from traditional drum scanners the idea of wrapping the original around an arc for increased sharpness. The film image is captured with a high-resolution CCD sensor that collects light in much the same way as those in film and flatbed scanners. Hasselblad's scanner optics remain stationary as the film passes between the light source and lens. Their vertical case design provides for a glass-free optical path. Signal noise is reduced through the use of an active cooling device mounted right on the CCD chip. Mounting film is a simple affair using any number of holders matched to specific film sizes.

Drum scanners were primarily conceived for production environments rather than home use. Improvements in consumer level image capture devices took a heavy toll on this market, and only a handful of models are still in production. There is a learning curve involved in wet mounting film to a drum, and even minor repairs can be costly. Small footprint, ease of use, and maintenance-free operation clearly favor flatbed and dedicated film scanners. The Hasselblad scanners are very easy to use, maintain film flatness without wet mounting, and provide resolutions of up to 8000 ppi. But they are not priced for the faint of heart. You could take out a car loan for less than the cost of their Flextight X5 model.

In terms of comparative quality, a drum scanner run by an experienced operator will produce sharper images over a wider dynamic range and resolve noise-free shadow detail right down to the grain structure of the emulsion. For difficult-to-scan negatives destined for large output, a drum scan can be the best way to faithfully replicate all of the detail in the film. One approach taken by many fine art photographers is to scan in-house for evaluation purposes or small print sizes and send select images requiring a higher degree of quality or enlargement out for drum scanning.

IN THE STUDIO...

See Figure 2.33. With the HP Designjet Z3100 (top left), I can output long-lasting color and black-and-white images up to 44 inches wide. The Epson Stylus Pro 9600 (top right) is a 44-inch printer outfitted with PiezoTone Selenium and Sepia monochrome ink sets from third-party manufacturer InkjetMall. The image PROGRAF IPF 5000 (bottom left) is Canon's 17-inch wide, pigment-based printer and includes a cassette tray for unattended printing of multiple sheets. The Epson Stylus Photo R2400 (bottom right) is loaded with UltraChrome K3 inks, while the smaller but similarly styled Epson Stylus Photo R800 prints with a K7 monochrome ink set from InkjetMall.

Figure 2.33 With the variety of fine art printers now on the market, I have found it difficult to settle on just one. Instead, I prefer to leverage the unique capabilities of different models for specific output purposes.

Printers

The ability to capture film images with optical clarity and to manipulate the resulting pixels with a high degree of precision occurred fairly early in the digital photography timeline. Moving beyond pixels to photo-realistic output on paper, however, has taken longer to achieve. Early digital output routinely fell short of darkroom prints, both in image quality and longevity. It was clear that widespread acceptance in the fine art market could only come when these shortcomings were adequately addressed.

Today, the quality and stability of the digital print have reached levels unimaginable just a decade ago. The best examples of digital output compare favorably to even the highest standards of darkroom printing. For the fine art photographer concerned with image detail, wide tonal range, and print longevity, there has never been a better time to print digitally.

Why Inkjets?

When consumer inkjets first appeared on the market, there was little indication that this technology would thrive, let alone dominate an entire industry. Initially positioned as cheap alternatives to laser printers, they were slow, produced dots you could spot from across the room, and used inks that easily smeared.

Epson's line of Stylus Photo and Stylus Pro printers almost single-handedly changed the perception of inkjet printers as tools suitable for photographic imaging. Developed specifically for photographic output, these printers attracted considerable attention for their use of variable dot sizes and "photo" ink dilutions. I'll talk more about both of those attributes in upcoming sections. The result: Suddenly, it was possible to create prints at home that took full advantage of high-resolution scan quality and software-based pixel editing. The inkjet printer industry continues to be a fast-moving one, with each

successive generation of printers exhibiting faster print speeds and greater image fidelity.

The photographic community's wide embrace of inkjet printers led to a rapid expansion of the digital paper market. After all, you can't print without it. The sheer number of available brands is mind-boggling. There are far more choices of media available for inkjet printing than we ever had in the wet darkroom. And you're not limited to the OEM product line of your printer manufacturer. Table 2.1 offers just a small sampling of third party papers that are compatible with a wide range of pigment-based inkjet printers.

The combination of consistent output, aggressive pricing, and wide range of media has made the term inkjet synonymous with digital print for most photographers. In the sections that follow, we'll look at some of the key technologies that have made inkjet printers the preferred choice for photographic output.

Table 2.1 A Sampling of Third-Party Fine Art Inkjet Papers

Vendor	Paper	Base Material	Weight (GSM)
Crane & Co.	Museo	Cotton	250, 365
Crane & Co.	Silver Rag	Cotton	300
Fredrix	901 Canvas	Polyester, Cotton	373
Hahnemühle	Photo Rag	Cotton	188, 308, 460
Hahnemühle	William Turner	Cotton	190, 310
Hahnemühle	Fine Art Pearl	Alpha Cellulose	285
Hahnemühle	White Velvet	Cotton, Alpha Cellulose	268
Innova Art	Soft Textured Natural White	Alpha Cellulose	190, 315
Innova Art	Cold Press Rough Textured Natural White	Alpha Cellulose	190, 315
Innova Art	Smooth Cotton Natural White	Cotton	190, 315
Innova Art	FibaPrint White Gloss (F-Type)	Alpha Cellulose	300
Legion	Somerset Enhanced	Cotton	190, 255, 330
Moab by Legion Paper	Entrada	Cotton	190, 300
Premier Imaging Products	Smooth Hot Press	Cotton	270, 500
Premier Imaging Products	Platinum Rag	Cotton	285

Pixels to Dots

A common source of confusion is the relationship between image resolution and printer resolution. This is due, in large part, to widespread misuse of the term dots per inch (dpi). As the name suggests, dpi refers to the number of physical dots that a printer lays down on paper. Monitors, scanners, and digital cameras do not render dots. They understand images as collections of pixels—their smallest component. We measure image resolution in pixels per inch, abbreviated as ppi. Sisyphus himself would probably balk at trying to stop people from using dpi to describe image resolution, but this is an important distinction. And it's one I'm counting on you to make. Doing so will make aspects of the printing process much easier to understand.

Even with this matter clarified, there is still no simple relationship between dpi and ppi in the conversion of image pixels to ink dots. It generally takes multiple dots of ink to represent a single pixel's worth of information. This is why a 1440 dpi printer doesn't require an image resolution of 1440 ppi. The exact dot to pixel ratio is a moving target for a number of reasons. Many printers are capable of laying down dots of various sizes within a given image. Dark areas of the image typically receive larger dots than regions comprised of highlight tones. Yet they are both describing image pixels of identical size. In addition, a printer's ink set contains multiple dilutions of a single hue. Magenta and cyan often have light, or photo dilutions, and three or more dilutions of black are becoming the norm. Last, but not least, the placement of these dots is determined by complex and largely proprietary algorithms specified by the print driver.

With all these variables at play, you'd go crazy trying to match pixels to dots on your own. Fortunately, the print driver handles this task automatically. It takes the incoming pixels and then interpolates the image resolution to arrive at the appropriate size and placement of ink dots. The question that often haunts photographers though is just how much resolution is necessary for the highest quality output. Common wisdom has long held that, for Epson printers, you should use an image resolution of 360 ppi.

Why 360? Well, Epson's printers typically have print head resolutions of 1440 dpi. The reasoning is that if there is a many-to-one dot-to-pixel relationship, the print driver automatically interpolates to a resolution divisible by 1440. So if the image resolution is already a divisible of 1440, there is less need for the print driver to manipulate the image pixels. Because an image resolution of 720 ppi produces extremely large file sizes and offers little real-world benefit in most instances, 360 ppi has become the de facto resolution for images bound for Epson printers. Canon and HP printers have print head resolutions of 1200 ppi, in addition to completely different ink delivery systems, dot sizes, and dithering algorithms. The only foolproof way to determine the best resolution for your printer is to test it.

In my own testing, I've found that the appropriate image resolution depends on even more factors. The paper's ability to hold a dot, the degree of image sharpening applied, and even the origin of the image file all play a role. Unsharpened images on matte paper hold up much better at lower resolutions than sharpened files printed on glossy papers. And files from a digital SLR generally print much better at lower resolutions than do film scans. For any given image, the differences—even under a loupe—between 300 or 360 ppi and higher resolutions are almost nonexistent. Remember that print drivers have a lot of sophisticated algorithms under their hood. So having it interpolate from say 525.7 ppi down to 300 or 360 is not going to result in visually perceptible quality loss. Given the number of image-dependant variables that can affect the outcome, your time is better served by keeping resolution in a range of 300 to 360 ppi than obsessing about printer driver interpolation. There are many issues that have a greater impact on print quality.

Dither

The first task of any photo-quality inkjet printer is to make discrete dots of ink appear to the naked eye as a continuous tone image with smooth gradations between tonalities. Accomplishing this feat requires three interrelated inkjet technologies—dither, dot size, and ink dilution—working together to provide a visually dot-free image.

The first challenge is that images can contain millions of colors, while the printer has only a handful of different inks. This is why inkjet printers contain the subtractive primaries cyan, magenta, and yellow (CMY) plus black (K). Used in varying combinations, these primaries are capable of creating an impressive amount of the visible color spectrum. The printer, of course, can't mix them together in a paint bucket. Rather, it lays individual dots of the primaries on top of one another to re-create the color of a single pixel in the image. Complex dithering algorithms—the Colonel's secret recipe of printer drivers—determine exactly how much of each primary needs to be laid down to create the desired color.

These dithering algorithms also determine the location of each drop of ink. This is a huge advantage of inkjet printing. By comparison, most offset presses lay down identical patterns of CMYK dots, simply varying their size to achieve lighter and darker tones. But our eyes are uniquely well suited to picking out repeating patterns so it is relatively easy to see dots when you look closely, as seen in the four-color postcard reproduction in Figure 2.34.

Dot Size

No dithering algorithm in the world will trick the eye into seeing continuous tone if the individual ink dots are visible. Reducing the droplet size (measured in picoliters) to microscopic levels makes for visually dotless prints but at the expense of print speed. The smaller the dot, the more of them you must lay down to cover a given area of the sheet. Small dots also require much greater precision in placement than larger ones.

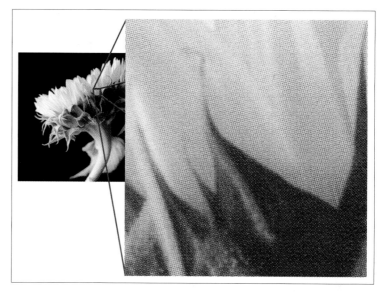

Figures 2.34 When this image is reproduced on an offset press, the dither produces a repeating pattern of CMYK dots, which can be seen in an enlarged scan of the postcard (right). These patterns are easy to spot—though admittedly not as prominent—with the naked eye.

Most printers that are optimized for photographic output use some form of multiple dot size technology that allows combinations of larger and smaller dots. In general, larger dots can be used in areas composed of darker tones and still appear to the eye as a smooth gradation. Smaller dots are used to render areas of finer detail and subtle highlights with impressive accuracy. This approach allows for reasonable print speeds without sacrificing print quality.

Ink Dilutions

The spacing of dots is also crucial to the illusion of continuous tone. Within a given ink density, lighter tones are achieved by spacing dots farther apart. Packing dots together in a cluster produces a darker tone. The dilemma in producing smooth highlights has been

that the space between dots can quickly become wide enough for the eye to distinguish. This explains why early inkjet models, for example, were much better at hiding dots in shadows than in highlights.

In general, it is preferable to lay down closely spaced dots of a lighter ink dilution rather than widely spaced dots of a stronger dilution. This led to the introduction of the light cyan and light magenta inks. These are weak dilutions of the full-strength cyan and magenta that can be printed into highlight areas while maintaining a dense enough spacing to appear "dotless" to the eye. The difference between full and photo dilutions can be seen in Figure 2.35. It is this same principle that led to the formulation of quad tone ink sets. I'll speak in detail about these later in the book, but the general notion is that three, four, or seven dilutions of black will produce smoother gradations over a wider tonal range than is possible using a single density of black ink.

From Dyes to Pigments

Epson's early photo printers came loaded with dye inks. Dyes are renowned for producing saturated colors, and they easily adhere to a wide range of media surfaces. Their great disadvantage has always been poor longevity. Noticeable fading can occur over months or even weeks. Responding to the longevity concerns voiced by those who sell their prints, Epson introduced the Stylus Photo 2000P. This desktop printer was the company's first attempt at a pigment-based ink set. While their previous dye-based inks were rated for a lifespan of less than 30 years, these inks were touted with a longevity of 200 years. As with most new technologies, this first generation of pigments was not without significant drawbacks. The color gamut was significantly smaller than that of dye inks. More worrisome, though, was that the prints were subject to metameric failure—drastic color shifts under varied lighting conditions. When used on glossy papers, another problem was introduced. Viewing a

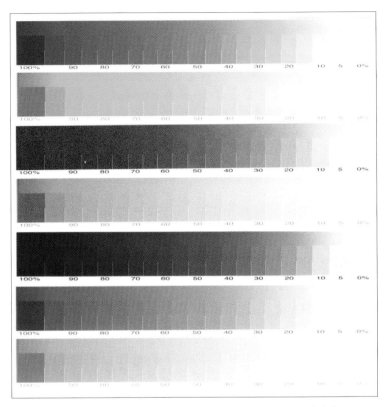

Figure 2.35 The Epson UltraChrome K3 ink set includes both full strength and diluted inks. From top to bottom you see output of cyan, light cyan, magenta, light magenta, black, light black, and light light black. *Image courtesy of Tyler Boley, Custom Digital*

print at oblique angles revealed a phenomenon known as bronzing in which shadow areas become highly reflective and obscure image detail, often appearing as a muddy brown sheen instead of the expected ink black. Fast forward to Epson's latest pigment-based inks—the UltraChrome K3s. This formulation combines a wide color gamut with the ability to adhere to glossy papers while reducing bronzing and metameric failure. Today, the story gets even more

interesting because both Canon and HP are offering pigment printers in both desktop and large format sizes that compete directly with Epson's Stylus Pro lineup. I'll talk a bit more about specific printers in the next section. Suffice to say that the industry has adopted the position that printers marketed to graphics professionals will use pigment-based inks, a very welcome move for fine art photographers.

The Printer Purchase

Until very recently, the answer to, "Which printer should I buy?" invariably included the word Epson. Make no mistake—they are still the biggest kid on the block. Their printers are being used to create some of the finest prints you'll ever see. But 2006 marked the dawn of credible competition from both Canon and HP in the fine art printer market. Of greatest interest to black-and-white photographers is that all three companies have developed printers with multiple dilutions of black ink dedicated to monochrome output. In the section that follows, I'll take a look at the current offerings of Epson, Canon, and HP with an eye toward key differences that can affect their suitability for fine art printing.

The Big Three: Epson, Canon, and HP

The battle for your printer dollars is essentially a three-horse race. It's interesting to look at the strategy that each company has taken in serving the fine art market. Pigment inks, multiple dilutions of black ink, and a monochrome print driver are common to all three manufacturers, but differences in ink delivery, printer calibration, and output size abound.

Epson uses a piezo-electric ink delivery system in its inkjet printers (see Figure 2.36). An electric current is applied to each nozzle, forcing ink droplets out of the print head and onto the paper. Why is this important? By varying the voltage applied to each nozzle, different sizes of ink droplets can be expelled from the print head. Back

Figure 2.36 Epson uses a Micro Piezo print head technology that produces variable size droplets using a relatively small number of nozzles. *Image courtesy of Epson America*

in "Dot Size," I talked about the benefits of producing dots of different sizes within a given print. Smaller dot sizes can mean finer rendition of detail and a visually dotless print. With a piezo-driven print head, an ink drop from any nozzle can be adjusted in size, on the fly. This method of ink delivery also produces relatively little wear and tear on a print head.

Epson's Stylus Pro printers all use the eight-color UltraChrome K3 ink formulation. There are actually nine inks in this set, but the photo black and matte black inks are never used simultaneously. Photo black is for use on glossy papers, while the matte black is optimized for fine art cotton and alpha cellulose media. The newest addition to the lineup, the Stylus Pro 3800 is a 17-inch wide printer that comes with a built-in Ethernet port. It introduces an updated dithering algorithm. Also new is the ability to load both photo and matte black ink cartridges and automatically switch the two inks between a shared print head, based on the media selection made in the print driver.

In an effort to increase color gamut and produce neutral monochrome images, Canon's newest printers ship with the 12-color LUCIA ink set, seen in Figure 2.37. Canon's ink delivery system is based on thermal head technology, in which the ink is rapidly

Table 2.2 Epson UltraChrome K3 Models

With its long head start in the fine art market, it is not surprising that Epson has such a wide offering of printers aimed at the professional market. Virtually identical technology is offered in a range of printer models.

Model	Printable Width	Roll Holder	Dimensions (in.)	Weight (lbs)
Stylus Photo 2400	13	Yes	$24.2 \times 12.6 \times 9.1$	34
Stylus Pro 3800	17	No	$27 \times 15 \times 10$	43
Stylus Pro 4800	17	Yes	$34 \times 14 \times 30$	84
Stylus Pro 7800	24	Yes	$46.3 \times 46.5 \times 29.3$	131
Stylus Pro 9800	44	Yes	$37 \times 47 \times 26$	198

Figure 2.37 Canon's LUCIA pigment-based ink set is comprised of 12 inks. From left to right: Yellow, Photo Cyan, Cyan, Photo Gray, Gray, Matte Black, Photo Magenta, Magenta, Black, Red, Green, and Blue. *Image courtesy of Canon USA*

heated in order to create a bubble that is then ejected onto the paper. The resulting inks drops are produced in a uniform dot size of four picoliters. With a dual print head design that packs a large amount of nozzles, fewer printing passes are required to lay down a given volume of ink. This translates into faster print times. Because thermal print head technology leads to wear and tear, Canon's print heads are user-replaceable.

Seeking to distinguish itself from the competition, Canon provides a Photoshop export plug-in for its imagePROGRAF line of printers that allows for image data to be processed in 16-bit mode and then sent directly to the printer with 12 bits of actual pixel data. Taking aim at one of the few consistent complaints directed at Epson, the photo black and matte black each has its own slot on the print head. There is no ink lost when changing from a glossy to a matte paper. These printers monitor the status of nozzles, and if a clog occurs, a cleaning cycle is executed. If there are nozzles that cannot be adequately cleaned, ink is rerouted to fully functioning nozzles.

Table 2.3 Canon LUCIA Models

Canon's pigment-based LUCIA inks are installed in three printers that are distinguished primarily by their maximum print width.

Model	Printable Width	Interface	Dimensions (in.)	Weight (lbs)
IPF5000	17	USB 2.0, Ethernet	$39.3 \times 28.9 \times 12.5$	99
IPF8000	44	USB 2.0, Ethernet	$74.5 \times 38.4 \times 45$	313
IPF9000	60	USB 2.0, Ethernet	$90.5 \times 31.6 \times 45.1$	365

HP has installed a new formulation of its Vivera pigment-based inks into its Designjet Z Photo Series printers (see Figure 2.38). Of most interest to black-and-white photographers is the 12-color ink set found in the Designjet Z3100 models. This is the first OEM quad black printing system. On matte papers, four dilutions of black are used simultaneously. By avoiding the use of color pigments when printing grayscale images, HP is giving top priority to image neutrality and longevity.

HP, like Canon, uses a thermal head technology in its fine art printers. In order to achieve the benefits of multiple dot sizes, HP has created two different nozzle sizes. In the Designjet Z Photo Series, the light gray, medium gray, light cyan, light magenta, photo black, and gloss enhancer are printed at 4 picoliters, while the remaining

Figure 2.38 The HP Designjet Z3100 printer is available in both 24- and 44-inch print widths. Both models come with a built-in spectrophotometer and a 12-ink system that includes four dilutions of black. *Image courtesy of HP*

Table 2.4 HP 8 and 12-Ink Vivera Pigment Models

HP has perhaps the greatest number of feature differences within its pigment-based photo printer lineup. All of these models provide USB 2.0 and Ethernet connectivity.

Model	Printable Width (In.)	Black Inks	Built-In Measurement Device
Photosmart Pro B9180	13	3	Densitometer
Designjet Z2100	24 and 44	3	Spectrophotometer
Designjet Z3100	24 and 44	4	Spectrophotometer

inks print at a size of 6 picoliters. The Z Photo Series printers also represent a milestone in color control. Mounted directly inside each printer is an Eye-One spectrophotometer. Printer calibration and profiling using a wide variety of OEM and third-party paper is an automatic process that is initiated right from the print driver. The desktop-sized B9180 has a built-in densitometer that can be used to calibrate the printer, bringing it back to a known state of performance. All of these printers monitor the status of print head nozzles and perform a cleaning routine when necessary. If there are nozzles that cannot be adequately cleaned, the printer automatically initiates additional passes of the print head to maintain image quality during the print.

It's very early in the newly competitive fine art printer market, and Epson still enjoys formidable advantages. Its printers enjoy a wide lead in third-party ink and paper compatibility. Some of this is obviously due to its big head start over its rivals. But Epson's choice of a piezo-electric ink delivery system has fostered a healthy

third-party monochrome ink market. It remains to be seen whether third parties will be able to devote the resources necessary to formulate inks compatible with the thermal print head technologies of Canon and HP.

Because of Epson's dominant role in the market, third-party paper manufacturers test their products for performance, longevity, and compatibility with Epson inks and printers. Both Canon and HP sell their own papers that are optimized for their inks. But many of you, I'm sure, have settled on some favorite papers. Should these substrates prove less than compatible with Canon and HP's printers, you may be less inclined to leave the Epson fold.

In the long run, increased competition from HP and Canon will benefit photographers as each company innovates in order to maintain or increase its share of the market. In Table 2.5, the largest desktop-sized pigment ink photo printers from Epson, Canon, and HP are compared. The inclusion of multiple black dilutions and built-in Ethernet ports are very recent developments in this price range.

Table 2.5 Desktop Printer Models

Model	Width	Inks	Black Dilutions	Interface	Price
Epson 3800	17	9	3	USB, Ethernet	$1,295
HP B9180	13	8	3 (Matte output) 2 (Glossy output)	USB, Ethernet	$700
Canon IPF5000	17	12	3	USB, Ethernet	$1,945

Output Size

The size at which you wish to print obviously plays a major role in your choice of printer model. Inkjet printers are commonly found in widths of 8.5, 13, 17, 24, and 44 inches. I will offer two caveats here. Before you decide that your work can only "sing" in 30 × 40-inch prints, make certain that your digital capture device can supply sufficient image data for that output size.

The second bit of advice is for those who print small. Most letter-sized printers will have difficulty handling heavy weight fine art papers. Their paper feed mechanisms are simply not designed for papers over 188gsm. So even if you only make contact prints, you will enjoy a much wider range of media options on a 13-inch wide printer. If you'd like the option of using a RIP with your printer, be aware that larger printers enjoy a wider variety of choices in this regard.

As a general rule, printers 17 inches and wider are built to withstand higher volumes of printing over longer periods of time. They are engineered so that individual parts can be easily replaced as they wear out. With 24-inch and larger models, you can typically expect on-site warranty service. In the event of a malfunction, a technician is sent to your location, usually the next business day.

Print Longevity

You can make the argument that inkjet prints have been scrutinized for longevity more than any other photographic medium. Fair or not, as a printmaker, you have the responsibility of being informed about the effect of your materials on print longevity. I'll talk more about this and other responsibilities in Chapter 8, "The Limited Edition." But here I'll discuss one of the biggest obstacles to talking about longevity in any meaningful way.

Longevity can only be properly understood in context of three interconnected factors: paper stability, ink stability, and display/storage

conditions. Let's first consider the paper stock. A bulletproof set of inks is of little use if the paper itself starts to deteriorate. The paper base must be free of acids or lignins that can deteriorate the pulp over time. Cotton rag papers have long been synonymous with longevity. More recently, advanced techniques of eliminating acids and other impurities from wood pulp, rather than its more expensive cotton counterpart, have led to the emergence of alpha-cellulose fine art papers. A growing number of paper vendors make datasheets, like the one in Figure 2.39, available on their Web sites. A crucial marker of longevity is the absence of acids in a paper stock. You want to look for a pH level between 7.5 and 10 and take note of the manufacturer's guidelines for storage.

We have seen that all the printers marketed to photography professionals use pigment-based inks. But there are pigments and there are *pigments*. The most stable pigment we know of is pure carbon. Its use in black-and-white photography predates the arrival of inkjet printers by a couple of centuries.

The challenge for the industry has been to leverage carbon pigment's lightfast benefits while maintaining the ability to produce prints in a range of tones. Carbon pigment, in its natural state, is rather warm. Its tone can be adjusted by simply adding color pigments. This offers the widest range of tones, and most OEM print drivers include sliders for toning control. HP has a particularly precise toning method for its Designjet Z Photo Printer Series that allows you to tint highlights, midtones, and shadows independently, as seen in Figure 2.40.

The drawback is that color pigments can be less stable than carbon. And certain colors seem to be more lightfast than others. Over time, a less stable pigment, like yellow, may fade more rapidly than cyan, creating a color imbalance in the print. A more lightfast approach is to alter the hue of the ink itself using a combination of specially processed carbon pigments. The available range is

Hahnemühle
FineArt

The Art of Expression
The Hahnemühle Digital FineArt Collection

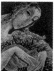

William Turner, 310 g/m²
Natural White, Genuine 'mould-made', 100% rag content

©2000 Jesús Vilallonga "Blue Malvi" - www.vilallonga.com

Product Description
Natural white mould-made watercolour paper with 100% rag content making it highly archival. A smooth surface that suits detailed work and watercolours.

Applications and Characteristics
The printed side of this paper has been specially coated for excellent image sharpness and optimum colour graduation. The coating also offers a very high level of water resistance.
Common applications include:
Fine art reproduction, business cards, greetings cards, post cards, menu and Novelty applications, certificates and presentation prints for display purposes.

Physical Characteristics

	Unity	Valuation	Test Norm / Notes
Test Conditions		23°C / 50% R.H.	CSS15
Weight total	g/m²	310	ISO536
Thickness	mm	0,62	ISO534
Whiteness	%	> 87,0	W₁₀ / D65, 2°
Opacity	%	> 98,0	DIN 53146
Media Colour		white	not bleached
pH-Value surface		6,0	
pH-Value total		8,3	DIN 53124
Water resistance		very high	
Cobb		80,0	EN 20 535
Ink limit	%	> 240	
Special features		-	

All indicated data to be understood as typical average values.

Conditions of use and storage
Use and store at a relative humidity of 35 to 65% and a temperature of 10 to 30° C (50° – 86°F.)
All recommendations and product indications are for your guidance, and are subject to our test criteria, these remain subject to change without prior notice. There is no guarantee that the same results can be consistent.
Use care in handling printed material, surface susceptible to abrasion.
Store papers in archive quality envelopes, folders, and boxes.
Use only archive grade tapes and glues for mounting & framing.

Hahnemühle FineArt GmbH · D-37586 Dassel · Hahnestraße 3 · Internet http://www.hahnemuehle.de · Tel. +49 (0) 55 61 / 7 91-2 35 · Fax +49 (0) 55 61-3 40

Figure 2.39 A datasheet like this one from Hahnemühle is available online and comes packed in every roll of their paper. It contains not only the paper's physical specs, but also temperature and humidity guidelines for its use and storage. *Image courtesy of Hahnemühle USA*

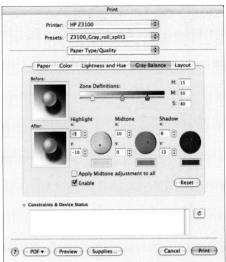

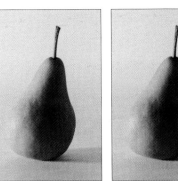

Figure 2.41 InkjetMall's PiezoTone ink set is available in four hues. From left to right are samples printed in Sepia, Warm Neutral, Selenium, and Cool Neutral. These tones are achieved without the use of dyes, making them very resistant to fading.

Figure 2.40 The position of the zone definitions sliders determines the ink region—in percentages—where a tint reaches maximum strength. In this example, a cool tint for the highlights is selected. This tint will ramp up from paper white, reaching its maximum saturation at 15 percent. The midtone tint reaches its maximum at 50 percent, after which it transitions into the shadow tint, which reaches its maximum at 80 percent before transitioning to ink black. Selecting the Apply Midtone adjustment box applies a single tint over the entire image.

much more limited than is possible with color pigments, but it results in hues ranging from cool to sepia with all the benefits of carbon pigment's permanence. Figure 2.41 shows a comparison of the tones available using specially processed carbon pigments. I'll talk in depth about the possibilities for altering the hue of monochrome prints, including split-toning in Chapter 6, "Black-and-White Inkjet Printing."

Cost per Print

An exact cost per print is difficult to establish. While paper size can be easily predicted, ink usage is dependent on the tonal range of a given image. A high key image will use different dilutions and amounts of ink than an image with a full range of tones from shadows to highlights. But it is still important to factor ink costs into the equation.

Back in the early nineties, fine art digital printmaking was limited to studios able to afford and maintain a $100,000 IRIS printer. The dilemma facing Epson when it decided to enter the photo printer market was how to introduce cutting edge print technology that was affordable to the mass market but could still turn a profit. Epson gambled (correctly) that if it sold printers at or near cost, it could generate profits with extraordinarily high markups on ink and paper. The idea was that a relatively low cost of entry would entice consumers to overlook the price of consumables, which would be many times the price of the printer over its lifespan.

The good news is that today you can buy a 44-inch wide Epson 9800 for just 5 percent of what a 35-inch IRIS printer used to cost. The tradeoff is that the ink will set you back $112 for just over 7 oz. of the stuff. The next time you complain about gas prices, take solace in the fact that your car doesn't run on UltraChrome.

Table 2.6 Calculating Print Cost

While larger sized printers have a higher initial cost, their larger capacity ink cartridges are more economically priced. This means a lower cost per print over the life of the printer.

Model	Maximum Print Width (in)	Single Ink Cartridge Capacity (ml)	Single Ink Cartridge Price	Ink Cost per ml	Cost to Replace a Full Set of Ink Cartridges	Printer Price
Epson Stylus Photo R2400	13	17	$15	0.88	$135	$850
Epson Stylus Pro 7800	24	220	$112	0.51	$1,008	$2,995
HP Photosmart Pro B9180	13	27	$32	0.84	$256	$700
HP Designjet Z2100	24	130	$75	0.58	$600	$3,395
Canon imagePROGRAF IPF5000	17	130	$75	0.58	$900	$1,945
Canon imagePROGRAF W6400	24	330	$153	0.46	$1,071	$3,495

IN THE STUDIO...

Products to help you create a color-managed imaging work-flow exist at a wide variety of price points (see Figure 2.42). You can spend, for example, as little as $500 for a printer-profiling bundle or upward of $5,000, depending on the features you require. To make color management work at all, though, you need, at a bare minimum, a tool to calibrate and profile your monitor and a consistent lighting source under which to evaluate print output.

Figure 2.42 Tools of the trade in a color-managed studio include, from left to right, color corrected light bulbs, a colorimeter, spectrophotometer, a viewing booth, and an IT8 calibration target to build scanner profiles.

Color Management Concepts

We've covered the range of equipment required to simply get an image onto paper. But as most of you have probably experienced, it's another thing to get the image you *expect* onto paper. In simplest terms, getting all of the components of the digital darkroom to play nicely together requires three basic steps. First, you measure the behavior of your input and output devices. Next, this behavior must be communicated as the image travels from one device to the next. Last, in order to realize the benefits of these first two steps, you must establish a consistent viewing environment in which to evaluate the image.

Ambient Environment

We intuitively grasp that our eyes require light to view an object. A notion less commonly understood—except by color geeks—is that we are not seeing the object at all, rather the light that the object reflects. It is the interaction between a light source and an object that determines what we "see." It follows then that a significant consideration for the digital darkroom should be the ambient light surrounding your working area.

Imaging Area

Few of us have the resources to design and build a home studio specifically for digital imaging, but there are a number of steps you can take to ensure that judgment of color, tone, and contrast occur under consistent and reasonably accurate viewing conditions. It is important to understand that two inherent assumptions about viewing conditions are being made during the process of calibrating and profiling devices.

The first is that the intensity of your lighting is consistent. As I noted earlier in the chapter, the optimum luminance setting for your monitor is based upon the light levels in the room. A screen brightness of 95cd/m2 may look great in a dim room but will likely appear washed out with all the lights turned on. Pick a comfortable light level before calibrating your monitor, and make sure any critical editing or evaluation is performed under this same condition.

The color temperature of your room light is also assumed to mimic natural light. One way of guaranteeing that an on-screen soft proof will not match the print is to work under the cheap fluorescent lighting used in offices. These lights impart an especially unpleasing blue-green cast to everything they touch. The ideal solution is to use full spectrum or daylight bulbs. These bulbs are designed to mimic the spectrum of natural light, providing even illumination without the yellow tint of household bulbs. OTT-LITE offers a VisionSaver line of desk and floor lamps that offer noticeable improvement over incandescent and halogen home lighting. Solux has developed a sterling reputation among museum and color professionals with its bulbs and fixtures. They offer desktop, wall mount, track, and recessed ceiling solutions in a range of color temperatures.

Why pay for a simulation of daylight when just opening the window blinds can give you the real thing? Sunlight shifts from cooler to warmer color through the course of the day. The angle of mid-day sun may shoot beams of light straight through your window at a much higher intensity than at other times of day. You don't have to eliminate every single trace of sunlight from your imaging room, but make sure that it does not fall directly on the monitor screen or fill the room with an orange glow in the afternoon.

You also want to avoid brightly colored walls. A room painted in hot pink will contaminate any light source you use. In similar fashion, wearing a neon orange Hawaiian shirt can also reflect unwanted color back onto the monitor screen.

Tone It Down

The modern operating system is full of color distractions. Thankfully, both Apple and Microsoft offer ways to keep them to a minimum. In OS X, you can replace the bright colors of buttons, menus, and windows with gray by opening System Preferences>Appearance, and selecting Graphite from the first drop-down menu. Windows XP users can right-click on the desktop and select Properties. Under the Appearance tab, go to Color Scheme and choose Silver from the pull-down menu.

The dock and its brightly colored icons can also be hidden from view on a Mac with the keyboard shortcut Option+Command D. To accomplish this in Windows, right-click on the taskbar, select Properties, and then check Auto-hide the taskbar. In both operating systems, moving the mouse over the area vacated by the dock/taskbar will cause it to reappear, ready for use.

Use Photoshop's full screen mode with menu bar (F) when making critical edits. This surrounds your image with a neutral background, eliminating desktop distractions. For times when full screen mode is not appropriate, like comparing multiple images, you can easily create a neutral alternative to the desktop backgrounds that came on your system. In Photoshop, create a new document whose pixel dimensions match your monitor. Fill the document with 50% Gray and save it to a folder as a jpeg. In OS X, open System Preferences> Desktop & Screensaver. Under the Desktop tab, select Choose Folder and find the folder containing the jpeg. It should now appear in the image panel. Click once, and it is now your desktop image. In Windows, right-click on the desktop and select Properties. Under the Desktop tab, press the Browse button to locate the jpeg. Press OK once to select the file and a second time to set it as the desktop image.

Print Evaluation Area

In fine art photography, the print is the truth. A buyer won't care how great it looks on your monitor if the actual print fails to resonate with her. An effective print viewing area is a critical tool when making aesthetic decisions about your work.

In my studio, I have dedicated a portion of a wall for print viewing by coating it with magnetic paint. As the name suggests, you can mount and remove prints using nothing more than magnets (see Figure 2.43). A large area of wall space allows for comparison of multiple images at a normal viewing distance. It also invites a contemplative interaction. With the print hanging vertically against a nondistracting background—as it would in a museum or gallery— you are freed from handling it and can immerse yourself in its nuances. If you work primarily with small prints, a small section of mounted corkboard can work just as well. You will have to allow a wider print border, though, so that the resulting pushpin holes can be trimmed off. Of course, however you display your prints for evaluation, the warnings about inferior lighting raised in the previous section still hold true.

Figure 2.43 A viewing wall with coats of metallic paint allows me to hang prints vertically using magnets. Overhead track lights are fitted with Solux color-corrected bulbs. I can evaluate prints side-by-side for subtle differences in paper texture and dot gain.

Viewing Booths

If empty wall space is at a premium, another—albeit expensive—option for smaller prints is a viewing booth, like the one shown in Figure 2.44. These color-corrected units come in a variety of sizes and illuminate prints under ideal lighting. The desktop models can be positioned close to the monitor for very accurate softproof-to-print comparisons. For this to work optimally, a model with a dimmer is suggested. You can then bring the luminance of the viewing booth to a level identical to that of the monitor.

Measurement Devices

One of the great ironies of color management is that we jump through hoops in order to produce repeatable objective results. Yet, the input to which this is aimed—human vision—is inherently subjective. Our eyes perceive the world in relative, not absolute, terms. Take any sheet of fine art printing paper. Looks white, right? Now hold it next to a page in this book. Chances are that what looked "white" a moment ago now appears to be off-white or cream-colored. In order to calibrate and profile your equipment with any degree of accuracy, hardware measurement devices must be used. "Eyeballing it" is not an option.

Colorimeter

A colorimeter, shown in Figure 2.45, is a hardware device designed to do one thing: measure the colors displayed by your monitor. It

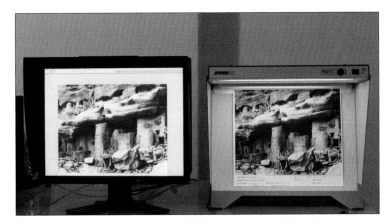

Figure 2.44 A viewing booth with a dimmer, like this GTI PDV 2e model, allows for accurate matches between monitor and print. Its compact single piece design makes it easy to set up, as well as carry between locations.

Figure 2.45 The Monaco Optix XR is recognized as one of the finest colorimeters produced for consumer use. Using it to calibrate my Eizo CG21 with ColorEyes software delivers more neutral color and smoother shadow detail than I get from other hardware/software combinations.

Table 2.7 Savvy Shopper

Listed below are some features to look for when shopping for crucial components of the digital darkroom.

Monitor	Computer	Scanner	Printer
A screen size of 19" or greater	Multiple Core processors	Optical resolution sufficient for your enlargement needs	A pigment-based ink set with multiple dilutions of black ink
A viewing angle of 170°	Maximum RAM capacity of at least 4GB	Wet mounting option	A longevity report detailing both the ambient conditions and media tested
Digital Input (DVI)	PCI slots	Holders that will accommodate your film formats (film scanners)	Compatibility with a wide range of third-party fine art papers
A 10-bit or higher internal LUT	Support for two or more internal hard drives	A transparency adapter that will accommodate your film formats (flatbed scanners)	
DDC-compliant Communication	FireWire 800 port A video card capable of DVI support for your intended monitor size	Support by third-party scanning software, such as SilverFast and VueScan	

does this working in concert with calibration software that commands the monitor to display various patches of color. Filters inside the colorimeter allow it to measure the red, green, and blue components of these colors in a way that mimics human perception of color. The best colorimeters excel at distinguishing low light values, resulting in more accurate shadow detail. The purchase of a colorimeter provides a relatively inexpensive entry into a color-managed workflow.

Spectrophotometer

Unlike a colorimeter, the spectrophotometer does double duty. It can be used to measure output from both monitors and printers.

And it is generally a more complex, and therefore more expensive, device to manufacture. Perhaps the most popular model among photographers is the Eye-One device from X-Rite, shown in Figure 2.46. Working in concert with printer calibration software, a spectrophotometer works by shining a known light source at a color patch. It then measures the spectral properties of the patch, specifically the intensity of light it reflects at various wavelengths. In this way, an accurate and objective description of the color patch is achieved, allowing for very precise printer calibrations and profiles. We'll discuss both calibration and profiling in detail in Chapter 3.

Figure 2.46 The Eye One spectrophotometer. It can be purchased with various software bundles that can calibrate and profile the output of scanners, monitors, and printers, as well as cameras and projectors. The device's high precision and affordable price made it a breakthrough product when it was first released in 2001. I use it to linearize printers, build profiles, and measure density values of paper/ink combinations.

Test Charts and Images

The stated goal of a color-managed workflow is predictable, consistent results. An important element in maintaining such a system is determining not only when there is a problem, but also identifying the culprit. When a print no longer matches what you see on the monitor, is the problem with the on-screen display or the print output?

An easy way to visually track the behavior of a device is with a test image. It does not have to be as precise or elaborate as the test files shown in Figures 2.47 and 2.48. It can be a regular image, like the example shown in Figure 2.49. Simply designate an image file to be your quality standard. When your system is fully calibrated and

profiled, then print this image. Store the print in a safe place, away from direct light. Make sure that the digital file itself is never altered. You can store it on a read-only device, such as a CD or DVD. If you suspect one day that your output has changed, simply print out the test image and compare it to the original print.

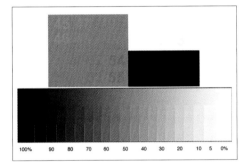

Figure 2.47 This image contains a standard black-to-white gradient. But it's unique in that it includes neighboring values in highlight, midtone, and shadow areas—many of which are not possible to print in this book. I use this not only to check for banding and posterization, but also as a visual guide to the dynamic range of a given printer/paper/ink combination. *Based on an image created by Jon Cone*

Figure 2.48 This test file is a more precise gradient that includes 100 patches evenly spaced between paper white and maximum ink black. *Image courtesy of the Digital Black and White The Print user group*

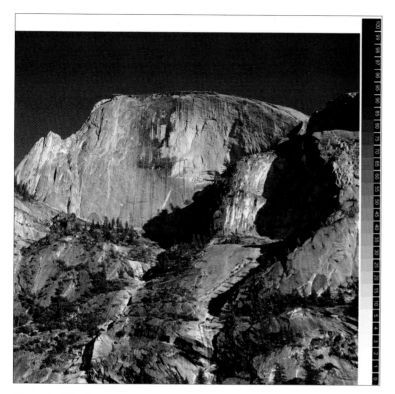

Figure 2.49 It's very easy to get lost in test images that we never need to produce in the real world. Here I have an actual image that contains a full range of tones. The gradient on the right? Well, I am a printmaker. Seeing input densities just makes me feel good.

Congratulations! You now have honorary geek status and can drop terms like scratch disk and dynamic range on unsuspecting cocktail guests. More importantly, you should have a sense of the number of tools required for an efficient and enjoyable digital darkroom experience. I realize that most of us would rather talk about images than computer equipment, but the digital revolution has put the onus on each of us to handle responsibilities that were once the domain of the photo lab. In the next chapter, we'll look at how to make all of these tools work together intelligently so we can spend more time creating images and less time wondering what went wrong.

Title Khufu Embraced By Nuit; *Dimensions* 18 ¼ × 12 ⅛ in.; *Paper* Hahnemühle White Velvet; *Ink Set* Vivera Pigment Ink; *Printer* HP Designjet Z3100

Case Study: Chester Higgins

Artist Bio

Chester Higgins is a photographer and author whose images have routinely given voice to those whose cultures have been marginalized in mainstream society. His work has been featured in some of the most prominent magazines in the country, and he has been a staff photographer for *The New York Times* for over 30 years. No fewer than five books of his photographs have been published to critical acclaim. His work is in the permanent collections of institutions such as the Museum of Modern Art, the International Center of Photography, and the Schomburg Center for Research in Black Culture.

✪ Download an mp3 audio file of this entire interview by visiting the book's companion Web site at www.masteringdigitalbwbook.com.

The Artist Speaks

Amadou Diallo: *You've described yourself as a cultural anthropologist with a camera. It would seem that, for you, photography is really a vehicle to explore humanity. I'd like you to talk a bit about your motivation to capture the images that you shoot. What compels you to pick up the camera?*

Chester Higgins: In the broadest sense, photography is my effort to explore humanity, but on the micro level, I'm really trying to explore my own humanity. In this country, we are often given skewed information to either give us a sense of identity that's not really ours or to make us not feel good about who we are.

Realizing this failure, I figured that the best way to serve my mind and self is to go and seek these answers about identity for myself: to find primary source material. I've tried to find a way, artistically, to portray this evidence about identity with images that are compelling, and at the same time, enlarge the framework of ethnic and racial identity.

AD: *The current project that you're working on is focused on the origin of religion. Could you talk a little bit about the genesis of that idea?*

CH: In my latest book, *Echo of the Spirit*, I talk about my experiences as a child in the southern Baptist church, and later, studying about world religions. I was quite impressed with the fact that every culture has a way of approaching the ultimate creative spirit. They may do it in different languages, but it all points to the same thing. It's like going down a highway and seeing that everybody's going the same way on a one-way street, even though we're driving different cars. And if we can accept the fact that everybody has a different car but we're all going the same direction, it simplifies things and takes out the tension.

My search for the roots of Western religion led me to Egypt. But as you start delving into that history, you realize that not only was it the platform or the stage for the *Old* and *New Testament*, but *that* stuff also came from somewhere else—deep inside of Africa.

So this "current" project has actually been a 25-year search of looking at antiquity sites, exploring ceremonies that have survived, all of these kinds of things. I'm trying to pull pieces back together that have been stretched thin. It's been quite interesting.

AD: *One thing this calls to mind is in a lot of the really great photography, you have this sense of distilling the central elements and doing away with all extraneous matter and getting to the source. And that seems to be quite parallel to what you've discovered here in this journey of peeling back layers of, in this case, the roots of organized religion.*

CH: Yeah, you're absolutely right. History is political, and so I'm trying to sift back through those things and look underneath those layers. I find it liberating both intellectually and artistically. The goal is to pull those two things together, so you get a real "aha" moment in an image. When people look at my images, what they take from them is influenced by how much they know or have studied about the subject. I realize that you communicate best when something is simple, so I try to come up with a very simple and effective icon.

At the same time, if you deconstruct my images based upon what you know about the subject, you begin to see additional information. You have the enjoyment of looking at the collective image, the collective whole. The more you know about what you're looking at, the more information you'll see that's there in the image.

AD: *The Pyramid of Khufu, which we feature in the book, is certainly one of the most celebrated and famous attractions or monuments anywhere in the world. How did you approach the task of photographing something that's so well known, but in a manner that reflects your own unique eye? How do you go about the process of creating a new way to look at an object that has been seen so many times?*

CH: The first time that I saw this monument, which is 45 stories high and a few blocks long on each side, was in 1973. I've been inside this structure many, many times for many different reasons: studying the people and studying the culture. Each time you revisit the same issue, you begin to see different possibilities that you didn't see before. The struggle has been: How do you make a picture, as you say, that everybody else has made a picture of? This latest image, I think, is stronger because it's made at night. It's trying to show this huge volume that's filling up the sky. I think it shows the monumental-ness of this structure, which is hard to explain to people.

For me, it's a distillation of what this object is, what it meant to the people who built it, what it represented for the person it was built in honor of, and what it represents spiritually, mathematically, philosophically. I've been searching, trying to see and feel essentially, the emotion that's in the stone of the pyramid. A photograph never lies about the photographer. And the reason I'm trying to capture these things in this picture is because those are the things that are important to me.

AD: *Have you found that the switch from film to digital has influenced the way that you think about capturing the images? Has it influenced your artistic eye?*

CH: As a staffer for *The New York Times*, I should point out I was the last person to switch from film to digital. In that sense, I was a purist. But in the beginning, there were a lot of kinks to be worked out. File sizes were very small, and digital just had a lot of limitations. Gradually, I began to shoot digital alongside film. I used the digital camera as my Polaroid to check my lights, to make sure they were balanced.

But, after having film destroyed in processing machines in some countries in Africa, I felt good that digital had reached a point that I could go and work with it. I have started shooting raw and now have a RAID server to store all of these huge files.

There's always a fear because hard drives break down, and you can lose images. You have to back up. And you know, there's going to be a new generation of something that's going to come out, whereas with the film I shot last year, it doesn't matter 20 years from now. I just take the negative, scan it, and I'm done.

But, you know, digital does have its advantages because I can put in an 8GB card, and I can shoot forever, whereas, with a roll of film, I'm always having to change at 36. Life is like that, so it's a balance of things.

AD: *Your career has spanned a period during which photography has really been used as an agent of social and cultural awareness. What's your take on the responsibility of the artist to shape the discussion of social issues, as opposed to just taking a pretty picture?*

CH: You're talking about an issue of consciousness. Just because you're an artist doesn't automatically place you at a higher level of consciousness. People are at different places in that regard. And you don't necessarily have to be into social justice or political things. Those artists who are engaged in social justice issues and political issues visit these issues because these issues ring loud in their own minds. In their own way, they try to make images that challenge everybody else to address the issues that they think people are not looking at enough.

One hopes that when others see this information, they will agree with you and will act accordingly, or will be moved to see things differently, based upon this new illumination that has been brought to them—because most of us are in our own little worlds, doing our own little things. Sometimes, it's not that we're hardened to one position or another, and seeing it another way, through someone else's eyes, could influence how we see these issues.

AD: *Who are some of the people who really have shaped who you are as an artist and as a photographer?*

CH: I have to be thankful to P.H. Polk, at Tuskegee, who put the first camera in my hand. He really demystified the process of photographing and really taught me the art of being a people photographer. Arthur Rothstein really was instrumental in taking my eye and training it in the alphabet of visual linguistics. He was the photo director of *Look Magazine* in New York City, as well as the first photographer hired by Roy Striker for Farm Services Administration. He opened the doors that allowed me to get to know other photographers like Cornell Capa, Eugene Smith, Ansel Adams, and Gordon Parks. All of them, recognizing my passion for what I want to do, were kind enough to give me time, help me, and give encouragement that helped me along.

3

Color Management for the Black-and-White Photographer

Black-and-white photographers need to understand color management. A couple of years ago, I don't know if I would have made that statement. Until recently, monochrome printing was so far removed from standardized controls and workflows that it made little sense to delve into the minutiae of color management. Today, though, hardware and software developments are bringing black-and-white printing slowly but surely into the fold of a color-managed methodology. We're still early in the transition stage, confronted with significant shortcomings. But the goal—standardized process control of grayscale images—is finally coming into view.

Simply put, there's now a great benefit to becoming well versed in color management's promises and practical applications. In this chapter, I'll present an overview of color management. I'll take you through the steps involved in calibrating and profiling equipment, explain the value of working spaces, and discuss soft proofing. Then I'll take a look back at the evolution of monochrome printing and show how color management can be incorporated into a grayscale imaging workflow. I'll end the chapter with one-on-one interviews with three individuals who have impacted the development of black-and-white imaging.

Reading about color management can feel a bit like having to finish all of your vegetables. It's good for you, but not as much fun as a bowl of ice cream. Understanding even the basics of how digital color is communicated is not a trivial task. Don't worry if some of the concepts take a moment to sink in. Over the pages that follow, you may find yourself asking why "color" management is even necessary for black-and-white imaging in the first place. Just remember that blacks and grays are colors, too, and they need to be accurately described during the capture, edit, and print process.

Color Management: What Is It?

Nothing in the digital darkroom, it seems, is shrouded in as much mystery as color management. What is it? How does it work? Can it make my prints match what I see on the screen? Part of the confusion stems from—to put it kindly—overly optimistic marketing hype. You almost expect to hear that a color-managed system can cure the common cold. This can make the whole endeavor seem like just an excuse to sell you more equipment. This is unfortunate, because there do exist a number of tools that can lead you to

predictable and consistent output. In a nutshell, that is what color management is all about.

Color management is your best bet to make digital imaging deliver on its promise of precision, repeatability, and efficiency. I would wager that on your worst day in the wet darkroom you never produced a print as unsatisfactory as some of your failed attempts with digital tools. Before pixels took over, there were a limited number of things that could go wrong, and when they did, mistakes were easy enough to pinpoint. Not enough time in the stop bath? Forgot to focus the enlarger lens? In digital photography, there are exponentially more variables and complexities at play. Now it's about monitor calibration, clogged print head nozzles, and incorrect settings in the printer driver dialog box.

In the broadest sense, color management seeks to return control of the production process where it belongs: to the sensibilities of the artist. Changes in input and output must be purposeful and aesthetically driven, rather than the result of unexpected hardware or software behavior.

Color Management: Why Bother?

"Okay, this chapter already sounds like it's going to make my head hurt. Suppose I just don't use color management?" The reality is that you simply can't avoid color management completely. Every time you open, edit, print, save, or just view an image online, certain assumptions are made about the color values of its pixels. The choice then is whether you want to have any say regarding those assumptions.

The key to making sense of color management lies in understanding why it's even necessary. After all, you just want your images to *look right* —on the screen and on paper. Well, it turns out this is asking quite a lot. The world's oldest, and most complex color management tool comes in pairs resting in sockets conveniently centered

Managed Expectations: What Color Management Can (and Cannot) Do

Color management aims, above all, to give you accurate color, which may or may not be the desired color. Fine art photographers, in particular, are less interested in fidelity to the original scene than in the communication of a mood or feeling. Your aesthetic decisions still play a central role in crafting the image. Color management does, however, allow you to apply these decisions in a consistent and repeatable manner.

A color-managed system lets you preview how your image will appear on a specific output device such as an inkjet, Lightjet, or offset printer. It won't magically make these different devices produce identical versions of what you see on-screen, but it will show you any differences beforehand so that you can minimize them before committing to a physical print.

Calibrating and profiling your printer/paper/ink combination can lead to noticeably superior images, enabling you to get the most out of your investment in equipment. This does not mean you won't be tempted as better printers, papers, and inks come along. Your current setup will inevitably suffer in comparison with future offerings capable of finer detail, a wider tonal range, and greater resistance to fading.

Implementing a standardized system for defining color offers the potential for an image to be faithfully rendered by those receiving it. Communicating accurate color obviously has many benefits if the image is being viewed or printed by someone else. I use the word *potential* because, for this to work as expected, the person receiving your image must have, at minimum, a calibrated and profiled monitor.

No amount of color management will make a bad image great. Your skill and vision as a photographer is still paramount to producing exceptional work.

above your nose. The interaction of rods, cones, cornea, et al provides us with a wider range of hues and more precise detail recognition than any hardware/software combination on the market. Digital cameras, scanners, monitors, and printers are all attempts to mimic characteristics of human vision, within their limitations. It is in the context of understanding and compensating for these limitations that color management can lead us to images that *look right*.

I won't kid you. Color management has many complexities and can be frustrating at times even for experienced users. But at its core, it has just three basic functions. The first is to provide a common numerical reference by which input and output devices can describe color values. The second is to describe the limitations of these input and output devices. Finally, the third function is to translate color values from one device to another. When used in combination, these three steps allow an image to pass from one device to the next while maintaining its visual characteristics, as perceived by human vision under illumination of a constant light source. In short, the image appears the way we expect it to, from capture to print.

The Problems with Digital Color

The need for color management rests largely with the fact that each device in the digital darkroom comes with unique limitations in its ability to process color. Not only do we have the dilemma of translating color values from one device to the next, but also of making conversions when an input device records a color that the output device cannot display.

Spectrum, Dynamic Range, and Gamut

Our universe contains an incredibly broad spectrum of wavelengths. Only a tiny fraction of this spectrum is visible to humans. We call this *light*. Consider for a moment the wide array of hues, subtle contrasts, and tonal ranges we can see. It's pretty impressive. No single input device—film, scanner, or camera sensor—can record the entire range of visible light. Each captures a subset of the visible spectrum.

An input device's ability to distinguish between varying levels of light is described by its dynamic range. The wider the dynamic range, the more distinguishable colors it can record. Of course, we must view these captured colors through an output device, primarily the monitor. An output device is defined by its gamut—the specific range of colors it can reproduce. Unfortunately, it is very rare for the dynamic range of an input device to completely match the gamut of an output device. There are large areas of overlap—colors that each device can describe—but a camera sensor, for example, can capture colors that a monitor can't display.

In addition, we have this long-standing tradition of recording images onto paper. And a printer—another output device—will typically have an entirely different gamut than that of a monitor. Again, there is usually significant overlap between devices, as shown in Figures 3.1 to 3.3. But there are on-screen colors that just cannot be printed and printable colors that cannot be displayed on-screen.

Figure 3.1 The white frame overlay represents the gamut of an LCD monitor. The underlying color object shows the gamut of an older pigment-based inkjet printer using a matte paper stock. While there are some colors in the printer/ink/paper gamut that cannot be rendered on-screen, it is clear that the monitor is capable of displaying many more colors than can be printed.

Figure 3.2 Here, you can compare the gamut of a current pigment-based inkjet printer on a glossy paper to the same monitor gamut. You can see that with this printer/ink/paper combination, a much greater percentage of the monitor's colors can be reproduced on paper.

Figure 3.3 This illustration compares the gamuts of two LCD monitors. While the gamut shapes are similar, it is obvious that the monitor represented by the white frame overlay can display a greater range of colors.

Device-Dependent Color

Our problems have just begun. In the digital realm, input and output devices must attach numerical values to the colors they interpret. But each type of device "sees" color differently, as demonstrated in Figure 3.4. The same color object can produce markedly different color values on each device. It's also common that two different color objects produce an identical color value on one or more devices. In short, a monitor value of 150, 100, 60 does not refer to the same color as a scanner value of 150, 100, 60. Send these same numbers directly to the printer, and you're guaranteed to have an original, screen view, and print that are significantly different.

Figure 3.4 The color meaning of any set of RGB values varies according to the device or color space that created them. Here, we see the same RGB color value of 150, 100, 60, as defined by the ProPhoto color space (left), a scanner (center), and a printer, (right). Identical numbers from different sources produce results that differ visually.

Here's something to chew on. Every device is capable of producing different color output for the same RGB data. So each device then must use different RGB values to produce identical color output. But if the scanner, monitor, and printer all use different RGB numbers, then which value is the correct one? Well...none of them. The RGB color model is device-dependent. That is, its values are meaningful only when attached to the specific device or color space that created them. They have no intrinsic relationship to the way that humans perceive color. I'll wait while you pour yourself a drink.

Device-Independent Color

Fortunately, scientists have developed color models based entirely upon the way human beings perceive color. The most popular of these is known as CIE Lab (1976), or simply Lab. This is a device-independent model that establishes an absolute definition for color values. RGB and CMYK and grayscale (K) models describe the way hardware devices interpret color. Lab describes the way humans perceive color. Because the goal in using scanners, cameras, monitors, and printers is to produce output for us to view, a numerical model based on human color perception is of great importance.

We have seen that a single color object may elicit different RGB numbers from both our scanner and monitor and yet another set of CMYK values from our printer. But the color object has only one Lab value. So the Lab color model is perfectly suited as a translator for the different languages that our devices speak. Using it, we can attach numerical values to the way we perceive color. It's hard to overstate Lab's importance. Without it, RGB, CMYK, and K values are subjective numbers relevant only to the device that produces them. But, armed with an objective numerical model of color, we can define precisely how a particular device interprets color and thus accurately translate device-dependent color values, as demonstrated in Figure 3.5.

Figure 3.5 In the sRGB color space, a value of 207, 104, 86 (left) produces the same Lab values as 184, 150, 70 in the Adobe RGB (1998) color space (right). To maintain identical color between different color spaces or devices, you must use different RGB values.

Color Number Cacophony

In most books on digital photography, you'll be bombarded with references to various color numbers. RGB, CMYK, Lab, K, and HSB make for an alphabet soup of color models, but they are all simply methods of describing color. Let's take a look at Photoshop's Color Picker dialog in Figure 3.6 to see how they are related.

With the ability to describe the same object in different color models, you can convert an image between color modes and maintain the same visual appearance. Don't confuse the K value in the CMYK set with the K model that Photoshop uses in grayscale image mode. The K percentage in grayscale mode is determined by the brightness value. The formula is simple: $100 - B = K$.

Figure 3.6 The selected patch is a midtone gray. It has a brightness (B) value of 50 percent; an RGB value of 128, 128, 128; a Lab value of 61, 0, 0; CMYK ink percentages of 45, 37, 37, 2; and an HTML value of #808080.

RGB into CMYK

We're almost out of the woods, but printing images brings up a final obstacle. Scanners, camera sensors, and monitors rely on an RGB color model. In this additive model, colors are reproduced by mixing the red, green, and blue primaries in varying proportions. It's additive because 100 percent red, green, and blue produces pure white. Conversely, a complete lack of these primaries results in pure black.

Why RGB?

The RGB color model is patterned after the way our own eyes work. Embedded in our retinas are three layers of cones. Each layer responds to long, medium, and short wavelengths, respectively— roughly corresponding to red, green, and blue light. It is from just these three receptors that our entire visible palette is created.

The vast majority of printing devices—from lasers, to inkjets, to commercial presses—uses a subtractive color model. CMY (cyan, magenta, yellow) inks are used in combination to produce a wide array of colors. In the subtractive model, 100 percent cyan, magenta, and yellow produces black. In practice, however, the inherent impurity of the inks prints a muddy tone. The solution has been to add a black ink (K) to compensate. If you send 0 percent of the three primaries, you lay down no ink and end up with white. But the exact tone of white—more precisely paper white— is entirely dependent on the media used when printing.

At the beginning of this chapter, I said it was impossible to avoid color management altogether. Printing is a great example of a situation where color data is converted behind the scenes. Inkjet printers are based on a CMYK ink model. Today's printers boast light cyan and light magenta for smoother gradations and even have multiple dilutions of black to accommodate grayscale images. Yet, the printer manufacturers encourage us to send RGB or grayscale, not CMYK image files, to the printer. What gives? Every time you send RGB or grayscale data to an inkjet, the printer driver automatically converts the color numbers to a subtractive color model—like CMYK—that is compatible with the loaded ink set. This conversion happens without user input and cannot be turned off. Fortunately, most drivers do an excellent job with these conversions, producing high quality images without forcing us to work in CMYK or Lab color modes.

Still with me? Good. If this is starting to feel like more information than you need for monochrome images, hang in there and repeat after me, "Blacks and grays are colors, too." Soon we will look at the practical applications of color management with specific attention to grayscale images, I promise.

Out-of-Gamut Colors and Rendering Intents

As you saw earlier in this chapter, different output devices have widely varying gamuts. Quite often one device will output colors that are impossible to reproduce on another device. It is not uncommon for an image to contain colors that the monitor can display but that the printer cannot reproduce. What happens when it's time to print? That depends largely on the type of rendering intent that gets applied to the image data. A rendering intent controls the conversion of the color values you see on the monitor to the gamut of the printer. The rendering intents most applicable to photographic reproduction are labeled perceptual and relative colorimetric.

A perceptual rendering intent relies on the fact that our eyes are more attuned to contextual color relationships than to absolute color values. When an image contains even a single color outside of the printer's gamut, all the color values in the image are shifted—

by the same amount—until the out-of-gamut color is placed inside the printer's range of output. Even though all of the colors' values have changed, a perceptual rendering intent allows the relationship of the colors to remain the same.

Consider an image with an orange buoy floating in a turquoise sea. The printer's gamut encompasses the buoy but not the color of the sea. In a perceptual rendering, the color of the sea is moved down into a range of blue that the printer can produce. All other colors in the image are moved by this amount as well. The buoy and the sea have both been altered, but by the same proportion. They will remain distinct colors by the same degree.

A relative colorimetric rendering intent aims to change as few colors as possible. Colors in the image that fall within the printer's gamut remain untouched. Any colors outside of this gamut are shifted to colors that the printer can actually reproduce.

Let's go back to our buoy in the sea example. In a relative colorimetric rendering, the color of the buoy remains the same. The color of the sea is shifted from turquoise to a similar tone that falls within the printer's gamut. The sea has changed, while the buoy has not. So these objects no longer have the same color relationship to each other.

Which method is better? It really depends on the image. If a significant number of colors are out-of-gamut, you may as well use a perceptual rendering and maintain the overall relationships. If just a few, out of the millions of colors in the image, are out-of-gamut, a relative colorimetric rendering will faithfully reproduce the vast majority of colors in the image. For a long time, perceptual intent was the preferred choice of photographers. In recent years, however, as newer printer and ink combinations with significantly wider gamuts have emerged, relative colorimetric has become an increasingly popular option.

Solutions for Digital Color

By now you may be convinced that achieving predictable and repeatable output requires a degree from MIT. Well, it's not quite as easy or foolproof as it should be, but some solutions have been developed to ease the pain considerably. The rest of this chapter is devoted to understanding and implementing the various color management controls. In doing so, you can resolve the seemingly incompatible nature of input and output devices.

The ICC Standard

It was recognized quite some time ago that for color management to actually work, there had to be a known set of standards and protocols by which to measure and communicate color. The International Color Consortium (ICC) is largely responsible for cross-platform and vendor-neutral specifications, both for describing color and converting device-dependent color values in a way that maintains the visual appearance of an image.

What Is a Profile?

For all of the importance it plays in a color-managed workflow, a profile is nothing more than a specially formatted text document that contains information about the color behavior of a given device. You can easily identify a profile. It will have the file extension .icc or .icm appended to its name.

Development of the ICC profile specification—a standard for describing the behavior of a device—was the first step in establishing a practical method for communicating color among scanners,

monitors, and printers. The importance of having such a widely adopted standard is difficult to overstate. No matter which of the many products you choose when building an ICC profile, the same basic information gets recorded and will work with all ICC-compatible hardware and software.

While ICC profiles must be generated, or at the very least acquired by the user, the job of actually implementing color management lies with the color management module (CMM). This is the software that calculates corresponding color values as an image moves from one profiled device or editing space to another. For Mac users, the two most commonly seen are Apple CMM and Adobe ACE. The former is part of the Mac OS, while Adobe's version comes installed with Photoshop. If you never realized that you even had a CMM, that's because it works largely behind the scenes and very seldom requires user interaction.

Keep in mind, a profile technically does nothing more than describe a device's behavior. And it comes into play only when you are moving images from one device to another or converting between color spaces. The job of a CMM is to read device data that is filtered through the device's profile, match it to device-independent values, and then remap these values to the appropriate device-dependent values of the destination device or editing space. This entire process of mapping and mathematical computation takes place nearly instantaneously, and with little to no user input.

The CMM is built around a profile conversion space—the hub through which input and output device data must pass. This conversion space is our old friend Lab (or sometimes a close variant) and ensures that all device-dependent color values are translated into numbers relevant to how we actually see color.

Profile Conundrum: Assign or Convert?

The following scenarios are sources of much confusion with regard to document profiles. An image arrives untagged—that is, with no color space profile attached. Or you want to take an image originally destined for print and create a version suitable for the Web.

Photoshop offers two commands: Assign Profile and Convert to Profile. Assigning a profile changes the appearance of the image but leaves the RGB, CMYK, or K numbers the same. Again, the color numbers are not altered, but simply redefined to reflect the behavior of the device or color space from which these values originated. In short, when you assign a profile, you change the meaning of the pixels, as seen in Figure 3.7.

Converting to a profile *does* change the color numbers. It maps them to new values that will maintain the visual appearance of the image. The first image in Figure 3.8 is tagged with ProPhoto RGB. But this image is destined for the Web, and many Web browsers cannot read embedded profiles—they simply assume sRGB. The wise move is to convert the image to sRGB. The color numbers will change in order to maintain the same visual appearance. To put it another way, you change color numbers when you want the image's appearance to remain the same.

In Photoshop, saving an image for the first time gives you the important option of embedding the current profile in the image. When you embed a profile, it is written to the image file, and any ICC-savvy application can render its color accurately on-screen.

Figure 3.7 The screenshot at left has no embedded profile, but I know that the Mac OS assumes sRGB for its user interface. By choosing Edit>Assign Profile, I can select sRGB as the source of the image (center). At right, the visual appearance of the image is now correct. The numbers have not changed, only their meaning.

Figure 3.8 With the image in ProPhoto RGB (left), the color sampler reads 132, 82, 24. When you convert the image to sRGB (center), the same color sampler now reads 192, 85, 0 (right). But the images appear identical.

Calibration and Profiling: Kissing Cousins

Although the tasks are often lumped together, calibrating and profiling a device are two separate endeavors. Yet they are both essential steps in building a color-managed system. Calibrating a device involves bringing its behavior to a known and repeatable standard. When you calibrate a device, you are actually changing its behavior to produce the best result of which it is capable. Only when a device performs consistently can it be of any use in a color-managed workflow.

Once a known and repeatable state of behavior is reached, the device is then profiled. A profile is simply a numerical characterization of the device's behavior. A profile does not alter a device's behavior. It produces a record of the behavior. The ability to characterize the behavior of a device is what allows for the translation of device-dependent color values as an image moves from one device to the next.

I liken this endeavor to a runner preparing for a race. A regimen of nutrition, rest, and training is devoted to maximizing her ability to run consistently over a given distance. She is calibrating her performance. When registering for the event, she submits her previous race results so the organizers can group her with runners of similar ability. These prior race results are her profile. They characterize her (past) behavior and thus predict her performance in the upcoming race.

I'll continue this analogy just a bit further. To be of any use, our runner's previous race results must have occurred under similar conditions to the upcoming race. Her placing in a marathon in Alaska will have little relevance to what she can do in a 100-meter dash in the Arizona heat. Similarly, for a device profile to be valid, it must always be used under the exact conditions in which it was created. This gets especially tricky with printer profiles, which I'll discuss shortly, because variables like paper, ink, and even print heads must remain constant. If any of these conditions do change, a new profile is required.

Monitor

There are a variety of tools available to calibrate and profile a monitor, but they all work on the same premise. First, the user selects color temperature, luminance, and black level values. Next, a calibration is performed, which attempts to match these presets by adjusting the monitor's hardware settings. Then a series of patches is displayed on-screen and measured with a colorimeter or spectrophotometer. These patches are generated using known color values. The measurement device tracks how near, or far, the actual patches are from what was expected. Finally, an ICC profile is written, which details the behavior of the monitor so that other ICC-aware components understand precisely how the monitor displays color.

In the following example, I will use ColorEyes Display Pro to calibrate and profile an Eizo CG21. ColorEyes Display Pro offers a number of useful calibration features. Before calibration even begins, the software checks to see if the monitor supports two-way communication via DDC protocols. If a DDC-enabled monitor is found, you can select the Utilize Digital Controls option, shown in Figure 3.9. As I mentioned in Chapter 2, DDC communication allows for precise monitor adjustments to be carried out without user intervention. It also reduces the task of monitor calibration and profiling to a simple three-step procedure.

ColorEyes Display Pro also allows for the use of an L* gamma target, seen in Figure 3.10, in addition to the more traditional 1.8 and 2.2 gamma tonal response curves. L* is based on the CIELAB/CIELUV color models and was designed to provide a transition from black to white that more closely mimics our visual perception of brightness.

Figure 3.9 ColorEyes has determined that this monitor is DDC-enabled. By checking the Utilize Digital Controls option, I ensure a precise and automated calibration that will perform adjustments primarily through the monitor's 10-bit LUT, rather than in the 8-bit video card LUT.

Now that the monitor and calibration software have established communication, we are ready to calibrate and build a profile.

1. Set the white balance, luminance, and gamma settings for the calibration (see Figure 3.10).

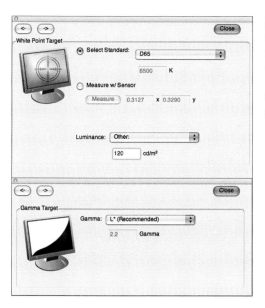

Figure 3.10 I have set the white balance to the D65 standard, chosen a luminance of 120 cd/m2, and selected L* as my gamma target.

2. Attach a measurement device to the monitor and begin the calibration process (see Figure 3.11).

3. Name and save the monitor profile (see Figure 3.12).

ColorEyes Display Pro includes two important profile validation tools. At any time after calibration and profiling, you can run the Validate Current Profile test, as seen in Figure 3.13. This command measures a small selection of on-screen color patches and compares the expected results with what your monitor actually produces using the current profile. Differences are measured in Delta E (dE) units. A change in color of less than 2dE is considered to be visually undetectable.

Figure 3.11 During calibration, no fewer than 75 patches of known color values are displayed. The resulting on-screen color is measured with a colorimeter. Notice that the most dramatic corrections are made to the monitor's 10-bit LUT, rather than to the video card's LUT.

Figure 3.12 A name and destination for the new profile have been selected. ColorEyes has automatically appended the profile's date and time of creation to the file name.

Figure 3.14 The Gray Balance tool allows you to view and add iteration points that specifically target non-neutral areas of your monitor's output.

Figure 3.13 After profiling was completed, I used the Validate Current Profile option to measure the accuracy of the newly created profile. The results show that any differences between expected and measured results are now well under 1dE.

It shows the default calibration points. If you find an area exhibiting a color cast when viewing this gradient, simply click the problem area to add a custom point that will be included in subsequent calibrations.

Once calibration and profiling are complete, it is absolutely critical that no brightness, contrast, or other settings are adjusted on the monitor. A profile is only valid under a specific set of conditions. Some software even includes the option to lock out or disable user-controllable buttons on the monitor once a profile is written.

Monitor calibration and profiling is not a one-time deal. The physical behavior of a monitor changes over time. That's a change in the conditions under which a profile was built. Most color gurus recommend recalibrating and profiling at least twice a month.

A Gray Balance feature allows you to compensate for monitors with unusually poor color balance. During a normal calibration, 15 neutral patches are displayed and measured. When you call up the Gray Balance option, a gradient, like the one in Figure 3.14, is displayed.

Scanner

A scanner is perhaps the most straightforward device in the digital darkroom to calibrate and profile. For starters, most do not have user-adjustable hardware settings to configure. Second, they have a fixed light source that is fairly stable and housed in an isolated environment. In addition, most scanners go through an initialization or self-calibrating routine upon startup and between scans, which leads to very consistent device behavior. So barring any service repairs, you generally won't need to calibrate and profile more than once.

You do need to make sure that any software controls, such as brightness, contrast, sharpening, and exposure, are turned off when measuring the scanner target. If your scanner can capture both reflective and transparent media, you'll need to create a separate ICC profile for each.

In the following example, I will calibrate and profile an Epson 1680 flatbed scanner using the IT8 function of SilverFast Ai. No matter which software you use to create an ICC scanner profile, you need two things: a physical target to be scanned and a text file containing the known Lab values of this particular target. In order for this text or reference file to remain valid, it is important to handle and store the scanner target carefully. The colors printed on the target must remain stable between the time they were measured by the target vendor and the time they are scanned by the user.

1. Locate a target that is appropriate for the type of scanner behavior—reflective or transparent—you want to calibrate and profile (see Figure 3.15).

2. Place the target onto the scanner and perform a prescan (see Figure 3.16).

3. Call up your preferred calibration software (see Figure 3.17).

4. Initiate the calibration and profile-generating process (see Figure 3.18).

Figure 3.15 At left is a transparent target used to build profiles for slide film. At right is a reflective target that will be used to build a profile for reflective media. Each target is numbered and includes a reference file containing the Lab values of each color patch.

Figure 3.16 You load the IT8 target on the scan bed just as you would any other piece of film. It's important to make sure that no auto adjustments or sharpening is activated.

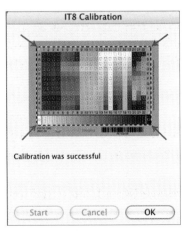

Figure 3.17 When you activate its calibration module, SilverFast prompts you to align a marquee along the edges of the IT8 target's color patches.

Figure 3.18 Once the scanner finishes reading the patches in the IT8 target, a confirmation screen is displayed. You can click OK to let SilverFast begin building the profile.

5. Name and save the scanner profile (see Figure 3.19).

Once a profile is created, a quick look in SilverFast's CMS options tab (see Figure 3.20) shows that the newly created profile is now set as the default for the scanner.

Figure 3.19 A profile is created, and you are prompted to save it in the user/Library/ColorSync/Profiles folder.

Figure 3.20 The profile for transparent media that was created in this example is now associated with this scanner's output and ready for use.

ICC Profiles and Negative Film

ICC scanner profiles do not apply to negative film, whether color or black and white. Remember that the goal of using a profile is to render the original as faithfully as possible. This is very useful for slides and prints, but not for negatives. It's rare that you'll want to reproduce an orange film mask or an inverted-color image! To address this situation, most scanning software offers a range of settings tailored for specific film emulsions that automatically neutralizes the mask and processes the image as a positive.

Printer

A few short years ago, the tools required to profile a printer were prohibitively expensive. The majority of photographers relied upon outside profiling services to generate custom profiles. There are now a number of options for in-house profiling. But producing even a reasonably accurate printer profile can still be a challenge simply because of all the variables involved. For starters, the printer must be in top working condition. Clogged nozzles, a failing print head, or out-of-date inks can negatively impact the production of a profile target. Printer behavior can even be affected by large changes in temperature and humidity. At the risk of beating a dead horse, a profile is only valid when used under the exact conditions in which it was created. The printer model, ink, paper, and driver settings must remain constant for a particular profile. If any of these specs change, the profile is no longer valid. Each ink and paper combination on a given printer will require a separate profile.

Ink Limit and Linearization

As with monitors and scanners, a calibration must be performed before a profile is created. With printers, the calibration process is distinctly separate from the profiling stage, and the degree of calibration possible varies greatly depending on the software used.

In fact, many entry-level profiling packages ignore calibration altogether.

Clogged nozzles aside, two of the most important calibration decisions revolve around ink limit and linearization. The thickness and coating of an inkjet paper determine how much ink can be absorbed. Several things can occur when too much ink is laid down on a paper. Bleeding describes what happens when ink dots spill over beyond their initial placement, much like a drop of liquid spreads over a paper towel. Mottling will show up as grainy-looking, uneven areas of ink. Another issue is that beyond a certain point, laying down more ink actually leads to a density reversal—ink patches actually get lighter. So it becomes very important to determine precisely how much ink a particular paper can handle.

The next step is to ensure that the printer is capable of a smooth gradation of tone from paper white to maximum ink. You accomplish this through a process known as *linearization*. To linearize a printer's output, you print a target image that starts with paper white (no ink) and gradually lays down more and more ink until the predetermined ink limit is reached. You then measure this printed target with a spectrophotometer, taking note of the actual versus expected ink densities. This procedure is performed separately for each channel of ink: once for cyan, magenta, yellow, and black, for example. The aim is to eliminate abrupt shifts in density and produce a smooth gradation of tones, like those shown in Figure 3.22. No inkjet printer will achieve this perfection unaided, however, due to the nonlinear behavior of print head mechanisms. The purpose of a linearization routine is to make the necessary adjustments to the printer's ink output to compensate for this behavior.

If you've never before considered things like ink limits and linearization, there is a good reason. The media setting you choose in the OEM printer driver performs these adjustments behind the

scenes each time you send a file to print. Selecting Premium Glossy paper in the Epson driver, for instance, will trigger a different ink limit and linearization adjustment than choosing Double-Sided Matte.

The printer driver that comes on your manufacturer's install CD is not your only option for getting image data to your printer. A RIP (Raster Image Processor) is a stand-alone software application that, among other things, allows you to completely bypass the OEM printer driver. One of the most important benefits of a fully-featured RIP is that the user can determine both ink limit and linearization. The StudioPrint RIP from ErgoSoft has a built-in linearization tool that prints out ever-increasing input values of an ink channel, as shown in Figures 3.21 and 3.22. An Eye-One spectrophotometer is used to automatically read density data back into the RIP. The ink limit describes the point beyond which laying down more ink fails to achieve greater density. With an ink limit determined, StudioPrint uses the density data to adjust the volume of ink output for each input value. This adjustment enables the printer to produce linear output between paper white and ink black. It makes a 40 percent K input print exactly twice as dark as a 20 percent K value. After the printer's behavior is measured, the RIP alters the input values it sends to the printer to achieve the appropriate density of ink on the paper.

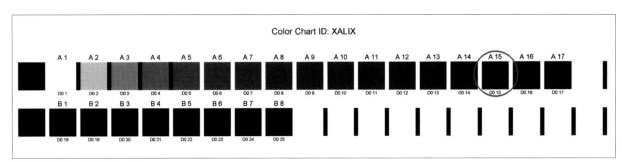

Figure 3.21 With the printer in an uncalibrated state, the ink channel—in this case, black—ramps up very quickly to its maximum ink load. In fact, after patch A15 (circled), increases in input values actually yield decreases in density. So this is where I will set my ink limit for this paper.

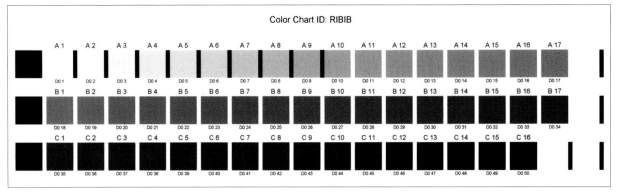

Figure 3.22 Printed after a successful linearization, this target shows 50 steps of smooth gradations from paper white to ink black.

Profiling

Once calibration is complete, you are finally ready to profile the behavior of the printer. The basic procedure for creating a printer profile is to print a specially prepared image file and measure the resulting print with a spectrophotometer. But the successful creation and use of printer profiles hinges on a number of factors.

Each profiling software package comes with one or more printer target files. Examples of these are seen in Figure 3.23. A target may consist of anywhere from 40 to over 1,000 color patches. The idea is to send a range of color values to the printer and compare the appearance of these colors when output on paper with known Lab input values. These Lab values are listed in a reference file specific to each target.

The goal when using a printer target is to send color values to the printer driver without modification. So it is crucial that the target is not converted to a working space. It must remain untagged. Photoshop's Print dialog must also be configured to leave color data unchanged, as seen in Figure 3.24. All color adjustments must be disabled in the printer driver itself. These steps are critical and ensure that the data is not altered before being converted into dots on paper. Finally, you must take note of the various settings you used when actually printing the target, as shown in Figure 3.25.

The next step is to measure the printed target; however, it's important to let the inks dry completely before doing so. Both color and density can shift significantly during drydown. Some pigment ink and rag paper combinations can take 24 hours or more to reach their final state, even if the prints are dry to the touch immediately after printing.

By now, the final steps of profiling should feel familiar. The color values of the printed target are compared with the Lab numbers used to create the digital file. By comparing what was expected to

Figure 3.23 Each printer profiling application includes its own profiling targets. Seen here are single page targets from PrintFIX PRO (top), Eye-One Measure (center), and ProfileMaker Pro (bottom).

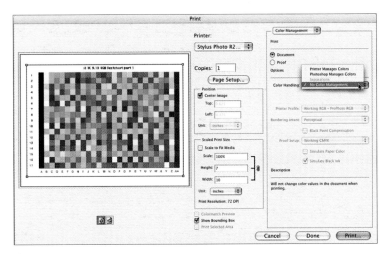

Figure 3.24 By selecting the No Color Management option in Photoshop CS3's Print dialog, you ensure that the color values in the target will not change on the way to the printer driver. You must also leave the print size and resolution untouched.

Figure 3.25 The profiling wizard in PrintFIX PRO prompts you to record the media and quality settings used when printing the target. These exact settings must be used each time you print a real image with the resulting ICC profile.

print with what actually was printed, the precise amount of adjustment required for a visual match can be determined.

Again, the keys to maintaining a profile's integrity lie in using identical ink and paper, maintaining a consistent range of temperature and humidity levels, and employing the same driver settings used to output the profile target when printing actual images.

Profiling for Monochrome Output

You may have noticed that the profiling targets in Figure 3.23 contain relatively few gray patches. Printer profiling has long been a process geared toward color output. But things are changing, slowly but surely.

The patches included in a profiling target represent a small sampling of possible colors that real-world images may require a printer to reproduce. There is an art to deciding which and how many color patches to include in a target. No vendor would create a target with the tens of millions of colors that your printer can actually reproduce. In fact, adding more patches can sometimes lead to less accurate profiles. But it stands to reason that if your focus is on producing monochrome images, then you would want a target with significantly more gray patches than those seen in Figure 3.23.

Canned Versus Custom Printer Profiles

I stated earlier that a printer profile is specific to a particular printer/paper/ink combination. Because not every person who buys a printer can be expected to create his own profiles, manufacturers include a set of canned profiles. Even if we assume that only experts with the best equipment produced these profiles, they have a major flaw. They characterize a printer other than the one you are using. There can be considerable unit-to-unit variation within a single model of printer. And factors like the wearing of print heads, temperature, humidity, and driver settings can noticeably affect a printer's output.

That leaves photographers seeking the highest print accuracy to either create custom profiles on their specific equipment or have professional profiling services do the same.

Recently, though, we have been seeing manufacturers increase the accuracy of their canned profiles by offering end users the ability to calibrate the printers to the state under which the canned profiles were created. Epson offers a free software utility called *ColorBase* for its current line of Stylus Pro printers. With ColorBase installed, the user prints a target and measures it with a spectrophotometer. The calibration software analyzes the printed target and writes a set of instructions that adjusts the data sent to the printer driver every time you print. HP goes several steps further. Its printers can perform their own internal calibration at the press of a button. Measurements are conducted right inside the printer, requiring no user involvement.

The idea is that if you can bring the printer back to the exact behavior of the unit used to create the canned profile, this profile will be much more accurate for the end user. This is a welcome development, even for photographers who will still need to make custom profiles. The better the calibration, the less work a profile has to do to produce accurate color. In Figures 3.26 through 3.28, we take a look at some real-world benefits of printing with a custom profile.

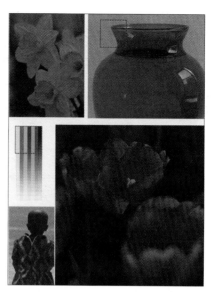

Figure 3.26 This is a test file I created to evaluate color output.

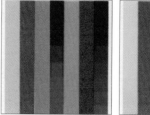
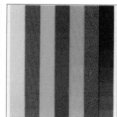

Figure 3.27 At left is a scan showing enlarged output from a printer using the manufacturer's canned profile. At right you see the same printer's output, but this time with a custom profile. Notice how much more detail exists in the blue color wedge.

Figure 3.28 At left is the print using the canned profile. On the right, a custom profile was used. Notice the substantial change in the hue of the vase and the more neutral background afforded by the custom profile.

Roy Harrington, whose popular QuadTone RIP (QTR) will be discussed later in this chapter, developed a target, seen in Figure 3.29, for creating grayscale ICC profiles. The idea is that once calibrated, an Epson printer—with OEM or third-party inks—can have its grayscale output measured to achieve a neutral and smooth tonal range from paper white to ink black. The concept is not new, but QTR provides a mechanism for users to create their own ICC grayscale profiles, a significant step in the evolution of a color-managed black-and-white workflow.

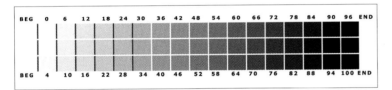

Figure 3.29 This grayscale target, included with QTR, consists of 51 patches of various densities. A spectrophotometer can be used to measure the ink densities.

A newer approach to user-generated profiles for monochrome output comes from ColorVision. Their profiling package, PrintFIX PRO 2, devotes considerable resources to creating neutral output using OEM inks and print drivers. I'll cover this product in more detail later in this chapter and in Chapter 6, "Black-and-White Inkjet Printing." PrintFIX PRO 2 can create standard color profiles in the familiar manner. What sets it apart, however, is its ability to characterize with great precision the combination of inks necessary to produce a neutral and linear grayscale image, as explained in Figure 3.30. It is designed for printers with multiple dilutions of black. Having two or more black inks greatly reduces the amount of color pigments needed to create monochrome prints. This, in turn, reduces metamerism and pronounced color casts.

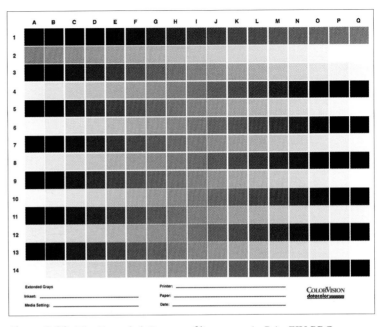

Figure 3.30 The Extended Grays profiling target in PrintFIX PRO includes gray patches along with low saturation color patches. These color patches are used to determine the amount of colorant that must be combined with a printer's black dilutions to reach a Lab-neutral gray.

Working with Color Spaces

Earlier in this chapter, I noted the primary shortcoming of device-dependent RGB color numbers—they can only have meaning in relation to the device that created them. An additional problem stems from the fact that the devices themselves are neither linear nor neutral in color rendering. A scanner RGB value of 4, 4, 4 is not twice as bright as a value of 2, 2, 2. Furthermore, equal amounts of red, green, and blue do not result in a neutral tone, as seen in Figure 3.31.

Figure 3.31 At left is an RGB value of 128, 128, 128 created in the sRGB color space. At right is the same 128, 128, 128 value when the color space is set to a scanner profile. This illustrates the difficulty you would have color balancing an image in a device-dependent color space.

A Rose by Any Other Name...

You will often hear the terms *color space, working space,* and *editing space* used interchangeably to describe linear color models. This causes no great harm, as they all refer to the same thing. Technically, however, the term *working space*—popularized by Adobe—refers to use inside of Photoshop. While some feel the term *editing space* more accurately defines its purpose, *color space* is the industry standard name. In this book, I'll use color space except where Photoshop's dialogs and menus specify working space.

Adding to the potential for confusion, when a color model is embedded in an image, it's usually referred to simply as a *profile.* I'll use the more precise *color space profile* to distinguish it from a *device profile.*

Now remember that the CMM compensates automatically for this device behavior by remapping the RGB numbers through a Lab-based color model. But when you edit an image, you are working directly with the pixel values. Can you imagine having to color correct an image where a value of 138, 126, 142 is required to produce a neutral midtone? Neither can I. To avoid such a scenario, you need the ability to describe color in a linear fashion where equal amounts of the primaries are rendered as neutral. Fortunately, this is the

raison d'être of color spaces. When you designate a color space, device-dependent values are not only translated into objective color, but they are also mapped into a space that is intuitive—unlike Lab—and well behaved, yielding predictable results when pixel values are altered.

A color space is a synthetic, artificially created model—that's why it can be linear. The two most commonly seen color spaces for RGB images are Adobe RGB (1998) and the ubiquitous sRGB. But there are many others. They are distinguished primarily by their gamut—the range and volume of colors they can describe. Converting an image to a small-gamut color space like sRGB runs the risk of tossing out unique color values recorded by the capture device. This is commonly referred to as clipping, and it obviously should be avoided when possible. But a color space using the largest gamut possible can present issues when you compress that gamut into that of an invariably smaller output device. The search for a middle ground explains why there are some many color spaces available. I'll talk about choosing among the various color spaces in the next chapter.

Of course, you also need a way to work in Photoshop with grayscale images. So it's not surprising that Photoshop offers a grayscale color space. Since gamut and neutrality are nonissues with grayscale images, though, it may seem odd that Photoshop lists no less than seven working space options—with different gamma and dot gain values.

Grayscale Color Spaces

To understand the function of grayscale color spaces, we must go back to the era before color management took hold. Due to a difference in graphics rendering between the Apple and Microsoft operating systems, identical K values would display differently on each system, as seen in Figure 3.32. Specifically, a grayscale image would appear darker on a monitor connected to a Windows machine than it would on a Mac. In order to create a visual match

between a midtone gray in both color spaces, a file in a gamma 1.8 color space would require a different K value than a file in a gamma 2.2 color space, as demonstrated in Figure 3.33.

Figure 3.32 Both patches are set to 50 percent K. The patch in a gamma 2.2 color space (long associated with a Windows OS) is darker than the patch in a gamma 1.8 color space (left), which was the standard on Macs.

Figure 3.33 Both of these patches are a visual match. The patch in the gamma 1.8 color space (left) is set to 50 percent K. The patch in the gamma 2.2 color space is set to 43 percent K.

By defining both a Gray Gamma 1.8 and Gray Gamma 2.2 color space and allowing for a Lab-based translation of their K value, Photoshop gave Mac and PC users the ability to view an image with identical contrast and brightness, regardless of the platform used to create it. Users would apply a gamma of 1.8 to images created on Apple's OS and use a gamma of 2.2 for images originating from a Windows machine. Thankfully, in today's color-managed workflow, the Mac/PC divide is no longer an issue. You can use either color space. The important thing is to embed the color space profile if you are distributing your images so that recipients can view it accurately. I should point out that the choice of a 1.8 or 2.2 gamma for a color space has no relation to the gamma setting used when calibrating your monitor. They do not need to match.

Apple and the Gamma 1.8 Mystery

Why did Apple choose a gamma of 1.8 for its graphics rendering? Common wisdom has it that this gamma was a closer match to the output of its LaserWriter printers. Remember those? This fudge was an early attempt to match the monitor to the print, without benefit of soft proofing and other color management tools.

Photoshop also includes dot gain settings of 10, 20, 25, 30, and 35 percent as working space options. Once again, this was an attempt to simulate the behavior of an output device—in this case, a printing press—on the monitor. When an ink dot hits the paper, it spreads. This is unavoidable, although modern inkjet coated papers do a remarkable job of minimizing this behavior. When adjacent dots spread, or bleed into each other, the density of the print increases—it gets darker. Dot gain is used to describe the amount of increase in density at the midtone value. A dot gain of 10 percent means that an input value of 50 percent K produces a printed patch that measures 60 percent K. Similarly, a dot gain of 30 percent means that when you send an image file containing 50 percent K, it will actually print at 80 percent K.

The dot gain working spaces were developed to compensate for this density boost. Assigning an image to the Dot Gain 10 percent color space visually brightens the image. The K numbers remain the same, but since the specified dot gain will increase density of the output, Photoshop decreases the density of the input. Specifically, it alters pixel definitions to the degree necessary, so that a 50 percent K input will now produce a 50 percent K output on paper. This brightening of the image reaches maximum effect at the midtone value and tapers off into the highlight and shadow regions. The result is indistinguishable from what would happen if you called up the Curves tool and set an input value of 128 to an output value of 154, as demonstrated in Figures 3.34 and 3.35.

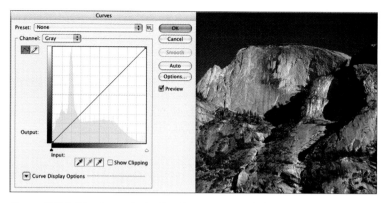

Figure 3.34 The image is displayed on-screen with the desired luminance.

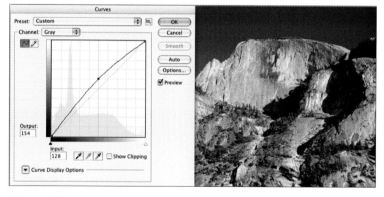

Figure 3.35 A curve is applied that simulates the brightness adjustment needed to compensate for a dot gain of 10 percent once ink hits the paper. The dot gain adjustment makes the image appear brighter on-screen but ensures that it will print as it appears in Figure 3.34.

It should be obvious that dot gain settings are specific to the printer/paper/ink combination. It is, after all, the interaction of these three that determines the density increase of a print. So in addition to its preset grayscale working spaces, Photoshop allowed users to create custom working spaces by providing their own dot gain values. In the dark days before profiles, linearization, or soft

proofing were available to black-and-white photographers, the creation of custom dot gain settings for each printer/paper/ink combination was the only option for controlling output. I won't bore you with the details of this process, but it was nobody's idea of fun.

One final benefit made possible by Photoshop's adoption of working spaces was that you could have multiple images open, each displayed in its own working space. Grayscale, RGB, and CMYK images could now be viewed simultaneously with accurate color values.

Configuring Photoshop's Color Settings

Okay, so how do you actually use color spaces? The first order of business is to properly configure Photoshop's Color Settings options, seen in Figure 3.36, so that unwanted and unexpected conversions do not take place when you open an image. Photoshop defines separate working spaces for RGB, Grayscale, and CMYK

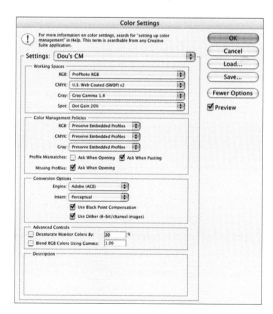

Figure 3.36 To configure your working spaces, color management policies, and conversion options in Photoshop, go to Edit>Color Settings.

images. Best of all, after you have determined an optimal configuration, you can save it with a descriptive name and call it up at any time using the Load button, or more conveniently, the Settings drop-down menu.

I'll ignore the CMYK and Spot working spaces, as both are beyond the scope of this book. The choice of your RGB working space determines the gamut of colors available for any new document you create. In essence, you're choosing the size and range of your color palette. In addition, each time you open an existing image, Photoshop will look to see if its embedded color space profile matches your chosen working space. I'll cover what happens when they don't match in the next section, but there's a lot less potential for user error if your default working space matches the color space profile of your images.

I strongly recommend the use of ProPhoto RGB as both the default working space and preferred color space profile of images headed for print. Its wide gamut ensures that colors contained in scanned film and raw captures will not be inadvertently clipped. It also encompasses the gamut of today's—and likely tomorrow's—inkjet printers.

Because a grayscale working space does not define a color gamut, the choice here is less critical, but for most purposes it should be limited to a Gray Gamma 1.8 or Gray Gamma 2.2. Again, the more foolproof solution is to choose a working space that matches the embedded color space profiles of your existing images.

Handling a Mismatch

When a mismatch occurs between the default working space and the color space profile of an image, Photoshop can do one of three things. It can ignore the color space profile altogether, as if it never existed. It can honor the embedded color space profile, making behind-the-scenes adjustments to accurately display the image. Or

it can read the embedded color space profile and automatically convert the image to the default working space. In Figure 3.37, you'll see what happens when an untagged image (no embedded profile) is opened when the Missing Profiles: Ask When Opening box has been selected in Color Settings.

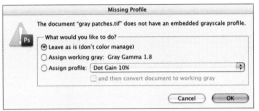

Figure 3.37 Photoshop recognizes that this image has no profile embedded and offers you three options.

In the vast majority of the mismatches you encounter, you are going to want to preserve an embedded color space profile. It was embedded for a reason—most times, a good one. So this makes for an excellent default behavior. And remember, it's just that, a default. You can always manually handle profiles under the Edit menu by choosing Assign Profile or Convert to Profile. If you're still feeling unsure of your default choice, you can check the Ask When Opening boxes for profile mismatches. Photoshop will then throw up a profile mismatch dialog box and ask you what to do (see Figure 3.38). I'll warn you, though, that this gets to be old in a hurry.

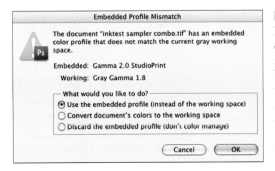

Figure 3.38 When Photoshop encounters a profile mismatch, the radio button defaults to the choice specified in your active Color Settings preset. Back in Figure 3.36, I chose the Preserve Embedded Profiles option.

The Untagged Profiling Target

One instance where you never, ever want to convert an untagged image is when opening a target used for making a printer profile. Profiling targets require that no adjustment be applied to the pixel values or their appearance.

Soft Proofing: The Magic Bullet?

Soft proofing was touted as the final piece of the color management puzzle. No longer would we have to waste paper and ink fine-tuning an image. We could view it on-screen, exactly as it would print. Well, that was the theory anyway. Don't get me wrong—soft proofing has an important and useful role to play, once you read the fine print.

The very first thing to make clear is that the goal of soft proofing is to simulate on-screen the behavior of a printer. Going to View>Proof Colors in Photoshop does not change pixel values in your image to make the print match the display. Think of soft proofing as more of an early warning system, showing you just how different the print will be from what you have created. Once you are made aware of the difference, it is up to you to fine-tune the image file for optimum print results.

Soft proofing faces two unavoidable hurdles. The first is that color, tone, and contrast will always be perceived differently on a monitor than on a print. The monitor provides its own light source, which is a backlight that illuminates the image. With a print, ink on the paper reflects light from an external light source. Without delving into the physics and color science behind all of this, these are simply two different methods of transmission. They will never be perceived as exact matches, no matter how much software magic we throw at it.

The second obstacle is that most of us make prints at sizes significantly larger than that of our monitor screens. The size and distance at which an image is viewed plays a large role in our perception of that image. What happens when you compare an 8×10 print with a 30×40 print of the same image? At the larger size, detail becomes more apparent and shadows will tend to open up. The overall effect is a slight loss of contrast. So if you soft proof with an on-screen image matching the physical dimensions of an 8×10, you may not be completely satisfied with the full size print. Sure, you can zoom in on-screen to match the magnification of the large print, but then you lose the ability to view the entire image. In short, you have much greater flexibility when viewing a print than is possible on a display.

Even if we take into account the limitations stated earlier, we must understand that certain assumptions are made in the mathematical wizardry that allow for soft proofing. The first is that the lighting conditions used to view the print are going to match those of the monitor. If you soft proof in Photoshop and then view the print under an incandescent household bulb, you will never get a match. Your monitor illuminates the screen at a specific color temperature and intensity. Soft proofing assumes that your print viewing conditions are comparable to that of the display.

How do you create the appropriate print viewing conditions? A desktop viewing booth is one—albeit expensive—option. A viewing booth uses color-corrected bulbs to match the temperature of the display, and the better models include a dimmer so that you can match the luminance, or brightness, of the monitor as well. A more economical route is to buy daylight spectrum lamps from Solux or OTT-LITE. This way you can illuminate the print with a color temperature closer to that of the monitor. The only luminance adjustment, however, will come via the wattage of the bulb.

Digital Black and White: Then and Now

The black-and-white photographer has been something less than a full class citizen throughout these early stages of the digital revolution. Mainstream tools and workflows are often developed with the much larger color market in mind. There are signs, however, of a new commitment to black and white by some of the industry's major players. The latest generation of printers from Epson, Canon, and HP all use multiple dilutions of black ink. Recently developed semigloss media that mimics the look and feel of traditional fiber-based papers while surpassing the Dmax of silver darkroom prints has been met with great enthusiasm. And we're starting to see grayscale print and profiling options based on color management standards.

We're not completely where we need to be. The ICC specification needs to explicitly address grayscale profiles. And a growing pattern of litigation by Epson against non-OEM ink cartridge suppliers has the potential to do great harm to the third-party ink market. No one can predict with certainty the changes in store over the next few years. But in this section, we're going to step back and take a look at how we arrived where we are today. Understanding the evolution of the process may give us some insight into what the future holds. If nothing else, it will provide an appreciation for those who paved the way and for how difficult getting even a mediocre black-and-white print used to be, not so very long ago.

CMY Versus Monochrome Dilutions

It has always been difficult to achieve neutral gray tones on paper using CMY inks. The inherent impurity of the inks themselves is what led to the addition of a black ink channel. But with only a single black ink, you must use combinations of the primary colorants throughout the entire tonal range of a grayscale image. Layering color ink dots on top of each other in order to produce gray, as seen in Figure 3.39, raises two important issues.

Even small shifts in hue in a monochrome print can be disturbing. And color pigments can be prone to metameric failure—that is, they shift color noticeably under different light sources. A single print may exhibit any number of color shifts—from green to magenta—depending on the light source and the specific combination of color pigments in the print.

In the traditional darkroom, black-and-white prints typically enjoy greater longevity than color processes. So the bar for digital monochrome prints has always been relatively high. Extensive use of color pigments in rendering a grayscale image can lead to fade differential. Simply put, not all colors fade at the same rate. Yellow pigment is generally much less stable than, say, cyan. So even if a black-and-white print begins life with its desired tone, it is likely to change over time as the color pigments fade at different rates.

The solution to both of these issues is to use multiple dilutions of black to produce neutral grays in a print. The use of a single tone of colorant greatly reduces the objectionable nature of metamerism. A print can still appear slightly warmer or cooler depending on the quality and temperature of light—that's part of the phenomenon of color perception. But any shift will be less dramatic and remain consistent throughout the tonal range of the print.

Figure 3.39 At left is an enlarged scan of output printed with a monochrome ink set. On the right is an enlargement of the same image when printed with color pigments.

Piezography and the Quad Black Revolution

Jon Cone's Piezography system was the first commercially available method of producing fine art black-and-white prints in the digital darkroom. A large part of its appeal lay in the fact that it was developed for use on desktop Epson printers, providing a low-cost entry to fine art printing.

Until the debut of Piezography in 2000, getting even a satisfactory monochrome print from an inkjet was an exercise in frustration. The Epson printer drivers provided a limited tonal range. Shadows blocked up fairly quickly, and in highlight regions, you could actually see individual printer dots with the naked eye. Producing a neutral tone using color inks was yet another obstacle. Even if you managed to mitigate these factors, the dye inks common to these printers could fade significantly in a matter of weeks.

Mature scanner technology coupled with the precision of Photoshop allowed us to create richly detailed grayscale images. With a well-calibrated and profiled monitor, we could accurately view these image files on-screen. But we simply could not print them with any degree of fidelity—certainly nowhere close to the quality to which photographers were accustomed in the traditional darkroom.

The Piezography breakthrough was the ability to produce an extraordinarily wide tonal range in a visually dotless print by substituting four dilutions of black ink for the normal CMYK ink set. This quad black approach used a black, dark gray, medium gray, and light gray set of carbon pigment inks. By using four different shades of black, the various tones in an image could be produced by assigning these dilutions to specific densities of the print. Fortunately for the end user, a specially designed printing interface—the Piezography BW plug-in handled this partitioning of inks automatically. It also included settings for many of the popular fine art papers.

A second generation of inks soon followed that offered improved longevity and was available in four tones—warm, cool, selenium, and sepia. The system was not without its shortcomings, however. Running pure pigment inks, with their greater viscosity, through the extremely fine nozzles of Epson inkjets required a fair amount of diligence from the end user. Frequent nozzle checks and print head cleanings were the norm. An even bigger limitation, from a color management perspective, was the lack of a simple way to soft proof this output. The paper and ink settings included with the plug-in were akin to canned "profiles." And with significant unit-to-unit variation among the printers, users often saw different results on identical printer models.

PiezographyBW ICC, released in 2003, signaled a new era in color managing grayscale images. The printing plug-in was discontinued

in favor of an approach based on the ICC profile standard. The Piezography team created grayscale ICC profiles that could be used for color-managed printing from any ICC-aware application. You could even use Photoshop's soft proofing capability to preview the paper and ink tone. Profiles were made available for all four Piezography ink tones and many of the popular fine art papers. One drawback was that the proprietary grayscale ICC profiling software developed by Cone Editions was not made available to users. For those not satisfied with using canned profiles, however, the iQuads system that soon followed included a custom profiling service. This was exactly the type of procedure that had long been available for color inks. Users could print a target and receive a grayscale ICC profile created for their specific printing conditions.

The most recent implementation of the Piezography system revolves around a completely new ink formulation. Dubbed Piezography K7, this set contains—you guessed it—seven dilutions of black. Dividing or partitioning the tonal range among seven ink dilutions provides extremely smooth transitions between tones, and it offers increased print detail in the shadows and highlights. This ink set, while still containing a high pigment load, flows more easily than its predecessors through the Epson print heads and dampers, requiring significantly fewer nozzle cleanings—a welcome respite for third-party ink users. And the K7 inks are available in neutral, sepia, and selenium tones.

A "hardware" method of split toning is possible by combining multiple K7 tones within a single seven-ink dilution. You simply mix and match cartridges—using one black, then three sepia cartridges in the darker gray positions, and three selenium cartridges in the lighter positions, for example. In this scenario, you are still using all seven dilutions in a given print; they will just be comprised of varying hues of ink.

The K7 ink set does require a specialized printing interface to accommodate its seven-ink partition of the grayscale image. The two pieces of software optimized for printing this ink set are QuadTone RIP and StudioPrint 12, both of which I will talk about shortly.

MIS Tones It Up

All photographers like having options, but black-and-white photographers seem to crave them like oxygen. The introduction of Piezography quad black inks gave users a wider tonal range without color shifts. But users soon began asking for the ability to produce prints of varying tone on the fly, without resorting to color pigments. MIS Associates took up this challenge by offering variable tone black-and-white ink sets.

The availability of six, seven, and eight-ink Epson printers made this feasible. MIS decided to use a four-ink monochrome system and set aside the printer's remaining ink slots exclusively for toning. With an MIS UltraTone ink set, the base set of carbon pigments is augmented with toning inks that contain lightfast color pigments. You dial in a warmer or cooler tone by adjusting the degree to which these toner inks print, alongside the carbon quad black configuration. With the same ink set installed in a single printer, you can vary tone on a per-print basis. And by using relatively small amounts of color pigments—only where needed for toning—much of the longevity benefit associated with a carbon pigment ink set is maintained.

MIS's variable toning approach owes its existence to photographer and longtime digital printmaker, Paul Roark. He creates modifications of their inks that mimic densities of the Epson inks. This means, in their most basic use, they can be printed directly through the Epson driver with no additional hardware or software. You control the toning for a given image with adjustments to the Epson driver's built-in color control sliders.

For those who want more precise control along with a greater variation of toning options, MIS provides Photoshop Curves settings, also created by Paul Roark, for a number of popular matte and glossy papers. In this printing workflow, you temporarily convert the image from grayscale to RGB and load a supplied curve for your chosen paper. Printing is still done through the Epson driver, but the RGB conversion and curve adjustment make it impossible to preview on-screen how an image will print.

RIPs Tuned for Black and White

A number of large format printer owners use a RIP. This specialized printing software bypasses the OEM driver. It allows for additional control of output and usually offers extensive layout features. For black-and-white photographers, the RIPs of greatest interest have been those that drive monochrome ink sets.

The first RIP available to Piezography users was the PiezoPro RIP. This was a decidedly unpolished piece of software that did not even offer an on-screen preview of the image to be printed. Its proprietary print engine was optimized solely for the original Piezography ink set. There was no option for custom profiles. In this workflow, users were required to manually create custom dot gain settings in Photoshop in order to preview print output. This was a time-consuming workaround that was not capable of simulating paper and ink color. In effect, the monitor was adjusted to emulate the printed output by editing the image in the custom gain working space.

ImagePrint, developed by ColorByte Software, was loaded with many professional layout features and was the first major RIP to offer explicit support for quad black inks. Their print engine, however, revolved around a proprietary profiling system. ColorByte included many popular grayscale ink and paper combinations and even offered to create profiles for users preferring different media. But because of their "black box" approach to profiling, users could not create their own profiles for quad inks.

StudioPrint: A Precision Tool for Printmakers

It was against this backdrop that ErgoSoft released StudioPrint 10, with the promise that users could calibrate their printer for any monochrome ink set on any paper. StudioPrint offered black-and-white printmakers the ability to tightly control print output. Instead of relying on outside vendors for proprietary profiles, you could linearize, or calibrate, the output of individual ink channels. Color printmakers have long had this ability. What set StudioPrint apart was that multiple dilutions of black ink could be controlled and partitioned according to their densities. Any inks you could physically load into the printer could be mixed together in order to create a smooth grayscale. Complete control of how the inks were laid down was placed in the hands of the user.

StudioPrint was, and still is, a professional level application, with a price to match. But the degree of control it offers over nearly every aspect of printer behavior makes it well suited for those who like to tinker.

QuadTone RIP: Big Control, Small Price

Like many great ideas, the genesis of QuadTone RIP (QTR) grew out of frustration. Its creator, Roy Harrington, had a printer and ink combination that was no longer supported with a printer driver on his operating system of choice. This motivated him to write a shareware program, based on open source code, which could serve as a printer driver for his large format Epson.

Roy's background as a black-and-white photographer led him to add support for a number of third-party monochrome ink sets, as well as Epson's UltraChrome K3 inks. Like much more expensive RIPs, QTR allows you to linearize a printer so that it performs optimally for a given paper and ink combination. Once the QTR

printer driver understands the output behavior of the printer, it automatically converts the grayscale input values of the image file to the output values that determine output through the available ink channels. Users of variable toning monochrome solutions, like MIS ink sets and even Epson's own Advanced B&W Photo mode, can adjust toning on the fly by calling up the appropriate curve set in the Print dialog (see Figure 3.43).

The printing features of QuadTone RIP make it an attractive and economical alternative to commercial RIPs, but perhaps its most striking feature is the bundled profile-generating tool that lets users create ICC grayscale profiles. I'll talk more about this capability later in this chapter and in Chapter 6.

OEMs: The Empire Strikes Back

Given that profit margins from ink sales are the linchpin of Epson's business model, no one could have expected the company to ignore the third-party black-and-white ink market forever. And in 2005, Epson introduced the UltraChrome K3 ink set. With the introduction of three monochrome inks, a black, medium gray, and light gray, Epson raised the bar for OEM black-and-white printing. The leap in quality for black-and-white output from Epson's previous products was stunning. This formulation reduced metamerism and bronzing to acceptable levels, while limiting the amount of color pigments being used to generate neutral tones.

The popularity of the UltraChrome K3 ink set did not escape the notice of Canon and HP. Both companies have since released pigment-based printers with multiple dilutions of black. Canon's 12-ink LUCIA formulation includes two gray dilutions in addition to a photo black and matte black. HP's flagship Z3100 series printers signaled the first OEM quad black solution. On matte papers, four monochrome inks are used simultaneously for grayscale images. No color ink is used to produce neutral grays, blacks, or highlights. This makes the Z3100 an attractive option for photographers who are concerned first and foremost with image stability.

So what does all this mean for black-and-white photographers? For the first time in the digital revolution, we have a choice of suitable OEM systems in addition to the third-party solutions upon which many of us have relied for so many years. It bodes well for future innovation and performance that the emergence of three respected rivals in the fine art printing segment coincides with improved black-and-white output over previous OEM solutions.

Grayscale Management

So how does color management work for black-and-white photographers? Have we finally escaped from the shadow (no pun intended) of the much larger color photography market? In terms of hardware—cameras, scanners, monitors, and printers—we've never had it so good. Calibration, profiling, and raw file conversion tools enable accurate descriptions and rendering of grayscale images throughout most stages of the workflow. Can we make a print that matches what we see on-screen? Well, the devil is in the details, as they say, and the degree of control you have over the final output still depends a great deal on your choice of printing software. In the following section, I'll briefly compare three options available to black-and-white photographers with regard to color management. I will revisit the available options in much greater detail in Chapter 6.

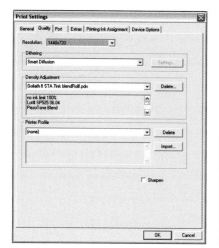
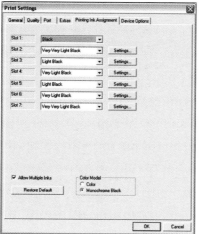
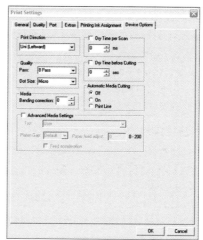

Figure 3.40 From left to right, you can see the Quality tab, Printing Ink Assignment tab, and the Device Options tab.

Closed-Loop Calibration

StudioPrint offers an exceptional degree of control over how ink is laid down on the paper (see Figures 3.41 and 3.42). This is accomplished by creating detailed print environments for every paper and ink combination. A single print environment contains information about the ink limit, linearization, dot size, dot placement, and ink channel assignments. While these print environments can be continuously calibrated to maintain consistent output over time, they cannot be used outside of the StudioPrint driver. You cannot use them to soft proof. It is possible, however, to create a custom gamma color space in Photoshop that mimics the contrast delivered by your print environment. This approach does not preview paper and ink tone but will give a fairly accurate sense of highlight and shadow detail that you can expect in print. StudioPrint offers users access to a number of options that determine output. In Figure 3.40, we take a look at some of these choices.

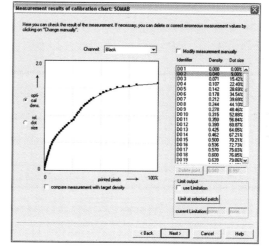

Figure 3.41 Here you see a graph of density target measurements. In this case, 50 patches were printed, covering the range from paper white to maximum ink black.

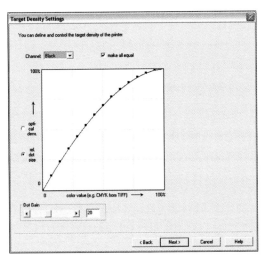

Figure 3.42
StudioPrint applies a user-adjustable dot gain on top of its linearized output. The default is a value of 20 percent.

Output density is tightly controlled through StudioPrint's built-in calibration feature.

StudioPrint does not create grayscale ICC profiles, but you can apply a dot gain setting to match printer output density to monitor output.

Grayscale ICC

QTR attracts much attention as an inexpensive alternative for generating high quality black-and-white output. Its most significant contribution from a color-management perspective, however, is the bundled QTR-Create-ICC tool. This single piece of software allows anyone with a spectrophotometer to create an ICC-compatible grayscale profile, regardless of the monochrome ink set they have installed. You simply print a provided grayscale target and measure

the density of its patches. The result is a profile that can be used for soft proofing in Photoshop, as well as printing through any ICC-aware application. It's hard to overstate the usefulness of this profile-generating tool. With its introduction, black-and-white photographers could characterize any monochrome or split-toned inkjet output in a format adhering to ICC specifications.

QTR comes with its own printer driver (see Figure 3.43), bypassing the Epson driver dialogs.

Perhaps the most appealing feature of QTR is that it allows you to create grayscale ICC profiles. To do this, you need a spectrophotometer and a copy of ProfileMaker's Measure Tool utility (see Figure 3.44).

Figure 3.43 The QTR printer driver includes canned curve sets for the more popular fine art papers.

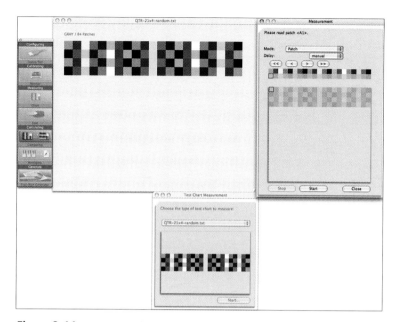

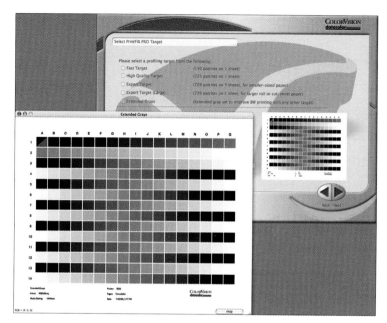

Figure 3.44 MeasureTool, a utility bundled with the free demo version of ProfileMaker, provides an interface for measuring the QTR profiling target with any number of spectrophotometers on the market.

Figure 3.45 In PrintFIX PRO, you can characterize precise black-and-white printer behavior by printing and then measuring patches from the Extended Grays target.

Color-Controlled Black and White

PrintFIX PRO 2.0, the hardware/software profiling bundle from ColorVision, has added some features that bring monochrome output squarely into a color-managed workflow. As in its previous version, PrintFIX PRO 2.0 can be used to generate color profiles by measuring patches from a supplied color target. What sets this package apart, however, is the ability to print an Extended Grays target, like the one shown in Figure 3.45. Measuring this target with the bundled spectrophotometer characterizes the hue of a printer's multiple black dilutions. You can then bundle this data into a new profile that describes the amount of color pigment necessary to achieve a neutral black-and-white print with smooth gradations of density throughout its tonal range (see Figure 3.46).

ColorVision's use of the Extended Grays target addresses some major needs of black-and-white photographers. A comparison of the gray inks provided by Canon, Epson, and HP will show that they all differ in hue. It is also well documented that the choice of paper can influence the color of monochrome inks as well. You may love the tone that HP's Vivera inks produce on one paper but find that another paper yields a slight warmer or cooler tone. PrintFIX PRO uses the measurement data from its Extended Grays target to determine the amount of color pigment necessary to bring the printed color of the gray inks as close as possible to 0 values for both

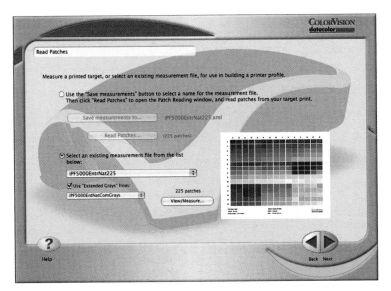

Figure 3.46 By selecting the Use Extended Grays From option, you can incorporate the measurements from an Extended Grays target with the standard color target measurements when building a new profile.

Digital Black-and-White Pioneers

Concluding this chapter are exclusive interviews with three individuals who have developed tools specifically for fine art monochrome printing. Although they bring different backgrounds, experiences, and resources to their work, they each share a passion for both the craft of black-and-white photography and the technology that continues to move it forward. Their inventiveness and commitment are reflected in the vibrant community of end users that has nurtured black-and-white digital photography from the beginning.

the a and b Lab axes. A Lab value where a=0 and b=0 is the objective definition of a neutral color.

But what if you *don't* want a dead neutral tone? Perhaps you'd like a warmer, cooler, or even split-toned interpretation of the image. PrintFIX PRO 2.0 leverages the gamut of the OEM color ink sets to dial in tints and split tones right inside the profile. I'll take a detailed look at this in Chapter 6. But the idea is that by creating profiles specific to not only paper and ink but also tint, you can print a single grayscale image file in any number of hues without reworking the actual file. You can even import Photoshop RGB curve settings into the profile for a level of toning precision beyond that available in most OEM printer drivers.

Jon Cone

Jon Cone is a master print maker and creator of Cone Editions, a collaborative printmaking studio that has been involved with digital printing for more than two decades. He is also the founder of Inkjet Mall, whose Piezography system made high quality black-and-white printing possible with Epson desktop printers.

○ Download an mp3 audio file of this entire interview by visiting the book's companion Web site at www.masteringdigitalbwbook.com.

Amadou Diallo: *Talk a little bit about Piezography's evolution from a quad tone or four-ink printing solution to your current ink set, which uses seven dilutions of black.*

Jon Cone: I actually introduced photographers to quad black printing about five years prior to the Piezography system, with a solution that used IRIS printers.

AD: *Was this DigitalPlatinum?*

JC: That was DigitalPlatinum, and I debuted it publicly at the PhotoPlus Expo in 1998. That's how I met George DeWolfe and John Custodio. These two photographers introduced me to the idea of developing a monochrome setup for the Epson printers.

I had been printing quad black prints for photographers, and what we were really trying to do was imitate large-scale platinum printing because those materials really had gone into extinction. The sole maker of large-scale platinum paper had stopped its production, and so DigitalPlatinum was for me a way to preserve photography. It is probably still my most amazing system to date. It had a very unusual toning, and the printer itself had 31 different variable size ink drops.

Essentially, what quad black infers is there are four dilutions of black ink, and there was a similarity between the IRIS printer and the Epson Stylus Color 3000. Both had four print heads. What the Piezography system did was introduce quad black printing to a much wider audience because the Epson was many times cheaper than an IRIS printer.

I began selling Piezography in 2000. Eventually, we came out with a support for an Epson 1160, another four-ink printer, and then when we came out with support for the six-ink photo printers, like the 1200...an incredibly unruly printer. What we did with the six-ink printers was take those quad inks and double them up. You have a black, a dark, a medium, and a light. We doubled up the dark, doubled up the medium, and put these duplicated tones in the photo cyan and photo magenta positions. So we had six-ink printers, but they were still running a quad black system.

So the next step was 2003 when I introduced PiezographyBW ICC. By this time, I had a whole new generation of ink. We still had four inks: black, dark, medium, and light, but what we ended up doing in the photo positions was using lighter dilutions in combination with the existing inks. We ran a medium dilution along with the dark ink, and a light dilution with the medium ink. Print quality was just amazingly increased.

2004 was the first time I really saw the seven-ink systems that other people were developing. I had won the PMA Best in Black-and-White award for Piezography BW ICC that year. And when I put a print that we produced with a six-ink printer right next to a septone print done on a seven-ink printer like the 2200, I could see visually that we had a much higher fidelity. While the septone systems and the toning systems were using seven-ink printers, they were not using seven dilutions. They were using a warm set and a cool set. You had a warm toned light, medium and dark, and a cool toned light,

medium and dark, plus a black. You dialed in warm or dialed in cool, but you never used all seven dilutions at once. They did not divide the grayscale image up into seven parts, or partitions. What I did differently I think was to look at a seven-ink printer as a potential for creating a higher standard.

So if I was going to come up with a variable toning system—which was important to photographers—I was going to see how much further I could raise the bar. And using seven dilutions is visually superior to four. It is even superior to a six-ink dilution. You can use such weak dilutions for the highlights, and the crossovers are not present. So for the Epson 2200, I decided to do two things. Make seven dilutions for the highest standard possible, and then make an ink that was achromatic, meaning neutral, to the human eye, without color. So that when we printed it on paper, the tone of the paper—just like in a traditional silver darkroom—would impart the final color to the print.

AD: *These innovations seem driven by taking the output process to the ultimate level of photographic fidelity.*

JC: Absolutely. I mean I have always specialized in choosing the smaller market rather than going for the money market. It's about whatever I can do to increase fidelity. Now we are starting to do split tones—splitting between, say, sepia and selenium or neutral and sepia. It looks more photographic than ever.

AD: *You are steeped in the traditions of printmaking, and it seems that that's really shaped your approach to digital printing. It seems as if that perspective made you open to a lot more possibilities.*

JC: I started out at the School of Photography at Ohio University. About halfway through, I switched over to printmaking. What I discovered when I started working with the IRIS printers and drum scanners was a perfect blending of photography and printmaking. You're doing both of them at the same time.

Another thing that really drove me to digital was that I was trained by the first Fellow Printer of The Tamarind. His name was Donald Robertson. The Tamarind had some strict ideas about what collaboration should be. I think Ken Tyler said it best. "As a collaborator, as a master printer, you are handmaiden to the act." We were taught that we really shouldn't interfere with the artist; we shouldn't make their mark. But with Cone Editions, which was founded as a collaborative printmaking studio, I found that in order to approach a major artist, spark their imagination, and make them want to work with me, I had to invent tools specifically for them. I invented some oils and pastels. I did all kinds of etching techniques, hybrid photogravures for various people. And sometimes that mark making required a lot of participation from me, and that began to become a conflict. What I loved about the digital realm was that it was completely virtual. The artist didn't touch the pixels. I didn't touch the pixels. The thing I was always fighting against—how much a master printer should be involved—didn't matter with digital. The physical matrix didn't exist. Everything is in software code until you have an actual print.

AD: *Should the ultimate goal of digital printmaking, and in particular inkjet printing, be to replace what we've been able to do in the darkroom or instead create a distinctly unique medium?*

JC: Well, I speak for myself. I have two responsibilities. One is to preserve the traditional values of photography, When I first started doing monochrome, I knew then and there that my goal would be to try and preserve the values that I love about photography. Because if I didn't do something like this, the scientists would do it. And you end up with Epson engineers and Canon engineers, and they're not really

photographers. And then the tools that photographers eventually inherit…well, they may not be the most photographic.

So I want to preserve the ideals of photography, but at the same time, the tools that we developed surpass what traditional photography could do—just in terms of tonal range and how perfectly linear our systems can be. They react more like the human eye than they do like silver. So where it goes from here it's hard to say, because who's going to be in control of creating the tools?

AD: *As photographers, we have always been an obsessive bunch about virtually every aspect of the craft. Now, with digital, it has really taken the obsession with equipment to an even greater level. Do you feel it's too easy with all of the technology advancements today to overemphasize technique and what the tools can do at the expense of one's own creative vision? Do you feel photographers should be looking at dither patterns with a 10x loupe in determining, "Oh, this is a good quality print, or it's a poor quality print?"*

JC: I would caution a digital photographer today in terms of technology. You could hold up as an example the traditional photographer when he went to see a curator for the first time. When he went into the gallery, he didn't talk about the technique. He didn't talk about the lens or shutter settings, but about the light, the moment, the content. I mean, content is everything when it gets down to it. None of that can ever bore the viewer, the dealer, or the curator. I can tell you that no one really ever wants to hear about pixels! So I would caution digital photographers not to talk about technique and really to concentrate on the content.

I suppose, what the loupe would tell a photographer is whether this medium is good enough for him to be very expressive on. Then the loupe gets put away.

AD: *In the fine art world, how have you seen the acceptance of digital prints evolve?*

JC: I'll talk a little bit about what I'm doing now for Gregory Colbert.

AD: *He's done the big Ashes and Snow exhibit that has gotten a lot of attention. It came here, through New York.*

JC: Yes, the next stop is Tokyo. He's an amazing photographer. He's using both paper and projection and doing some amazing experimental photographic printmaking. First, I would say that artists have to really accept the medium. With Gregory, you have someone who has adopted these digital tools—and bravely. The art world can't reject beautiful, visionary artwork; it moves towards it. If one can produce really significant and beautiful fine art and beautiful photography, no matter what the tools are, then the fine art world moves towards it. That's just inevitable.

AD: *Today we've got a wide choice of printers, inks, and papers. Canon and HP are now jumping into the printer market. What are some of the areas that you feel have room for significant improvement, specifically with regard to black-and-white printing for the fine art market?*

JC: I'm working on those right now. I'm working on a whole new inking system coming out of the intense development I'm doing right now. Probably the biggest thing I would like to see is the creation of a purpose-built platform for black-and-white photographers. That is a purpose-built printer, purpose-built inks, and a purpose-built media. Right now, what we're trying to do is adapt tools. We're taking Epson's printers, and we're adapting inks to them. But Epson has to make compromises because no one in their right mind would build a printer for a specific black-and-white ink market.

I would also like to see less erosion of those federal laws that permit us to put inks into printers.

AD: *The third party vs. OEM issue.*

JC: That's certainly under attack right now. Under the current administration, there has been some weakening of antitrust laws. I don't want to suddenly see that the only tools photographers have available are those with the stamp that Epson puts on them, or Canon, or HP. It's like eliminating all the racing from an automobile manufacturing process. Great advancements come from racing teams around the world. And that's why those manufacturers support those teams. Those inventions get into the process and end up in consumers' hands.

AD: *They get to see what works, what doesn't work, and how they can market it. With the K3 ink sets, for example, Epson switched to three dilutions of black.*

JC: Exactly. But they still have color ink in their black-and-white prints. And the reality is, no matter what kind of longevity ratings you're going to get out of the system, once you start putting color ink into a monochromatic print, you're going to have uneven fading.

So they're not necessarily making the tools that are going to allow a photographer's work to head towards the future intact with the color and tone that they envision. That was certainly the criteria that I put into my second and third generation of inks, a real stability.

It's interesting what HP has just done and what Canon did before that. I think these two companies have really put out some interesting products recently that are really going to force Epson into rethinking what they've done. They never saw HP coming. HP is making the most amazing hardware ever. So the whole market is getting very, very interesting, and maybe they'll be busy with each other for a while.

My platform of choice right now is these gigantic Roland printers. In the studio in New York, I have a 110-inch printer and a 64-inch printer. I have 12 ink slots. I am partitioning images with sometimes seven and eight partitions across two different inks. I'm creating inks as I want. The Roland is an amazing platform, and the software tools I have to run that printer are amazing. You know, you have StudioPrint yourself.

If you can begin to think of monochromatic images not as grayscale or RGB, but think of them as very multilayered images of information...I'll take that work I'm beginning to do and put that into the desktop printers.

There are tools out there that we really haven't seen being used for digital printmaking yet. I just want to see what's out there, what the capabilities are. I'm not only a developer; I'm also a printmaker.

Paul Roark

Paul Roark is an accomplished fine art photographer who specializes in black-and-white landscapes. But he is perhaps best known among his peers as architect of the MIS variable tone black-and-white ink sets.

✪ Download an mp3 audio file of this entire interview
by visiting the book's companion Web site at
www.masteringdigitalbwbook.com.

Amadou Diallo: *I'd like to begin by asking you if you could talk a little bit about your current printmaking setups.*

Paul Roark: My main printer for large prints is the Epson 7500 with a modified black-and-white ink set that I've designed.

On the small end, I am actually a big fan of Epson's entry-level printers like the C88, which I use with the MIS EZ B&W ink set.

Above the 8 × 10 size, I have a 2200 and a 2400. The 2200's getting a bit long in the tooth. The 2400 is just an outstanding printer. And in that printer I also have a custom ink set. I'm using a very, very simple modification of what Epson already provides. I simply replace their yellow ink with a light dilution of pure carbon.

I have a lot of printers, but to be perfectly honest, I could live with just one desktop printer and my 7500. MIS and I work together a lot. It's more of a de facto working relationship, nothing formal. I design these inks for MIS, not as a paid consultant. I do it for free, because I want to advance the state of the art. They just happen to have a business model in which they will make whatever people want. And it turned out people like the ink set formulas I came up with, so they end up making them.

It's turned into a mission for me, to be honest. I want to get affordable, top-quality black-and-white out there to everybody, without them having to pay the horrendous ink prices that the big companies charge. And so the support of the C88 and the 2200 that I've mentioned, with these MIS inks, basically gives starving artists, students, and retirees on Social Security a way that they can print black-and-white that is as good as what the most expensive equipment can produce.

AD: *One thing that I notice talking to people that are heavily involved in digital black-and-white printing is that there is a real passion there. Because at some level everyone is going beyond what the OEM, out-of-the-box experience will give you—all in pursuit of a higher level of quality.*

Could you take us through some of the steps involved in the ink design process? Are you blending the inks, mixing them by hand? How does that actually work?

PR: Well, it's evolved over the years. I was a darkroom guy for several years. I saw digital coming and tried digital internegatives, the digital imagesetter, all different sorts of things. Finally, it was Jon Cone's Piezography that convinced me that inkjets really could do the job. I was frankly amazed. But after a couple of months of using his system, I just didn't like the tone of the ink. I needed some way to get a tone that was more pleasing to me. So my first contribution was what I called the Variable Piezo ink set. I published all the formulas on the Yahoo Piezography3000 forum. This got me removed from the forum and incidentally led to the creation of the Digital Black-and-White Print forum.

As far as ink design, I want carbon to be the primary constituent. The question is how does one get a primarily carbon image that nonetheless has the tones that you want across the full tonal range? It's not easy to do. A single mix of ink will print with one tone on a given paper. So I started a variable tone

approach, first with the Variable Piezo, and then moved over to MIS, based on cost and fade tests that I did. One channel is typically carbon because I want to maintain the ability of the printer to print a pure carbon image. That is the most durable and light-fast image we know how to make.

AD: *So you get the longevity advantages, but the trade-off is you're going to get a warm tone…*

PR: Yeah. And in fact, with some of the newer papers like Crane's Museo Silver Rag, pure carbon is so close to a traditional sepia, that I'm dropping support for the sepia tones. At any rate, the basic issue is how do you get a printer that can do carbon and also run cooler to the neutral range and maybe just a little bit beyond the neutral? Some people like actually a bit of a cool image.

The variable tone method is simply a way to have one channel be carbon and the other channel comprised of a mix of inks, such that as you blend them into the carbon channel via software instructions, your tone goes from the carbon to neutral and maybe a bit cooler.

If you start with the premise that you're going to have pure carbon, then you're really looking at what toners will accomplish the goal of neutralizing this warm tone. My toners inevitably end up being a mix of primarily carbon and cyan. Cyan is a very light-fast pigment and better suited, in my view, than magenta, largely because it stays in suspension when mixed with the carbon and can control the color on the paper.

AD: *Canon and HP have released their own pigment-based photo printers. Could they pose a threat to Epson's dominance?*

PR: I'm just delighted to see the competition. I had a previous career in anti-trust law enforcement. So competition is in my blood. I want to promote it whenever possible. We're going to have to see how all that plays out.

AD: *I am wondering if we could step back a bit from the technology and if you would mind talking about your own photography. Who were your influences? What do you look for when composing an image?*

PR: I look for impact. I look for a macro and a micro sort of pattern. I want to get the attention of the viewer. And the question is, "How do I convey what I see and how I reacted to it to somebody who is not in this environment and does not really have the same context?" I want to grab their attention first. I want to pull them up to the image, and I want there to be enough of what I call the *micro pattern*, the things of interest in the image, to keep them involved for a long time. In terms of how I actually see things, I must say I think Rembrandt is the master. His use of light and the way he controls the eye is beyond what any photographer has achieved. I just think it is amazing how he has tapped into our mental processes to capture our interest and keep us looking at his images. If I had to pick one person that I found influenced me, it would be Rembrandt—not a photographer.

AD: *Do your printing or editing tools inform some of the choices that you make when you are shooting?*

PR: They actually do. They have changed some things. The ability to zone focus and combine images on the computer takes us to a different level. Even when you used lens tilt, you were still restricted to that one plane of focus, plus a little depth of field on each side. With zone focus, you can get everything. The ability to combine the dynamic range of multiple exposures… now I can capture from the shadows behind trees to the disk of the sun.

Knowing what I can do post-exposure in Photoshop has certainly influenced what I can capture, which is really cool.

I am now able to have a final image that is closer to what I see on the negative than I was ever able to get in the darkroom. Not to say the darkroom hasn't produced some incredibly good images. The masters show that in spades. But digital for me is closer to what I saw in the field and what I see in the negatives. That is a real advance.

AD: *There is always the comparison it seems of inkjet prints to silver gelatin prints. Do you think this is a fair comparison? Should we be looking to replicate previous standards from the wet darkroom, or should we look towards creating a new medium?*

PR: I think there's been an evolution of different mediums. I mean, we didn't start out with gelatin. Photography has gone through a series of different technologies. Silver gelatin was what I would call the final culmination of the wet darkroom process, and it set a very high standard. I do think it's fair to compare whatever new technology is challenging the current king. With digital, quite frankly, I think we've now beaten the silver print.

Which is more archival? The digital print is more archival. Acids are attacking the silver print, because of its buffered paper base. The cotton paper that's never seen an acid stop bath or all the chemicals is simply going to outlast the silver print. In terms of fading, carbon may not be quite as good as silver that's been totally toned, but almost nobody ever fully tones a silver print.

In terms of Dmax, we've beaten the silver print with the new glossy papers. Museo Silver Rag can achieve a 2.4 Dmax. You're never going to get that in a silver print. In the wet darkroom, the only way you're going to get a bright, high-contrast highlight is to bleach, and that introduces even more chemical problems. With inkjets, we can push that highlight right up to the paper white. I think the silver print is simply relegated to an alternative process category at this point.

I think the digital papers do still have room for improvement. One of my main criticisms is the durability of the surface. What I see really is that the physical damage to prints from handling is worse than the fading in most situations. The matte papers that we are using are just a disaster in terms of scuffing the blacks. If you take a Hahnemühle Photo Rag with a hundred percent black or a deep black anywhere and you touch it, it's ruined.

The glossies, you can spray them with a nice spray like Print Shield, and then they'd be able to withstand fingerprints. The technology that's gone into the new glossy papers from Crane, as well as Innova and Hahnemühle, is a major step forward, not only visually, but also in terms of the durability of the surface.

AD: *That's something that doesn't get discussed a lot.*

PR: No, it doesn't. People are so obsessed with the Dmax, metamerism—which is terrible—and gloss differential, but the physical durability of the print really needs to be focused on.

Roy Harrington

Roy Harrington has managed to combine the skills of a photographer and print maker with those of a software programmer to develop a product called *QuadTone RIP*. This software, known by its users simply as QTR, features an inexpensive printer driver that produces exhibition quality black-and-white prints on a variety of third-party inks and papers using Epson printers. It also allows for end user calibration and the creation of fully functional grayscale ICC profiles.

✪ Download an mp3 audio file of this entire interview
 by visiting the book's companion Web site at
 www.masteringdigitalbwbook.com.

Amadou Diallo: *I'd like to begin by asking if you could talk a little bit about the current setup that you use to print your own black-and-white images. What are some of the tools that you've settled on for optimum results?*

Roy Harrington: I use Epson printers. That's what QuadTone RIP is based on. My large printer is an Epson 7500. I'm currently running it with some of Piezography's Neutral K7, which is actually only K6 on that printer. The other printer I use primarily for my own work is the Epson 4000. In that printer, I have some MIS inks, and currently I've been doing more with the photo ink papers.

AD: *Like the Innova F-type Gloss and the Hahnemühle Fine Art Pearl?*

RH: I've mostly been using the Crane Museo Silver rag. I like the tone of that, but they're all very similar.

AD: *What are some of the factors that you use in choosing between the hardware and ink options you have, other than just image size?*

RH: The paper makes a big difference. Photo Rag happens to be the one that I've really liked. It's kind of become the standard. In finding what inks to work with, obviously the black is the biggest issue—what do you get for Dmax? The Piezography inks and the MIS inks and actually the Epson matte black are all very good for blacks.

I think the color of your black-and-white print is probably more important than the color of your color print. You are more sensitive to it. That's probably where I've spent most of my time in everything that I've done with black-and-white printing on the computer—and actually even before that, in the darkroom. What is the tone of the print, and how does that relate to what it feels like? Is it what you want? Is it neutral, is it warm, is it cool in tone? Different images have different needs. I try to get something that feels good for the subject. And when I do a show, I like to have all the prints look similar in tone. So I think the colors of the inks have probably been the most important thing in inkjet printing.

AD: *I'm wondering how you would compare the current state of digital printing for black-and-white photographers with what we could produce, say, 4, 5, 6 years ago? What are some of the key changes that you've seen in terms of advancing print quality?*

RH: Print quality is pretty much two things: the inks and the paper. Papers have probably increased most dramatically. They're getting better and better. And they're getting more geared to individual taste. And the ink's gotten better. Back when we were trying to print with just Epson color inks, you only had one black. Things like color casts—all kinds of problems would happen. To have multiple blacks or grays in a printer was a major advance.

AD: *Exactly. One thing that I'm very curious about is your role with developing QuadTone RIP. Independent software development is quite an undertaking to say the least. What was your motivation for creating QTR, and how did the idea come about?*

RH: It came about sort of by accident. I wanted to get into bigger printers, and I bought a 7500 in late 2002. But it was an old printer, and Apple had switched from OS9 to OS X. Well, here I was with a brand new computer that ran the newest operating system. But I had this old printer, and Epson was not going to upgrade their drivers to run on OS X.

I got wind of this open source project that had been going on for several years called *Gimp-Print*. As I started to use Gimp-Print, I found it had control of all the different inkjets, which seemed quite useful. People were saying, "Boy, I wish we could control these inkjets instead of having to send these RGB files" that mysteriously get converted into CMYK. If you could control these inks individually, you could do a lot. I slowly worked on it, just for my own use at the start. I wasn't doing anything fancy, I just wanted to be able to control the inks and learn how they got laid down on the paper.

The whole concept with black and white is that you have multiple shades of gray, and you use the light parts in the light parts of the picture, and you gradually get into darker grays as you get darker parts of the image.

When I started getting this going, there were a few people that I knew were interested in having that capability. As I got things working, I said, "I'll give you this and see what you can do with it." There were a few people that did a lot of work of actually helping me figure out what was useful. Slowly, I got to the point where the software was easy for others to use.

At this point, I just put it on my Web site and let people download it. It started becoming more and more popular. I found

myself doing more tech support. And also, people were asking, "What about this printer, what would it do it for that one?" And I thought, well, the only way to really try it on those printers is to buy those printers. It's at that point that I decided to make it a shareware product. It was a way to get a little bit of money for it. People just had to donate the money for the product. I still do that to this day.

AD: *Well, one of the things I've found most interesting about, at least the latest incarnations of QTR, is the fact that, using that spectrophotometer gives black-and-white photographers an opportunity to be full citizens in a color managed workflow. I wondered if you could talk a little about the role color management plays when using QTR. You've got the ability to create fully functional ICC profiles, correct?*

RH: That's right. All the black-and-white efforts that I knew of back then worked by manual trial and error. You'd tweak the curves, send out step wedges, and say, "I need a little more shadow detail opened up." The whole ICC concept has been around for quite a while, but the black-and-white side had always been neglected.

AD: *Sure. It seems that all the approaches that come out have the little asterisks behind them. "This is our proprietary method, and so you have to take what we give you."*

RH: That's right. But why not make it so it works as good for black and white as color? Because having part of your workflow be color-managed and some of it—the black-and-white printing—not being color-managed is really weird. Color management is built into all these editing programs. It is built into the operating systems. It deals with black and white, as well as color, internally, but you need to have the profiles to do it.

I figured out what the ICC formats and underlying ideas were and got to the point where color management would basically

control the luminance of your prints, so that what you saw in brightness on your screen would be the same as on the print. At least as close as you can get. Obviously, blacks are not the same on the screen as they are on paper.

AD: *It seems there is a never-ending debate over how close inkjet prints today are or even should be to darkroom output. Do you think it's important for the new process to mimic the old one? Should we be looking to replicate what we are doing in the darkroom or just forge ahead and say we're looking to create a distinctly unique medium here?*

RH: You look at what you did before and say I want the new process to be at least as good. But they are different mediums. This has happened before in photography. When silver gelatin came out, lots of people went to silver printing, but we still have people doing wonderful platinum printing these days, and it's a different look. It's a different feel. Interestingly enough, I think inkjet prints on matte paper look more like platinum than silver gelatin prints.

AD: *I'm just curious about what you see happening in the future. What advances would you like to see?*

RH: Well, I think most of the stuff is going to be pretty evolutionary, slowly increasing in capability. The Epson printers are slowly getting bigger heads, getting faster, getting more automated in terms of maintaining themselves. We'll probably see more inks, more heads, but the basic technology is the same. I think I can still make a better print with my ancient 1160 than with my 2400, if I put the right inks in the older printer.

The Epson 2400 is, interestingly, quite close to what I do with QTR in terms of not using as much color inks and instead using black inks. The strange thing is that you have two drivers now. One thing they did not do is address color management with black-and-white printing. My QTR-Create-ICC profiling stuff is really independent of my driver part. So you can use it with the Advanced B&W Photo driver in exactly the same way. You'd make the color ICC profiles with a color profiling product, and you'd make the black-and-white profiles with QTR Create ICC. You can do soft proofing, you can print through it. It does all the color management things that you'd like to do.

4

Digital Capture

For all of the complex and powerful tools at our disposal in the digital darkroom, one of the greatest determinants of print quality is the integrity of the image pixels themselves. We've all heard the axiom *garbage in, garbage out.* Yes, you can often salvage a usable print from a poor image file, but this usually involves compromises in output size, acceptable viewing distance, or even emotional content. The primary focus of this book is to produce work that communicates a personal style and a unique vision. When creating fine art for galleries and collectors then, we must aim for a final image without technical flaws or other compromises that discourage a viewer's engagement with the work.

With easy access to reproductions from the entire history of visual art, let alone photography, we do not lack for examples of emotionally satisfying imagery. Of course, there is no precise formula for crafting an image that grabs and sustains a viewer's attention. A work of art is, by definition, greater than the sum of its parts. But the tools and techniques used to create the image must be transparent, allowing the viewer to be immersed in a dialogue with the piece.

Content must determine technique, rather than the other way around. Some images demand high contrast, with deep rich blacks,

in order to sing. Others are more effective with a muted tonal palette. Our responsibility as practitioners of the photographic craft is to make aesthetic decisions based on as much of the image data as we can make available. In Chapters 4, 5, and 6, we will explore ways to maximize image quality throughout the capture, edit, and print stages.

I'll begin this chapter with an emphasis on the artistic and technical evaluation of the image in its earliest tangible form. I will then examine the options available during both film and digital image capture that maintain the highest possible image quality. The goal is simple: to derive the maximum amount of image data with which to craft your vision.

Image Evaluation

Any serious consideration of how to manipulate an image must begin with a careful examination of its content. The image will undergo many transformations—both artistic and purely technical—on its way to becoming a fine print. An awareness of its original attributes and how they may enhance or detract from an emotionally satisfying work should drive the decisions made during each stage of its production.

Why did I choose this image? How do I envision its final form? What does it have to offer? These are the macro level questions that can lead us to formulate a vision of what the work could become. A clear vision of the image's potential is a precursor to a work that communicates a unique point of view. I'm not suggesting you prepare a 20-page thesis on the profundity of your masterpiece. But thought must be given to traits inherent to the existing image that excite you. What characteristics set this image apart as a unique statement you wish to share with the rest of the world?

After you've found the magic, as it were, it is time to take a more technical look at the image and identify elements that impart its personality. Is the image driven primarily by contrast, by detail, or by subject matter? Are there particular elements in the image that compete for attention with what you view as its primary focus? What print and presentation materials will best convey your interpretation of the image? I think of these as micro level questions that can lead us to specific sets of choices during the editing and production stages.

No two photographers see alike or envision the same interpretation for an image that deeply resonates with them. So the answers to all of these questions are highly personal. What you do with these digital ones and zeros is image and artist dependent. I'll share with you some of my own thought process when creating an image in Chapter 7, "The Imaging Workflow."

If I can generalize about one thing, however, it is this: At no time should we settle for a loss of information due to improper application of our tools. By carefully examining the image in its earliest tangible form, we become familiar with its identifying traits, both obvious and subtle. This is a prerequisite for leveraging the maximum amount of information at our disposal into a successful image.

Reading the Negative

Obviously, you cannot capture detail or sharpness that does not exist on the negative, so it is important to examine the film on a light box with a loupe during the image selection process. You need to identify areas of subtle highlight and shadow detail, as well as determine whether there is sufficient sharpness in areas of primary focus. Not every image has to be tack sharp to be effective, of course. Abstract expressions of form and shape can produce a compelling narrative. But it's important to establish the nature of the image in its analog state so that you don't spend time later searching for something that simply isn't there.

I also find that the time spent poring over the negative can be a creative stimulus. The abstract inverted image encourages an examination of interpretive possibilities that can dissipate once the image is converted to a positive one. As viewers, we tend to accept a positive image as a "truth" that documents a reality. With the image still in its inverted form, we are under no constraints of reproducing what actually existed in front of the lens. As the examples in Figures 4.1 and 4.2 illustrate, the conception of the final form an image takes can often occur precisely because of reading the negative.

Once a negative has been selected to scan, you want to ensure that all of the information on the film is adequately recorded. I'll go into detail about achieving this later in the chapter. When determining whether or not your scanner is sufficient for your needs, the simplest test is to see if it is capable of resolving at least as much detail as you can see on the light table with a loupe. If you find that your scanner is leaving data behind, it's time to address shortcomings in your scanning technique, hardware, or both.

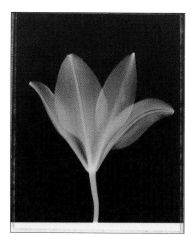

Figure 4.1 While studying this negative on the light table, I decided that the glow of the lily's petals would be best communicated by *not* converting the image to a positive.

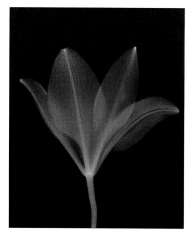

Figure 4.2 After some adjustments for contrast and heavier midtones, this final interpretation reflects my emotional response to the negative rather than my intent when photographing the subject.

Analyzing Digital Capture

With a digital camera, the collection of ones and zeroes that download from your camera or card reader become your reference for examining image data. Raw files are uniquely suited for providing maximum image data, as I'll discuss shortly in "Raw Versus JPEG." Perhaps the most important diagnostic tool for image evaluation is the histogram, available in Photoshop and other image editing software. Before we lose ourselves in the content or subjective qualities of an image, it's a good idea to determine whether the contrast of the recorded scene actually fits within the dynamic range of the camera.

A histogram, seen in Figure 4.3, shows the relative distribution of tones over a fixed tonal range. If the image data falls within these boundaries, you have usable detail with which to manipulate freely. Evidence of tonal clipping, shown in Figures 4.4 and 4.5, indicates there are pixel locations where no detail could be distinguished. They were simply recorded as maximum highlight or shadow values. At this early stage, once clipping has occurred, there is very little that can be done to recover the missing data, particularly in shadow areas. So great care must be taken to ensure that you start with as much distinguishable data as possible.

Figure 4.3 A histogram is a visual representation of the relative number of pixels located along the tonal range from maximum black to maximum white.

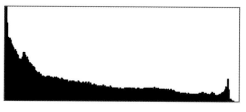

Figure 4.4 The sharp spike in pixel volume at the far left indicates a large percentage of pixels with no shadow detail. This is indicative of blocked shadows that occur when the camera cannot distinguish low light values.

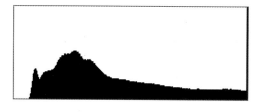

Figure 4.5 The thin vertical line at the far right of the histogram indicates that a large percentage of pixels have been mapped to level 255—maximum white. This is an example of "blown" highlights.

Blown Highlights: Lost in Space?

Those of you not weaned on reruns of this late '60s TV series will have to excuse this reference to the space robot with flailing arms shouting "Warning! Warning!" But the image often comes to mind when the highlight clipping alerts start flashing on the screen of my digital camera.

When shooting raw, it's important to note that you enjoy a wider dynamic range than is possible with a camera-processed JPEG. But the in-camera histogram reflects the color space and JPEG compression set in the camera, even when you are bypassing both by shooting in raw mode. So you have to take the blown highlight warnings with a grain of salt. They are valuable, to be sure, but they are much more conservative in their results than will be the case when you actually import the raw file into your preferred raw converter software.

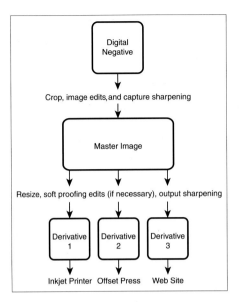

Figure 4.6 In a master/derivative workflow, a single digital negative spawns a number of derivative files. Separate versions are optimized for a specific type of output.

Master and Derivative Files

In order to consistently present an image at the highest possible quality, it seems obvious that you should optimize its appearance based on the type and size of output required. But quite often a single image is called upon to serve many tasks. You may be printing editions at multiple sizes. There may be a need for offset press reproductions on postcards or other promotional material. And, of course, you're likely to want the image available on a Web site. Each of these output methods comes with different requirements for file size, bit depth, color space, sharpening, and possibly even contrast.

A sound workflow must be flexible enough to generate files specifically tailored for each method of output. I propose a master/derivative workflow, outlined in Figure 4.6, in which a single image spawns multiple versions, each optimized for a specific output. I will describe the basic steps.

I refer to the first instance of an image file's appearance on the computer as the *digital negative*. This is either an unmodified scan of the negative or a raw file from a digital camera. This file is in 16-bit mode at the highest resolution afforded by the capture device.

A detailed archiving/backup workflow is beyond the scope of this book, but I strongly recommend that the digital negative be duplicated and safely archived at the earliest opportunity. Archiving a high-resolution, 16-bit version of the film scan means that you can avoid having to rescan a piece of film if you later decide to print it at a larger size. You can also use this file to create a new interpretation of the image with access to all of the original image data. With digital camera files, the digital negative becomes even more crucial since there is no film backup available in the event of a lost or damaged file.

Once a copy of the digital negative has been cropped, edited, and sharpened to retain detail lost in the digital conversion, it is saved as a *master image*. The file is still in 16-bit mode and embedded with

your working color space. It represents your final vision of the image, as rendered on-screen. It is from this master image that each purpose-specific derivative is created.

The first derivative is likely to be for an inkjet print. It is resized to the appropriate print dimensions. After viewing the print derivative in soft-proofing mode, minor edits to this file may be required to compensate for contrast and gamut limitations of the printer. And last, but not least, appropriate output sharpening is applied to compensate for the inevitable image softening that occurs when ink is sprayed onto paper. See "Capture Sharpening" later in this chapter for a more detailed discussion.

A second example of a print derivative could be a promotional piece to be output on a commercial press. This derivative may need to be converted to CMYK. It will almost certainly need image edits to reduce overall contrast. Highlights at 5 percent ink coverage or less may simply blow out to paper white. And subtle shadow detail between 95 and 100 percent is likely to block up on a noncustom print run. The specific halftone settings of the press, as well as choice of paper stock, play a big role in determining the appropriate output sharpening.

Most images will at some point need to be optimized for viewing online. This represents yet another derivative. In addition to the obvious need for drastic downsampling, it is a good idea to convert even grayscale images to sRGB. This is the default color space assumed by Web browsers, very few of which can actually read embedded color space profiles. Size-appropriate output sharpening is required. The amount and type of sharpening necessary for an 800 × 600-pixel Web image differs substantially from that required for a 30 × 40-inch inkjet print.

Generating purpose-driven derivative files increases storage requirements and demands a well-planned organizational structure. But by making adjustments that account for output destination and

image size, each file can communicate your vision of the finished image to a much greater degree of fidelity.

Matching Resolution to Output

The digital revolution has undeniably altered our perceptions of print size. In the wet darkroom, relatively few photographers had access to equipment that could produce anything larger than a 16 × 20-inch print. Today, inkjet printer models are available that can print 44 inches wide and beyond. So the temptation to "go big" is understandable. But when your concern is for the utmost in image quality, there comes a fundamental realization: The amount and quality of pixels, rather than maximum printer width, should determine print size.

Size Does Matter

Whether shooting digital or film, the choice of format plays a crucial role in maximum print size. A high-resolution scan of 4 × 5 film offers greater enlargement options than that of 35mm film, for example. In similar fashion, a medium or large format digital back will yield files that can print—at identical resolutions—substantially larger than those from the smaller sensor on a DSLR.

But while it's easy to focus on the megapixel count, it's the quality of the pixels that matters most. One of the biggest differences between images from a full-frame DSLR compared to those from a point-and-shoot model is reflected in the size of the individual photosites that capture light. Figure 4.7 shows the relative size difference between a 35mm full frame sensor and the APS-sized sensor common to pocket cameras. If you stuff an equal number of photosites onto a physically smaller chip, the size of each photosite must be reduced. As the size of a photosite shrinks, its light-gathering sensitivity decreases along with its capacity to record greater intensities of light. The result? Images with significant noise and color fring-

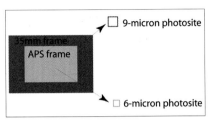

Figure 4.7 The difference in area between a 35mm and APS-sized sensor means that for an equal pixel count, the photosites on the 35mm sensor will be significantly larger. A large photosite has superior light-gathering characteristics compared to a smaller one.

ing (artifacts along high-contrast edges). The sensor's dynamic range will be narrower as well. It is not uncommon for a full frame DSLR to produce an image at an ISO of 400 that is noticeably cleaner than a 100 ISO image captured with a point and shoot. In short, a 10-megapixel camera with a large sensor will produce richer and more detailed images than a 10-megapixel camera using a smaller-sized sensor.

Resampling Pixels

After an image is digitally captured, there is no shortage of options for changing the number of pixels contained within the file. Downsampling refers to the act of throwing out pixels in order to reach a smaller print size or resolution, as seen in Figure 4.8. This is a relatively harmless procedure. The only drawback is that drastic reductions produce a less sharp result. Selecting Photoshop's Bicubic Sharper algorithm when downsampling is an effective way to compensate for this loss.

Upsampling, as you would imagine, increases a file's size by adding pixels, as seen in Figure 4.9. And therein lies the rub. Photoshop cannot reach back in time and add pixels from the original capture. Instead, it creates brand new pixels and interpolates (or assigns color values to the new pixels) based on the luminance of pre-existing pixels. The math behind this is complex but boils down to a best guess at what the new pixels should look like.

Figure 4.8 At left, the file has a document size of 19 × 13 inches at 300 ppi. When you reduce these dimensions with the Resample Image box selected (at right), you are tossing out pixels in order to achieve a smaller image. Along the top of the dialog box, you can see the file size has also been reduced—from 21.2MB to 2.11MB.

Figure 4.9 At left, the image has a document size of 19 × 13 inches at 300 ppi. When you increase these dimensions with the Resample Image box selected (at right), you are asking Photoshop to create additional pixels. The 21.2MB file will grow to over 72MB when these pixels are added.

The first thing to remember is that upsampling does not add more detail to an image. In fact, it tends to obliterate finely detailed objects. Photoshop offers a Bicubic Smoother algorithm to minimize pixilation, but upsampled images—particularly from scanned film—are fairly easy to spot, both on-screen and in print. It is always preferable to start with sufficient optical resolution at the camera or scanner stage.

If you want to adjust output size without altering pixels, you can uncheck the Resample Image box in Photoshop's Image Size dialog box, as seen in Figure 4.10. You'll notice that this grays out the pixel dimension boxes. The volume of pixels will remain the same. What changes is the space between them. A file containing 100 pixels at one inch by one inch will contain 100 pixels per inch. If you change the print size to two inches by two inches, the resolution becomes only 50 ppi. You have not altered the number of pixels, but simply spread them over a greater print area.

Figure 4.10 At left, the image has a document size of 19 × 13 inches at 300 ppi. When the Resample Image box is unchecked (at right), the only way to increase document size is to reduce the resolution. Setting a resolution of 180 ppi allows you to print this image at 31 × 21. Pixel dimensions remain unchanged.

Figure 4.11 Files from digital cameras default to a resolution of 72 ppi (at left). If I require 360 ppi for a high quality print, I can simply type in this resolution (at right), and the document dimensions will automatically reflect the corresponding print size.

With the Resample Image option deselected (see Figure 4.11), the Image Size dialog box is useful for determining the maximum print size appropriate for the native resolution contained in an image.

Capture Sharpening

Along with death and taxes, photographers must contend with the fact that all forms of digital capture lose some image sharpness compared to the original source. The physics behind the conversion of photons to electrons dictates that a degree of softening will result. With film, the optics of the scanner, number of elements within the path of focus, and the flatness of the film greatly affect image sharpness. As a rule, PMT-based drum scanners deliver noticeably sharper results than CCD film scanners, which in turn are usually sharper than most flatbed models.

Files from most digital cameras yield noticeably softer images when shot in raw mode. Part of this can be traced to the anti-alias filter that is often placed in front of the sensor to minimize moiré patterns and color artifacts. These filters effectively blur the incoming image so that artifacts and jagged edges do not appear in areas where data from the sensor must be interpolated via a demosaicing algorithm.

The late Bruce Fraser was a staunch (and quite convincing) advocate of a multistage sharpening strategy. In essence, this approach divides image sharpening into separate steps. Capture sharpening, which we are discussing now, aims to restore sharpness lost due to the reasons I described previously. In Chapter 6, "Black-and-White Inkjet Printing," we will look at output sharpening, which addresses the "softening" effects of various types of image output.

In Figures 4.12 through 4.15, you can take a look at images captured from four different input devices and the benefits they all receive from sharpening supplied via the PhotoKit Sharpener plug-in from PixelGenius. The magnified crops are shown at 400 percent screen view so you can see sharpening's effect at the pixel level.

Figure 4.12 The original flatbed scan of 120 film (above) is given 6 × 6 Positive Film capture sharpening with a Superfine Edge Sharpen effect (center). The result is below.

Figure 4.13 The original drum scan of 35mm film (above) is given 35 Slow Negative Film capture sharpening with a Medium Edge Sharpen effect (center). The result is below.

Figure 4.14 The converted raw file from a DSLR (above) is given Digital High-Res Sharpen capture sharpening with a Medium Edge Sharpen effect (center). The result is below.

Figure 4.15 The converted raw file from a large format digital scan back (above) is given Scanning Back Sharpen capture sharpening (center). The result is below. Because these files were captured at such high resolution, the magnified crops represent an area roughly four times the size of the previous examples. *Image courtesy of Better Light*

Digital Camera Capture

Capturing images with a digital camera has undeniable appeal for many photographers but does require mastery of additional steps to get the most out of an image. In this section, I'll discuss the benefits of shooting in raw mode, give an overview of sensor capture, and look at the processing controls offered by a raw converter. Shooting with a digital camera sensor (see Figure 4.16) places many of the technical and quality control burdens associated with a photo lab squarely in your lap. The payoff is the unprecedented control you have over the processing of an image *after* the shutter is tripped.

Figure 4.16 The DALSA CCD sensor packs 33Megapixels onto a surface area twice that of 35mm film. *Image courtesy of DALSA*

Raw Versus JPEG

Shooting in JPEG mode has many convenient benefits. For example, virtually any software that imports images can read the JPEG format. File sizes are kept very small. The powerful microchips inside digital cameras can process a JPEG's color balance, sharpness, and contrast on the fly and render output with a film-like response to contrast. The number of user-selectable image parameters available on a DSLR can make your camera seem like a miniaturized one-hour photo lab.

The price for this convenience, however, is a loss of precision, flexibility, and control. The majority of a JPEG's characteristics have been cast in stone by the time it is written to the memory card. You can, of course, perform edits in Photoshop, but because these JPEGs are 8-bit files, there is very little pixel "overhead" to accommodate major tonal adjustments. The JPEG format also uses a lossy compression algorithm, meaning the drastic reduction in file size for which JPEGs are known is accomplished by discarding pixel information. Furthermore, this data loss is cumulative. Each successive compression of a given JPEG results in the loss of unique pixel values.

When you shoot in raw mode, you are deferring virtually all image processing decisions other than focus, shutter speed, and ISO. Raw files are high-bit collections of luminance-based pixel data. Cameras are capable of capturing 12 or even 14 bits of data per channel. One of the most important benefits of a raw file is that it makes use of the full dynamic range of which the camera's sensor is capable. A raw file contains usable information over a significantly greater contrast range than was ever possible with slide film.

You can distinguish tones with greater precision over a wider tonal range by shooting raw. But the benefits don't stop there. White balance and exposure adjustments can be made nondestructively,

Photoshop Bits

If raw files contain either 12 or 14 bits per channel, why does Photoshop only have 8- and 16-bit modes? The simple answer is that Photoshop treats anything above 8 bits per channel as a 16-bit file. While a 14-bit raw file will contain more unique data than a 12-bit file, they are both converted into a 16-bit format in Photoshop. This approach simplifies image processing and maintains compatibility with file format standards like TIFF, which can only support two bit depths: 8 and 16. You'll often see the term *high-bit* used to refer to anything greater than 8 bits per channel, eliminating the need to distinguish between 10-, 12-, or 14-bit files.

A Raw Conundrum

For all of the benefits of raw files mentioned earlier, I am compelled to note one potentially significant limitation. Every camera manufacturer understandably wants to apply proprietary enhancements to their raw captures so that their images outperform the competition. Unfortunately, this has led to a proliferation of undocumented raw file formats.

If you own digital cameras from more than one company, you've got multiple file formats that can only be fully decoded via raw converter software provided by the camera manufacturer. As it stands today, every third-party raw converter on the market has had to reverse engineer some aspect of the encoding process in each of these raw formats. Some vendors are more forthcoming than others in facilitating this, but all of them generate proprietary data related to sensor capture that they would like to remain private for competitive reasons.

What does this have to do with us? Potentially plenty. With the rapid introduction of new camera models, it is not difficult to imagine a camera vendor or third-party software developer dropping support for "obsolete" raw formats generated by older model cameras. Now even if you continuously upgrade to newer cameras, you've still got older raw files archived somewhere that I'm sure you'd like to be able to open years or decades down the road. Few, if any, companies are going to want to maintain support for every digital camera ever made, so it's quite conceivable that years hence you will have a collection of raw files and no software to process them.

which means that you are never permanently altering the original image data. We'll take a look at these steps in more detail later in this chapter, but the idea is that a raw file enables you to take advantage of every last ounce of your camera sensor's performance. The trade-off is that you must now "develop" each image yourself. At a bare minimum, a raw file must be converted to a color, gamma-corrected image. Virtually every image will require adjustments to highlight, shadow, and midtone areas for pleasing output. So if JPEGs are analogous to shooting slide film, where "you get what you get," then raw files are much more like negatives, requiring interpretative steps to produce a finished image.

Each raw file will need to be processed through raw converter software before you can even view the image. Because raw files are always rendered as color images, you will also have to manually convert the image to grayscale. Before we delve into the specifics of raw conversion, though, let's take a look at how the camera sensor creates an image.

Just look at the ubiquitous nature of TIFFs and JPEGs for comparison. The reason that so many different types of software—from image editors to word processors—can read them is that the formats are openly documented. A budding computer programmer can go online and download the complete specifications for either format. If raw file formats were this accessible, the chances of your finding raw converter software 10 years from now that is compatible with today's files would exponentially increase.

Back in the mid 1980s, an attempt to head off a similar situation among scanner manufacturers resulted in the TIFF (Tagged Image File Format) specification. It was created as a documented file format so that all scanners could write files with the widest possible adoption among third-party imaging software.

In this vein, Adobe has put considerable effort behind the DNG (Digital Negative) file format. DNG is a documented file format, based on the TIFF standard, that Adobe is encouraging both camera vendors and software developers to adopt. The idea is that if cameras from different manufacturers can store raw data in an identical format, third-party software support for new camera models can happen more quickly and without the need to discontinue support for older cameras. In the meantime, Adobe has made available the Adobe DNG Converter, which can convert your proprietary raw file into the DNG format. It can be downloaded free of charge at www.adobe.com/products/dng.

It's too early to predict how this will all play out, but I do recommend that you become familiar with the issue of raw file compatibility. A good online resource for doing just that is openraw.org, the Web site of the OpenRAW working group, which is advocating for public documentation of RAW image formats.

Collecting Photons

One of the great ironies for black-and-white photographers is that while raw files are always rendered on-screen as color images, they are comprised exclusively of grayscale luminance data. Camera sensors are made up of tiny photosites whose job is to record incoming intensities of light. The photosites themselves are color-blind. Each photosite converts the amount of light it receives during an exposure into an electrical charge of identical proportion. Bright light causes a big charge, while low levels of luminance yield a smaller charge.

Each photosite corresponds to a single pixel in the rendered image. But remember the photosites are only responding to luminance, or brightness, levels. Placing a red, green, or blue filter over each photosite is what generates color information. A red filter placed over an individual photosite ensures that only wavelengths corresponding to red light pass through and initiate a charge at this location. The camera's software has been programmed to recognize any luminance value reported by this photosite as an instance of red light.

The Bayer Color Filter Array

If you've spent any time with Photoshop's eyedropper tool, you intuitively understand that, in an RGB image, a single pixel is comprised of three values—one for each primary. But I've just noted that each photosite on the camera's sensor is filtered for just a single primary color. To produce the full visible spectrum of color, the majority of camera sensors must rely on software interpolation to infer the two missing color values.

Instead of simply alternating red, green, and blue filters over the entire sensor, the majority of sensors utilize a Bayer color filter array, in which there are twice as many green filters as red or blue. This array, illustrated in Figure 4.17, was developed to more closely mimic human vision, based upon the fact that our eyes are more sensitive to green light.

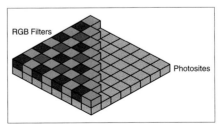

Figure 4.17 The Bayer color filter array was developed in the mid-70s but has become the most widely used mosaic in single shot digital cameras.

Bayer Pattern Alternatives

Although the Bayer filter array is hands down the most commonly used mosaic on sensors, there are two interesting alternatives. Foveon's X3 technology eliminates the need for color demosaicing by employing three layers of photosites on its sensors, as demonstrated in Figure 4.18.

The Better Light scanning backs employ another approach to digital capture. These backs mount onto large format cameras and use a trilinear CCD, shown in Figure 4.19. Operating much like a vertical scanner, the CCD unit moves to scan the scene one line at a time. The trilinear sensor captures three physical rows of data per line. A color filter covers each row. One is covered by red, the other green, and the last has a blue filter. In this manner, the full color information at any given point is captured. As with Foveon's approach, the collection of full color information by the sensor not only yields more accurate color, but it also avoids the need for an anti-alias filter and its image-softening effect.

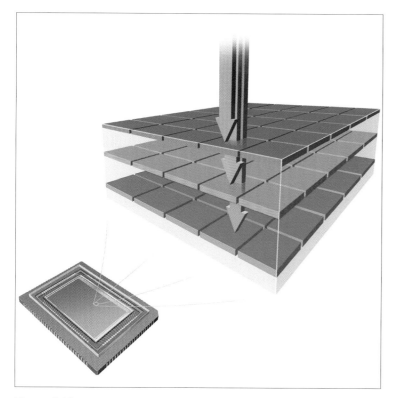

Figure 4.18 The Foveon X3 sensor records full color information for each image pixel without interpolation. Each layer is embedded in silicon, which absorbs red, green, and blue light at different depths. *Image courtesy of Foveon Inc.*

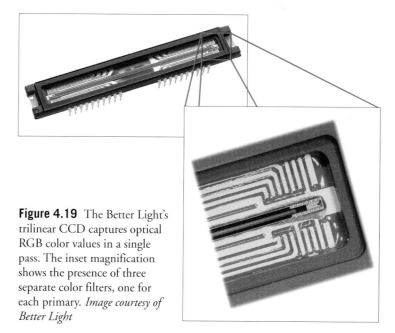

Figure 4.19 The Better Light's trilinear CCD captures optical RGB color values in a single pass. The inset magnification shows the presence of three separate color filters, one for each primary. *Image courtesy of Better Light*

Linear Capture

Regardless of the color filter array technology, all sensors capture data in a linear fashion. That is, a sensor will always record a 2x increase in luminance as twice as bright. What's the big deal, you say? Well, human vision perceives light in a subjective and decidedly nonlinear manner, as Figures 4.20 and 4.21 demonstrate. We never register a doubling of luminance as being twice as bright. We will not even perceive identical luminance increases in the same way if one occurs to pixels in shadows and the other to pixels residing in the highlights.

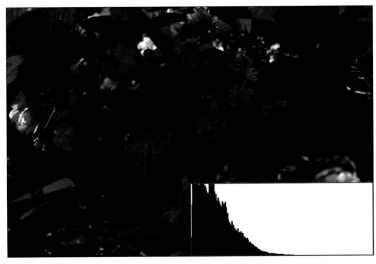

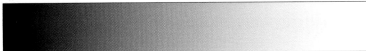

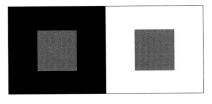

Figure 4.20 Human vision is by necessity adaptive. There are only three, not four, different tonal values in this image. Both gray squares have the same density. A dark background makes objects appear lighter, while a light background has the opposite effect.

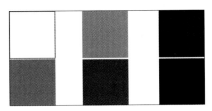

Figure 4.21 We perceive the paired groupings of tones to be at different degrees of contrast, but in each case, the top element in each pair is exactly twice as bright as the bottom element.

Figure 4.22 This is a raw file as it appears in a linear gamma. Note that the bulk of the histogram (inset) is bunched up toward the shadow end. Below the image is a gradient created in a linear gamma 1.0 color space.

The concept of linear capture has two ramifications for photographers. The first is that a raw file, in its linear state, will usually appear dark and without sufficient contrast, as shown in Figure 4.22. It will require a substantial tone curve adjustment that maps the linear data to a gamma-corrected response that better approximates human visual perception. Figure 4.23 shows just such an adjustment. The good news is that most raw converters preview this type of adjustment upon image import, saving you the despair of thinking that all of your images are underexposed. But this gives you some idea of the processing that must take place with every raw file you import from your camera.

Let's consider a 12-bit DSLR with six stops of dynamic range. It can distinguish a total of 4,096 discrete gradations between stop one and stop six, as shown in Figure 4.24. If the brightest luminance the sensor can record is assigned to level 4,096, linear capture dictates that a luminance measuring exactly half that brightness must be assigned to level 2,048. Refer to Figure 4.25 and note that 2,048 lies at the midpoint of available tones.

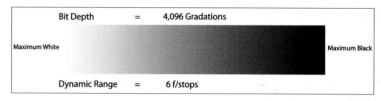

Figure 4.24 Dynamic range determines how far apart the maximum white and black are from each other. Bit depth describes the precision with which the tonal range can be divided.

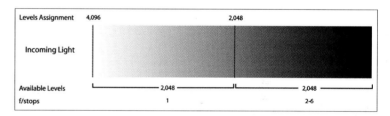

Figure 4.25 With 12 bits of data available, level 4,096 represents the brightest white the sensor can record. A luminance measuring half that intensity is placed at level 2,048.

Figure 4.23 A raw converter will apply a strong tone curve, like the inset shown, to map the linear data from the sensor to a more visually appropriate rendering of output values. Below the image is a gradient created in a gamma 2.2 color space that more accurately mimics human visual perception.

Raw Exposure

There is a second, and even more important, issue. The very nature of linear capture means that much more information can be recorded in highlight regions than in the shadows. Here's why.

Like any other input device, a camera's sensor has a fixed dynamic range—the contrast between the darkest black and brightest white it can distinguish. Let's think of this in photographic terms and describe the dynamic range as f/stops. The sensor also has a bit depth, which determines the number of gradations available over the entire range of f/stops.

Keep in mind that f/stops are also linear. They do not divide luminance into equal portions. Instead, each successive f/stop records half the light of the previous one. This means the first f/stop devours exactly half—2,048 levels—of the camera's bit data. F/stops 2 through 6 are relegated to the remaining 2,048 levels. As shown in Figure 4.26, each remaining stop receives smaller and smaller pieces of the pie. At the sixth f/stop (containing a scene's darkest values),

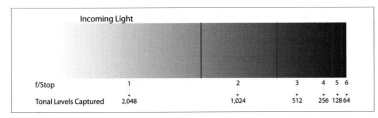

Figure 4.26 As the incoming light levels decrease, the discrete levels available to describe them decline as well. By the time the darkest values are recorded, there are no more than 64 levels remaining.

there are only 64 tonal levels devoted to shadow details. With such little "headroom" in the shadows, attempting to significantly open up dark areas when editing usually leads to either banding or posterization, as seen in Figure 4.27.

In short, the camera chip records substantially more detail for a brighter scene element than a darker one. The optimal exposure technique is to place as much of a scene's tones in the first stop of the camera's dynamic range as possible. This is often referred to as exposing to the right because the histogram will appear bunched to the right. You do have to take care to avoid clipping the highlight data. During the editing process, you can then darken the image to your taste, pushing detail-rich highlight and midtone capture values to their proper places. When the goal is to maximize usable data, it's always preferable to darken an image rather than to lighten one, as Figure 4.28 demonstrates.

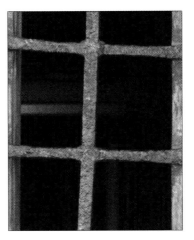 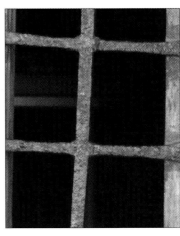

Figure 4.28 A Curves adjustment to brighten the darker image (left) reveals artifacts in the shadows that are simply not present in the brighter image (right). The enlarged crops are shown at a screen view of 200 percent.

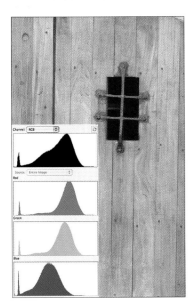 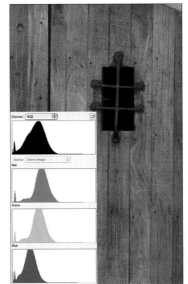

Figure 4.27 The exposure on the left puts significantly more data to the right side of the histogram than the exposure on the right, resulting in a brighter image.

Raw Converter: You're the Boss

As you've seen already, a linear raw file needs a lot of processing on its way to becoming a compelling photographic image. Fortunately, there is no shortage of software packages to address these needs. Often referred to with the generic label of raw converter, these applications vary significantly in both price and features. Some offerings are lean and mean and focus on simply processing raw images. For a growing number of apps though, the actual raw converter is but a small part of a broader toolset that can include asset management and print layout capability. At a minimum, they all will convert grayscale linear data to an RGB gamma-corrected image.

The more you learn about the very nature of a raw file, the easier it is to understand just how much work must be done by the raw converter. In its native state, a raw file is an unprocessed collection of luminance values. Much of its data relates the electrical charges given off by light-sensitive photosites as their electrons were excited by the presence of photons.

The first task of any raw conversion engine is to translate this data in a manner that is visually perceptible. A raw file is akin to a recipe for creating an image. The raw converter must assemble the ingredients and follow a set of directions in order to produce an image. So from the very first time you see your raw image, you are viewing

Table 4.1 A Cornucopia of Raw Converters

The enormous sales of professional level DSLRs have fueled an explosion in the number of raw converters on the market. Applications run the gamut both in features and price, with one-person startups and giants like Adobe and Apple all competing to be your raw converter of choice. Below is a sampling of some of today's most popular offerings.

Converter	Company	Platform	Demo	Price
Adobe Camera Raw	Adobe Systems	Mac, Windows	30 days	Bundled with Photoshop
Photoshop Lightroom	Adobe Systems	Mac, Windows	30 days	$299
Aperture	Apple Computer	Mac	30 days	$299
Bibble	Bibble Labs	Mac, Windows, Linux	Yes	Pro $129, Lite $70
BreezeBrowser	Breeze Systems	Windows	15 days	Pro $70, Std $50
Capture One	Phase One	Mac, Windows	30 days (Pro), 15 days (LE)	Pro $499, LE $99
DxO Optics Pro	DxO Labs	Mac, Windows	21 days	Elite $299, Std $149
LightZone	Light Crafts	Mac, Windows	30 days	$250
Raw Developer	Iridient Digital	Mac	Yes	$100
SilkyPix Developer Studio	Ichikawa Soft Laboratory	Mac, Windows	14 days	$140

an interpretation of the linear data. Different raw converters use different instructions to process the image.

I mention all of this to drive home the point that at this early stage—viewing the image with your raw converter—the file is of limited use to the outside world. In order to be viewed in Photoshop or any other image editor, the raw image must be converted into an RGB or Grayscale gamma-corrected color space. This involves quite a bit of computer processing and accounts for the time it takes to batch process files as TIFFs or JPEGs.

Another important feature is the ability to make nondestructive changes to a raw file. Adjustments to white balance, color space, exposure, and so on are never written directly to the raw file. The raw converter software stores them simply as instructions or recipes to be applied to a saved version of the image. The raw file itself always remains in its original state. The great benefit here is that you can always go back and reinterpret the image from a pristine copy. There is no quality loss involved in making multiple versions of the same raw file. Let's take a look at some of the operations common to most raw converters.

Demosaicing Algorithms

Back in "Collecting Photons," I discussed the fact that most digital cameras only capture one-third of a scene's actual color information. To produce a full color image, the missing pixel data must be interpolated from existing color values. This process is referred to as *demosaicing*. All software vendors have their proprietary algorithms for computing missing color data, and there is no shortage of debate among photographers as to the "best" raw conversion engine. But, in general, the math involves examining neighboring pixels to determine what the missing values were most likely to be.

The demosaicing process begins the moment you import images into your raw converter software. The color filter array is analyzed, and pixels are interpolated behind the scenes. In fact, this is a large part of what goes on while the import progress bar is displayed. In case you got excited back when I mentioned that raw captures are grayscale, this process is not user-adjustable. So you'll never be able to prevent your image from being processed in color. But there are workarounds, which I'll discuss in the sidebar "Color? We Don't Need No Stinkin' Color."

Programmers for each raw converter application have devised their own prescriptions for achieving color fidelity, image detail, and dynamic range from a given collection of linear data. Run a single image through 10 raw converters at their default settings, and you are likely to get 10 different interpretations. But there are so many controls at your disposal for fine-tuning the results that it is rare when a raw converter cannot be coaxed into pleasing output.

So in the four sections that follow, I'll discuss raw edits in a general fashion and illustrate examples with screenshots from Adobe Camera Raw (ACR) 4. Aside from being a very capable raw converter, ACR comes bundled with Photoshop, and it is therefore likely to already be a part of your toolbox.

Setting White Balance

Once the image has been rendered on-screen, the flexibility inherent to raw file processing becomes apparent immediately. Camera makers have dedicated considerable computing power to evaluating color balance. But the range and complexity of lighting scenarios you encounter will often require post-capture adjustments. For example, an image shot indoors under incandescent lighting will have a yellowish cast, while an outdoors scene on an overcast afternoon will appear decidedly cooler.

After an image is loaded into your raw converter, one of the first orders of business is to set the desired white balance. ACR offers two parameters for controlling white balance, as seen in Figures 4.29 and 4.30. The Temperature slider allows you to specify a color temperature in Kelvin units. Kelvin numbers increase as light

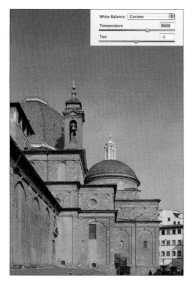

Figure 4.29 Moving the Temperature slider to the right makes an image appear warmer (at left). Moving the slider to the left gives the same image a cooler tone.

Figure 4.30 Moving the Tint slider to a positive value (left) adds magenta to the image. Setting it to a negative value adds green to the image.

becomes cooler. Ambient light that measures 6500 Kelvin, for example, is much bluer than light that registers at 2700 Kelvin.

ACR's Temperature slider is a correction tool. The value displayed in its box is the presumed color temperature of the captured scene. Moving the slider to the right increases the presumed Kelvin number. ACR then makes the image colors warmer to compensate for this cooler ambient light.

If you think of Temperature as making adjustments along the blue (cool)-yellow (warm) axis, then Tint is best understood as movements along the green-magenta axis. Adjusting the Tint helps to fine-tune any color balance issues not addressed by the Temperature setting.

By far the easiest method for setting accurate white balance is to use ACR's White Balance tool, shown in Figure 4.31. With the eyedropper selected, simply find a midtone or highlight object that you know should be neutral and click on it. The RGB values at this pixel location will automatically be set to equal amounts. The rest of the colors in the image shift accordingly. White balance can also be used as a creative tool to intentionally reinterpret the ambient light conditions. Some examples of this are shown in Figure 4.32.

Now adjusting color balance has long been possible in Photoshop. But with a raw file, you don't induce any pixel degradation. You are not changing the color value of the pixels, but merely redefining them. Remember that a sensor records luminance values—nothing

more, nothing less. The association of RGB values with this lumi-nance data is a software-based process that relies on color filters to distinguish between red, green, and blue light. Changing the white balance merely reconfigures the meaning of these color filters.

 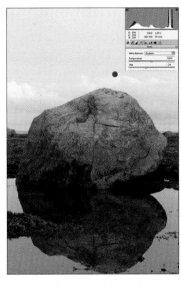

Figure 4.31 At left, the camera's built-in white balance set this pixel (circled) in the clouds at 229, 230, 246. After clicking it with the White Balance tool, these RGB values are equalized at 234, 234, 234. All colors throughout the image are adjusted accordingly.

Figure 4.32 Here you see three vastly different renditions of the image made possible simply by adjusting the Temperature setting from left to right: 5150K, 9100K, and 3400K.

Color Space Conversion

Once you've gone through all the trouble to capture and process a raw file, it's important to consider the conversion parameters when processing the image to a TIFF or JPEG. The Workflow options area of the ACR interface allows you to set the color space, bit depth, pixel dimensions, and output resolution for the converted version of the image. The settings are sticky, meaning that their values do not change on a per-image basis. When you have them configured to your liking, you will only need to revisit them if you want to make a change.

The choice of color space is one of the most important, if not the least understood, of these options. Each color space has its own unique gamut of reproducible colors. You can think of a color space as your palette. The larger your palette, the more distinct colors you have available. The choice of an ideal gamut can spark hot and heavy debate among color geeks over issues like white point reference and quantization errors. I won't bore you with those details. But one thing is clear. For high-quality images, you don't want to use a color space with a gamut smaller than that of your camera sensor. This can lead to clipping, which is the loss of distinct pixel values. Figures 4.33 to 4.35 show the effect that color space can have on the colors in your images.

Highlight Recovery

I mentioned in the sidebar "Blown Highlights: Lost in Space?" that in-camera histograms are less than reliable indicators of highlight clipping when you're shooting raw. But what happens when you really have clipped the highlights?

ACR includes a Recovery slider that can reclaim some clipped high-light data, as shown in Figures 4.36 and 4.37. I'll emphasize the word *some* because impressive though it is, the Recovery feature is not magic. In highlights where only one channel is clipped,

Figure 4.33 If I convert this raw file to sRGB, significant highlight clipping (shown in red) occurs in the blue channel. The histogram indicates not so much an exposure problem, as a gamut limitation of the sRGB color space. It does not contain the blues found in the sky.

Figure 4.35 The best solution, however, is to convert to ProPhoto RGB. The color space has a wide gamut, which encompasses virtually all of the colors that a camera sensor can record. The choice of an appropriate color space has saved unique pixel data without requiring exposure adjustments.

Figure 4.34 If I convert this same file to ColorMatch RGB, I can significantly reduce the blue channel clipping. More of these colors exist within the ColorMatch RGB color space than did in Figure 4.33.

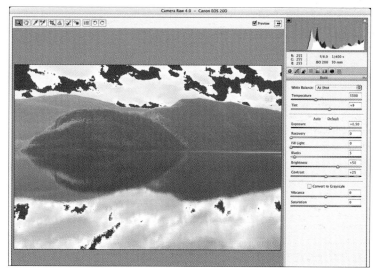

Figure 4.36 This otherwise interesting image suffers from clipped highlights in the clouds. The dynamic range of the scene was simply too wide for a single exposure from my DSLR.

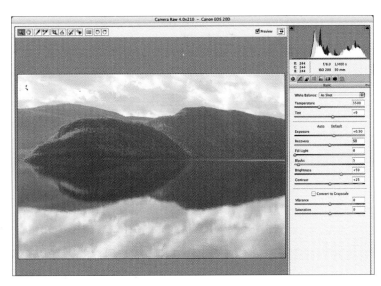

Figure 4.37 Setting the Recovery slider to 50 allows me to reclaim significant areas of highlight detail without having to darken the overall image.

Figure 4.38 You adjust the Point Curve (left) by adding a point along the curve and moving it up, down, left, or right. The Parametric Curve relies instead on a series of sliders to make tonal adjustments.

Recovery's algorithms will rebuild missing channel data to provide reasonably accurate highlight detail. But if all three channels are severely clipped, there is little to be done beyond making the blown highlights less prominent by darkening them. It goes without saying (but I'll say it anyway) that the more distinct image data you begin with, the more creative options you make available. Shooting in raw mode is not a license for poor exposure technique.

Tone Curves

In ACR 4, there are now two options under the Tone Curve tab, as shown in Figure 4.38. The Point Curve will be familiar to users of earlier versions of ACR and functions similarly to the Curves tool in Photoshop—albeit on linear sensor data.

The Parametric Curve, however, is new to ACR and aims to present an easier to grasp method of tonal adjustment. Instead of adding

points to the curve, you can move any combination of seven sliders. The three sliders directly beneath the curve window designate the shadow, midtone, and highlight regions. By moving them either left or right, you constrain or expand their tonal definitions, as shown in Figure 4.39.

In order to actually make an adjustment, you move the sliders to either increase or decrease the luminance values. You can choose individual settings for Highlights, Lights, Darks, and Shadows. The position of the three region-defining sliders constrains any individual adjustment, as shown in Figures 4.40 through 4.42.

Cumulative Curves

The effects of the Point Curve and Parametric Curve are cumulative. If contrast adjustments are applied to both windows, each setting will be applied to the image when it is rendered as a gamma-corrected TIFF or JPEG file.

Figure 4.39 I've added colored overlays here to differentiate the four slider regions you define in the Parametric Curve. Yellow indicates the Shadows, green shows the Darks, cyan identifies the Lights, and magenta defines the Highlights. At right, you can see I have adjusted the default positions of the two outermost sliders. Note the Shadows and Highlights definitions have been constricted, while the Darks and Lights definitions have been expanded.

Figure 4.41 Here, I set the Shadows value to −30. The tonal adjustment is largely confined to the region defined by the endpoint slider (circled in red). Midtones and highlights are not affected.

Figure 4.42 Here, I used a combination of values to increase luminance primarily in the Lights region, while limiting the effect in the adjoining Highlights area.

Figure 4.40 Here, I set the Highlights value to −50. The tonal adjustment is largely confined to the region defined by the endpoint slider (circled in red). Midtones and shadows are not affected.

Digital Artifacts

Sooner or later, as you scroll across one of your digital camera images at 100 percent view, you're going to spot pixels that just don't look right. This may manifest as a cyan or magenta color fringe along a high contrast edge. It may be speckled RGB pixels obscuring detail. The artifacts may be particularly prevalent in a single channel—like the blue one—or distributed primarily in heavy shadow areas.

Causes

Digital artifacts, or noise, are an unfortunate companion to digital capture. Images captured in low-light, at high ISOs, or with multi-minute exposures are likely candidates to have a significant number of artifacts. Much of the digital artifacts you see are caused by two factors.

The first is the color pixel interpolation used in the demosaicing process. Whether this process happens in the camera or later in a raw converter, two-thirds of the pixel data must be interpolated to produce a full color image. While the interpolations perform admirably in a large majority of situations, high contrast edges can throw them off the mark quite noticeably.

The second enemy of a clean image is digital noise. Random patterns of RGB pixels that do not convey image detail appear most often with high ISO settings. As you increase the ISO value, you're asking the sensor to amplify the signal it receives. This amplification allows it to register the low luminance levels as discernible signals, and thus produce a relatively bright image within a short exposure time. Unfortunately, it's not just image luminance that gets amplified. Your DSLR has much more in common with the computer under your desk than the insides of a film camera. All of the electrical signals generated by the camera's processor are zipping around in tight confines. It's inevitable that some of these signals get picked up by the sensor in its hyper-sensitive state. And the heat generated by all of these components—including the sensor itself—can contaminate legitimate image signals. The result? Image noise.

Solutions

Can you avoid these artifacts? I already mentioned high ISO settings and long exposures as culprits. But the relationship between sensor size and megapixel count is an important factor as well. We intuitively understand that more pixels yields larger images. But all pixels are not created equal. The size of a sensor's actual photosites is a crucial determinant of image quality. If two cameras share identical megapixels but one sensor is smaller, it stands to reason that the photosites must be smaller as well. The smaller the photosite, the less sensitive it is to light, and the more it must be amplified to read a given luminance level. In general, a full frame sensor will outperform a smaller sensor even when the number of megapixels is identical. The smaller sensor will produce more noise and other artifacts at much lower ISOs.

There are obviously going to be occasions when long exposures and high ISO settings cannot be avoided. Or you may simply have a camera prone to producing artifacts. An entire cottage industry, it seems, is devoted to reducing digital noise from camera files. In Table 4.2, I list some of the more popular offerings. Don't overlook

Table 4.2 Noise Reduction Software

One sign of the growing number of photographers grappling with noise and artifacts—both from scans and cameras—is the number of products on the market addressing the issue. Here are six solutions available in both Mac and PC versions.

Product	Company	Photoshop Plug-In	Stand-Alone App	Price
Dfine	Nik Software	Yes	No	$100
ISOx Pro	FM Software	Yes	No	$20
Neat Image	ABSoft	Yes	Windows Only	Pro: $60, Home: $35
NoiseFixer	FixerLabs	Yes	No	$30
Noiseware	Imagenomic	Yes	Yes	Pro: $50, Standard: $30
Noise Ninja	PictureCode	Yes	Yes	Pro: $80, Home: $45

the noise reduction features already offered in your raw converter software.

Color to Monochrome Conversion

At first glance, having to convert every raw file to monochrome can seem like an unfair burden placed on black-and-white photographers. Wouldn't it be great to just have a grayscale digital camera instead? Until that camera becomes commercially available, we can take solace in the fact that powerful conversion tools exist that allow for a level of control over hues and saturation that were simply not possible with panchromatic film—even with a bag full of filters.

The fact that ACR is bundled with Photoshop and not sold as a stand-alone application in no way indicates a lack of features or performance with regard to editing raw files. In fact, with this latest version of ACR, Adobe has added many features originally seen in its stand-alone Lightroom product. Nowhere is this more evident than in the addition of a Convert to Grayscale option. Adobe Camera Raw now has tools dedicated to creating monochrome, tinted, or even split-toned images from raw files.

Desaturated RGB

Even if the tool in your raw converter is labeled Grayscale, the resulting TIFFs or JPEGs may be rendered as desaturated images still in RGB mode. ACR will actually convert to Grayscale mode on the fly, but this behavior is far from universal in other converters. If your black-and-white images are indeed RGB files, you must manually convert them to single channel grayscale images by going to Image>Mode>Grayscale in Photoshop.

Let's see how this works. In the Hue/Saturation/Luminance tab, click the Convert to Grayscale box for either a default or auto conversion, depending on your preference settings. In either case, there is ample room for adjusting these parameters, as Figures 4.43 and 4.44 illustrate.

ACR also offers the ability to create split tone images. When used in conjunction with Convert to Grayscale, you can emulate wet darkroom techniques of displaying cool and warm tints in separate tonal regions. The degree of control available is demonstrated in Figure 4.39.

Figure 4.43 After opening the original raw file (top), I used the Grayscale Mix tab in ACR (center) to precisely control the luminance of color elements within the image. At bottom is the resulting image.

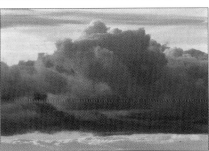

Figure 4.44 After converting the image to black and white (top), I used ACR's Split Toning controls (center) to designate a cool tone in the highlights and a warmer tone in the shadows (bottom). I also adjusted the Balance slider to give a bit more preference to the highlight tint throughout darker image tones.

Color? We Don't Need No Stinkin' Color

Raw files are always processed as RGB images. We can't change that. But if you shoot primarily for black-and-white output, you can avoid the distraction of seeing your monochrome visualizations previewed in full color. Adobe Camera Raw, like many other raw converters, lets you save custom presets of image parameters. It also lets you designate any of these custom settings as new defaults. In Figure 4.46, I have converted an image from my Canon 20D to monochrome and saved the adjustment as a default rendering. ACR will

now use this default automatically for all images tagged with this camera's serial number.

Now here's the neat part. Because Adobe Bridge pulls raw adjustments from ACR, all images created by this camera will inherit the same monochrome treatment, as illustrated in Figure 4.47. In order for this to work as expected, make sure that Bridge's preferences are set to create high quality thumbnails, as shown in Figure 4.45. This is a simple two-step procedure.

1. Set the preferences in Adobe Bridge to generate image thumbnails from scratch for each image, rather than using the camera-generated color thumbnail.

2. Choose a monochrome setting and save it as the new default.

Adobe Bridge now displays all raw files from this camera with monochrome previews. Keep in mind that because ACR edits are nondestructive, you can always reset the Camera Raw defaults and return to a full color image preview.

Figure 4.45 Go to Bride>Preferences> Thumbnails and select the High Quality Thumbnails option.

Figure 4.46 Choosing the Save New Camera Raw Defaults option instructs ACR to apply the current setting to any files originating from this particular camera. ACR distinguishes cameras by their serial number.

Film Scans

The digital darkroom gives you unprecedented control over both global and local contrast of your film negatives. One of the most creatively rewarding aspects of a film-to-digital workflow is that some interpretive decisions that used to be made exclusively in the field, like plus and minus development and the use of contrast filters, can be deferred until the image editing stage.

But for all the changes digital has wrought, photography remains a cumulative process. A well-made negative leads to a superior image file, which allows for a rich and detailed print. A well-exposed negative shot with a good lens and a tripod will always produce technical rewards in the digital darkroom. In the rest of this chapter, we will look at factors that contribute to capturing maximum image quality from film and examine the important step of scanning through four very different pieces of software.

Film Format and Resolution

Your choice of film format still plays a major role in the amount and quality of enlargement you can expect from any scanner. A larger film size captures greater detail and requires less resolution to achieve a given print size than a smaller format. If you're contemplating 30 × 40-inch prints from your 35mm negatives, have a look at Table 4.3 and see how much easier that is to accomplish with larger film.

As the enlargement factor of your film increases, so does the grain structure of the film itself. Beyond a certain size, film grain will often be the limiting factor with regard to detail resolution. High-speed emulsions simply resolve less image information, due to the prominence of grain, as seen in Figure 4.48.

Figure 4.47 With the color information completely desaturated, you can view all of your images with a monochrome preview.

Table 4.3 Film Format and Print Output

The larger the film, the larger the maximum print size at a given resolution. In this table, you'll find the scanning resolution and file sizes required for different film formats to print with a resolution of 300 ppi in grayscale mode. Note that these numbers are approximations based on full frame scans. Any cropping of the negative will increase scan resolution requirements.

Format	Print Size (inches)	Scan Resolution (ppi)	16-Bit File Size (MB)
35mm	8 × 12	2550	17
35mm	16 × 24	5100	66
35mm	24 × 36	7640	149
35mm	30 × 45	9550	232
645 (120)	8 × 10	1400	15
645 (120)	16 × 21	2750	59
645 (120)	24 × 32	4100	132
645 (120)	30 × 40	5100	206
6 × 7 (120)	8 × 9	1050	13
6 × 7 (120)	16 × 18	2050	51
6 × 7 (120)	24 × 28	3050	115
6 × 7 (120)	30 × 35	3800	180
4 × 5	8 × 10	610	14
4 × 5	16 × 20	1200	55
4 × 5	24 × 30	1800	124
4 × 5	30 × 38	2250	193
8 × 10	8 × 10	310	14
8 × 10	16 × 20	610	55
8 × 10	24 × 30	900	124
8 × 10	30 × 38	1130	193

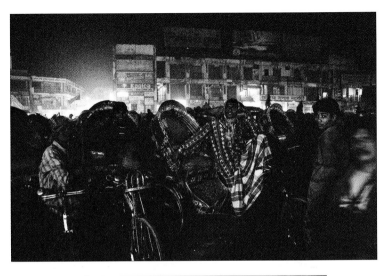

Figure 4.48 This image was shot with 3200 speed negative film. As the enlarged crop shows, there is an abundance of grain that obscures fine detail. Making a large print from this negative would merely accentuate grain, not resolve detail.

Scanner Resolution

Table 4.3 illustrated the need to consider the resolution requirements for your film enlargements, but that is only half the battle in achieving the best possible film scans. Simply capturing a greater number of pixels does not always return more image detail. A more accurate measure of resolution is to determine a scanner's ability to distinguish fine detail.

One way to determine this is to scan a resolution target that consists of a series of precisely placed horizontal and vertical bars. Perhaps the best-known target in the photographic community is the 1951 USAF Resolution Target, shown in Figure 4.49. Each set of black-and-white bars is called a *line pair*. The line pairs alternate between black and white at relatively wide distances along the edge of the target and gradually move closer together toward the center. You perform the test by capturing the target at one of your scanner's noninterpolated resolutions and examining the resulting scan. It's important to turn off both sharpening and contrast adjustments for an accurate representation of your scanner's optical capabilities. You are looking for the line pair one size larger than the instance where the black-and-white bars become blurry or completely indistinguishable altogether.

In Figure 4.50, I have scanned the target both on my drum and flatbed scanner. As you would expect, the drum scanner resolved more detail than the flatbed, even at identical resolutions. What does this mean? A higher and lesser quality scanner can each return an identically sized image file with a matching number of pixels. But the file from the optically superior scanner will hold more useful image details.

Most users are familiar with the process of setting resolution in their scanner software. What may be less known, however, is that even though you can type just about anything you want in the resolution box, a scanner has only a fixed number of optical resolutions.

Figure 4.49 The 1951 USAF target contains line pairs with ever-decreasing spaces between them.

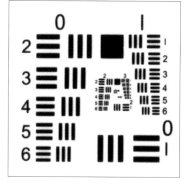 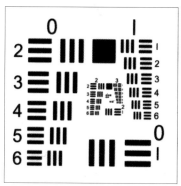

Figure 4.50 The flatbed scan (left) and drum scan were performed at identical resolutions. The drum scan has resolved more of the line pairs and thus has greater resolving power than the flatbed, even at the same resolution.

For a CCD scanner, these optical resolutions correspond to the number of photosites or pixels on the sensor.

When you select a non-native resolution, the scanner will always scan at a nearby physical size and then interpolate up or down to reach your requested resolution. How good are your scanner's interpolation algorithms? When there's a mismatch between the target and optical resolution, does the software scan above or blow the target resolution? If you can't answer these questions, the safest route

to maximum image quality is to avoid interpolation in the first place. SilverFast scanning software offers a quick optical resolution feature, shown in Figure 4.51.

Figure 4.51 I have set a scan resolution of 1000 (left). Ctrl-clicking on the resolution box (right) reveals that SilverFast will actually scan at its next highest optical resolution of 1200. After the scan, it will automatically downsample to reach my target.

Shadow Noise

Scanner-induced shadow noise arises out of the same conditions I described for digital cameras in "Digital Artifacts." This is another area where the PMT technology found in drum scanners can outperform the more common CCD scanner. For those who do not own a drum scanner, one reasonably effective approach to reducing noise is a multisampling feature found in certain scanner models and also available in SilverFast from LaserSoft Imaging. This technique relies on the fact that noise created from heat or nonimage-related electrical signals will be random by definition. Instructing the scanner to take two or more passes at the film allows the scans to be averaged, and software automatically eliminates any pixel information that does not appear in the same location in consecutive passes.

The drawbacks are twofold. The first is that the scan time is obviously increased since the image is being scanned more than once.

The more serious issue occurs if the scanner cannot keep the film in perfect registration during each pass. This causes the software to eliminate actual image data because its position has shifted slightly. The result is a noticeably softer image.

Many of the scanners with built-in support for multisampling have the ability to take multiple samples at each step down the length of the film, rather than scanning from top to bottom and then repeating. This reduces alignment issues.

Grain Reduction

In the battle to reduce objectionable film grain, there is no shortage of software tools available either as stand-alone products or Photoshop-compatible plug-ins. One of the benefits of PMT drum scan technology is the ability to compensate for grain at the hardware level. Drum scanners typically have a range of aperture settings to control the spot size of the image-forming light source. Measured in microns—one millionth of a meter—a small aperture tightly focuses light onto a very small area on the film. When a spot size is optimized for the scan resolution and the grain structure of the film, the scanner is literally resolving each particle of grain. This represents the greatest capture of detail possible.

In the case of high-speed or push-processed film, however, the grain-to-image detail ratio is much higher. Resolving at the grain level may not be desirable because it makes the film grain overly prominent in the resulting scan. In this situation, you can open up the aperture slightly to minimize the detail of the grain structure, while maintaining a relatively high degree of image detail. Figure 4.52 illustrates the difference between scans of very high-speed film at identical resolutions, but with different aperture sizes.

Wet mounting your film, as I discussed back in Chapter 2, can also help to minimize film grain. Absent either of these capabilities, you are left with a number of software tools for softening the image.

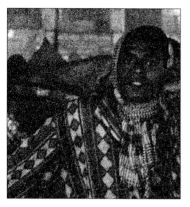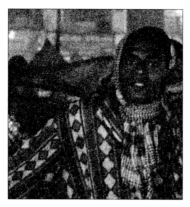

Figure 4.52 The crop on the left was scanned at 4,000 ppi with an aperture of 6 microns. At right, the same resolution was paired with a 19-micron aperture. At the larger spot size, I have maintained image detail but greatly reduced the prominence of the film grain.

Great care must be taken to balance the reduction of grain against loss of image detail.

Third-Party Scanning Software

To those who complain about OEM raw converter software, I like to remind them of just how bad the scanner software that shipped with most units used to be. A clunky user interface and even low quality image previews can be worked around to varying degrees. But for a long time, OEM software was so devoid of anything other than the most basic features that it was often impossible to utilize the full dynamic range of which the hardware was capable.

Back before digital cameras took off, the rapid pace of scanner development meant that users were likely to own more than one scanner—a flatbed for 8 × 10 negatives and a dedicated film scanner for smaller formats, for example—or upgrade every couple of years. When each scanner came bundled with its own proprietary software, this meant having to learn a new interface and feature set for each scanner.

The concept behind third-party scanning software was that if a single company supported scanners from many different vendors, users could work with a familiar interface, even if they owned or later upgraded to different scanner models. And without the burden of building the hardware, a software company could devote its full resources to optimizing the scanner's inherent physical capabilities.

The two most popular software scanning solutions are SilverFast from LaserSoft Imaging and Ed Hamrick's VueScan application. Through extensive license agreements, SilverFast comes bundled with scanners from just about every major manufacturer of flatbed and dedicated film scanners. VueScan has claimed a very loyal following among individual photographers, both for its features and low cost. Both of these packages support the majority of currently shipping scanners, as well as an impressive array of legacy models. Product updates with new features and additional hardware support are frequent. We will look at some of the features of these and other scanning solutions at the end of this chapter.

Edit Now or Later?

An ongoing dilemma among photographers has been whether to perform image adjustments before or after the film is scanned. There are several competing impulses here. On one hand, Photoshop is the de facto standard for image editing. It's a tool with which most photographers have at least some experience, and it can be used on all manner of raster images, regardless of the scanner that captured them.

The contrary argument is that by optimizing a scan for pleasing output at the time of capture, you can bypass Photoshop and create a print-ready image by pressing the scan button. The user interface of most scanning software today sports an ever-growing number of image editing, color management, and production tools. Figures 4.53 through 4.57 show just a few of the editing options available in the two most popular scanning titles, SilverFast and VueScan.

Figure 4.53 Using the Gradation Curves tool in SilverFast, you can edit points along the curve in one of three ways. You can click and drag them with the mouse, type output values, or move the sliders.

Figure 4.55 The NegaFix feature in SilverFast includes prebuilt profiles for a wide range of negative film stocks, both color and black and white. If your particular film is not included, you can adjust the expansion parameters and save a custom preset. Here, I have created one for Polaroid 55PN.

Figure 4.54 The Histogram tool in SilverFast has shadow, midtone, and highlight sliders. The densitometer in the left corner provides before and after pixel values.

Figure 4.56 The Color tab in VueScan houses the bulk of the image editing parameters. A clipping preview offers a visual alert for blocked shadows, blown highlights, along with out-of-gamut, and even infrared pixel data. The green overlays show highlight clipping, and the blue indicates shadow clipping.

Figure 4.57
Adjustments to white point, curve output, and brightness can be made to eliminate the clipping seen in Figure 4.56.

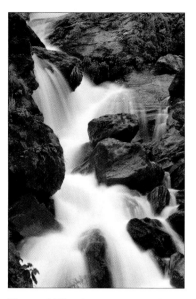

Figure 4.58 This image was edited before the final scan using Digital PhotoLab and a drum scanner. It has pleasing contrast, and its histogram (right) shows a full range of tones captured directly from the scanner's A/D converter.

Optimized Scans

If you are going to manipulate image settings in your scanner software, it is imperative that you understand the capabilities and functions of the adjustments. These will obviously vary with your choice of software. But at minimum, you need an image preview area large enough to make critical editing decisions as well as a densitometer so that you can objectively observe pixel values both before and after your adjustments.

It is also helpful to be able to save and load your adjustment settings. If you scan negatives of similar exposure and subject matter, it's certainly a great timesaver to select a custom setting rather than having to start each adjustment from scratch. The image in Figure 4.58 is shown as it appeared directly from the drum scanner using the Digital PhotoLab software from Aztek. I'll discuss the features of this specialized scanning software at the end of this chapter.

Scanning Flat

Scanning "flat" refers to the practice of deferring all image adjustments to the post-capture stages of your workflow. In its purest

form, you disable the auto settings in the scanner software and simply apply the full dynamic range of the scanner to your film. Scans of this nature are referred to as raw, flat, HDR, or wide gamut, depending on the software you use. The basic idea is to leave the scanner endpoints at their widest setting and let the film data fall where it may without clipping. The full dynamic range of the best scanners will far exceed a normally exposed negative and result in a scan with no bright highlights or dark shadows, as the examples in Figures 4.59 and 4.60 demonstrate.

Scans of such low contrast require aggressive contrast adjustments, so it is crucial that you capture 16 bits of data when scanning flat. When you forego image adjustments in the scanner software, the

Figure 4.60 In this image, the long exposure produced a fairly dense negative. You can see just how much wider the dynamic range of the scanner is compared to the tones captured on film. The image will require a significant adjustment in Photoshop to expand the tonal range.

Figure 4.59 This image was scanned "flat" with no image adjustments applied. Even the conversion to a positive image was delayed until it was opened in Photoshop. It will obviously need highlight and shadow points set and midtone contrast increased.

scanning process itself involves little more than loading film and setting the resolution.

Hardware Versus Software Corrections

I have purposely declined to specify which of these two scanning approaches delivers the better quality final file. It's difficult to give an unqualified answer because there is such a wide range of hardware capability and operator experience.

I will point out that if—like most scanning software—the image adjustments are simply software manipulations applied after the scan but before the image appears on-screen, the question is largely academic. It is only when your scanning software makes hardware-level

adjustments—the ones that physically alter the behavior of the scanner—that issues other than a workflow preference come into play.

Digital PhotoLab, which I'll discuss shortly, is unique in that it controls several mechanical aspects of the scanners it supports. For the overwhelming majority of scanner software, the only hardware-based controls other than resolution are likely to be analog gain of the scanner sensor or multipass sampling to eliminate noise.

If the thought of learning another piece of software just to emulate techniques you can already accomplish in Photoshop gives you a migraine, scanning flat in 16-bit mode will save you from fiddling with scanner software adjustments. You can batch all scan negatives with the same setting and individually address each image's needs later in Photoshop. On the other hand, if you can have access to hardware parameters that actually give you cleaner or more precise pixel data from the start, then it makes sense to leverage this ability.

Scanning Black-and-White Negatives

We're going to end this chapter with a brief look at four different scanning applications and the tools they provide for scanning black-and-white negatives. This is not constructed as a software shootout, but as a basic look at the features most relevant for the highest quality grayscale output.

SilverFast

SilverFast's feature set grows exponentially with each release. There are Histogram and Gradation Curves adjustments, a clone tool, grain reduction setting, batch scanning capabilities, and printing and soft proofing options, just to name a few.

One of the features most relevant to black-and-white photographers pursuing a scan flat workflow has always been the 16-bit HDR feature. No matter the model of scanner, selecting 16 Bit HDR Grayscale in SilverFast's Scan Type menu disables all image adjustment parameters, as shown in Figure 4.61. Your scanner is now set to capture its full dynamic range with no endpoint adjustments, contrast edits, or sharpening applied. The negative will not even be converted into a positive image. If your scanner clips endpoints in HDR mode, this indicates it does not have a dynamic range wide enough to be suitable for your needs.

In an effort to extend a given scanner's effective dynamic range, as well as reduce shadow noise, SilverFast offers a Multi-Exposure feature, shown in Figure 4.62. When enabled, multiple scans are made of the selected film, each at a different brightness setting. SilverFast then averages these results to render the finished scan. Because noise is random, it will appear in different locations for each scan. SilverFast eliminates any pixel info that does not appear in the same

Figure 4.61 Selecting one of the HDR modes (left) not only cancels any existing adjustments, it grays out their menus to ensure that no additional processing is performed on the scan. Here are the image adjustment tools in normal mode (top right) and again in HDR mode (bottom).

location on every scan. Since different brightness settings were used for each scan, SilverFast can blend composite pixel data to form a wider dynamic range. It is much like merging two exposures, one light, one dark, and using pixels from each to expand the dynamic range.

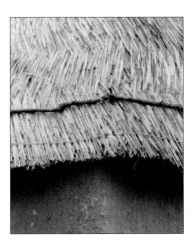
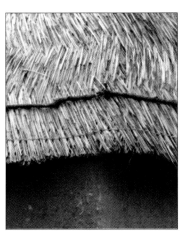

Figure 4.62 The Multi-Exposure option allows for multiple scans of the same image area that SilverFast will merge into a final scan. The first crop (left) was scanned with a Multi-Exposure setting of 8, while the crop on the right was scanned a single time.

VueScan

VueScan is the brainchild of amateur photographer and former NASA programmer, Ed Hamrick. What began as a way to coax more quality from his own film scanner has developed into an application that supports over 700 scanners on Mac, Windows, and Linux operating systems.

VueScan separates the scanning process into two distinct stages. Clicking the Preview or Scan button uses your resolution, bit depth, and exposure or multisampling settings to read the selected image from the scanner. The resulting data is stored in a memory buffer. It is to this buffered data that all other image adjustments are made. After the image has been edited to your satisfaction, it can be saved as a TIFF or JPEG format, available to be read by an image editor, such as Photoshop.

VueScan's image contrast tools are controlled either by moving sliders or typing in values, as shown in Figures 4.63 and 4.64.

Figure 4.63 The Black point slider underneath the histogram (top) can be adjusted (bottom) either by dragging it underneath pixel data in the histogram window or by moving the Black point (%) slider at the top of the Color tab.

Figure 4.65 FlexColor ships with a long list of negative film presets. Each one is optimized to convert a specific film stock into a positive image. Because this conversion is a software adjustment, a 3F scan from negative film will need to be converted to a positive image.

Figure 4.64 With the Image menu set to Graph Curve (left), the image contrast can be adjusted in three ways (right). Drag the sliders underneath the curve, drag the sliders next to the Curve low and Curve high box, or type directly into the boxes themselves.

FlexColor

Unlike both SilverFast and VueScan, Hasselblad's FlexColor capture software is designed for use only with its brand of capture devices. It does, however, drive Hasselblad's medium format cameras and backs, as well as the Flextight scanners. So if you're shooting digitally with a Hasselblad, you can use a familiar interface when scanning. A key philosophy behind the FlexColor software is the proprietary but TIFF-based 3F file format.

When you create a 3F scan, the full dynamic range of the scanner is utilized to create a 16-bit image file without processing applied. Because all of FlexColor's scanner adjustments—other than the resolution setting—are software-driven, the idea is that the processing steps (see Figures 4.65 to 4.67) can take place long after the film has been removed from the scanner. A 3F file can be loaded into FlexColor, and you have access to the same editing tools available when the image was still in the film holder about to be scanned.

Figure 4.66 FlexColor has a Levels and Curves interface with which to make image adjustments. You can also choose up to four detail locations. Each will be displayed in the Detail window at 100 percent screen view.

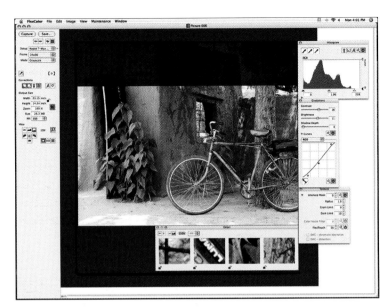

Figure 4.67 A slight Curves adjustment was made to bring down the shadows and brighten the highlights. These changes are nondestructive. No actual pixels in the actual image file are altered until you save a version of the file as a TIFF or JPEG.

Digital PhotoLab

The drum scanner industry virtually faded from existence with the rise of desktop CCD scanners. But while the performance gap has narrowed over the years, a PMT drum scan still has quality advantages over CCD-based film capture. Aztek is the only domestic manufacturer of drum scanners and has developed its professional scanning software, Digital PhotoLab (Windows only), to support its flagship product, the Aztek Premier drum scanner. Granted, this scanner's $40k price tag puts it beyond the reach of most individual photographers. But Digital PhotoLab also supports the drum scanners made by the now-defunct Howtek. The low cost and easy availability of these reconditioned scanners have made them a popular choice for photographers seeking maximum fidelity to their film originals.

Tight integration with the mechanical controls of the Aztek and Howtek drum scanners allows Digital PhotoLab a high degree of scanner control. What makes Digital PhotoLab so unique is that virtually all of its image adjustments are carried out on a hardware level. While most other scanner software employs software processing after the scan is complete, the Levels, Curves, and film characterization adjustments in Digital PhotoLab are actually written to the scanner's internal analog to digital converter.

Here's how it works. In Figure 4.68, the image is previewed with a Wide Gamut Negative film characterization. This is akin to scanning flat. This file will need a substantial image adjustment in Photoshop.

The contrast boost previewed in Figure 4.69 is, in fact, a hardware adjustment. When the actual scan is performed, the scanner itself

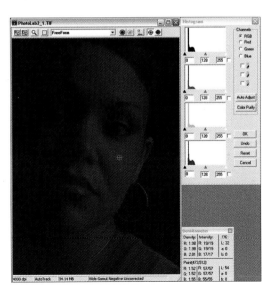

Figure 4.68 The histogram for this negative shows just how little of the scanner's dynamic range is devoted to actual pixel data.

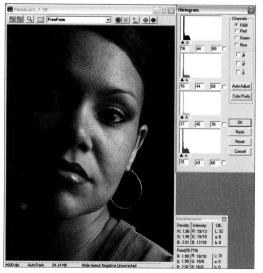

Figure 4.69 Setting the endpoints with the Histogram tool expands the color values over a much wider tonal range.

same crop area to compare the effects of your changes exactly as they will appear in the final scan. When scanning film at similar exposures, Digital PhotoLab offers a handy cut-and-paste feature shown in Figures 4.71 and 4.72.

As you've seen, there are a number of options to consider during the digital capture stage, and many of them have great impact on the possibilities for an image in later stages of the workflow. By paying careful attention to your tools and techniques at the outset, you can ensure greater artistic and technical control in the stages to come. In the next chapter, we will turn our attention to Photoshop and image editing techniques that can take full advantage of all of the care we've given our images during the capture stage.

is adjusted so that its internal dynamic range is now set to the values in the Histogram window. The scanner's black point is mapped to 16, its midpoint to 44, and its white point to 69. How is this different from making the same Levels adjustment in Photoshop?

Much in the way we think of editing a raw file, we are not pushing or pulling pixels to expand the image's tonal range. We are merely redefining their values. By reducing the dynamic range of the scanner to match the endpoints of the film, we avoid the destruction of unique pixel data that occurs with a software Levels adjustment. The full bit depth of the scanner has been targeted exclusively to the actual range of tones present in the image.

Image evaluation in Digital PhotoLab is centered on the liberal use of detail scans. Before committing to an adjustment, you can select a portion of the image and have Digital PhotoLab generate a full resolution scan preview of the crop in a new window, as seen in Figure 4.70. You can make any number of detail scans from the

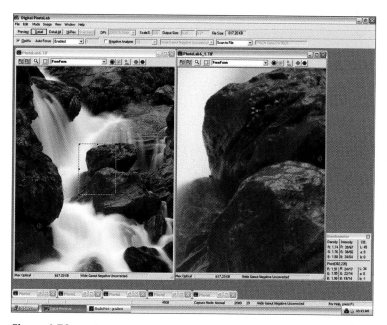

Figure 4.70 In the detail scan at right, you can judge the effects of changes to image adjustments and aperture size more precisely.

Figure 4.71 The image on the left was adjusted for pleasing contrast. Instead of duplicating my efforts in tweaking Levels ands Curves settings for the image on the right, I can right-click the image window and select Copy Attribute.

Figure 4.72 Pasting the edit parameters onto the image on the right applies all of the image settings with one click.

Case Study: Jean Miele

Artist Bio

Jean Miele is an internationally recognized photographer and educator with a long background in digital imaging. As a commercial photographer, he has worked for some of the largest corporations in the country. His fine art work has been exhibited in both museums and galleries in Europe and America. He regularly teaches seminars and workshops on Photoshop techniques at renowned institutions like the International Center of Photography and the Santa Fe Workshops.

✪ Download an mp3 audio file of this entire interview by visiting the book's companion Web site at www.masteringdigitalbwbook.com.

The Artist Speaks

Amadou Diallo: *One of the things that I've always found most interesting about your work is that while you freely make creative use of Photoshop in your images, they still exhibit a very strong link to the lineage of classical black-and-white photography. In your own work, how do you reconcile the freedom that digital editing and compositing allows with the aesthetics of traditional photography?*

Jean Miele: It's interesting that the question is phrased that there needs to be a reconciliation. The "traditional photographs" that I was always in love with—1920s, 1930s, 1940s, landscapes—those works, while considered straight photography, always inspired me, in part, because of the tremendous amount of interpretation involved with the photographic process. That is, even these so-called straight photographs were really highly manipulated. So for me, photography—the fun of photography—has to do more with making photographs than with documenting the world. It's not so much about capture, it's about transformation and interpretation. So whether you're doing that in a darkroom or whether you're doing that on a computer, it's the same to me. The only difference is that a computer is much more powerful and allows us more control.

AD: *Taking into account the amount of controls and the flexibility that you have with the computer and Photoshop, do you find that the techniques you've developed for the post-processing of your images influence how you previsualize an image? When you're actually out there shooting, do you think about what you can do later in Photoshop or how you can print this to get the impression that you're after?*

JM: Absolutely. One thing is that I'm aware that I don't need to get the contrast and the tonality exactly right in the field. What I want to do is make a capture so that I have lots of choices later.

The other thing I often find myself doing is photographing pictures that are "almost"—maybe there's a beautiful sky but the foreground isn't so great, or where there's one element that's really strong but that is not complete by itself. I may be able to combine this together with another photograph later or several other photographs later to make a really powerful complete image. So I am very conscious in the field of what's possible later. Not in a let's-fix-it-later-in-Photoshop way, but in the sense that this can be part of something really good.

Title Hydro-Electric Dynamo
Dimensions 15 ½ × 15 ½ in.
Paper Innova Soft Textured
Natural White
Ink Set PiezoTone
Sepia/Selenium Tone blend
Printer Epson Stylus Pro 9600

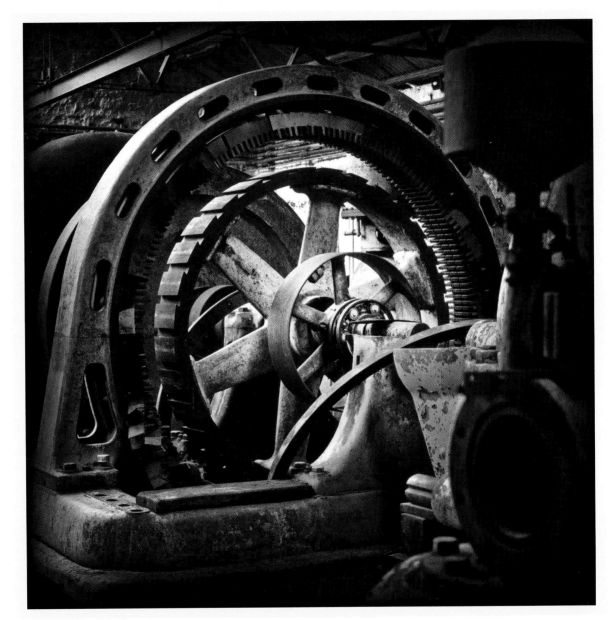

AD: *Well, I think that harkens back to a long tradition in visual arts of found objects—taking things, isolating them from their elements, and then using them to create a completely new interpretation.*

JM: Right. Or think about the Hudson River School of painting, where those guys would sit for hours and hours or even days in front of a particular scene, and they would just watch and sketch, noticing how the light was in different parts of the scenes. And what they might do is put together the most beautiful pieces of light that they had seen in particular areas over weeks or months and make that into one big painting, which is kind of what I'm doing with my landscape photographs.

AD: *That's an interesting connection. It really does take photography into the lineage of painting, of visual arts in general. In that sense, the advanced tools that we have today are still put to the same types of uses that artists have been doing all along.*

JM: For me, the technique is fabulous. I mean, I love the computer, I love Photoshop, but it's not the point. The point is I can make these great pictures, that I can make beautiful photographs. So while I'm in love with the technique, the technique is just a means to an end. So I'm just happy that the tools are getting better and better—hopefully, helping me to make better and better pictures.

AD: *You've used various methods of digital printing over the years. Can we talk about the evolution of your choices in digital output?*

JM: For me, the first process was traditional silver printing in a darkroom. I printed in a darkroom for over 15 years. When the first color inkjet printer came out, that was a really exciting breakthrough. And while the print quality on the first generation wasn't up to making fine prints, there's been this continuous improvement. Now it's interesting to me that there's such a big dichotomy drawn between digital prints and "traditional prints."

For me, it's all about the fine print. I mean, I'm in love with the Paul Strand portfolios that were printed by gravure in the 1930s and then reprinted by Aperture in the '60s. And those were just really fine prints, even though they were ink on paper. I'm in love with the prints that were made by Edward Weston and Ansel Adams and the photographers who followed in their footsteps, because those are just really beautiful objects.

So whether it's inkjet printing or whether it's traditional printing or whether it's gravure printing, it's all about making a really great print on a beautiful surface that has a full tonal range.

What I was doing for a long time was printing traditionally, and I was frustrated by the lack of control. And then when Photoshop came along, it allowed me to control the tones and the specific areas of an image much more specifically, so that was exciting. But the technology for actually printing the images well has only recently come into its own.

For a long time, I was printing on machines like the LightJet and Polielectronica, which are basically digital C printing machines. They use a laser to expose photographic paper, much the same way that an inkjet printer sprays ink onto a piece of paper. The head moves back and forth, but it sprays laser light, exposing photographic paper. I was one of the first people to use this technology to print black and white, and I still think those are really beautiful prints. That was the first sort of satisfying digital printing for me, because at the time the inkjet printers still were having a lot of problems with color crossover in black and white. There were still questions of resolution and dot size, and the manufacturers hadn't really had enough time to develop the paper media to the extent that they have now.

AD: *The hydro dam image that's reproduced in this book is part of your* Vestiges of Industry *portfolio. I'd like for you to talk a little bit about the genesis of this project. What draws you to these abandoned machines and tools? What are you trying to communicate to viewers?*

JM: One of my favorite things about being a photographer is that it's an excuse to just wander the world looking for images. Just to get in a rental car and drive down the road and see what you find. While I was looking for landscapes, I started to come across these incredible abandoned places and machines. I was drawn to them partially because I thought they would make good photographs, but primarily because they ask so many questions. You're in the middle of nowhere, and you stop in a place like that hydroelectric plant in Oregon. You walk in, and it's just like a cathedral.

What I was wondering when I was there was: When was this made? Who made this? Which local towns used the power from here? Who designed these machines? How long ago did they die? How long ago did this thing completely fall out of service and start being reclaimed by nature? Who came and worked here every day, and lovingly maintained and repaired and installed the machines and kept them going and had their coffee there and spent every working day with their friends sitting in this place that's now completely abandoned? No one knows where the people went or what happened or any of that.

On top of that, there's the idea that these things, these machines, were the height of technology when they were produced, the same way that the computers that we're talking about are the height of technology now for us. One of the things that I'm thinking when I'm making these pictures and looking at them is, how long will it be before someone looks back at our lives and asks the same questions?

AD: *With this particular image, part of my excitement in working with you and producing an inkjet print of this image was that you're an incredibly experienced Photoshop user and you offered me the opportunity to reinterpret this image for inkjet output. What was it like to take an image that you had previously printed through another medium and had interpreted in one way, to turn that over to a printmaker and see a new interpretation in a different medium?*

JM: It was really exciting for me, not because I think of you as a printer, but because I think of you as a very accomplished image-maker in your own right. This brings us full circle in our conversation back to the idea of photography as interpretation. I was excited to see how *you* would see my image. The final print that you made was an interpretation I never would have thought of, that, in many ways, was very different and even more powerful than what I would have done because of the way I think about image making. I have my habits, which include going for more contrast, more tonality, more light in the center of the image to bring attention. Your interpretation really showed a different way of thinking.

I think there are more possibilities for us to make photographs that reflect who we are as people and as photographers than there have ever been before. It's just really fun. It's fun that the technology gets better and better, giving us more and more choices.

5

Photoshop in Black and White

If you've bought this book—let alone read this far—you don't need a sales pitch extolling the virtues of Photoshop. But you're not alone if you feel a bit overwhelmed by all its options and unsure of how to get the most out of your images. The product name aside, Photoshop includes a broad array of tools that extend well beyond photographic image editing. The software enjoys an astonishingly diverse user base—from artists to forensic scientists—and is employed in all manner of pixel manipulation. In short, it is a very complex program, and no single user would ever have the need to master each and every feature.

The number of items in the Tools palette alone can be daunting. The good news for black-and-white photographers is that only a fraction of Photoshop's features are required to emulate wet darkroom processes. In this chapter, I'll take a look at the tools, techniques, and concepts that enable precise grayscale image editing and lead to superior quality images suitable for the fine art market.

In this chapter and elsewhere, I'll be referring to Photoshop's currently shipping version, CS3. This upgrade has significant enhancements, among them a new and robust tool for converting color images to black and white. The bulk of the tools and techniques I'll demonstrate, however, can be applied to earlier versions of Photoshop as well. I'll make special note of any steps that are only available in CS3.

Two Flavors of Photoshop

For the first time, Adobe is shipping two professional versions of its venerable pixel-editing app—Adobe Photoshop CS3 and a higher priced Adobe Photoshop CS3 Extended. As the names suggest, CS3 is not a stripped-down version of Photoshop. Instead, CS3 Extended introduces specialized 3D, video, measurement, and analysis tools aimed at a relatively small subset of Photoshop users. All of the tools discussed in this chapter are available in the lower priced CS3 version. For traditional photographic image editing, you'd be hard-pressed to justify the added cost of the Extended version.

Counting Light

Photoshop measures pixel luminance on a scale of 0 to 255. But when placing dots onto paper, ink density is often discussed in percents. So it's worth a moment to reconcile the two numbering systems. A luminance of 0 delivers maximum black, the equivalent of 100 percent ink on paper. A luminance of 255 is maximum white, which translates to 0 percent ink or simply paper white. I'm not suggesting you memorize the luminance to ink density values in Table 5.1. But much of this chapter will come a bit easier if you remember that as a luminance value increases, the ink tone becomes lighter.

Table 5.1　Pixel Luminance to Ink Density Conversion

This table compares Photoshop's pixel luminance values with its corresponding ink density values. These conversions are based on a color space with a gamma value of 1.8.

Pixel Luminance	0	16	32	64	128	144	160	192	255
Ink Density (%)	100	94	87	75	50	44	37	25	0

A Study in Contrast

For those interested primarily in grayscale images, Photoshop is perhaps best understood simply as a contrast tool. At some point in the editing process, you inevitably must alter pixel luminance in one of two ways. You can either take pixels of similar tonal values and pull them apart for an increase in contrast, or you can push pixels with distinctly different luminance values closer in tonality for a decrease in contrast.

In this light, it is easy to see Photoshop's roots in traditional darkroom practices. Of course, Photoshop goes well beyond simple mimicry of analog burning and dodging techniques. What Photoshop allows, first and foremost, is the ability to make contrast adjustments with pixel level precision. You can experiment with and easily apply any number of global adjustments, which will affect the entire image area. But the real creative power of Photoshop comes into focus when you limit contrast adjustments to particular tonal or spatial regions of the image. In fact, the ability to apply localized yet seamless edits is the foundation of Photoshop mastery, and it will be discussed in greater detail in upcoming sections, as well as in Chapter 7, "The Imaging Workflow."

The Benefits of 16 Bits

I'm sure you've heard the advice to work with 16-bit images for optimum results. But you may have heard also that 8-bit data is sufficient, because printers typically ignore the higher bits of data. So what's the lowdown?

As I mentioned back in Chapter 2, an 8-bit image can display up to 256 gradations from white to black. This level of precision is sufficient to trick the human eye into perceiving continuous tone. Your goal is to always end up with at least 256 gradations when it's time to print an image. The problem is that with each iteration of edits, you throw away distinct pixel values and thus reduce the available number of gradations. Figure 5.1 shows an 8-bit image and its pre-edit histogram.

A very common Levels adjustment, seen in Figure 5.2, is one that sets highlights to white, shadows to black, and adjusts the midtones. But the resulting histogram, shown in Figure 5.3, reveals numerous gaps in pixel data.

Figure 5.1 You can see from the histogram that this image contains no pure whites or blacks.

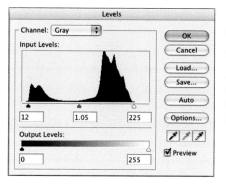

Figure 5.2 Setting the shadow and highlight endpoints stretches the pixel data to encompass a wider tonal range. I also made a small adjustment to the middle slider to brighten the overall image.

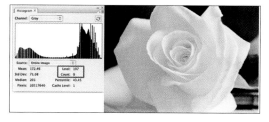

Figure 5.3 Gaps are visible in the histogram as a result of the Levels adjustment. The histogram's statistics show that at level 197, there is zero pixel data.

My contrast adjustment took the existing pixels in the image and pulled their values away from each other to expand the image's range of tones. And because I began with no more than 256 levels, each gap indicates a level for which there now exists zero pixel data. So a very mild editing step—a contrast boost—has resulted in an irrevocable loss of data. In Figure 5.4, I repeat the same Levels adjustment, but this time on the 16-bit version of the image.

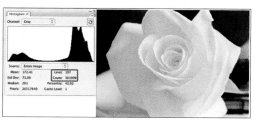

Figure 5.4 This 16-bit image file had the same edits applied as the version in Figure 5.3. Note both the smooth histogram and the high pixel count at Level 197.

A 16-bit file in Photoshop contains 32,769 discrete levels. In contrast to the 256 levels available in the previous example, there is now plenty of overhead to replace data thrown away by the Levels adjustment. Compare the histogram of the 16-bit version to the one in Figure 5.3.

So does this mean an image is unusable when gaps appear in its histogram? Well, not exactly. For one thing, your monitor—expensive though it may be—is a decidedly low-resolution device. Depending on the size and pixel count. a monitor generally doesn't resolve much more than 100 pixels per inch. It is simply incapable of rendering the damage indicated by the histogram. So gaps in a histogram are largely irrelevant if images are destined solely for the Web.

A high-resolution device like a printer places much greater demands on image data. Fortunately, though, most printer drivers do a remarkably good job of compensating for missing pixel data. In my experiences, an image with slight to moderate gaps in the histogram will show very little evidence with the naked eye. But some types of image content are more delicate than others. In a large detailed portrait, skin tones may show some rough tonal transitions that would go unnoticed in a busy forest scene, for example.

It's very important to remember three things. First, once data is lost, it's never coming back. Second, gaps in the histogram will only increase as future edits are made. Finally, output devices are constantly increasing in resolution and ability to capture fine detail.

The printers of tomorrow may very well be able to reproduce flaws that go unnoticed with current hardware. It is therefore crucial that you maintain your images in as healthy a state as possible. Editing an image in 16-bit mode eliminates this game of Russian roulette.

So why even bother with 8-bit files? For starters, they are much more compatible. In fact, the most commonly used flavor of the ubiquitous JPEG format will only encode 8-bit image files. Photoshop will not show JPEG or GIF as format options when you save a 16-bit image. So anything bound for the Web must inevitably be reduced to 8 bits.

An 8-bit file requires only half the storage space of its larger sibling and generally takes less time to process in Photoshop. When editing a 16-bit file, it doesn't take much more than a few image and adjustment layers for file sizes to spiral out of control.

It's also worth noting that the vast majority of printer drivers cannot process more than 8 bits of data per channel. Yes, most drivers will accept 16-bit files, but then they typically reduce them to 8-bit files on the way to the printer. You're getting no quality increase from the printer, just sending a big file that will take longer to print.

It makes sense to work with 16-bit data only when it produces a benefit in quality and to use the more compact 8-bit version of an image file when compatibility and speed take precedence. In Chapter 7, I will detail a workflow that emphasizes 16-bit data during the editing stage, yet allows for the creation of 8-bit versions suitable for printing and sharing via the Internet.

Toolbox

Photoshop contains over 60 separate items in its Tools palette alone (see Figure 5.5). Once you select one, an options bar appears, providing a host of parameters that you can alter to control its behavior. But for our purposes, most of the tools and options can remain shrouded in mystery. Oddly enough, some of those least useful for high-quality image editing have the most photographic-sounding names. Dodge, Burn, Sharpen, and Blur are relatively crude tools for which Photoshop has more precise and flexible alternatives. In the section that follows, I will give a detailed look at the tools and options I've found most useful for traditional photographic image editing.

Figure 5.5 In Photoshop CS3, the Tools palette has been collapsed into a single column. The keyboard shortcut for each tool is displayed to the right of the tool name. You can click on the top left corner of the palette to revert back to the legacy, two-column design.

Everyone has his or her own cherished tools. And in Photoshop, there are often multiple, and equally valid, approaches to solving the same problem. If I skip one of your gems in favor of an unfamiliar tool, don't take offense. In fact, one of the best ways to increase your proficiency with Photoshop is to examine new and different ways to achieve a desired effect. This will often lead to a more efficient working method or a higher quality result.

Faster Tool Shortcuts

By default, Photoshop requires you to hold the Shift key while pressing a tool's shortcut letter. Want to select tools using one finger instead of two? Go to Photoshop>Preferences>General, and deselect the Use Shift Key for Tool Switch option.

Tools Palette

The Marquee tool (M) is most often used for selecting broad swaths of an image when hard edges and abrupt tonal transitions are not a concern. You simply click and drag until the area you want to select is within the marquee's boundaries. You have the option to choose a rectangular or elliptical shape. You can also select a single row or column of pixels. See Figure 5.6 for Marquee tool options.

Figure 5.6 In addition to Normal, the Marquee tool can be set to a Fixed Ratio or Fixed Size.

Setting a ratio of width to height in the options bar automatically constrains the shape of the marquee to that format, no matter the size of the selection. If you know in advance the exact pixel or print dimensions of your selection, follow these steps.

1. In the Marquee tool options bar, set the Style to Fixed Size.

2. Type the pixel or print size dimensions into the Width and Height boxes.

3. Click once in the image, and a marquee of that size is automatically drawn.

The Move tool (V) can relocate layers and selections within an image or even move them to another open document. In the latter case, you'll want to hold the Shift key while dragging. This step will register the item that's being moved dead center with its destination. See Figure 5.7 for Move tool options.

Figure 5.7 Checking the Auto Select Layer option will automatically switch the tool's focus to the topmost layer containing pixel data at the tool's current location. Without this option, the tool is restricted to the layer highlighted in the Layers palette.

The Polygonal Lasso tool (L) lets you select irregularly shaped areas of the image via a series of mouse clicks. I recommend this tool over the Carpal Tunnel-inducing Lasso tool, which requires you to hold down the mouse button during the entire selection process.

The Quick Selection tool (W) is a newcomer to CS3, and Photoshop's engineers think so highly of it that it's replaced the Magic Wand as the default tool choice when you press the shortcut. Their optimism is well justified. Quick Selection is a fully adjustable brush tool. Simply painting inside an area selects its outlying edges. You can easily add noncontiguous selections, as well as

subtract unwanted selections. See Figure 5.8 for Quick Selection tool options.

Figure 5.8 The Auto-Enhance option triggers a more precise, but processor-intensive edge detection routine that fine-tunes your selection after you release the mouse. You may find the superior results a worthwhile trade-off for the speed hit.

As soon as your selection is made, the Refine Edge button becomes available. Clicking this button calls up the Refine Edge dialog box (see Figure 5.9), where you can fine-tune the selection edges with no less than five selection parameters at your disposal. There are also five different selection preview modes available. Adios, Magic Wand!

Figure 5.9 In the Refine Edge dialog box, hovering the mouse over each adjustment or preview mode brings up useful descriptions of their function at the bottom of the dialog box.

The function of the Crop tool (C) is self-explanatory. Perhaps less obvious is that once a crop is drawn, its marquee can still be resized or rotated to align with a straight edge in the image. Press Return to commit to the crop. See Figure 5.10 for Crop tool options.

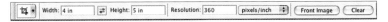

Figure 5.10 Much like the Marquee tool, you can type pixel or print dimensions directly in the Width and Height boxes for constrained proportions when cropping. In addition, you can type in a Resolution value to add a down-and-dirty resampling to the crop process.

The Healing Brush (J) is my tool of choice for light to moderate spotting of dust and scratches. It clones pixels from a source point to a destination, but unlike the Clone Stamp tool, it automatically matches texture, lighting, and shading detail to the destination area. See Figure 5.11 for Healing Brush options. Using the Healing Brush is a simple two-step process.

1. Option-click to determine the source point from which to sample pixels.

2. Click to indicate a destination for the cloned sample.

Figure 5.11 The Aligned option enables the source point to change in direct relation to the destination point as you move the mouse. The Sample menu allows you to determine the layer(s) from which to clone pixels.

The Aligned option is a crucial setting for ensuring expected Healing Brush behavior. With this option enabled, the source point and destination point remain at a fixed distance. If you disable this option, you will always be cloning from the same source pixel, regardless of the location of the destination point you select. In CS3,

you have the option to either include or ignore adjustment layers when using the Healing Brush. You set your preferred behavior by toggling on or off the icon at the far right in Figure 5.11.

The Brush tool (B) is absolutely essential to working with masks and combining image layers. You paint simply by clicking and dragging the mouse. See Figure 5.12 for Brush tool options.

Figure 5.12 The Brush tool has a staggering number of options. Brush diameter, feathering, stroke opacity, and blending mode can all be set independently.

The last four blending modes in the drop-down menu shown in Figure 5.12 are not active in Grayscale or Multichannel mode. The brush's source color is always the Foreground Color currently set in the Tools palette.

The History Brush tool (Y) is a hidden gem for painting in edits from previous states of an image. It offers a fast and precise method

of localized editing, which I'll describe later in this chapter. The History Brush options bar is identical to that of the regular Brush tool, seen in Figure 5.12. Before you can use the History Brush, however, you must first select a source state, as demonstrated in Figure 5.13.

Figure 5.13 In the History palette, you define a source by clicking in the leftmost box of either the snapshot or history state from which you want to paint.

In Figure 5.13, the initial snapshot, generated when the image was opened, is set as the source. Painting with the History Brush will replace pixels altered by the Curves and Shadow/Highlight adjustments with those from the image at its initial state.

The Gradient tool (G), as its name suggests, lets you create a smooth gradation of tones, simply by drawing a line in the image window. As I'll demonstrate later in this chapter, it can be used in combination with an adjustment layer to seamlessly blend localized contrast edits. See Figure 5.14 for Gradient tool options.

Figure 5.14 The Gradient Picker allows a choice between several preset grayscale and color gradations. You select a gradient fill from the row of highlighted icons. From left to right, they offer Linear, Radial, Angle, Reflect, and Diamond options.

The Eyedropper tool (I) measures pixel values from any layer within the active document, as well as other open documents. Clicking a pixel will automatically set Photoshop's Foreground Color to the selected pixel's color value. You can use the Color Sampler tool to place markers at up to four locations in an image. The color value at each marker's location is conveniently displayed in the Info palette. CS3's renamed Ruler tool displays measurement coordinates, including the angle, along which it is drawn. See Figure 5.15 for Eyedropper tool and Color Sampler tool options.

Figure 5.15 The Sample Size pull-down menu is available with either the Eyedropper or Color Sampler tool active. It allows you to specify the precision of reported pixel values.

The drop-down menu in Figure 5.15 offers a number of sampling options. Point Sample measures the single pixel over which the tool hovers. Selecting 3 by 3 Average samples a grid of the three pixels immediately surrounding the pixel over which the tool hovers. It then displays the mathematical average of these pixels as its result. The 5 by 5 Average works in the same way, but it samples a grid of five surrounding pixels. CS3 has added four larger sampling grid options.

The Hand tool (H) offers the most convenient way to move around the image in any direction. But this is one keyboard shortcut you really shouldn't bother to memorize. A better approach is to invoke it temporarily by pressing the spacebar on your keyboard. This allows you to keep your current tool active.

The Zoom tool (Z) obviously increases and decreases image magnification. More experienced users will never actually press Z

because there are more useful shortcuts. To view an image at 100 percent, press Cmd+Option 0. To fit the image to the window size, press Cmd+0. Press Cmd+plus to zoom in and Cmd+minus to zoom out. When you need to zoom in on a specific location, press Cmd+Spacebar and draw a marquee around the desired region.

The Screen Mode (F) cycles through different viewing options (see Figures 5.16 to 5.20). CS3 introduces a new Maximized Screen Mode and also sets screen modes on a global, rather than per-document basis. If you have five image windows open and change the mode on any single image, the rest will automatically change as well. All of the modes have backgrounds that are preset to middle gray. But each mode can be set individually to display a separate background color by right- or Ctrl-clicking the background area.

Figure 5.16 In the Standard Screen Mode, an image opens with document information along the top and bottom of a moveable window.

Figure 5.17 The new Maximized Screen Mode retains document info at the bottom of the window and surrounds the image with a solid background to eliminate desktop distractions.

Figure 5.19 Full Screen Mode with Menu Bar lets you drag the image anywhere, including under palettes, while still providing a solid background around the image.

Figure 5.18 When you zoom in using Maximized Screen Mode, the image remains within the screen boundaries set by the palette docks on either side. Scroll bars allow for horizontal and vertical panning.

Figure 5.20 Full Screen Mode does away with the OS menu bar, providing as much screen real estate as possible for your image.

Scroll with Key Commands

When spotting an image, it's helpful to move one screen section at a time. To do this, use the Page Up and Page Down key to move vertically. Press Cmd+Page Down to move to the right. Press Cmd+Page Up to move to the left.

Get It Straight

The Ruler Tool provides a fast and accurate way to straighten an image. Drag it along the edge of any item in the image that you want to be perfectly level. Now go to Image>Rotate Canvas> Arbitrary. Photoshop has automatically entered the precise angle adjustment that will bring the line you drew to horizontal or vertical. Press OK, and voilà, the image is perfectly straight.

Palette Essentials

As Photoshop has added features over the years, managing the growing number of palettes has become a challenge for users, to say the least. In fact, the driving force behind a dual monitor setup for most photographers is the sheer number of palettes. Large savings in productivity are possible by simply moving the palettes to a separate display. If a two-monitor setup is not an option, you'll certainly want to limit precious screen estate to only the most used palettes. In this section, I'll talk about the uses for and options contained in the six palettes I'll be using throughout the rest of the book.

New to CS3 is a collapsible dock (see Figure 5.21) in which you can collapse palettes into a very small space. Each palette is represented by an icon to allow for easy identification. The size of the dock automatically adjusts as palettes are expanded or collapsed. Individual

Figure 5.21 The dock in CS3 can house palettes in (from left to right) a collapsed, expanded, or minimized view.

palettes, as well as those grouped in a set, can be minimized with a single click above the palette tab.

Info Palette

The Info palette, shown in Figure 5.22, contains a host of essential information about an image. If I were stranded on a desert island—with a laptop running Photoshop—and forced to take only one palette, this would be it. See Figure 5.23 for Info palette options.

Figure 5.22 The value of the pixel directly under the cursor is displayed. Grayscale images show in percentages, with 0 percent indicating paper white.

Figure 5.23 The Info Palette Options dialog box allows you to configure the type of information displayed by the Info palette.

You can select a Secondary Color Readout of Grayscale, RGB, or Lab, among other choices. I find it very useful to have the document size, profile, and print dimensions available at a glance. The Scratch and Efficiency readings are helpful when working with larger files on a laptop or an older computer with relatively little memory.

Histogram Palette

While an image's histogram is available in the Levels tool, it is much more useful to view it in its stand-alone palette. For starters, the palette's histogram displays a live update as you perform pixel adjustments in any tool. The histogram's original shape becomes a gray silhouette behind the updated histogram that reflects your current changes. Figure 5.24 shows this superimposition. One note of caution is in order. The Histogram palette reverts to a cached view whenever you bring up an adjustment window. The practical effect is that you will always see gaps in the live histogram, even with 16-bit image files. Photoshop is simply devoting your computer's

resources to calculating pixels rather than ensuring a deadly accurate histogram. After your edit is processed, the gaps will disappear, as long as the adjustment was carried out in 16-bit mode. If these temporary gaps simply ruin your day, CS3 allows you to update the cache even while in the Levels dialog box, for a clean overlay that resembles the one in Figure 5.24. You pay a steep hit in speed, however, as Photoshop must pause to calculate the new histogram.

Figure 5.24 Here is the Histogram palette as it appears during a Levels Adjustment. The original histogram is displayed in gray behind the live adjustment, which is superimposed in black. You can see here that the pixel values were pushed to the brighter end of the histogram.

The Histogram palette also allows you to view the composite and individual channels at the same time. With any image containing more than one channel—whether RGB or Grayscale with an alpha channel—you can have each channel's histogram displayed underneath the composite, as shown in Figure 5.25.

The statistics option can be interesting if you're really into the math of Photoshop, but you can certainly lead a healthy and productive Photoshop life without enabling it. You will often see the warning icon in the histogram palette. This is simply a heads-up that, in the interests of speed and usability, Photoshop is displaying a cached, less accurate version of the histogram. To manually update the histogram, simply click the warning icon, the refresh button located directly above it, or—if you bill by the hour—select Uncached Refresh in the Histogram's palette options menu.

Figure 5.25 Selecting All Channel View in the Histogram palette displays each color channel separately.

Figure 5.26 This image has had a total of 10 steps performed in the current session. I can move "backward" to any previous step by simply clicking on it in the History palette. The active state is always highlighted in blue.

History Palette

On the surface, the History palette (see Figure 5.26) may appear to be nothing more than Photoshop's version of multiple undos. Each step in an editing session triggers a saved state in the palette, named for the tool or dialog used to alter the image. At any point, you can revert back to an earlier History state by clicking its name in the palette.

In addition, you can create a snapshot (see Figure 5.27)—a History state that will now appear in the top portion of the palette along with a thumbnail. A snapshot has some benefits over the normal History state. The task of remembering all of your edits causes Photoshop to use up more RAM. To keep things from bogging down, the default limit on the number of History states is 20. After that, older states are deleted to make room for newer ones. You can increase the number of remembered states via the Preferences menu, but at the expense of higher RAM usage.

Figure 5.27 You create a snapshot by clicking the camera icon at the bottom of the History palette. By default, Photoshop automatically creates a snapshot—using the filename—each time an image is opened.

A snapshot prevents you from losing access to an important stage in your editing session. It remains in the palette until you close the image, regardless of the number of edits you make. Think of a snapshot as a safety net. Say you're about to experiment with a vastly different interpretation of the image, or you have reached a particularly

pleasing state. A snapshot offers a quick method of recovery should subsequent steps not turn out as planned. And, unlike a History state, a snapshot can be given a descriptive name. During a long editing session, it's easy to forget the purpose of an unnamed snapshot. For all of their convenience, though, it's very important to remember that neither snapshots nor History states are saved after an image is closed.

Another great feature of the History palette is that any state or snapshot can be used to create a new image. Simply click the palette's options menu, shown in Figure 5.28, and select New Document.

Figure 5.29 In Photoshop, a color image is a composite of two or more grayscale channels. From left to right, you can see the default channels for an RGB, CMYK, and Lab file. Use the eye icon to the left of each thumbnail to hide or show the individual channel.

Figure 5.28 Selecting New Document with a History state or snapshot active will duplicate every aspect of the image in that particular state to a new image file.

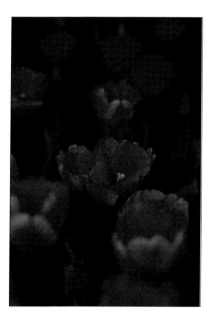

The History palette offers much greater flexibility than simply undoing editing steps. But it becomes most useful in combination with the History Brush, which I'll talk about later in this chapter.

Channels Palette

The Channels palette automatically shows the individual color channels for images in RGB, CMYK, or Lab mode, as shown in Figure 5.29. An RGB image will have three separate channels of unique pixel information, as shown in Figure 5.30. Grayscale

Figure 5.30 The brightness values of an individual channel's pixels reflect the amount of the corresponding primary color present. Here, an RGB image containing lots of red shows a red channel noticeably brighter than the green and blue channels.

images begin with only a single channel, but that does not diminish this palette's importance in grayscale mode, because this is also where alpha channels are stored. Layer masks and any other saved selections are given a dedicated alpha channel like the one in Figure 5.31. It is directly on this channel that modifications to the selection or mask are made.

Figure 5.31 A selection was saved as an alpha channel. Along the bottom of the palette are shortcuts for loading a channel as a selection, saving a selection as a channel, and creating a new channel. The trashcan icon is used to delete a channel.

Whenever a selection is saved, or a mask created, a new channel is added to the palette. Photoshop can store up to 56 channels per image.

Channels are quite flexible. They can be used as a layer mask, saved to a new document, or modified with the Brush tool or contrast filters to fine-tune the selected portions of the image. They can be merged or added to other image files. They are often great starting points in creating contrast-based masks for localized edits. We will make use of channels later in this chapter by combining individual color channels with a great degree of control to create a monochrome image from an RGB file.

Layers Palette

The Layers palette is similar in appearance to the Channels palette, but it has a host of additional options. The most noticeable is the Blending Mode drop-down menu at the top, seen in Figure 5.32. I'll discuss the blending modes in greater detail later in this chapter. For now, just remember that an image or adjustment layer affects all layers below it. The Opacity slider determines the degree to which a layer hides or reveals underlying layers. Figure 5.33 shows an image layer at different opacities. There must be at least one non-Background layer in an image in order to set opacity. A number of adjustments to a layer can be invoked via the icons along the bottom of the palette, as shown in Figure 5.34.

In case you were wondering, the Fill slider differs from opacity in only one respect. Opacity affects every element in a given layer. Fill is not applied to blending modes and layer styles. They are immune from its effects.

Figure 5.32 Each layer has access to a separate choice of blending mode.

Figure 5.33 The opacity layer controls the degree to which a top layer hides or reveals the layer directly beneath it. At left is an image with the top layer set to 30 percent. At right is the same image, with the default opacity of100 percent in the top layer.

Figure 5.34 The Layers palette has seven shortcut icons along the bottom. They are, from left to right: Group Layers, Add a Layer Effect, Add a Layer Mask, Add a Layer Adjustment, Create a Layer Set, Add a New Layer, and Delete the Currently Selected Layer.

Navigator Palette

The Navigator palette, shown in Figure 5.35, is as simple as it is useful. Besides offering a way to confirm and change image magnification, the red-outlined proxy view area shows the position of your current screen view in relation to the magnification and placement of the on-screen image. You can navigate to various regions of the image by dragging the proxy view area or just by clicking your desired destination in the palette's image thumbnail.

Figure 5.35 The red boundaries of the proxy view area outline the portion of the image currently viewable in the document window. In this example, I am zoomed in at 400% on the top right section of the image.

Levels

The Levels dialog box provides perhaps the most direct link between Photoshop and the traditional Zone System practiced by many black-and-white photographers. But to understand the Levels tool, you must first come to grips with the histogram. A histogram shows information about an image's tonal range. Its appearance is determined by the pixel data contained in an image. So images of different contrast will produce different looking histograms. We'll use the portrait in Figure 5.36 to examine the workings of the histogram.

The image tones are determined by pixel brightness or luminance. The luminance is measured on a scale from 0 to 255. A completely black pixel registers a luminance value of 0. A completely white pixel has a value of 255.

The horizontal axis of the histogram is fixed, regardless of the image. The far left end of the histogram is reserved for pixel values of 0 and the opposite end for values of 255. Now let's imagine the histogram as being divided evenly into ten zones or tonal regions. Each zone represents a tonal range along the scale of black to white. Figure 5.37 illustrates this concept.

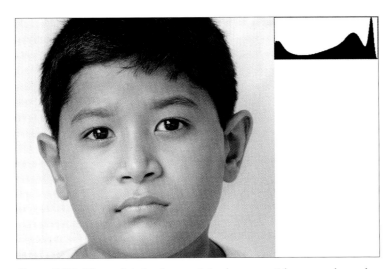

Figure 5.36 The undulating bar graph in the upper-right corner shows the relative distribution of pixels over a tonal range of maximum black to pure white in the portrait image.

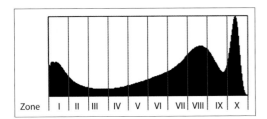

Figure 5.37 By superimposing these zones over the histogram's distribution of pixels, you can see that this particular image contains a fair number of pixels down in zone one. Zone eight shows a slightly greater concentration of pixels. And almost midway into zone 10, you can see a huge spike in pixel placement that gently tapers off before reaching a pure white pixel value.

Keep in mind that while the tonal endpoints are fixed, the vertical axis is relative. You can't accurately determine the volume of pixels at any given luminance value just by looking at the height of the graph. And Photoshop's histogram is not dividing pixels into just 10 zones, but into 256 discrete levels. The histogram has to accommodate a wide range of distribution scenarios within a fairly small user interface. So the histogram window is, by necessity, a fairly general overview. If your secret inner-geek has been wishing for more precise information, there is a statistics view available in the Histogram palette, shown in Figure 5.38, which should satisfy your craving. And don't worry, I won't tell a soul.

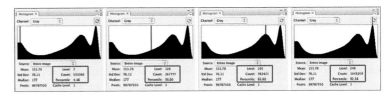

Figure 5.38 The histogram from the portrait image is repeated here four times, each with a different luminance level highlighted. The statistics view tells us a lot about the volume of pixels and their relation to specific luminance levels.

Using Figure 5.38, you can analyze the pixel distribution with a bit more precision. In the shadows, you can see that there is a greater concentration of pixels with a luminance value of 7. There are a relatively small number of pixels at the midtones value of 128. There are a high number of pixels, however, with a luminance of 195, which is a light-medium gray. And finally, at a luminance of 240—a near white that still holds detail—there exists a very large number of pixels.

You can examine the statistics for Level 195 and see that there are 762,421 pixels with this luminance value. These pixels also have a luminance greater than or equal to 63 percent of the total pixels in

the file. If you map this additional information onto the histogram from Figure 5.37, you can make a more precise correlation between pixel luminance and distribution. Figure 5.39 shows this relationship.

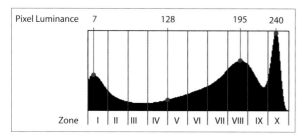

Figure 5.39 I have superimposed the pixel luminance values from Figure 5.38 onto a single histogram. You can now see where they fall within our "zone" definitions.

Of course, none of this gives us any subjective information. Is it a satisfying image? Does it move us emotionally? These are all questions to be deferred until later on in the editing process. But as a diagnostic tool, the histogram packs a lot of information into a relatively simple interface.

Now that you can read a histogram, let's take a look at how the Levels tool interacts with it to alter image contrast. Note the three Input Levels sliders directly beneath the histogram in Figure 5.40.

The location of the black point slider along the horizontal axis indicates a pixel luminance of 0. Wherever this slider is moved, all pixels immediately above it and to the left of it are set to 0. Think for a moment about the implications of this. As you move the black slider to the right, any distinct pixel values located above and to the left of the slider's position are mapped to the same luminance: zero. Once this mapping is applied, those previously distinct pixel values are erased.

Figure 5.40 The Levels tool has three input sliders, one each for setting the black point, midtone, and white point of an image.

In a similar fashion, the location of the white point slider indicates a pixel luminance of 255. Any pixels located directly above and to the right of this slider's location are mapped to maximum white, with no detail preserved. The middle slider sets the midtone value. Any pixels sitting directly above this slider are set to a luminance of 128.

Whenever a new instance of the Levels tool is called up, the sliders are at the default positions seen in Figure 5.41. To make a contrast adjustment, you move one or all of these sliders. With our superimposed Zone system as a guide, we will look at the interrelated nature of each of these sliders in the following series of illustrations.

You drag the black point slider to the right (see Figure 5.42) when you want to darken the image. This step sets pixel values to lower luminance levels.

The Histogram palette gives an even better view of what's going on. In Figure 5.43, you can see clearly that beyond moving just the shadow regions, I also reduced the brightness of midtones and to a lesser degree, highlights. The entire histogram has been pulled to the left. Note that the gaps you see in the Histogram Palette window are not indicative of fully rendered image quality. Photoshop

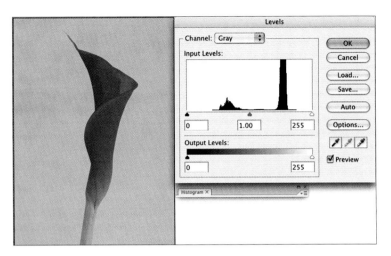

Figure 5.41 This image currently has no pixels above the black point slider, and thus no deep blacks.

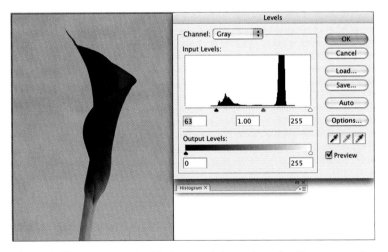

Figure 5.42 By moving the black point slider to the right, I have mapped level 63 to level 0.

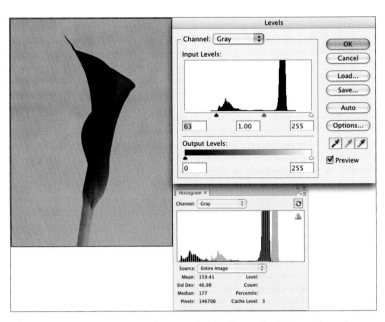

Figure 5.43 Moving the black point slider affects all of the pixels in the image. The gray outline shows the distribution of pixels before the Levels adjustment.

is using a cached preview that always shows gaps, even in 16-bit images. Click the Refresh button after closing the Levels dialog to update the histogram.

After you commit to the Levels adjustment in Figure 5.43, the histogram will reflect this redistribution of pixel luminance values (see Figure 5.44).

Figure 5.45 shows the effect of dragging the white point slider to the left.

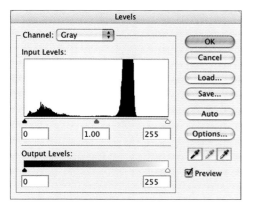

Figure 5.44 After darkening the shadows, you now see a histogram that extends much further into the shadow end of the histogram.

The middle slider is best understood as a global brightness adjustment that affects both highlight and shadow values to a similar degree. Figure 5.46 shows the effect of dragging the middle slider to the left.

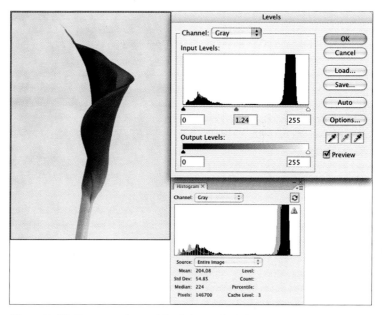

Figure 5.46 Dragging the middle slider to the left moves the entire range of pixels to higher luminance values, resulting in a brighter image.

Figure 5.47 shows the effect of dragging the middle slider to the right.

The adjustments in Figures 5.42 to 5.47 demonstrate the global nature of all three Input sliders. Moving a single slider can affect pixels throughout the entire tonal range. The intensity of the adjustment does taper off. The farther the original pixels are from the slider's location, the less they will be affected. But it is impossible to limit big tonal adjustments to specific pixel values using the Levels tool.

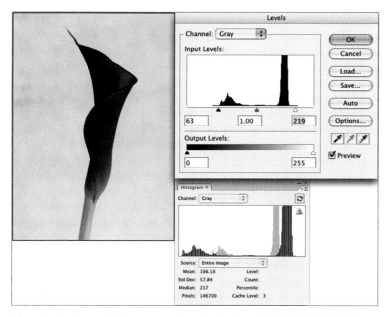

Figure 5.45 When I drag the white point slider to the left, the highlights, midtones, and shadows become brighter. The effect is strongest in the highlights and tapers off in the darkest pixel values.

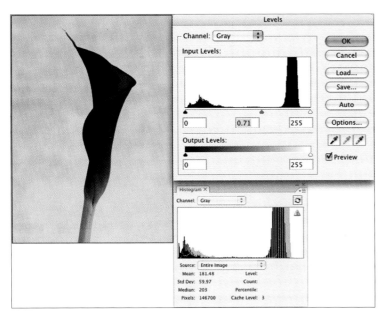

Figure 5.47 Dragging the middle slider to the right places the entire range of pixels at lower luminance values, resulting in a darker image.

As a diagnostic or educational tool, the Levels interface has much to offer. There is no quicker way to determine whether highlight or shadow values have been clipped than glancing at an image's histogram. Most new Photoshop users can intuitively grasp what Levels does once they move the sliders around a few times. Because of this, Levels is generally the first editing tool with which most users become familiar.

But this tool has decided limitations. Chief among them is the inability to restrict the tonal range of shadow, midtone, or highlight adjustments. In addition, there is no direct correlation between pixels represented in the histogram and their location in the image itself. A histogram can tell you there are a lot of pixels, say at level 192, but it does not show you where they exist in the image. There

is no direct comparison of before and after values. Yes, you can place color samplers at up to four locations in the image, but this must be done before opening the Levels dialog. Last, but not least, you're stuck with only three inputs at which to initiate an edit. There is simply not a lot of precision possible with this tool. When delicate and localized edits are called for, using Levels is like writing calligraphy with a jackhammer.

Shadows and Highlights

One of the keys to establishing appropriate contrast in a print is the setting of values for your shadows and highlights. The questions appear to be simple. How dense should my deepest shadows appear? And how near to paper white should my brightest highlights be rendered?

But there are inherent compromises involved. The more you open up shadows to reveal small and subtle details, the duller a print may feel at a normal viewing distance. And a print with broad areas of blown-out highlights may have great contrast, yet feel distinctly flat or one-dimensional.

Great care must be devoted to choosing and setting shadow and highlight endpoints. A good deal of precision is required so that you may separate near black details from maximum shadow values. You can push specular highlights to paper white, giving a print some needed pop, but this move should not cause near white pixel values containing useful image detail to be obliterated.

Before you can map your shadows and highlights to the appropriate tones, you must identify precisely where they occur in the image. Fortunately, the Levels tool—and in CS3 the Curves tool—contains a threshold command that takes the guesswork out of finding both the darkest and brightest pixels. I will illustrate this technique in the following steps.

1. Hold down the Option key.

2. Click on the black point slider to make the entire image window become white (see Figure 5.48).

3. Drag the black point slider to the right (see Figure 5.49).

You can always toggle between the threshold and normal view by pressing and releasing the Option key. This puts the pixels in context with the grayscale image, making their location easy to remember. Next, we will locate the brightest pixels in the image.

1. Return the black point slider to its default position.

2. Hold down the Option key.

3. Click on the white point slider to make the entire image window black (see Figure 5.50).

4. Drag the white point slider to the left (see Figure 5.51).

Once you have identified precisely where the darkest and brightest pixels reside, you can set them to *appropriate* endpoint values. I emphasize the word "appropriate" for two reasons. The first is that not every image is meant to contain deep blacks and bright whites. A high-key shot may contain no three-quarter or shadow tones whatsoever.

The second factor to consider is that identical endpoint values can have drastically different appearances when sent to various output devices. If the image is going to be viewed on an uncalibrated monitor incapable of distinguishing values between 12 and 0, any pixels with a luminance of 10, for example, will appear just as black as those with a luminance of 0. The same holds true for print output. In the right hands, today's inkjet printers can print visually distinct values at 98 percent and 100 percent black. Print that same image in your local newspaper, however, and everything from 85 percent on down may print as a dark ink blob. In Chapter 7, I'll demonstrate the benefits of optimizing your images for specific types of output.

Figure 5.48 When you hold down the Option key while clicking the black point slider, you invoke Photoshop's hidden threshold command. If there are no pixels currently set to a luminance of zero, the entire image window goes white.

Figure 5.49 Black pixels start to appear as the slider passes under pixel data contained in the actual image. The pixels that appear first are the darkest tones in the image.

Figure 5.50 When you hold down the Option key while clicking the white point slider, you invoke Photoshop's hidden threshold command. If there are no pixels currently set to a luminance of 255, the entire image window goes black.

Figure 5.51 White pixels start to appear as the slider passes under pixel data contained in the actual image. The pixels that appear first are the brightest tones in the image.

Curves

The Curves tool allows for extraordinarily precise and subtle edits to very specific tonal ranges within an image. You can adjust shadow values without affecting midtones in the slightest and tweak highlights without disrupting overall image contrast. You can still make edits as broad and dramatic as those with the Levels tool when the occasion warrants. In fact, you'd be hard pressed to make an edit via Levels that you could not duplicate using Curves. So why do so many users reach instinctively for the Levels tool when Curves has so much more to offer? Simply put, the Curves tool has always been a more abstract concept for Photoshop users to grasp. But with CS3, Photoshop's engineers have given this tool a new interface, seen in Figure 5.52, that addresses many of the things that had people scratching their heads, or worse, when attempting to use it. The most obvious change—apart from its larger size—is the addition of a histogram. It remains static, giving you a visualization of pixel distribution around which to fine-tune your curve.

Figure 5.52 The Curves tool dialog has been redesigned in CS3 and graced with new features. If you find the histogram to be more distraction than help, you can disable it in the Curves Display Options menu.

The Baseline option, when selected, provides a static diagonal that allows easy comparison of the current location of a curve section compared to its unedited state, as seen in Figure 5.53.

Figure 5.53 This curve's shape is significantly altered from its original state. Pixels falling along the curve below the baseline have gotten darker. Pixels falling along the curve above the baseline have gotten brighter.

For many years, the only reason I bothered to invoke the Levels tool was to locate endpoints before making adjustments, a technique I described earlier in the sidebar "Shadows and Highlights." In CS3, black and white point sliders have been added to the Curves dialog. I can now use the same technique without having to switch tools (see Figures 5.54 and 5.55).

Why is it important to have a clipping preview? The preservation of image detail at either end of the tonal range can often make the difference between an image that sustains a viewer's attention and one that only merits a quick glance. One of the great advantages with digital editing and printing is that you can render highlight and shadow details with a precision that is not possible in the wet darkroom. So instead of unwittingly throwing away detail, the Show Clipping option lets you preview the pixels to be affected before you commit to the adjustment.

Figure 5.54 With the Show Clipping option selected, it is easy to identify the darkest pixel values by moving the black point slider to the right. Setting an Input value of 10 to an Output value of 0 maps all of the pixels at right to maximum black.

Figure 5.55 The white point slider works the same way. All of the pixels highlighted in threshold view have a luminance of 226 and higher and will be mapped to 255, or maximum brightness.

This is not to say that you should never set pixels to their maximum values. Specular highlights and deep rich shadows are essential components of visual communication. You do need pleasing contrast, after all. The key, though, is to make sure that any image detail necessary to communicate your vision of the image remains available to the viewer.

Now that you've gotten the new features out of the way, it's time to roll up your sleeves and figure out how to actually use the Curves tool. The curve lies on a graph with two axes. The gradation bars along each axis distinguish the shadow and highlight regions, which lie at opposite ends. The horizontal axis represents input values. This describes—from 0–255—the luminance of image pixels before any contrast adjustment is applied. The vertical axis denotes output values. These are the luminance values to which pixels are set after any contrast adjustments are applied. If it's starting to feel like the Curves tool was built for math majors, Figures 5.56 to 5.58 should make things a bit easier to understand.

Notice that in addition to a numerical display, the Curves tool gives you visual confirmation of the intensity of these luminance changes. The farther a point is displaced from the baseline, the greater the luminance change. So in Figure 5.58, you can tell at a glance that shadow values have been affected more than the highlights. The midtones have been altered the least.

This, in a nutshell, is how the Curves tool operates. Sections of the curve that are pulled below the baseline darken pixels, while sections above the baseline lighten them. Any part of the curve remaining on the baseline indicates there have been no changes in pixel luminance.

Points can be added by clicking anywhere along the curve. Once added, a point can be moved vertically. This changes the output value for a given input value. A point can also be moved laterally.

Figure 5.56 The highlighted point along this curve began at an input value of 77. Once this edit is applied, pixels throughout the image at this luminance will be pushed to a luminance of 50. They will darken.

Figure 5.57 The highlighted point along this curve began at an input value of 151. Once this edit is applied, pixels at this luminance throughout the image will be pushed to a luminance of 153. They will brighten slightly.

Figure 5.58 The highlighted point along this curve began at an input value of 175. Once this edit is applied, pixels at this luminance throughout the image will be pushed to a luminance of 188. They will brighten.

This changes the input value for a given output value. But I don't want to ever catch you clicking on the curve to add a point. There's a much better way.

Click-drag the cursor over any part of the image, and you will notice a hollow circle scurrying along the curve. Its location corresponds to the luminance value of the pixels underneath the cursor, as seen in Figure 5.59. You can easily place this point along the curve by pressing the Cmd key while you click on the image, as shown in Figure 5.60.

Each time you invoke a new instance of the Curves tool, you're presented with the same diagonal line, whether you've applied previous curves or not. After spending some time with this tool, you will start to get a feel for the various shapes and how they affect contrast. In Figures 5.61 to 5.64, we will look at the presets that ship with CS3 and their resulting shapes.

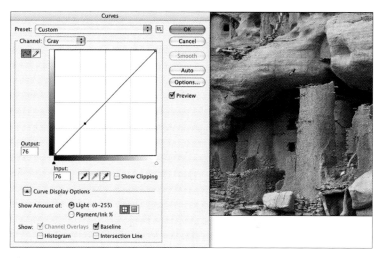

Figure 5.60 A Cmd-click places this point on the curve and automatically highlights it so you can adjust its position.

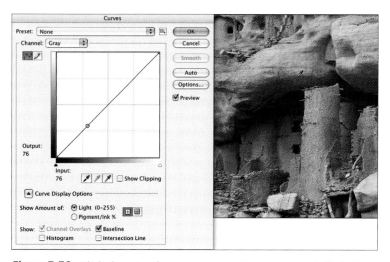

Figure 5.59 Click-dragging the mouse over an image automatically indicates a pixel value's location on the curve. The pixel value becomes a hollow circle along the curve.

Figure 5.61 The preset, *Lighter*, opens up the midtones significantly, while tapering off in intensity at both the highlight and shadow endpoints.

Figure 5.62 This curve preset darkens the midtones significantly, while again tapering off in intensity at both the highlight and shadow endpoints.

Figure 5.65 With this curve, I have targeted two small tonal areas for adjustment. The highlights have been brightened and a small region of mid-tones has been darkened. This is a very subtle edit! But it is one that can often provide the fine-tuning that separates a stunning image from a merely good image.

Figure 5.63 This curve preset darkens the shadow regions considerably, while increasing the brightness of highlights by a very small amount. The bulk of this contrast adjustment is limited to the three-quarter tone, or near shadow area.

Figure 5.64 This curve preset not only darkens three-quarter and shadow tones more aggressively than in Figure 5.63, but it also significantly opens up the quarter tones and highlights.

In the contrast boost seen in Figure 5.64, shadows are darkened, highlights are brightened, and the midtones are altered by a much smaller degree. This is a classic S-curve (note its shape), a variation of which is commonly used to add "punch" to flat, dull images.

These presets give you a hint of the Curve tool's flexibility. You can further restrict contrast adjustments to specific tonal regions by placing points that serve to lock down, rather than shift, input and output values. In Figure 5.65, I created a lock-down curve in which the majority of the points serve to restrict the movement of the curve.

Cycle Through Curve Points

Using the mouse to select a point on the curve without accidentally nudging it can be an exercise in frustration. Instead, cycle among points on a curve with the keyboard shortcut Ctrl+Tab. If you've placed a lot of points, you can save time by using Shift+Ctrl+Tab to cycle backward.

Choose Your Curve Numbers

In CS3, the Curves tool makes it easy to choose how to display input and output values. Choosing Light in the options menu gives the ubiquitous 0–255 numbering system. Choosing Pigment yields percentages, 0–100. The choice is yours.

But toggling between the two does swap the highlight and shadow ends on the graph. Popular convention when using Curves is to show highlights at the top and right ends of the axes. The vast majority of books and tutorials use this arrangement, which is only available by choosing the Light option. In grayscale mode, the Info palette, by default, shows you ink percentages. You can always view them there while adjusting a curve.

Adjustment Layers

When applying image adjustments like Levels or Curves, you have two options. Edit directly on the pixels or store the editing instructions as a separate adjustment layer that sits above the image layer(s). The results are visually identical, but using an adjustment layer can have significant advantages.

An adjustment layer is nondestructive, meaning it previews the edit without permanently changing the values of underlying pixels. At the start of this chapter, I mentioned that most Photoshop edits involve throwing away significant pixel data. This is a cumulative process. Each successive edit further degrades the image. One way to minimize this loss is through the use of adjustment layers. With an adjustment layer, Photoshop keeps track of what will be done to the pixels when the image is flattened and gives you an on-screen rendering of that result. You can see the effects of the edit, but it has not yet been applied to any pixels. Think of it as a what-if option where you don't permanently commit to the edit until the adjustment layer is merged or the image file is flattened. At any point before the layer is merged or flattened, you can re-edit the adjustment. Tweak points on a previously generated curve or reposition Levels sliders, and you're simply changing the recipe before you cook the meal. You can have multiple adjustment layers above an image, and when the time comes to flatten the image, Photoshop will combine the adjustments into a single edit before applying them to the image's pixels. Adjustment layers can produce noticeably less damage to the histogram of an 8-bit file, and I encourage their use in cases where you cannot work with a 16-bit version of the image.

Adjustment layers have all the benefits of any other type of layer. The opacity and blending mode can be altered. A layer mask, which I'll cover later in this chapter, can be attached to limit the edit to specific areas of the image. And for quick before-and-after views, you can toggle an adjustment layer on and off by clicking on its eye icon in the Layers palette.

Adjustment layers seem like the greatest thing since sliced bread. What's the catch? File size and memory usage. Adding adjustment layer masks can quickly turn a modestly sized file into a space-hogging behemoth. This becomes an even bigger issue when editing 16-bit files, which are twice as large to begin with. For example, a 29MB TIFF file can grow to 59MB with the addition of an adjustment layer mask. And with a larger file size comes greater demands on memory. A 16-bit file with just a few layers may be excruciatingly slow to work with on an older computer.

If you're the indecisive type or simply like to experiment with vastly different edit options, adjustment layers are manna from heaven. You can tweak edits over days, weeks, or even years. But you must be judicious in your use of them, or file sizes can become unmanageable. As the number of adjustment layers increases, it also becomes important to give them descriptive names so you can remember what you were trying to accomplish in the first place.

You've just seen quite a few examples of Curves in action. But to fully appreciate its flexibility and precision, you must spend time using it on your own images. That's when the light bulb usually goes off. Images that never quite achieved what you wanted with the Levels tool now suddenly blossom to life using the more refined adjustments that Curves allows. The whole concept of input and output values and abstract curve shapes can take some getting used to. A great way to begin using Curves is to simply apply the presets that ship with CS3. They cover a very useful range of adjustments. And if a preset is close, but not quite what you envisioned for an image, just modify it by adding, deleting, or moving points. In CS3, you no longer have to start with a blank slate, staring at a diagonal line. You can also save your own settings in the Presets Options flyout menu to the left of the OK button.

Once you begin to feel comfortable with Curves, make sure to pat yourself on the back. The ability to tailor an image precisely to your vision is greatly enhanced with a solid understanding and application of the Curves tool.

Blending Modes

One of the biggest confidence boosts you can give yourself in Photoshop is to understand how its blending modes work. Blending modes can be used to create layer masks, spot extremely dirty images, or apply contrast adjustments. They are also the centerpieces of the Calculations command, which I will cover later in this chapter. And there's simply no discounting the envy from fellow Photoshop users as you toss off a gem like, "…so I made a new layer, set it to Multiply, and reduced opacity to 40 percent."

To grasp the concept of blending modes, you must understand that whenever you stack one layer or channel on top of another or paint with a brush tool, you are combining pixels. Each pixel in the top layer, channel, or brush is combined with the pixel directly beneath it. Remember that every pixel has a numerical value, from 0 to 255, with 0 equaling black and 255 designating white. A blending mode is simply a formula that controls how these two sets of pixels interact. For a blending mode to have any effect, it must be applied to the top-most layer or channel or to the brush tool being used to paint.

Here's how it all works. A blending mode compares identically placed pixels from two sources and performs mathematical operations on their numerical values when certain criteria are met. The math produces a result that is immediately visible and will usually differ significantly in appearance from either source. The most common sources for a blending mode are two image layers, an adjustment layer plus an image layer, two channels, or a brush tool plus a layer or channel. Photoshop makes an important distinction

between these sources, based on where the blend is designated. The layer, channel, or brush that is actually set to the blending mode is known as the blend color. The underlying layer or channel is called the base color. The blend color changes the base color into a *result*— how the image appears after the blending mode is applied. Blending modes produce a top-down effect. So for any layer or channel you want to alter, you add a layer or channel above it that is set to a blending mode. Or you simply paint with a brush set to a blending mode.

Your choice of blending mode answers the following question: Will one set of pixels completely replace the other, or will the pixels merge to produce a completely new value? I have to concede that blend color and base color are not the most intuitive names, especially for grayscale channels and layers. For simplicity, I will refer to the blend color as source 1 and the base color as source 2. This has the added benefit of matching the naming convention used in the Calculations dialog, which I'll explore later in this chapter. In the following examples, I'll be using two image layers to demonstrate the effects of all but the most obscure blending modes.

The goal of the examples is to help you develop a general sense of which type of blending mode is appropriate in a given situation. Don't worry, I don't know anyone who always picks the "right" mode on the first try. The myriad of possibilities is just too complex. And with Photoshop, playing around with different options is simply a part of the never-ending learning process. But by taking a bit of time now to study their effects, you'll be able to significantly narrow your choices, based on what you're trying to accomplish with an image.

I have chosen two separate grayscale files to illustrate the effects of blending modes. Figure 5.66 contains solid areas of color. This provides a simple way to visualize what is happening to the pixels. Of course, this type of synthetic image has limited use in the real world.

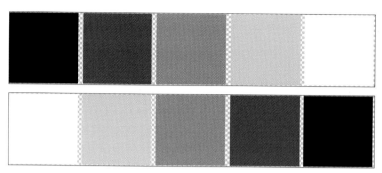

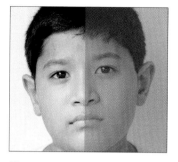 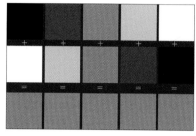

Figure 5.66 Source 1 (top) contains patches of solid tone with pixel values, from left to right, of 0, 64, 128, 192, and 255. Source 2 (bottom) is composed of the same patches, but in reverse order of 255, 192, 128, 64, and 0.

So the portrait in Figure 5.67 will show the blending modes' effects on a photographic image encompassing a full tonal range. Source 1 is always the layer above source 2.

Normal is the default and most straightforward of the blending modes. The two sources are combined based on the opacity of

source 1. When its opacity is set to 100 percent, source 2 is completely hidden. Figures 5.68 and 5.69 show the result of combining image layers at 50 percent opacity.

Figure 5.68 Setting source 1 to 50 percent opacity allows exactly half of its density to obscure source 2.

Figure 5.69 When the pairs of pixel values 0 + 225 and 64 + 192 are combined at 50 percent opacity, they each produce a midtone gray. The middle patches were both at 128 from the start.

 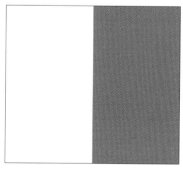

Figure 5.67 This portrait of a young Bangladeshi serves as source 2, while source 1 is filled with two colors. The left half is set to each mode's neutral color, which negates the effect of the blending mode. The right half is filled with a pixel value of 118.

The modes that follow belong to three broad categories. There are modes that darken an image and those that make an image brighter. And last, there are modes that increase contrast by simultaneously darkening and brightening different tonal ranges within a given image. To make these distinctions easier to remember, blending modes are grouped by function in Photoshop's menus, as shown in Figure 5.70.

In this book, we will be concerned with only the darkening, lightening, and contrast groups. The composite group blends are disabled in grayscale mode.

Figure 5.70 In the Layers palette, the blending modes are grouped by function and separated by vertical rules.

The Yin and Yang of Blending Modes

Each darkening mode has a corresponding lightening mode that performs its opposite function. The opposite of Darken is Lighten. The opposite of Multiply is Screen. Color Burn and Linear Burn have as their opposites Color Dodge and Linear Dodge, respectively. By concentrating on the effects of either the darkening or lightening group, you can then infer what the mode's opposite effect will do without too much trouble.

Darken is another easy one to grasp. This blending mode compares corresponding pixels of source 1 and source 2. At every location, the darker pixel completely replaces the lighter pixel. Figures 5.71 and 5.72 show the result of combining image layers in the Darken mode.

Composite Modes? *Fuggedaboutit!*

CS3 introduced two new blending modes: Darker Color and Lighter Color. These differ from Darken and Lighten in that they work on composite, rather than individual, channels. Since grayscale images have a single channel of pixel data, we can safely ignore these modes, giving us two less modes to fuss over.

Darkening Group

Another key distinction to remember when trying to predict, or simply understand, a mode's effect is the neutral color associated with each mode group. White—a pixel luminance of 255—is the neutral color for the darkening group. The presence of a white pixel in source 1 prohibits the blend from taking effect at that location. Where this occurs, the result is always identical to source 2.

Figure 5.71 On the right side of the image, the face is revealed only where source 2 pixels are darker than 118, which is the value of source 1's pixels. Eyes, hair, and shadows are revealed, while the rest of the skin tones remain hidden.

Figure 5.72 The two lightest patches in source 1—pixel values 192 and 255—have been replaced completely by their source 2 counterparts—pixel values 64 and 0.

Multiply is a little trickier. Here, the corresponding pixels of source 1 and source 2 are not simply compared but yes, multiplied. For those interested in the math—all three of you—the formula looks like this: source 1 pixel luminance * source 2 pixel luminance/255. The last step of division keeps the result within our 0–255 luminance range. And since black has a luminance of 0, if either of the two source pixels is black, the result is always black. Figures 5.73 and 5.74 show the result of combining image layers in the Multiply mode.

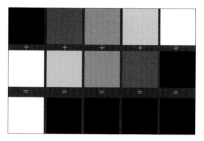

Figure 5.75 On the right side of the image, large areas have been clipped to black. The darkening effect is much greater in shadow areas than brighter ones. The white of the eye moved from 227 to 203, while tones along the outer ear decreased in brightness from 117 to 18.

Figure 5.76 Four of the five patches got darker, as expected. For reasons known only to Photoshop engineers, the white pixel in source 2 acts exactly as a neutral color would in source 1, preventing the blend from taking effect. Note that if the white pixel value is changed to 254 instead of 255, a darker result does occur.

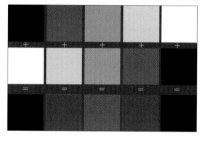

Figure 5.73 On the right side of the image, source 1 and source 2 pixels have been multiplied. This always produces a darker result, except where there is a white pixel.

Figure 5.74 The middle three patches have all become a darker shade of gray. Wherever a source pixel is black, the result is always black.

Color Burn produces a darker image by decreasing luminance values. But it acts much more aggressively on darker pixels than lighter ones. The degree of darkening is determined by the brightness of source 1's pixels. The effect is a darkened result by way of a significant contrast increase. Figures 5.75 and 5.76 show the result of combining image layers in the Color Burn mode.

Linear Burn produces an extreme decrease in brightness, but with much less contrast than a color burn because it lowers the luminance of lighter tones by a similar degree as it does darker ones. The resulting image will have a relatively narrow tonal range with few, if any, highlights. Figures 5.77 and 5.78 show the result of combining image layers in the Linear Burn mode.

Lightening Group

Black—a pixel luminance of 0—is the neutral color for the lightening group of blends. The presence of a black pixel in source 1 prohibits the blend from taking effect at that location. Where this occurs, the result is always identical to source 2.

Figure 5.77 On the right side of the image, you can again see a dramatic darkening effect, but with much less contrast than Figure 5.75. All of the affected pixels are darkened by a similar degree. The white of the eye moved from 227 to 94, while tones along the outer ear decreased in brightness from 117 to 9.

Figure 5.78 Each square has now gone to black.

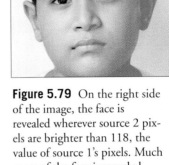

Figure 5.79 On the right side of the image, the face is revealed wherever source 2 pixels are brighter than 118, the value of source 1's pixels. Much more of the face is revealed than back in Figure 5.71. Dark areas like hair and eyes are hidden, appearing instead as pixel values of exactly 118.

Figure 5.80 The two darkest patches in source 1—pixel values 0 and 64—have been replaced completely by their source 2 counterparts—pixel values 255 and 192.

Lighten compares the corresponding pixel values of both source 1 and source 2. This time, though, it is the lighter pixel that completely replaces the darker pixel. Figures 5.79 and 5.80 show the result of combining image layers in the Lighten mode.

Screen performs the inverse mathematical operation of Multiply. I'll spare you the formula. The result is a lighter image with reduced contrast. Figures 5.81 and 5.82 show the result of combining image layers in the Screen mode.

Color Dodge produces a lighter image by increasing luminance values. But it acts much more aggressively on lighter pixels than darker ones. The degree of brightening is determined by the brightness of source 1's pixels. The effect is a lighter result by way of a significant contrast increase. Figures 5.83 and 5.84 show the result of combining image layers in the Color Dodge mode.

Figure 5.81 On the right side of the image, source 1 and source 2 pixels have been screened. This mode always produces a result lighter than source 1.

Figure 5.82 The middle three patches have all become a lighter shade of gray. Wherever a pixel in either source is white, the result is always white.

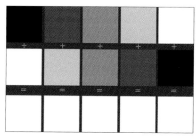

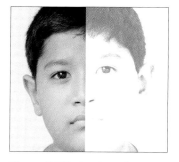

Figure 5.83 On the right side of the image, large areas have been clipped to white. The brightening effect is much greater in highlight areas than darker ones. Tones along the outer ear increased in brightness from 117 to 255, while strands of hair increased from 9 to 23.

Figure 5.84 Four of the five patches went to white, as expected. For reasons known only to Photoshop engineers, the black pixel in source 2 acts exactly as a neutral color would in source 1, preventing the blend from taking effect. Note that if the black pixel value is changed to 1 instead of 0, a brighter result does occur.

Figure 5.85 On the right side of the image again, you can see a dramatic brightening effect, but with less contrast than Figure 5.83. All of the affected pixels are brightened by a similar degree. The white of the eye moved from 227 to 255, while strands of hair increased in brightness from 9 to 136.

Figure 5.86 Each patch has now gone to white.

Linear Dodge produces an extreme increase in brightness, but with much less contrast than a color dodge. The resulting image will have relatively few shadows and is much more prone to highlight clipping than the other modes in this group. Figures 5.85 and 5.86 show the result of combining image layers in the Linear Dodge mode.

Contrast Group

Midtone gray—a pixel luminance of 128—is the neutral color for the contrast group of blends. The presence of a midtone gray pixel prohibits the blend from taking effect at that location. Where this occurs, the result is always identical to source 2.

For the portrait image, I'm going to change the source 1 color on the right half of the image to a darker value of 50. This will allow for much more dramatic contrast results that can be more easily seen on the printed page. The source 1 color on the left half of the image will remain set to this mode's neutral color—in this case 128.

Overlay creates contrast by using one of two earlier blending modes. Pixels in source 2 darker than middle gray are multiplied. Pixels in source 2 that are brighter than middle gray are screened. The result combines the multiplied or screened value with the source 1 pixel to reflect the lightness or darkness of the original source 2 value. The final result is a contrast increase that tapers off nicely at the shadows and highlights, preventing clipping of endpoints. Figures 5.87 and 5.88 show the result of combining image layers in the Overlay mode.

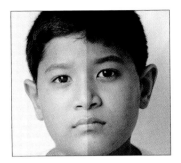

Figure 5.87 On the right side of the image, you can see a contrast increase much milder than the burn modes. Shadow values in the hair are not clipped.

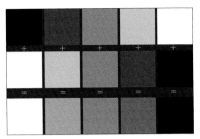

Figure 5.88 In addition to middle gray, the white and black pixels in source 2 remain unaltered. The remaining two grays give mildly contrasting tones for a result.

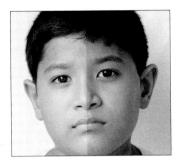

Figure 5.89 On the right side of the image, you can see the shadows and highlights change to the same values as in Figure 5.87. But the tones between these endpoints are adjusted to a significantly smaller degree. The result is less contrast than in the Overlay mode.

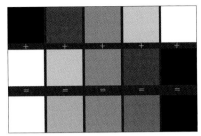

Figure 5.90 In addition to middle gray, the white pixels and black pixels in source 2 remain unaltered. Patch number 2 is darkened because the source 1 pixels are darker than 128. Patch number 4 is lightened because the source 1 pixels are brighter than 128.

Soft Light lightens or darkens pixels based on the luminance of source 1's pixels. Where source 1 pixel values are greater than 128, the result is brighter. Where source 1 pixel values are less than 128, the result is darker. Figures 5.89 and 5.90 show the result of combining image layers in the Soft Light mode.

Hard Light also lightens or darkens pixels based on the luminance of source 1's pixels. Where source 1 pixel values are greater than 128, the underlying pixels are screened and thus brightened. Where source 1 pixel values are less than 128, the underlying pixels are multiplied and thus darkened. Figures 5.91 and 5.92 show the result of combining image layers in the Hard Light mode.

Vivid Light is also similar to soft light, but here the result comes from a contrast, rather than brightness change. Where source 1 pixel values are greater than 128, the result is of lower contrast and thus brighter. Where source 1 pixel values are less than 128, the result is of higher contrast and thus darker. Figures 5.93 and 5.94 show the result of combining image layers in the Vivid Light mode.

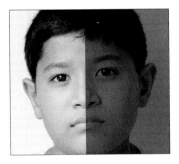

Figure 5.91 On the right side of the image, all of the source 2 pixels are multiplied since the source 1 pixels are darker than 128.

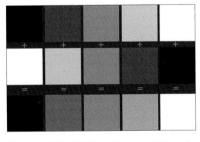

Figure 5.92 Unlike Figures 5.88 and 5.90, the white pixels and black pixels in source 2 are changed. Patch number 2 is darkened much more than in Figure 5.90. Patch number 4 is lightened much more than in Figure 5.90.

Figure 5.93 On the right side of the image, pixels have undergone a dramatic contrast adjustment.

Figure 5.94 The white pixels and black pixels in source 2 are changed. Patch numbers 2 and 4 both show a greater contrast difference between source 2 and the result than in Figure 5.90.

Figure 5.95 On the right side of the image, pixels have undergone a decrease in brightness identical to the linear burn seen in Figure 5.77.

Figure 5.96 All of the source 2 pixels have been completely replaced by the source 1 pixels.

Linear Light differs from soft light in that it uses a linear dodge and burn to adjust brightness. Where source 1 pixel values are greater than 128, the result is linear dodge, which increases brightness. Where source 1 pixel values are less than 128, the result is a linear burn, which darkens pixels. Figures 5.95 and 5.96 show the result of combining image layers in the Linear Light mode.

Pin Light is a souped-up combination of darken and lighten modes. It compares corresponding pixels and replaces source 2 pixels when the following conditions are met. Wherever source 1 is greater than 128, underlying pixels darker than source 1 are lightened. Wherever source 1 is lower than 128, underlying pixels lighter than source 1 are darkened. Absent these two conditions, no change to source 2 pixels occurs. Figures 5.97 and 5.98 show the result of combining image layers in the Pin Light mode.

Hard Mix is similar to choosing Image>Adjustments>Threshold. Light values go to white, and dark values move to black. This mode has no neutral color. Figures 5.99 and 5.100 show the result of combining image layers in the Hard Mix mode.

Figure 5.97 On the right side of the image, every instance of pixels in source 2 lighter than source 1 has had a Darken mode applied.

Figure 5.98 The white pixels and black pixels in source 2 have been replaced. The result for both patch numbers 2 and 4 is a color value of 128.

Figure 5.99 Various degrees of threshold have been applied to all pixels.

Figure 5.100 Various degrees of threshold have been applied to all pixels.

Phew! That was an exhaustive review of blending modes, but it's really just the tip of the iceberg. In all of these examples, the opacity of source 1 was set to 100 percent. Experimenting with different opacities adds an untold number of options for obtaining desirable results. Blending modes are rarely useful at full strength, so before dismissing one as too harsh, try lowering the opacity of source 1 or your brush.

Selections

It doesn't take long for even a new Photoshop user to learn how to apply global contrast adjustments to an image. What does take time to master, however, is the ability to apply localized edits. In this section, we will look at ways to manipulate distinct portions of an image without creating the abrupt transitions or dreaded masking lines indicative of sloppy Photoshop work. Editing that does not call attention to itself obviously requires good technique. But I want to stress the importance of emulating the behavior of natural light when the goal is to produce images where content retains priority and technique is transparent to the viewer.

In Figure 5.101, my goal is to give the sea stacks more contrast, while still maintaining the mood of the overcast morning in which the image was photographed.

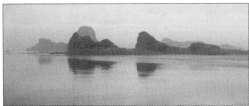

Figure 5.101 The original scan is very flat with too many grays.

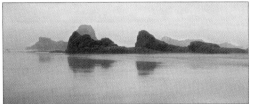

Figure 5.102 I use the History Brush to restrict a Curves contrast boost to the foreground sea stacks, leaving the rest of the image untouched.

Now that the sea stacks are more prominent, it makes sense that their reflections in the water should be heavier as well. Diffuse sunlight peeking through a thin veil of clouds often adds pockets of contrast to overcast days.

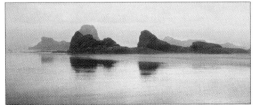

Figure 5.103 Again using the History Brush, I paint the initial curve adjustment over the foreground ocean up through the reflections of the sea stacks.

After two contrast adjustments, I still don't have enough separation between the foreground and background sea stacks. They appear to exist on the same plane. In determining why this is, I try to visualize the way this scene occurs in nature. As the low-lying clouds and light drizzle reduce contrast and visibility, nearby objects contain much more contrast against water and sky than do objects receding into the horizon. The key then is to maintain this sense of lowered

visibility by somehow obscuring detail and lowering contrast of background objects compared to those in the foreground. Figure 5.104 shows how I achieve this effect with the History Brush.

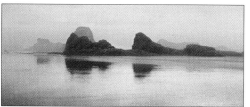

Figure 5.104 I use the History Brush to paint a curves contrast reduction over the distant sea stacks. By decreasing their contrast, and in turn visibility, I create a more three-dimensional feel to the image.

Selection Versus Alpha Channel Versus Layer Mask

Photoshop offers an astonishing number of ways to isolate areas of an image, from manually defining the area with a marquee tool to automatically choosing pixels of similar tonalities. Once an area is chosen, the range of options you have for working with it depends largely on whether you have created a selection, alpha channel, or layer mask.

A selection is a temporary isolation of pixels. After you deselect the marching ants or close the image file, it's gone forever. An alpha channel is simply a saved selection. It is saved into the Channels palette and is available until it is explicitly deleted from the image file. An alpha channel can even be copied to other documents of identical pixel dimensions. A layer mask is similar in appearance to an alpha channel, but is linked, in the Layers palette, with a specific image or adjustment layer. The benefit of a layer mask is that once created, any further editing of the mask automatically updates the pixel selection of the layer to which it is attached.

These differences revolve mainly around how the isolated area is to be used. Photoshop does its best to help you work efficiently in this regard. If you create a selection and then go to Layer>New Adjustment Layer, Photoshop will automatically attach a layer mask derived from this selection. By default, any edits you make in this new adjustment layer will be restricted to the pixels contained within your original selection or channel.

If you believe in photography as "writing with light," then it is not enough to do something in Photoshop just because it is possible. Human visual perception is very sensitive to unnatural behavior of light. By taking into account the location, type, and intensity of the light source in an image, you can draw a viewer into the work without calling undue attention to your editing technique.

Layer Masks

The layer mask is a popular option when you need to restrict contrast adjustments to specific areas of an image. The mask itself is a grayscale image and can contain any gradation from white to black. Predicting the effect of a layer mask is much simpler if you remember the following: White reveals and black conceals the item to which a mask is attached. In other words, areas of white in a mask allow the attached item to be visible. Areas of black in a mask make the attached item invisible. A layer mask can be attached to an adjustment or to an image, as shown in Figure 5.105.

Figure 5.105 At left, a layer mask is attached to a Curves adjustment. Because the mask is completely white, the adjustment is applied globally to the Background layer. At right, a layer mask is attached directly to an image layer. Where the mask is black, the Layer 1 image will be hidden, allowing the Background layer to be visible.

A layer mask is not limited to just white or black. Shades of gray can be used to control the strength of a mask's hiding or revealing capabilities. A light gray mask color will only slightly hide, while a dark gray color will more severely hide the attached item. A common use of grays in a mask is to seamlessly blend localized edits, avoiding unnatural and abrupt transitions that scream, "I've been Photoshop'd." In Figures 5.106 and 5.107, the goal is to use a Curves adjustment to darken only the right half of the image.

Figure 5.106 The Curves adjustment layer reveals the edit only on the right half of the image, but there is an abrupt shift in contrast where the black and white areas of the mask meet.

Figure 5.107 Applying a gradient to the layer mask smoothes the transition from black to white by using intermediate shades of gray. The result is a seamless edit.

You can paint blacks, whites, and grays into an existing mask using the Brush tool. Switching between tones is easy.

1. Press the D key to set the Tool palette's foreground and background colors to their defaults.

2. Press the X key to toggle between painting with black or white.

3. Adjust your brush opacity in the options bar to paint with a shade of gray.

Photoshop makes it very simple to convert a selection into a mask for localized editing. If you're working with a flattened image, first unlock the background layer by double-clicking its icon. Make a selection, and then go to Layer>Layer Mask>Reveal Selection. Alternatively, you can simply click the Add Layer Mask icon in the Layers palette. Photoshop will create a mask in which areas within your original selection are white, while the remaining pixels are protected with black.

In some images, however, you'll find it is easier to select the areas you do *not* want to edit. Photoshop can handle that just as easily. With your selection active, go to Layer>Layer Mask>Hide Selection. You can also simply Option-click the Add Layer Mask icon. With either method, the mask will show the selected area is black, while everything else is white.

As I mentioned, a mask can be refined continuously, and the changes will be reflected immediately in the underlying image. Often, you can start with a rough mask in order to judge the appropriateness of a localized adjustment. Once you are satisfied with the contrast change, you can go about softening the edges of the mask for a seamless blend with the unaltered pixels. This is a good opportunity to use the Gaussian Blur filter, as seen in Figures 5.l08 and 5.109. This filter works by taking high contrast edges and reducing their contrast. By bringing the white and black pixels closer together in tonality, the edge becomes gradation that allows for smooth transitions along the edges of the mask.

Figure 5.109 An aggressive to the Radius value creates an area of transition from white to black along the mask's edges. This allows for a more seamless blend between masked and nonmasked pixels.

Layer masks have less obvious uses in Photoshop. Figures 5.110 and 5.111 show how an empty adjustment layer can be used to boost density in an image quickly and efficiently. Empty layer masks add no overhead to file size, so this density boost retains the flexibility of duplicate image layers without increasing file size.

Figure 5.108 While this mask has the desired shape, the hard edges of high contrast will leave a masking line around any edits I apply. The default Radius of 0.1 in the Gaussian Blur dialog essentially leaves the mask edges untouched.

Figure 5.110 An adjustment layer is added to the image. No actual edit will be applied to the layer, so almost any type of adjustment layer will do. Here, I chose to add a Curves layer.

Figure 5.111
Simply changing the blending mode of the adjustment layer to Multiply blends the image with itself. The result is an image with greater density. I reduced opacity to 60 percent to limit the strength of the blend.

History Brush

One of the most effective yet overlooked tools for applying selective edits is the History Brush. When used in conjunction with the History palette, it presents one of the most precise yet quickest methods of seamlessly restricting contrast adjustments to specific locations of an image. Earlier in this chapter, you saw how the Curves tool can limit adjustments to certain tonal regions. But what happens when you want to isolate pixels of a given luminance *and* image location? You may want to open up the shadows beneath a subject's eyes while ignoring pixels of identical value underneath her chin, for example.

Many users would instinctively go about creating a mask. This is a valid approach, as you saw in the previous section. But even the simplest of masks requires three separate steps. You first make a selection, save it as an alpha channel or layer mask, and then apply the edit. The History Brush offers a much more intuitive and seamless edit with much less work.

A Quick History Blend Method

Here's a quick way to blend an image with itself using the History Brush.

1. Open an image.
 By default, Photoshop sets the source for the History Brush to a snapshot it creates as soon as the image is opened.

2. With the History Brush selected, choose a blending mode from the options bar.

3. Paint on the image.
 Photoshop calculates the result using the snapshot as the blend color and the current history state as the source color. And since no edits have been made yet, they are identical. You are blending the image with itself. Note that when blending pixels with identical values, neither the Darken nor Lighten mode will produce a change.

As noted earlier, every change during an editing session is recorded in the History palette. And at any time, you can create a snapshot of the file's current state. The History Brush allows you to paint to or from any state or snapshot in the History palette with a couple of exceptions (see the sidebar below). We'll see the History Brush in action in the following section.

When History Doesn't Work

Both the History source and History destination state must have an identical bit depth, color mode, and pixel dimensions. Alter either one of these, and the History Brush will be inactive. So it's best to perform crops and mode conversions before or after, but not during crucial editing steps.

The beauty of the History Brush is that you do not need to make a selection. You simply paint over the areas you want to adjust. You can vary the brush's size and opacity and even set its blending mode. The default History Brush has a nice feathered edge, which enables a seamless blend into nonbrushed areas, even when examined at Actual Pixels view. This saves you the extra step of blurring or feathering a selection that is necessary after creating a mask.

There is one significant downside, however. Because History states and snapshots are lost as soon as the file is closed, this work must be done in a single session. But I think you'll find that in a number of instances, this limitation is offset by the speed and ease of use of this technique. Virtually endless possibilities for localized adjustments are your reward for experimenting with this often-overlooked tool.

Localized Edits in Action

Photoshop offers a dizzying array of options for making selections that allow for seamless edits. In the examples that follow, I will demonstrate four particularly useful tools.

Example #1: The History Brush can be used to selectively paint in a previously made edit that blends smoothly with surrounding pixels, as shown in Figures 5.112 to 5.115.

Example #2: The Threshold command, available in the Image>Adjustments menu, can quickly convert pixels to black and white, as shown in Figures 5.116 and 5.117.

Now that our basic selection has been made, just a quick bit of fine-tuning is needed, as shown in Figure 5.118.

Figure 5.112 The lack of contrast around the subject's open collar diverts too much attention away from his intense gaze.

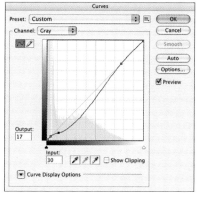 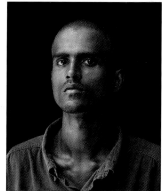

Figure 5.113 A Curves adjustment that holds the highlights while pulling down midtones and shadows fixes the problem area. But other parts of the image are now too contrasty.

Figure 5.114 I saved two snapshots in the History palette. One was saved before the curve was applied—named "precurve"—the other directly after. Selecting the History Brush, I set the image state to the *precure* snapshot and the History source to the *curve* snapshot.

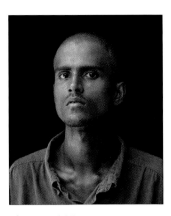

Figure 5.115 By simply painting over the neck with the History Brush and varying its opacity, I have limited the Curves edit to the desired areas of the image.

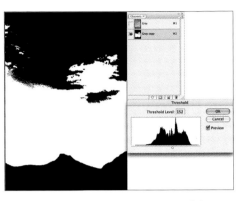

Figure 5.117 Before invoking Threshold, we must create a copy of the channel on which to apply the command (left). In the Channels palette, select Duplicate channel. At right, a Threshold level of 152 automatically separates the mountain range from the sky and clouds.

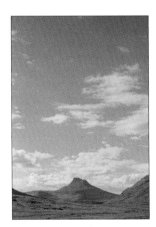

Figure 5.116 To mimic the effect of shooting with a red filter, this image will need a more aggressive contrast adjustment in the sky than in the rest of the image.

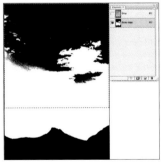

Figure 5.118 The sky area that remains in black is easily removed by drawing a marquee (left) and going to Edit>Fill to replace it with white (center). After loading this channel as a selection, a view in Quick Mask mode (right) shows that the sky is selected, while the mountain is protected.

It is now very easy to apply localized adjustments with the Curves tool, as shown in Figures 5.119 to 5.121.

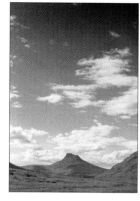

Figure 5.119 A fairly strong Curves adjustment adds contrast to the sky and clouds.

Figure 5.120 We must now edit the mountain range. But since I already have a mask separating it from the sky, I can simply choose Select>Inverse so that the mountains are selected and the sky is protected.

Figure 5.121 A Curves adjustment that brings down midtones and shadow in the mountain range provides a balance in contrast with the sky.

Example #3: The Load Channel as Selection button on the Channels palette is, in truth, a luminosity selection tool. It selects pixels based on their brightness. A pure black pixel is completely masked. A pure white pixel is completely selected. What about the pixels that fall in between? As a pixel increases in brightness, it is selected with greater opacity values. A pixel at 240 may be selected akin to painting in Quick Mask mode at 90 percent. On the other hand, a pixel with a value of 50 may be selected akin to painting in Quick Mask mode at only 20 percent. This leads to very complex and nuanced selections that are virtually impossible to create by hand. A luminosity-based selection is helpful for adjusting contrast, while protecting either highlights or shadows, as Figures 5.122–5.126 illustrate.

Example #4: Last, but certainly not least, is the brand new Quick Selection tool, introduced in Photoshop CS3. The tool is very intuitive. You simply paint over an area to select it. A number of adjustment parameters are made available through the Refine Edge dialog box, after your initial selection is made. In Figures 5.124 to 5.126, you can see this tool in action.

Figure 5.122 Clicking the Load Channel as Selection icon creates a nuanced selection that gives preference to pixel values above 128.

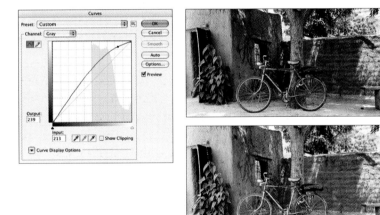

Figure 5.123 A Curves adjustment (left) that brightens highlights is prevented by the luminosity selection in 5.122 from opening up the shadows. Compare the results of the same curve applied to the image with the selection active (top right) and applied globally (bottom right).

Figure 5.124 Painting just a couple of strokes inside the vase with the Quick Selection tool gives a selection of the entire object (right).

Figure 5.125 Clicking the Refine Edge button brings up a dialog where you can fine-tune the selection and preview it against a white or black background to check edge transitions.

Figure 5.126 Converting the image to RGB mode, I can colorize the vase using the Hue/Saturation tool.

Color to Black and White

The desire to convert a color slide or a negative into a black-and-white digital image was, for many years, limited to a relatively small segment of photographers. You could achieve terrific results in Photoshop through a number of implicit techniques. Photographers had their favorite techniques, and debates often centered on the best method of conversion. But the need to convert a color image to grayscale has exploded in recent years with the popularity of high quality and affordable DSLRs. Any photographer shooting in raw mode is faced with an RGB image. There is, to the chagrin of some, no commercially available black-and-white digital camera. A clear signal of the emerging need for conversions can be found with the introduction of a brand new tool in CS3. Black and White is Photoshop's first tool aimed solely at converting a color image to monochrome.

Converting color images to black and white, or more precisely grayscale, offers some exciting possibilities, whether the image originated digitally or on film. The ability to enhance or minimize tonal differences directly from RGB data gives us a level of contrast control that is simply not possible with panchromatic black-and-white film. Photoshop gives you a virtual tool bag of filters with which to adjust contrast for a satisfying grayscale image.

When working with an RGB image, you find a Channels palette with four items: a composite channel, followed by one for each of the additive primaries. Clicking any of the primaries will turn your color image into grayscale, using only the densities represented by that specific channel. Pretend the monitor is your camera, and the image file is an actual scene. Clicking the red channel is akin to placing a red filter over the lens when shooting black-and-white film. And we all remember just what it is a red filter does… right? A red filter lightens its own color but darkens its complementary color. Shoot a red flower against a light blue sky with this filter, and the flower gets light and the sky gets dark.

Clicking the green channel lightens greens and darkens reds. The blue channel lightens blues and darkens yellows. If one of these "filters" grabs your fancy, just highlight your favored channel and convert the image to grayscale mode. The data from the remaining two channels is now tossed aside. Note that you can create your own custom blend by using Photoshop's Channel Mixer, which I will discuss shortly.

Black and White

The new Black and White command in CS3 is, by itself, a compelling reason to upgrade if you regularly convert color images to black and white. It sports an intuitive interface, offers a great deal of tonal control, and gives you the option of saving and loading custom settings. It's available via Image>Adjustments>Black and White, or as an adjustment layer in Layer>New Adjustment Layer>Black and White.

The flexibility and control stem from the fact that you can control the luminance of six separate hues—the additive and subtractive primaries RGBCMY. A black-to-white slider and percentage box are associated with each hue. Moving a slider toward the right brightens the values of its associated color. Moving the slider to the left performs the opposite function. The brand new algorithms for these sliders do not require that you stick to combinations totaling 100 percent in order to prevent clipping. You have quite a bit of latitude here. In fact, the slider range for each hue runs from negative 200 to positive 300 percent for highlights.

Perhaps the most unique feature of this new tool is the ability to quickly identify the dominant hue at any given image location. Once the dialog is invoked, the cursor turns into an eyedropper icon. Click anywhere in the image, and the appropriate hue is automatically highlighted and ready to be adjusted, as seen in Figure 5.127. Black and White comes with some useful built-in presets (see Figures 5.128 to 5.130), but the ease of use of the eyedropper and

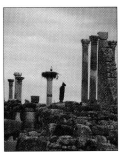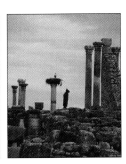

Figure 5.128 The original RGB image (left) is followed by the default conversion setting (center), which leads to the converted image (right).

Figure 5.127 Click once on an image area, and the dominant hue at the pixel location is automatically highlighted in the dialog. You can alter values either by dragging the sliders or by using the Up and Down arrow keys.

Figure 5.129 The Infrared preset.

Figure 5.130 The High Contrast Blue Filter preset.

sliders practically begs for you to experiment. Figure 5.131 shows a custom setting that was created very quickly and easily.

Figure 5.131 For this custom setting, I brought down red (bird's nest) and blue (sky), while increasing the luminance of yellow (columns) and green (foliage).

Channel Mixer

Channel Mixer has long been a popular method of color to monochrome conversion due to its obvious analogy to contrast filters developed for black-and-white film. You always start with an RGB image, as I have in Figure 5.132. As the name "Channel Mixer" would suggest, you mix the RGB channels in varying percentages to achieve a pleasing contrast. For best results, it has long been cautioned that the sum of the channels remain at or near 100 percent. In CS3, the Channel Mixer dialog includes a Total field, which keeps track of your combined channel percentages. Be aware that you can always go in a negative direction on any of the channels. You also have a Constant slider (see Figure 5.133).

This helpful addition performs a composite luminance adjustment on all three channels. If you've got your contrast mix of channels just right, but the image is a little too dark or too bright, altering the Constant value will adjust all three channels in brightness by the same amount.

Figure 5.132 The original RGB image in full color.

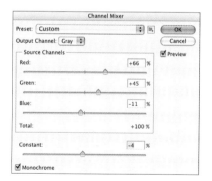

Figure 5.133 For this custom setting, I mixed the red and green channels and set the blue channel to a negative value. I darkened the image slightly by reducing the Constant value.

Calculations

The Calculations method of color to black-and-white conversion is by far the least intuitive of the bunch. The dialog is decidedly spartan with no color patches, sliders, or presets. And Calculations allows a maximum of just two channels to perform the conversion. But what it does offer is significant—the ability to combine channels using both a blending mode and opacity value. Going to Image>Calculations brings up the dialog window. Figure 5.134 shows its myriad options.

In the examples that follow, I am using a single RGB image for both Source 1 and Source 2. The image has no additional layers, so I will use Background in both options. I can choose from a long list of blending modes.

Figure 5.134 You can designate any open image or images with matching pixel dimensions as Source 1 or Source 2. The option to save the result as a new document can eliminate the need for a Save As step when you want to maintain both a color and grayscale version of the image.

The first big decision in Calculations is which two channels to specify for the conversion. This will vary according to image content and your vision of the monochrome image. So it pays to scan the individual channels for a moment before opening Calculations. Remember, you can also choose to blend a channel with itself. In fact, the default setting for the Calculations dialog is to select the Red channel of a single image for both sources. Let's explore some of this tool's options by converting two images.

1. Select an RGB image (see Figure 5.135).

2. Blend any two channels using any of the available blending modes (see Figure 5.136).

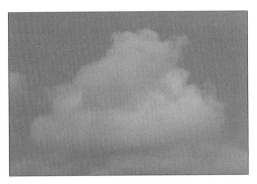

Figure 5.135 The original RGB image in full color.

Figure 5.136 The color image is relatively bright and of low contrast, so I have chosen to blend the Red and Blue channels using Color Burn. This darkens the image considerably and adds contrast.

1. Select an RGB image (see Figure 5.137).

2. Blend any two channels using any of the available blending modes (see Figure 5.138).

Figure 5.137 The original RGB image in full color.

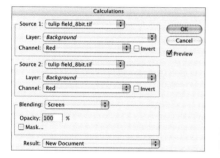

Figure 5.138 The color image is a bit dark, but with good contrast. The Red channel is brightest, so I have selected that channel in both Source 1 and Source 2. Setting the mode to Screen makes the tulips really pop.

There are a nearly infinite variety of choices available in Calculations. You can invert the channels before blending them and even create a mask based on any channel in any open document with matching pixel dimensions. It can be overwhelming, but after our exhaustive look at the Blending modes earlier in this chapter, you should be able to get in the ballpark quickly by narrowing your choices to a darkening, lightening, or contrast group. See, I wouldn't have put you through all of that for nothing.

Sharpening

The sharpening of pixels remains, if not the least understood, certainly the most often abused aspect of digital imaging. People either apply too much, which introduces artifacts that detract from the content of the image, or they undersharpen, hiding subtle and intricate details from the viewer. When, why, and how to sharpen an image are questions that need to be addressed. The answers will not only be image dependent, but also change according to the intended output of an image.

In short, you could write a whole book just on sharpening. Fortunately, no less an authority on imaging than the late Bruce Fraser did just that. *Image Sharpening with Adobe Photoshop CS2* is the definitive guide to understanding and applying appropriate sharpening. So rather than duplicate his efforts here, I will present a brief and general overview of the role sharpening must play in a fine art workflow.

The first step toward successful sharpening is an understanding of what sharpening does to the pixels in an image. Unlike a camera, enlarger, or scanning lens, no piece of software can optically focus an image. What Photoshop can do, very convincingly, is create apparent sharpness by increasing contrast among neighboring pixels. Wherever our eyes find strong contrast between adjacent pixels, we perceive an edge. Instances of strong edge contrast give us the visual sensation of a sharp, in-focus object.

It sounds simple enough, but here are just some of the issues with which edge sharpening must contend. As you increase contrast in an image, some undesirable things happen. Image detail gets lost, anomalies such as grain or noise are accentuated, and, as darker pixels head toward black and the lighter ones toward white, telltale halos surround these edges.

There's another issue. As anyone who has spent time sharpening can attest, different images have different sharpening needs. A head shot with lots of skin texture requires a different degree and type of sharpening than a detailed image of pine trees. Even within a single image, a cloudless sky in the background must be treated differently from a craggy boulder in the foreground. It stands to reason that sharpening should be applied selectively with regard for image content.

While the need for sharpening can indeed be minimized through superior optics in the capture stage, the sad truth is that any digital input device loses some sharpness compared to the original. This is inherent to the process of converting photons to pixels. So while a drum scan of a 4×5 negative shot on a sturdy tripod will look much sharper than a snapshot print scanned on a cheap flatbed, sharpening to compensate for image capture remains a necessity. And even the most expensive DSLRs produce noticeably soft images due to the demosaicing process necessary to produce a color image from raw data.

It gets worse. All output devices, from inkjets to printing presses, soften images as pixels are converted to dots on paper. Each type of output device differs in the severity of softening, and even within a single device, the type of media used can have a significant effect, as can the resolution of the image.

Whether or not you read Bruce Fraser's book, you can benefit from his conclusion that effective image sharpening must be a multistep procedure. You must first retain the sharpness of the original image by identifying the sharpening needs of the image content and applying the appropriate type of edge contrast. You must then compensate for the inevitable softening effect of the intended output device, at a given image resolution.

Are you depressed yet? Well, here comes the good news. The sharpening process, at its core, revolves around quantitative rather than random, aesthetic decisions. As long as fine-tuning control is offered

after an initial setting, a good deal of the grunt work can be automated. How? Through the use of a plug-in developed by PixelGenius, based on the work of Bruce Fraser.

Over the years, I've found few third-party plug-ins applicable to fine art workflows. But with a solid understanding of sharpening comes an appreciation of PhotoKit Sharpener, which addresses capture and output sharpening in an automated and nondestructive workflow. The plug-in works on 16-bit images. The only wrench in the works is that the plug-in requires RGB data. If you're scanning black-and-white negatives, you'll have to convert them temporarily to RGB to run the sharpening routines. But for those guilty of oversharpening or producing prints that are as sharp as they could be, it's an investment with immediate and lasting rewards.

Unsharp Mask: Always in Style

Because sharpening is a contrast adjustment, there are a number of techniques possible within Photoshop, including the relatively recent arrival, Smart Sharpen. But it would be a mistake to overlook the old standby, Unsharp Mask filter. With three adjustable options, this is a very flexible and powerful tool that can make a substantial improvement over an image that has no sharpening applied (see Figure 5.139). The Amount slider determines the overall strength of the filter to be applied. Radius shows the width of the contrast boost, or how far beyond the found "edge," the filter will apply the change. A Threshold value indicates how great or small the contrast of adjacent pixels must be to trigger an adjustment. In Figure 5.140, a contrast increase of 275% is applied 2 pixels outward from every neighboring pixel. Figure 5.141 shows that a contrast increase of 140% is applied .7 pixels outward, from only adjoining pixels with a contrast difference of 5 levels or greater. The latter result is a much gentler and smoother sharpening effect.

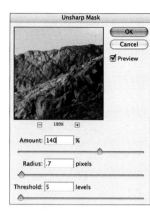

Figure 5.139 The original image and a magnified crop (inset), as they appear without sharpening.

Figure 5.141 Sharpening values of Amount: 140, Radius: .7, and Threshold: 5 produce a much gentler and more localized contrast increase.

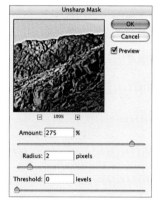

Figure 5.140 Sharpening values of Amount: 275, Radius: 2, and Threshold: 0 yield an oversharpened file with obvious halos along edges of contrast.

Soft Proofing

Photoshop offers the ability, under ideal conditions, to view an image on-screen with a remarkable fidelity to the way it will appear in print. I must stress *ideal conditions*. This seemingly straightforward task actually requires a lot of elements to work in combination in order to pull this off. The fact that a majority of users rarely achieve satisfying screen-to-print matches speaks to the number of issues involved.

The first order of business is to have a well-calibrated monitor, along with an accurate profile describing its behavior. Just as important is to have a well-calibrated printer, along with a profile valid for the exact conditions under which you will be printing. Photographers serious about digital imaging usually meet these two requirements fairly easily.

The final step—and where the wheels fall off for many—is to create a print-viewing environment that is consistent and conforms to

the color standards that your monitor and printer profile have been designed to simulate. Take a moment to view a single print in different lighting environments. How does it appear in open shade? How does it look in the warm incandescent light of your bathroom? And, most importantly, how does it appear in the room in which you compare your image on-screen to the one that came out of the printer?

It should become apparent that the appearance of even a monochrome print varies with the brightness and color temperature of its viewing environment. So before you can even begin to hope that a soft proof will provide a match between screen and print, you must define a consistent viewing environment. I covered these options is some detail back in Chapter 2, so I'll just repeat the point that at least one area in your studio be outfitted with a color corrected light source.

Once this is accomplished, you can leverage Photoshop's effective implementation of soft proofing to predict with a reasonably high degree of accuracy the tone and contrast of an image on a specific printer/paper/ink combination.

You may very well be wondering whether this attention to ambient light makes sense for images that ultimately end up in others' possession. These prints will be displayed in a wide range of lighting conditions, few of which are likely to be optimal. In a perfect world, you would educate buyers of your work about the proper display of your prints, and they would make the necessary adjustments to their display area. We all know this is rarely possible. However, you benefit greatly from establishing a baseline for the conditions under which you determine whether a print conveys the aesthetic content you intended. When you view your prints in consistent and color-balanced lighting conditions, you eliminate one of the biggest obstacles to consistent output. And the less time you spend figuring out why an image doesn't look the way you expected it to, the more time you can spend honing your vision.

In the next chapter, we will look at the technology, tools, and media available for actually putting these images onto paper.

6

Black-and-White Inkjet Printing

A longstanding knock against digital printing is that it is somehow cheating when compared to traditional darkroom methods. You don't get your hands in the soup, so to speak. In fact, all you have to do is press the Print button. At least that's how the argument goes.

Now, I won't deny the great convenience of sitting in a light-filled room checking your e-mail while your images are advancing line by line out of the printer. But I'd like to point out that you've had to read more than halfway through this book to arrive at the chapter devoted to actual printing. Placing ink on the paper is just one step in a very involved workflow. There is a significant amount of preparation required in the digital darkroom to arrive at the printing phase. Yes, clicking the Print button is simple. Getting to the stage where that click will produce a great result, however, is not.

Even with a carefully edited image that looks pleasing on the monitor, you have a number of decisions ahead of you in order to produce a print that fulfills the technical and aesthetic potential of the image pixels. The selection of a printer/ink/paper/driver combination tailored closely to your needs is often what separates a merely adequate print from a great one. There are a number of recent printer technologies to consider and a wide selection of media from which to choose. The ability to tint monochrome images introduces

another set of choices to be made, such as whether to perform the adjustment in Photoshop or in the printer driver. And once you actually achieve great print results, you want to maintain consistent output from print to print.

Don't get me wrong. We've never had it so good. But with choices, come decisions. And the hardware and consumables necessary for fine art printing represent a considerable investment when your aim is to keep your printing needs in-house. So it's important to understand the strengths and weaknesses of the available options. In this chapter, we'll look at ways to judge features with your specific printing needs in mind. We'll discuss recent advances in printing technology, as well as the importance of paper selection. I'll offer some basic preventative maintenance and explore some of the noteworthy features of OEM printer drivers and third-party RIP software. We'll end the chapter with a consideration of the element of craft that each of you, as printmakers, can imbue into your own work.

Matching Features to Needs

As a photographer, your number one interest in a printer is undoubtedly the quality of its output. Indeed, in the early years of inkjet printing, each new generation of hardware heralded a major

advance in image stability, color gamut, output resolution, or print speed. New models easily outperformed older ones, and the industry thrived on a rapid pace of advancements. This unrelenting upgrade cycle was hard on our wallets, but it allowed digital printing to grow into the billion-dollar industry that it is today.

Today, however, it is evolutionary rather than revolutionary upgrades that are the norm, at least with regard to photographic fidelity. It's much more difficult to choose between competing models using image quality as your sole criteria. You can make stunning prints with any of them. The most distinguishing attributes among offerings from Canon, Epson, and HP revolve around features, usability, and workflow rather than print resolution. Having a number of equally good options with which to express your photographic vision is a sure sign that digital printing is a mature technology.

The hard part, though, is that there is no *right* printer for everyone. This chapter will not conclude by telling you which printer to buy. Your individual needs, tastes, and working methods play a large role in determining the most appropriate printer/driver/paper/ink combination. What you will come away with, however, is the ability to prioritize your needs and match them with relevant features available from Canon, Epson, and HP's pigment-based photographic printers. In order to choose wisely among printer-related hardware, software, and media, you must take into account the type of images you print, how often you print, and whether or not you will be offering your printing services to other photographers.

Color Versus Monochrome Inks

There is probably no consideration more significant to black-and-white photographers than the choice of ink set to use for creating black-and-white prints. As recently as a couple of years ago, a chapter devoted to printing options for fine art monochrome prints

would have been very short. It would have invariably included the advice, "Buy an Epson and load it with a third-party monochrome ink set." That is still a viable option today, and one that I include in my own printmaking studio. But for the first time in the short history of digital printmaking, there are real alternatives that can be tailored more precisely to individual aesthetic and practical needs.

Back in Chapter 3, we examined some of the hurdles involved with creating monochrome prints with color ink sets. Color casts, metameric shifts under various light sources, and reduced longevity have long been the most common obstacles to darkroom quality prints. These are the very issues that gave rise to third-party monochrome ink sets. The best of these monochrome inks provide unsurpassed tonal gradation and intricate image detail, along with greater image stability. The Piezography K7 ink set, shown in Figure 6.1, uses seven shades of black for extremely smooth gradations of tone from the deepest shadows to paper white.

The ability to provide visually superior and longer-lasting black-and-white prints when compared to OEM inks is the driving force

Figure 6.1 The Piezography K7 ink set prints monochrome images using seven separate shades of black and is available in both cartridges (left) and bottles for users with continuous ink delivery systems. *Images courtesy of Inkjet Mall.com*

behind monochrome ink development. But in order to take advantage of this higher degree of print fidelity, you'll want to dedicate a printer exclusively to black-and-white output. Switching back and forth between OEM and third-party ink sets is a time-consuming and costly endeavor with wide format printers. Special flushing cartridges are necessary because long ink lines and reservoir tanks must be purged during the ink changeover. On smaller desktop printers, you can swap cartridges with minimal waste, but you still risk "gunking" up the works if the OEM and third-party ink sets create a viscous mess when they come into contact.

Setting up a printer for use with third-party monochrome ink sets involves a number of steps. With a brand new printer, you'll want to verify first that it is working properly with the OEM inks installed. This eliminates a key variable—the ink set—should troubleshooting become necessary.

To print with these inks, you'll generally need to acquire either additional print and profiling software or specialized printer profiles from the ink vendor. At the very least, you must adjust your workflow to compensate for the fact that you have installed inks with vastly different characteristics than those that shipped with the printer.

Quality Ink Alternatives

If you've only ever used the inks that came with your printer, you may associate the term *third-party ink* exclusively with the cheap knockoffs you find on sale at office supply stores. These are to be avoided at all costs because any savings at the register will be negated by poor, inconsistent print quality and reduced print longevity. In this chapter, I am referring not to these inferior inks, but to specialized monochrome ink sets that undergo rigorous quality and compatibility checks.

Because the monochrome ink sets tend to carry a heavier pigment load, many of them are suitable only for printing on matte papers. See the sidebar "Matte Black and Photo Black: What's the Deal?" for a longer discussion of this topic. Users of third-party monochrome ink sets who also have color or glossy needs generally end up with at least two printers. One is for black-and-white matte prints, the other for color and glossy output. If the expense and maintenance of a two-printer setup is not feasible, the OEM ink sets found in current pigment-based inkjet models may be an attractive alternative.

Ink Channels

Once upon a time—think 1999—inkjet printers were four-color devices. They came loaded with cyan, magenta, yellow, and black. When Epson introduced its line of Stylus Photo printers, designed expressly for photographic quality output, it added light cyan and light magenta to the mix. These six-color printers represented a major advance at the time. But less than a decade later, we now have models with up to 12 ink channels. Fortunately for black-and-white photographers, at least some of these additional channels have been devoted to monochrome inks.

Epson's UltraChrome K3 ink set (see Figure 6.2) includes a three level black ink formulation that greatly reduces color shifts, improves tonal transitions, and increases longevity of black-and-white prints compared to their earlier inks. Canon's 12-ink LUCIA pigment formulation also includes three dilutions of black. HP takes the lead in this regard, as the first printer manufacturer to offer a quad black ink solution. When printing on matte papers, the Designjet Z3100 printers use matte black, photo black, gray, and light gray simultaneously for nontinted black-and-white images.

I'll talk in more detail about the benefits of a multiple black ink set later in this chapter. The point here is simply that the expansion of ink slots to include more than a single black ink channel is a crucial development for black-and-white photographers. Today's OEM printer/ink/driver combinations produce monochrome output that stands head and shoulders above previous out of the box solutions.

Figure 6.2 Epson's UltraChrome K3 pigment-based ink set can be found in models ranging in size from 13 inches to 44 inches wide. *Image courtesy of Epson America*

Tints and Split Tones

For years, printer companies have heard photographers demand the ability to produce a neutral monochrome print. Technical hurdles aside, a dilemma for the R&D departments at these companies is that everyone has a different idea of how a neutral tone should look. The hue of a print is a very subjective choice. Photographers with experience in the traditional darkroom tend to favor a tone close to what they produced with wet chemistry. Of course, this can include a wide range of possibilities. One photographer may have preferred images slightly warm, while you may like them a bit cool. And still others want the ability to vary the hue on the fly, based on the

image content. In this section, we'll take a look at some of the available options.

Tinting with Monochrome Inks

Some monochrome formulations, like those from MIS Associates, set aside ink channels exclusively for toning a print either warmer or cooler. Others are designed to move between a warmer and cooler tone, based solely on the paper used for printing.

In addition to varying the hue of the image on a global basis, there are now increasingly popular options that allow you to apply a combination of hues within a single image, each restricted by tonal region. These split tones can provide cool highlights and warm shadows, for example. The Piezography K7 inks offer different ink tones in six of their seven shades that you can mix and match at will. You create a split tone by installing your preferred hue in the appropriate ink slot of your printer, as shown in Figure 6.3. The ink set contains seven shades of black. Each shade, except for the darkest black, is available in different hues. You can simply mix and match your preferred hues among the remaining six shades. All seven inks will be used simultaneously when you print.

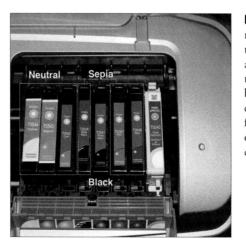

Figure 6.3 In this printer, neutral inks are installed in the three lightest shades, and sepia inks make up the three darker ones. The black ink is not toned. The eighth slot is filled with a flushing solution that is only used for nozzle checks.

Roy Harrington's Quad Tone RIP is a third-party printer driver that can be configured to print utilizing toner inks in combination with a four-dilution ink setup. With the inks, Paul Roark has designed for MIS Associates, you can dial in a warm, cool, or split-toned print, in which there are separate hues for highlights and shadows, by controlling the amount and placement of the toner inks.

Tinting with OEM Inks

If you opt to use a single printer and ink set for both your monochrome and color work, you gain the ability to tint your images over a much wider range of hues. You've got a full CMY-based ink set loaded right alongside the multiple black dilutions. You can leverage the wider palette of an 8- or 12-ink color setup for a consistent tint across the entire image or choose a split-toned approach in which highlights, shadows, and even midtones receive a unique hue. What's more, current OEM printer drivers provide the option to apply tints, and, in some cases, split tones to grayscale image data so you don't even have to convert the image to RGB. See Figure 6.4 for some examples. For more precise control, you can edit the image in RGB mode and use the Curves tool to apply the tints to specific tonal regions, as shown in Figure 6.5.

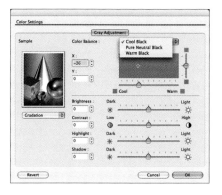

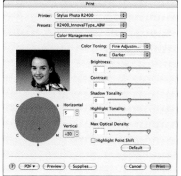

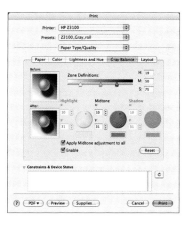

Figure 6.4 Today's printers allow you to tint grayscale images directly from the printer driver. From left to right are the tinting functions in drivers from Canon, Epson, and HP.

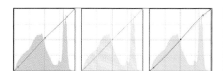

Figure 6.5 With the image in RGB mode, I can make a separate Curves adjustment to the red, green, and blue channels (left). This localized tint, or split toning, allows me to convert a monochrome image (center) into one that is cool in the highlights but warm in the midtones and shadows (right).

Tinting with PrintFIX PRO

The latest version of PrintFIX PRO offers a unique and fully color-managed approach to tinting and split toning grayscale images. As I discussed back in Chapter 3, PrintFIX PRO is a hardware and software package that provides a user-friendly interface for creating ICC profiles. A hand-held spectrocolorimeter, shown in Figure 6.6, is provided so that you can measure a printed target and thus characterize your printer's behavior.

Figure 6.6
Colorvision bundles its PrintFIX PRO software with a hand-held spectro-colorimeter to measure profiling targets. *Image courtesy of Datacolor*

The profiling software is designed exclusively for use with RGB printer drivers and color ink sets that contain multiple dilutions of black. Of most interest for black-and-white photographers is the inclusion of an Extended Grays profiling target. It contains a series of gray and near gray color patches. Its purpose is to more accurately define your printer's ability to produce a neutral grayscale. If the natural color of your printer's black inks is a bit warm, a profile generated with the Extended Grays measurement information will add the color pigments needed to neutralize the inherent tone of the monochrome inks. In short, you can create a black-and-white print that is much closer to an objectively neutral and consistent hue throughout the entire tonal range.

Taking this process a step further, PrintFIX PRO allows you to specify a particular tint at the time you are creating the profile, as shown in Figure 6.7. Because the profiler knows how much color to add for a neutral print, it can calculate the colorant needed for either a warmer or cooler tint. This ability to create tinted profiles for grayscale images is unique for a product in this price range.

Figure 6.7 PrintFIX PRO allows you to create tints that are placed directly in the ICC profiles for a consistent toning effect on any image with which the profile is tagged. Here, I have shifted from a neutral tone to a warmer one by adding cyan and yellow.

What really sets this profiler apart, however, is the ability to embed not just straight tints, but split tones directly into the profile as well. In Figure 6.8, I have made separate tinting parameters for the highlight and shadow regions. The tools provided have a fair amount of control, but correlating slider adjustments with actual print output involves a good bit of trial and error.

Fortunately, there is a more precise and visually perceptible method. PrintFIX PRO allows you to import a saved Photoshop Curves

Figure 6.8 When creating a profile in PrintFIX PRO, you can configure separate tint adjustments for both highlight and shadow regions. The resulting ICC profile will automatically apply this split tone for any image to which it is assigned during printing.

adjustment and bundle the tint directly into the profile. I will demonstrate the procedure in the following steps.

1. In Photoshop, convert the grayscale image to RGB mode.

2. Create a curve that adds color to the image (see Figure 6.9).

Figure 6.9 I created a curve that adjusts the red, green, and blue channels individually for a custom split tone.

3. Save the Curves adjustment (see Figure 6.10).

4. Import the Curves adjustment file into PrintFIX PRO (see Figure 6.11).

Figure 6.10 Using the Save Preset command (left), I save the Curves adjustment to Photoshop's default Presets folder (right).

Figure 6.11 The Import Curves File button in PrintFIX PRO's profile setup screen lets me navigate to a saved Curves preset.

5. Build the profile.

6. In Photoshop, go to View>Softproof>Custom and select the newly created profile (see Figure 6.12).

Figure 6.12 After PrintFIX PRO has built the ICC profile, I can open an image in Photoshop and go to View>Proof Setup>Custom to preview the tinting effect of the profile.

The idea behind PrintFIX PRO is that you leave the grayscale image pixels untouched. Any tints or split tones are created on the fly by applying a tinted ICC printer profile in your application's print dialog. This process is color-managed and therefore repeatable. The convenience of varying the tone of a black-and-white image simply through the choice of output profile is hard to underestimate and is a welcome addition to the toolbox.

Older Printers and Third-Party Inks

Should you decide to use third-party monochrome inks, your printer choices are limited to Epson hardware. The company that literally created the market for affordable photo-realistic inkjet printing was, until quite recently, the only game in town. So it makes sense that third-party developers have tailored their inks to Epson printers. Their Micro Piezo print head technology has also proven to be much more adaptable for aftermarket developers, compared to the thermal technology used in Canon and HP inkjet models.

While you may be limited to a single brand of printer, there are plenty of models from which to choose. Epson makes printers ranging from letter size desktop models to 44-inch wide behemoths. And you are not restricted to currently shipping models when looking to dedicate a printer exclusively to black-and-white output. The right ink set can coax stunning black-and-white prints from an older generation Epson printer that rivals or even exceeds the abilities of today's models. The small but dedicated user base of monochrome inks has, over the years, created a healthy market for older model, wide format Epson printers. A properly maintained machine can give many years of stellar service. I know photographers who still print on Stylus Pro 7000 printers, which were introduced back in 2000. Smaller desktop printers are, of course, not built with the same life expectancies, but they are a fraction of the price.

You may already have a spare printer (or two) as a result of upgrades in recent years. Many photographers simply take an older printer out of retirement and outfit it with a monochrome ink set. If you do have to look elsewhere for a used printer, there are obvious perils with secondhand and out-of-warranty equipment. The safest approach is to buy from a local source that will allow you to test the printer before you make the purchase.

Print Volume

The most obvious reason to consider purchasing a wide format printer over a desktop model is so that you can make larger prints of your images. But the size, weight, and maintenance involved with a big printer require a significant investment in money, space, and time. I can just as easily imagine a photographer who prints nothing larger than 11 × 14 but would benefit from a 24-inch printer as I can someone who makes 30 × 40 landscapes but would be better served making proofs on a desktop model and outsourcing for full size prints (see the sidebar, "Choosing a Print Provider"). It all comes down to print volume. Do you print every day or once in a blue moon? Are you constantly ordering more paper, or does a 20-pack of tabloid-sized sheets last you for months? Wide format printers are designed to run on a regular basis. The high-capacity ink cartridges, annual service contracts, and roll capacity all point to a machine optimized for regular production of images.

Printers are much easier to maintain if they are put to regular use. Print heads that sit unused for long periods of time can become clogged. All ink cartridges come with expiration dates, and pigments must be regularly agitated, either through regular printing or manual shaking, in order to remain in suspension. Ink doesn't go bad right after expiration like a carton of milk. But there is no guarantee that a cartridge will deliver optimum results after sitting on your shelf for two years. See "Pigment Settling" for a more involved discussion of this issue. The ink cartridges that come with wide format printers contain many times the ink of those in desktop machines. If you are considering moving up to a 24- or 44-inch model, examine ink and paper usage with your current setup. If it takes you months to run low on even a single cartridge in a desktop printer, there is little chance that you will reap the bulk pricing benefits of the larger capacity, wide format cartridges.

If you do print a high volume of images on a regular basis, however, don't underestimate the value of a wide format printer. You get a better value by purchasing high-capacity ink cartridges and larger paper sizes. On top of those savings, many retailers offer frequent-buyer programs that reward regular purchases with price discounts.

Choosing a Print Provider

When you've made the decision to have someone else produce your inkjet prints, there are a lot of unknowns. Below are some tips to make the process go as smoothly as possible.

1. Ask questions. Most printmakers will be happy to talk about the tools, materials, and processes they use.

2. Understand what services are included in the print price. Some providers will require you to sign off on a proof before the final print is produced. Are proofs included in the print price? Will you pay extra for additional rounds of proofs? Are reprints offered at a discount? If dust spotting and contrast adjustments are necessary, do they incur an additional charge?

3. View prints that the studio has made for other photographers. If this is not practical, ask for references from previous customers.

4. Plan ahead. Print jobs vary in complexity, and certain times of the year are busier than others. If you need a fast turnaround, be prepared to pay a rush fee.

5. Talk to the person who will actually be working on your image(s). In a large commercial outfit, this may be difficult. One benefit of small print shops is the ability to communicate directly with the person performing the scanning, editing, or printing.

Length of Ownership

The purchase of a wide format printer is generally the start of a long-term commitment. Epson, in particular, has long taken the approach of introducing newer technologies in their small format printers before migrating them into their most expensive models. This allows the company to test the marketability and performance of new features. But it also reflects the reality that with such robust and long-lasting wide format hardware, users are less likely to replace a perfectly functioning printer each time a newer model is released.

Wide format printers are engineered to much tighter tolerances and are built for a long life of service. These printers are not easily run into the ground, even under the most constant use. Parts that are prone to wear and tear are designed to be replaced. The size and weight of these printers do not lend themselves to carry-in or return shipping service. In-warranty service is performed at your location by a trained technician.

A desktop printer, by comparison, is built and marketed almost as a disposable product. There are very few serviceable parts, and where warranty service is offered, it is generally limited to the initial one-year period included with the purchase. In almost all cases, companies will simply exchange rather than repair a faulty printer.

Far be it for me to discourage people from plopping down their credit cards for the largest printer they can fit in their studio. But before committing yourself to a 200-pound machine that is delivered on a shipping palette, it pays to examine your printing needs. If you have only the occasional need for large prints—say when putting together a special exhibit or making an infrequent print sale—it may be far more practical to operate and maintain a desktop printer for everyday use and simply outsource your larger prints to a professional print studio.

Roll Versus Sheet Media

One of the advantages of moving beyond the small desktop models is the ability to choose between roll and sheet media. The 17-inch wide printers, in particular, offer the greatest flexibility with regard to paper handling. Sheets can be fed singly through a top-loading slot or stacked in a paper tray to be fed automatically one after the other. In addition, most printers in this size class have a roll holder option that makes it easy to print panoramic shots. Multiple images can be printed in a single job and then cut individually after printing. The popularity of these roll holders has led most of the major paper companies to offer their products in 17-inch rolls. The 24-inch and larger models have always come with the option to print from either sheets or rolls. Take note, however, that in these bigger printers, sheets must be loaded one at a time.

So which is better, sheets or rolls? It depends on a number of factors. The print dimensions of your images are the most obvious consideration. The largest paper size available in a cut sheet is generally 35 × 47. This was the most popular size back in the heyday of IRIS printing, and some paper manufacturers still supply it. But keep in mind that shipping costs have become prohibitive for this size, and safe handling in transit also presents a challenge. If your work exceeds this size in either dimension, then you have no choice but to print with rolls.

Even if your individual image dimensions are relatively small, you should consider how many images you typically need to print at one time. A major benefit of printing on rolls is that you can gang up a number of smaller images arranged across the width of the roll for minimum paper waste. When configured for roll media, the printer can run until the end of the roll is reached. Depending on the paper brand, the length of a roll can be anywhere from 40 to 100 feet. So you can queue up multiple print jobs to print unattended.

On my wide format printers, I will often set up very large images to print after hours so that the printer is not tied up during the day with a single print job. When printing from a roll, you can choose whether or not the printer will automatically cut each print as it is completed or simply spool everything out in one continuous roll, which you can manually cut once all jobs have been printed.

As I noted earlier, only the 17-inch wide printers allow you to load a stack of cut sheets. On the bigger machines, each sheet must be inserted one at a time at the conclusion of each preceding print. Roll printing is therefore a much more efficient affair. If you were to print a large number of small, single images on cut sheets, most of your day would be spent simply loading paper into the printer.

With their small footprint, rolls take up less storage space per square foot than sheets. You can store them vertically, preferably in their original packing materials, or wall mounted using spare roll holders, as shown in Figure 6.13. Sheets, on the other hand, should always be stored flat, either in their original packaging or in metal flat files, like the one shown in Figure 6.14.

The major downside to printing on rolls is that you must devise a method for removing the curl once the paper exits the printer. The De-Roller, shown in Figure 6.15, was designed to do just that and

Figure 6.14 Large metal flat files make for safe and convenient storage of cut sheets.

Figure 6.15 The De-Roller does one thing and does it well. It removes the curl from roll paper in a matter of seconds. It comes in both 24- and 50-inch widths. *Image courtesy of Glastonbury Design*

Figure 6.13 Have spare roll holders left over from older printers? You can use them for wall-mounted paper storage.

works well with cotton rag papers. More frugal printmakers have fashioned their own devices out of cardboard tubes or PVC pipe. With sheets, there is no such problem. They can be mounted and framed once the inks have dried. If your printer driver or RIP provides accurate centering, you can print on an appropriately sized sheet and not even have to trim the edges before framing.

There can be a slight cost savings for roll versus sheet media, as Table 6.1 demonstrates. But keep in mind that the amount of paper waste during actual usage often plays the greatest role in determining the better value. The choice between rolls and sheets is not an either/or situation. Many owners of large format machines stock

both. One very convenient feature of the Canon imagePROGRAF IPF5000 is that it not only has both a sheet and roll feed option, but also that paper can be loaded in each print path simultaneously. This makes switching back and forth between rolls and sheets a very easy task.

Table 6.1 Paper Cost

The table below compares the cost per square foot of both roll and sheet sizes for two matte papers from Innova Art and Hahnemühle in all of their available sizes. In both cases, the best value can be found in a roll rather than sheet format. Square footage calculations are based on retail prices from online vendors.

Paper Name	Sheet Size	Roll Size	Price
Hahnemühle Photo Rag 308	8.5 × 11 (50 ct)		$2.09/sqft
	11 × 17 (50 ct)		$1.95/sqft
	13 × 19 (50 ct)		$2.47/sqft
	17 × 22 (50 ct)		$1.92/sqft
		17	$1.94/sqft
		24	$1.78/sqft
		36	$1.73/sqft
		44	$1.87/sqft
Innova Soft Textured Natural White	8.5 × 11 (25 ct)		$1.38/sqft
	11 × 17 (25 ct)		$1.34/sqft
	13 × 19 (25 ct)		$1.35/sqft
	17 × 22 (25 ct)		$1.32/sqft
		17	$1.10/sqft
		24	$1.09/sqft
		36	$1.07/sqft
		44	$1.07/sqft

Service and Support

Inkjet printers are remarkably stable devices, especially when you consider the precision with which they must spray fine dots of ink onto a continuously advancing paper path. Wide format models are geared toward the professional market and are sturdily constructed. Their parts are designed to produce many years' worth of prints. There is always the possibility, though, that one day things will stop working the way they should.

A staggering array of both hardware and software routines are called into play every time you press Print. All it takes is one little glitch in this process for your print output to be significantly altered. You may have a paper feed advance issue. Perhaps a print head is damaged. A software upgrade to your printing application could conflict with your printer driver. Any number of things can prevent expected output. It's a good idea to consider the service and support options available when you're in the market for a new printer.

Models from Canon, Epson, and HP all come with a one-year warranty. But given the long service life of inkjet printers and the money you are likely to invest in consumables over the years, you may want to explore the optional extended warranties. Table 6.2 gives a brief overview of the service contracts available. The size and bulk of a wide format printer makes an on-site service plan a necessity. Under this arrangement, the printer manufacturer contracts with a technology support company who dispatches one of its trained technicians to service the printer at your location. A single out-of-warranty visit can easily run into the thousands just for labor charges, so an extended warranty can pay for itself very quickly.

Of course, not every problem requires a service visit. Your first line of defense will always be the product documentation that shipped with the printer. While it is rare these days to see a printed user manual, there should at least be a hard copy QuickStart or troubleshooting guide so you don't have to be at your computer to

Table 6.2 Extended Warranties

Canon, Epson, and HP all provide options for extending the one-year warranty that comes with a new purchase of their wide format printers. While each company has its own specific policies, the following plans all include telephone technical support and on-site repair service.

Company	Models	Additional Coverage	Cost
Canon	imagePROGRAF IPF5000	2 years	$500
	imagePROGRAF IPF8000	2 years	$2,400
Epson	Stylus Pro 3800	2 years	$319
Epson	Stylus Pro 4800	2 years	$479
Epson	Stylus Pro 7800/9800	2 years	$1,305
HP	Designjet Z3100	2, 3, or 4 years	$1,499, $2,249, $2,998

retrieve basic operating information. The electronic version of the manual will likely be either a PDF or an HTML document. The great thing about a PDF is that you can easily print a hard copy for yourself. HTML documents, on the other hand, are a nightmare to print and do not always have adequate search capabilities when you are using them on the computer.

The toll-free telephone support included with your original warranty should also be a good resource for troubleshooting. But it's worth asking other users about their experiences with tech support because the quality of service can vary widely. You want support from a company whose technicians are not only knowledgeable about the product, but have physical access to your printer model

so they can try to duplicate any issues you are experiencing. I've had experiences where a printer goes on the market long before the company's tech support staff receives their own unit. This obviously limits their ability to answer questions or resolve a problem.

The Web provides a great opportunity for companies to offer self-service support to their customers. At the very least, you should be able to quickly and easily download firmware and printer driver updates, as shown in Figure 6.16. Online user forums, however, will likely become your online reference of choice when encountering a printing problem. It is hard to beat the combined experience of tens, hundreds, or thousands of users who own the same equipment that you do—often trying to solve the same or similar problem. Discussion forums are open 24/7. And with an

Figure 6.16 Epson's Web site is easy to navigate and is frequently updated with the newest drivers and firmware updates.

international user base, it does not take long to get a reply. One of the more popular discussion forums is a part of Michael Reichmann's The Luminous Landscape Web site at http://luminous-landscape.com/forum. There you'll find a section devoted to printers, papers, and inks in which discussions of new and recent hardware are common. I should also mention an invaluable Web site created by John Hollenberg devoted to the Canon imagePROGRAF IPF5000. It has an exhaustive FAQ section, is continuously updated with tips, tricks, and workarounds related to this printer, and has a forum of dedicated users. This site is a great example of the information-sharing potential of the Internet. It is a must-visit for any owner of Canon's 17-inch pigment printer. You can visit it at http://canonipf5000.wikispaces.com.

Power On or Power Off?

There is always a lot of back and forth debate over the merits of leaving inkjet printers powered on continuously versus shutting them off after printing is completed. Most of the arguments center around reducing the amount of ink lost to automatic head cleanings each time the printer is powered back on. On the 13-inch and smaller Epson inkjets, leaving them on for prolonged idle periods can dry out the print heads. When powered off, these printers park the heads over capping stations that keep the nozzles lubricated.

The wide format machines are engineered for production environments where they are likely to be powered on all day. Models from Canon and HP feature sleep modes that allow for automated self-maintenance routines. So the option to leave them powered on 24/7 is compelling. But, of course, this has a cost to both your electricity bill and the environment. I'm in no position to lecture on greenhouse gas emissions with all of the hardware in my own studio. But it's important to have the information so you can weigh the costs and benefits yourself. Table 6.3 shows the electrical consumption ratings for the current 44-inch models from Canon, Epson, and HP.

Table 6.3 Power Consumption

Printers consume power. And big printers consume a lot. Notice how much more power is required for the thermal-based printers from Canon and HP. These figures are taken from manufacturers' maximum wattage specifications and may vary in individual use.

Model	Printing	Sleep Mode	Power Off
Canon imagePROGRAF IPF8000	190W	5W	1W
HP Designjet Z3100	200W	27W	1W
Epson Stylus Pro 9800	55W	6W	1W

Printing for Hire

Maintaining consistent, high-quality output has to be a primary focus when you want to attract clients. Back in the days when IRIS printers were selling for six figures, anyone with the means to own one had a distinct and compelling selling point. They had equipment that customers could never hope to purchase or maintain. Today, anyone with even reasonable credit can have a 44-inch printer delivered to his door.

Since you may very well own the same equipment as your clients, you must strive to operate it much better than they ever could. It's similar to capturing images. With all of the autofocus and exposure algorithms, give anyone a camera for long enough, and he's likely to take a great picture. But doing it on a consistent basis with an inspired eye is something else altogether. As a printmaker, you sell process control above all else. In this section, we will look at some of the more basic features to consider when printing for hire.

Connectivity

If you're going to print for others, you're likely to need more than one printer in your studio. Perhaps you need a sheet-loading 17-inch printer for small portfolio-sized projects, in addition to a wide format printer for large prints. You'll also need to consider a backup printing option should a malfunction occur in the middle of a rush job. As your number of printers increases, connecting each to your workstation becomes an issue. USB, while convenient, has a maximum communication length of 10 meters for a single cable, while the most common Ethernet protocol is rated at 100 meters. With this distance, you could keep printers in separate rooms, or on separate floors, and access them from a single computer.

Controlling all of your printers from a single workstation can save you some money if you're running a RIP. Some RIPs are licensed per printer, meaning that with two printers you need two licenses. But others are licensed per computer. In this scenario, you can drive two (or more) printers with a single license, as long as they are both connected to the same workstation. With a multiple port Ethernet switch, like the one shown in Figure 6.17, this is a relatively straightforward affair, assuming that all of your printers offer Ethernet connectivity.

Even if you forego a RIP and use the standard printer driver, there can be benefits to using an Ethernet connection for your printer. Prints can be sent from any computer on your network. If you have

Figure 6.17 With an 8-port gigabit Ethernet switch, you can move large files quickly between workstations, as well as access multiple printers from a single computer. *Image courtesy of D-Link*

assistants or partners in your studio, for example, you all don't have to wait to use a single computer in order to print. The Designjet Z Photo Series printers from HP, with their built-in profiling capability, make even better use of Ethernet connectivity. Immediately after creation, printer profiles made with the built-in spectrophotometer are stored on the printer's hard drive and the drive of the computer from which the profile was initiated. All other computers on the network running the HP driver and utility receive an update alert, and at the user's choosing, all current profiles will automatically be downloaded to that computer. That's about as easy as it gets for keeping multiple computers up-to-date with the most current profiles.

Calibration and Custom Profiling

Clients will come to you only if they're confident that you can produce high-quality prints repeatedly and consistently. A client may have you print an image in May and then ask for a reprint of it in January. They will expect output that is very similar, if not indistinguishable. The obstacles to achieving such a result are many.

A new batch of paper may arrive with a slight, but unannounced, coating modification that alters output. A client may want to reprint an image on a different paper but still expects a virtually identical match. Your printer may require a service call in which the print heads are replaced. Each of these scenarios requires that you have a method of spotting deviations in output and taking steps to compensate for them. More than anything else, you must have in place a mechanism for bringing your print output back to a known state each time you print. This is only possible with a well-planned approach to calibrating and profiling your printer's behavior.

The first step to getting a handle on calibrating and profiling is to decide the method in which you are going to drive your printer. One of the largest myths in digital printing is that inkjet printers are RGB devices. They are, in fact, CMYK devices. Even though

newer models now come loaded with red, green, and blue inks, these are secondary colorants used to extend the base CMY gamut.

But for the sake of simplicity, OEM printer drivers are designed to accept images in RGB or Grayscale mode. They simply convert the pixel values to CMYK behind the scenes. In the next few sections, we will take a look at the pros and cons of driving an inkjet printer as an RGB, CMYK, or single channel device.

Profiling Through the RGB Driver

The greatest, and often most persuasive, argument for pretending your printer is an RGB device is that is exactly how the OEM printer drivers are designed to operate. The software engineers who write the printer driver code include an automatic conversion from the RGB pixel data of an image file to the CMYK-derived instructions that are sent to the actual print head and cause dots to be fired. This conversion happens each time you print and without any prompting on your part. It's simply part of the data processing that begins as soon as you click the Print button.

The more affordable of the printer profiling software packages, like the one shown in Figure 6.18, are designed for use with the OEM printer diver. The ICC profiling targets are comprised of a series of color patches in RGB mode, whose pixel values are converted into CMYK on the fly by the printer driver. With relatively little cost, you can create your own custom profiles that will certainly be more accurate than the ones that came from the printer manufacturer. Your profile is compatible with any ICC-aware application that uses the OEM printer driver.

If you are printing with OEM inks and papers, using the native printer driver offers convenience and affordability. The image fidelity and accuracy of custom-profiled printer driver output is quite remarkable. The printer companies spend a lot of time, money, and effort to fine-tune driver performance for their inks and media. It is when you start to venture from this path into

Figure 6.18 The Eye-One Match profiling software supports printer profiling through the RGB printer driver. A choice of three different targets can be selected for measurement.

third-party papers and inks that the limitations of an RGB driver really begin to surface.

Profiling as a CMYK Device

Acting on the desire to communicate with your inkjet printer as the CMYK device that it really is can be a daunting, not to mention expensive, endeavor. I noted previously that the OEM printer drivers expect RGB data. So you need an alternate method of sending data to the printer. Most of the commercial RIPs allow you to control the printer as a CMYK device. In fact, one of the most valuable features of any good RIP is that it gives you output control over individual ink channels. Why is this a big deal?

Let's use the example of a Canon 12-ink printer, like the imagePROGRAF IPF 5000. It has cyan, magenta, yellow, red, green, and blue inks in addition to light (photo) dilutions of cyan

and magenta. It also includes two shades of gray and two separate blacks, whose use switches between matte and glossy media. A RIP like StudioPrint 12, shown in Figure 6.19, arranges these inks into seven separate ink channels. If you're curious about why 12 inks result in only seven channels, see the following sidebar, "From Twelve to Seven."

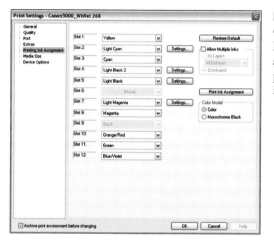

Figure 6.19 A CMYK-based RIP like StudioPrint can access each of a printer's ink slots individually.

The first step when controlling your printer as a CMYK device—even before building a profile—is to linearize your ink and paper combination. When you print a linearization target, like the one in Figure 6.20, you are instructing the printer to lay down its full range of output, from zero (paper white) to 100 percent, for each separate ink channel. The goal is a smooth, even gradation of tone with no abrupt shifts or reversals in density. You can measure the linearization target with a spectrophotometer, and the RIP computes the difference between expected and actual density results. It then builds a custom set of compensation values, commonly referred to as a *look-up table*, which automatically adjusts incoming pixel values so that they produce an expected result.

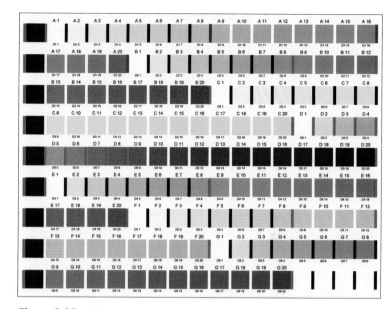

Figure 6.20 A linearization target is the result of firing each ink channel at values from zero to 100 percent. The Canon imagePROGRAF IPF500, whose output is shown here, is a seven-channel CMYKRGB device.

After you have linearized a printer. the next step is to build a profile, using the RIP and its paper-specific linearization data to print out and then measure a profiling target. You end up with a very precise characterization of your printer for a specific ink and paper combination.

In essence, this is what the printer manufacturers do in their R&D labs when optimizing their drivers for their branded media. A good RIP lets you do this for any ink and paper combination that your printer will accept. If getting your hands under the hood like this excites you, owning a RIP will give you a degree of control, particularly when using unique third-party media, that you cannot achieve with the OEM driver. If, on the other hand, this discussion has you reaching for an aspirin, take heart in the knowledge that today's

OEM printer drivers do a remarkable job of controlling ink output when you match the manufacturer's ink set with one of their papers.

From Twelve to Seven

When you linearize a printer, the photo dilutions of cyan and magenta are bundled with their full strength counterparts. The sole purpose of these dilutions is to allow a denser dot placement at lighter ink tones. If you start a cyan gradation that begins at paper white—no ink—the first ink to appear originates from the light, or photo cyan, position. The ink has a lighter density, so a greater concentration of dots can be placed to achieve a light tone. Without this dilution, full strength cyan dots would have to be used and would need to be spaced so far apart that the individual dots would become visible. In an identical manner, the gray inks are bundled with either the matte or photo black ink channel, depending on the media. They serve to extend the range of the black channel further into the highlight regions, again without producing visible dots. So even though Canon and HP printers have 12 physical ink slots, they are linearized as a 7-channel CMYKRGB ink set.

Profiling a Monochrome Printer

If you're going to install a third-party monochrome ink set, the standard linearization and profiling tools will not be of much help. They all operate with the expectation that a set of CMY-based colorants are used to generate output. But with a monochrome ink set, you are printing with a single channel—K—that just happens to be divided among four or more individual ink dilutions. But the concept of linearization is the same as described in the previous section. The only difference is that you are linearizing one channel of ink instead of seven. The least expensive option for creating a grayscale ICC profile that leverages this linearization data is Quad Tone RIP, which I discussed back in Chapter 2.

Self-Monitoring and Reporting

One of the many production-oriented features you'll find among wide format printers is the ability to access details about print jobs, ink and paper usage, and maintenance status. If you connect to the printer via Ethernet, you can view this information right from the Web browser of any computer on the local network. The information gleaned from these reports has many practical benefits.

Print often enough, and the cost of ink and paper will surpass that of the printer many times over. Estimating the cost of consumables plays an important role in determining your profit margins. In Figures 6.21 and 6.22, you'll see examples of ink and paper usage broken down for each job processed by the printer driver.

Figure 6.21 The Accounting tab, also available through the HP Printer Utility, provides ink and paper estimates for the most recent print jobs. You can choose to save this information as an Excel file (bottom).

Figure 6.22 The Canon GARO print utility also allows you to view detailed information about printed jobs right from your Web browser.

It's also important to keep a sufficient supply of ink cartridges on hand. This is especially true if you rely on Internet retailers for your supplies. You want to allow enough time for delays in order processing and shipping before you find a print job stalled by a flashing out-of-ink warning. Ink level indicators, like the one in Figure 6.23, make it easy to keep an eye on any cartridges that are getting low and plan accordingly.

Figure 6.23 Canon's ink level indicators make it easy to keep track of ink status and plan ahead for replacement cartridges.

A Black-and-White Renaissance

For much of the admittedly brief history of digital photography, there has been an overwhelming concentration on the color image. Black-and-white photographers have often been left to find refuge with innovative yet small companies catering to fine art monochromatic output. Today, there is a growing recognition of the importance of the black-and-white image. More photographers than ever before are exploring ways to translate their black-and-white darkroom work to the digital process. This didn't happen by

accident. In this section, we will focus on three key advancements in digital printing that have led us to the ever-growing number of options available for high-quality black-and-white prints.

Multiple Black Dilutions

In 2006 we saw the adoption of multiple black dilutions among all three of the major photo-inkjet manufacturers. This was a watershed moment in digital printmaking. It instantly validated the approach pioneered by advocates of multiple black ink sets, who have long held that a single position black ink was insufficient to express the range of tone and level of detail required for black-and-white images. How much of a difference can multiple black dilutions really make? In Figures 6.24 to 6.26, you can look at an extreme resolution test created by Geoff Spence of InkjetMall.com that clearly shows the benefits in print resolution afforded by an ink set that devotes seven shades of ink to the grayscale image. These images are courtesy of Geoff Spence.

Figure 6.24 To test for resolution of extremely fine print detail, a Gosper curve was created, and its path filled with one-point text.

Figure 6.25 This drum scan shows the print output of the resolution test with a three-position black ink set. At this scan resolution, you can also see the slight use of color pigments.

Figure 6.26 A drum scan of the print output from a monochrome ink set with seven shades of black shows a much more accurate rendition of the text.

The path to the highest quality of black-and-white output is undeniably through the use of multiple shades of black ink. The multiple-black ink set also has significant ramifications for print longevity. Using more black ink and less color pigment simply creates a more fade-resistant image. The technology that allows printer companies to fit 8- and 12-ink positions in a single printer opens up a world of possibilities with regard to tonal gradation, image detail, tinting, split tones, and likely other benefits that have yet to hit the market.

Pigment Ink Formulations

The now universal switch to pigment-based inks for photographic quality inkjet printers moves the longevity of digital prints closer to the gold standard of a selenium-toned silver darkroom print. In fact, you could argue that with the careful steps required for proper fixing and washing of darkroom prints—let alone the very small number of images that were toned for longevity—more photographers are creating longer lasting prints with digital inkjet than ever were in the traditional darkroom.

Printer companies have certainly heeded the call from the fine art segment of the market for greater longevity. Figure 6.27 shows preliminary longevity data for the HP Designjet Z3100 printers. The full document is available for download from Wilhelm Imaging Research's Web site, www.wilhelm-research.com. Given the short development history of the fine art inkjet printing market, it is astonishing that we have longevity estimates exceeding 250 years for black-and-white prints.

Another benefit of these newer pigment formulations is their ability to stabilize and dry down to their finished state relatively quickly on most paper media. This makes calibration and profiling a much faster, and more foolproof, process.

HP Designjet Z3100 – Print Permanence Ratings (preliminary[1])

Display Permanence Ratings and Album/Dark Storage Permanence Ratings (Years Before Noticeable Fading and/or Changes in Color Balance Occur)[2]

Paper, Canvas, or Fine Art Media Printed with HP Vivera Pigment Inks	Displayed Prints Framed Under Glass[3]	Displayed Prints Framed With UV Filter[4]	Displayed Prints Not Framed (Bare-Bulb)[5]	Album/Dark Storage Rating at 73°F & 50% RH (incl. Paper Yellowing)[6]	Unprotected Resistance to Ozone[7]	Resistance to High Humidity[8]	Resistance to Water[9]	Are UV Brighteners Present?[10]
HP Premium Instant Dry Gloss Photo Paper	>150 years	>250 years	102 years	>250 years	now in test	very high	high	no
HP Professional Satin Photo Paper	now in test	now in test	now in test	now in test	now in test	now in test	high	no
HP Super Heavyweight Plus Matte Paper	>230 years	>250 years	103 years	>300 years	now in test	very high	moderate[11]	no
HP Hahnemühle Smooth Fine Art Paper	>230 years	>250 years	122 years	>300 years	now in test	very high	moderate[11]	some
HP Hahnemühle Textured Fine Art Paper	now in test	now in test	now in test	now in test	now in test	now in test	moderate[11]	no
HP Hahnemühle Watercolor Paper	>230 years	>250 years	114 years	>300 years	now in test	very high	moderate[11]	no
HP Professional Matte Canvas	now in test	now in test	now in test	now in test	now in test	now in test	moderate[11]	no
HP Collector Satin Canvas	now in test	now in test	now in test	now in test	now in test	now in test	moderate[11]	no

Black-and-white prints made with HP Vivera Pigment Inks

Display Permanence Ratings and Album/Dark Storage Permanence Ratings (Years Before Noticeable Fading and/or Changes in Color Balance Occur)[2]

Paper, Canvas, or Fine Art Media Printed with HP Vivera Pigment Inks	Displayed Prints Framed Under Glass[3]	Displayed Prints Framed With UV Filter[4]	Displayed Prints Not Framed (Bare-Bulb)[5]	Album/Dark Storage Rating at 73°F & 50% RH (incl. Paper Yellowing)[6]	Resistance to Ozone[7]	Resistance to High Humidity[8]	Resistance to Water[9]	Are UV Brighteners Present?[10]
HP Premium Instant Dry Gloss Photo Paper	>250 years	>250 years	250 years	>250 years	now in test	very high	high	no
HP Super Heavyweight Plus Matte Paper	>250 years	>250 years	250 years	>250 years	now in test	very high	moderate[11]	yes
HP Hahnemühle Smooth Fine Art Paper	>250 years	>250 years	250 years	>250 years	now in test	very high	moderate[11]	some
HP Hahnemühle Watercolor Paper	>250 years	>250 years	250 years	>250 years	now in test	very high	moderate[11]	no

Note: Additional papers are currently being tested.

> 250 years indicates "greater than 250 years" and that tests are being continued.

©2007 Wilhelm Imaging Research, Inc. Reprinted here with permission. This document originated at <www.wilhelm-research.com>
File name:<WIR_HP_Z3100_2007_01_10.pdf>

Figure 6.27 These preliminary tests show remarkable image stability from HP's Vivera ink set on HP-branded media. The first table shows longevity ratings for color prints. The one that follows is for prints produced exclusively with the black ink dilutions. *Data provided courtesy of Wilhelm Imaging Research*

Enhanced Printer Drivers

Recent advances in OEM printer drivers have created a condition in which more linear behavior from the printers is possible when using the manufacturer's ink and paper. As discussed earlier in this chapter, the greatest benefits of a user-generated linearization via a RIP are now largely confined to instances where third-party inks and media are employed. Another benefit of improved linear behavior is that a custom profile created using a current printer's RGB driver gives better results today than was possible with earlier models.

Two things have facilitated higher quality profiles. For one thing, production tolerances have improved so that there is much less unit-to-unit variance within a given printer model. In addition, the printer drivers have become more advanced and better able to control output behavior. In short, today's printers perform much closer to an ideal printing state. The job of a profile then is greatly reduced. The complex math behind them can be devoted to small adjustments of hue and density, rather than the huge corrections needed to compensate for radical deviations from expected behavior.

Profiles are asked to do much less of the heavy lifting than they were with previous generations of printers and drivers. With the latest printers, very serviceable profiles can now be created using far fewer patches. This has made handheld spectrophotometers more attractive to a wider audience. And with less of a need to concentrate on compensating for nonlinear printer behavior, third-party developers can turn their attention to more specialized tasks. A product like PrintFIX PRO, which I discussed earlier in this chapter, exists because its engineers could leverage the linear behavior and multiple-black technology of the current printers from Canon, Epson, and HP to fine-tune output for neutral and linear black-and-white output.

Even if you stick with the canned profiles that ship with your printer, OEM printer drivers now offer options specifically for black-and-white output. We'll take a look at some of those later in "Printer Driver Settings." The point is that the inclusion of multiple black dilutions has lowered many of the obstacles to producing pleasing black-and-white output. The out-of-the-box performances of printers from Canon, Epson, and HP are vast improvements over what was possible just a few short years ago. While there are still benefits to using a RIP, these latest generation

of OEM printer drivers and ink sets are making the additional purchase of a RIP an option, rather than a requirement for black-and-white photographers.

Papers

Browse through any retailer's catalog of inkjet papers, and you'll be overwhelmed by the number of brands and products available. How to make sense of it all is a common question among photographers. The first thing to realize is that there are only a handful of high-volume paper mills around the world. So many of the competing brands are using a similar and, in some cases identical, paper base.

A paper must be optimized specifically for inkjet printing. This happens at a conversion plant where the inkjet receptive coating is applied. Each of the larger paper companies has developed its own coating formulas. You will find a wide range of performance with regard to saturation and Dmax. But within a particular manufacturer, a single coating formula is generally used among most, if not all, of their fine art papers. You can therefore expect to see only small variations in behavior within their product lineup. If one paper from Company X does not deliver satisfactory results, it's best to move on and try another brand altogether.

This Side Up

Papers optimized for inkjet printing are given an ink receptive coating—usually just on one side. If you're in doubt as to which is the printable side, take your fingernail or a small blade and scratch across a discrete corner of the sheet. The coating layer will flake off rather easily, identifying the side on which you should print.

Beyond Paper

There are an astonishing number of fine art materials from which to choose for your inkjet prints. And while I focus throughout this book on paper, keep in mind that canvas, aluminum, and even gold surfaces treated for inkjet output are available. There are also do-it-yourself options, like the inkAID liquid coatings that you can apply to the surface of virtually any material that will fit through your printer.

Surface Texture

Perhaps the broadest distinction we can make among print media revolves around the tooth, or surface texture, of the paper. There are relatively smooth sheets, those with a more prominent grain, and others that have a texture so pronounced that they become an integral part of the image. In Figure 6.28, you can see examples of papers with different textures.

The question then becomes which type of texture will enhance the communicative abilities of a given image. For tightly cropped portraits, you may prefer a very smooth surface that does not

Figure 6.28 Fine art inkjet papers come in a number of different surface textures and paper colors. Sheets without optical brighteners will appear decidedly off-white, compared to an artificially whitened stock.

accentuate prominent pores or skin blemishes. You also don't want the paper to compete with the subject for the viewer's attention. A rugged landscape of rocks and earth, on the other hand, may benefit from a paper with a prominent tooth that accentuates the texture and tactile nature of the subject.

Image size can also play an important role. I find that an overly rough paper surface can sometimes overwhelm a very small print. This same paper may be fantastic on larger prints, even of the same image, because the relationship of paper texture to image detail is reduced. Of course, there are no hard and fast rules. The choice of paper is a personal one. You will likely find that your own tastes evolve over time as you become more familiar with the printmaking process.

Ink Compatibility

You've found the perfect paper. It has a luxurious tooth, is just the right brightness, feels good in the hand, and is available in your preferred size. But does it print well with your ink set? The interaction between paper base, coating, and ink is a complex one that involves much more chemistry and physics than I ever had in school. The sad, simple truth is that not all papers perform the same way with all inks. For starters, some are optimized for dyes, others for pigments. But even if you choose a paper designed for pigment inks, there is the strong possibility that one company's inks will differ from another's in monochromatic tone, ink coverage, and Dmax in a printed image.

Each printer manufacturer, of course, sells house brand papers optimized for their own ink sets. But there is a vibrant and healthy third-party paper market that should not be ignored when searching for your ultimate paper. Because Epson had such a long head start in photographic inkjet printing, most paper manufacturers test their fine art papers for compatibility with the Epson UltraChrome

pigments. This does not automatically mean you can't get wonderful results from Canon, HP, or third-party monochrome ink sets. But a safe bet is to always test a small sample pack for compatibility with your ink set before investing in a large paper order.

You want to make sure that ink is readily absorbed into the coating layer. Prints should be dry to the touch immediately out of the printer. On glossy media, there should be no chalky residue transferred to your fingers if you touch a shadow area of the print. You will also want to hold the sheet at various angles, without seeing gloss differential, commonly referred to as "bronzing," shown in Figure 6.29.

For the deepest blacks possible, you want to verify that the sheet can handle a relatively high ink load. Laying down too much ink on a paper will result in paper cockling. The paper will actually buckle under the stress of too much ink. In severe cases, the ink may simply pool on the sheet or run off. If this occurs, the only solution is to reduce the ink load, either by selecting another media setting in the printer driver or by applying an ink limit using a RIP.

Keep in mind that the need for a dark and heavy black is an aesthetic determination. There are times when a muted range of tones is not only appropriate, but also desirable. In Figure 6.30 you will see two papers with extremely different printing characteristics. Each image has its own unique needs. Simply printing on a different paper can result in a dramatically different print.

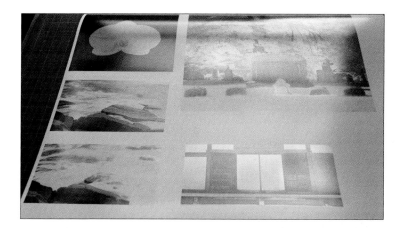

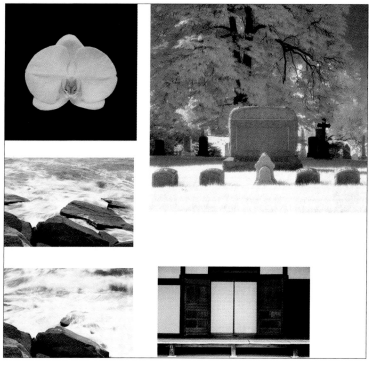

Figure 6.29 Gloss differential can become an issue with some pigment inks and glossy paper surfaces. When light is reflected off the print at oblique angles, areas with relatively little ink can appear completely blown out, while areas with heavy ink load appear "bronzed." At right, the image as it appears on-screen.

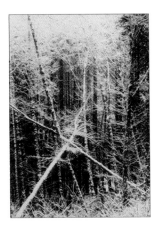

Figure 6.30 The rich deep blacks of the fiber-based gloss sheet on the left, combined with a bright white surface, yield a print with an extremely wide contrast range. The Japanese uncoated paper on the right yields a muted palette of tones but offers a three-dimensional luxurious feel that can bring out ethereal qualities in an image.

Matte Black and Photo Black: What's the Deal?

When Epson introduced its first generation of UltraChrome inks in the Stylus Photo 2200, photographers were offered two interchangeable black inks. The photo black (PK) was optimized for glossy media, and the matte black (MK) was meant exclusively for use with fine art matte papers. Why do we need separate ink for each type of media?

Luster, glossy, and other resin-coated media and their inkjet receptive coatings are very friendly to dye-based ink sets but were not generally compatible with pigment inks. Epson, with its PK ink, developed a way to encapsulate its pigmented inks with a polymer so that they could adhere to these types of paper surfaces. In addition to trading some longevity for compatibility, this created another problem. The PK ink yields a disappointingly low Dmax on matte

papers. The MK is a nonencapsulated pigmented ink that gives significantly higher Dmax values on matte papers. It cannot be used, however, with the coatings on glossy media, including the popular fiber base-type papers that were introduced in 2006. Figure 6.31 shows what happens when MK ink is printed on a glossy paper surface.

If you want to print on both glossy and matte media with the same printer, you'll need to make sure the printer is capable of switching from MK to PK on the fly, or with minimal hassle and expense if a cartridge change is necessary.

Figure 6.31 The large pigment particles in a matte black ink will not adhere when printed on a glossy paper. Even if the ink appears to have bonded (left), a quick wipe of the thumb reveals a chalky residue (right).

Storage and Handling

In Chapter 8, "The Limited Edition," I will discuss paper's role in print longevity in much more detail. But selecting an acid-free media with minimal optical brighteners is only the first step in the crusade against premature deterioration. Once you have the paper in your possession, there are a few basic storage and handling practices that protect it from environmental contamination. Below are several tips for proper storage and handling of fine art papers.

- Store paper in its original packaging when it is not being used.
- Avoid storing paper in extremely humid conditions.
- Don't store paper where it will come into physical contact with chemically unstable or acid-generating substances.
- Periodically check paper that has been in storage for stains or discoloration. Yellowing along the edges of a paper is a sure sign of the migration of harmful and acidic elements and can ruin entire batches of paper relatively quickly.
- Store paper far away from any food sources that can attract insects or vermin.
- Use cotton gloves when handling paper.
- Don't allow the printable side of the paper to come into contact with oils or liquids.
- Allow paper time to acclimate to an appropriate temperature and humidity before printing.
- When stacking finished prints, always interleave a thin, acid-free tissue paper between each print to avoid abrasion and scuffing of the paper surface.
- When packing prints in tubes, always roll them with the print side facing inward. This not only protects the printed image, but it also counteracts the curl from roll papers.
- Maintain a clean work surface that is devoted exclusively to paper handling. This reduces the opportunity for the migration of harmful substances to the paper.

Less Is More

With so many different paper brands on the market, it takes no small amount of self-control to settle on a few select stocks. But committing to a relatively small selection of papers has its advantages. The most obvious is that you can become intimately familiar with the nuances of a given paper. Much like the photographer who picked one film and developer combination and learned its strengths and weaknesses, you can understand how to exploit a paper's characteristics to your advantage, if you're not constantly trying out new products. Each paper has its own character and interacts with images in a unique way.

Remember that it is not only the paper base that affects your image. The inkjet receptive coating plays a crucial role as well. Black-and-white prints can shift in tone, either subtly or dramatically, when printed on different papers. The good news is that most of the large paper companies have a consistent coating across their matte and glossy product lines, respectively. If you love the tone of your prints on Innova Soft Texture, for example, chances are good that you can achieve the same hue on their Cold Press Rough Texture. But switching to Hahnemühle German Etching is likely to yield a different tone of gray.

Printing Gotchas

The most obvious trade-off for the precision and convenience of digital printmaking is the staggering number of elements you must troubleshoot when things go wrong. Low quality or inconsistent output can be the result of software corruption, interface connection bugs, or undocumented changes to ink and paper formulations, in addition to plain old printer hardware issues. The good news is that for all of the complexities involved, the process of sending pixel data in return for dots on the page happens successfully the majority of the time.

As photographers, rather than computer technicians, there are limits to our abilities to diagnose and correct problems. But there are some preventative measures you can incorporate as part of a regular routine that can increase the odds of consistent print results.

Ambient Environment

For all of the fancy technology built inside of an inkjet printer, it's fundamentally a mechanism for putting dots of ink onto paper. The physical interaction between a liquid and absorbent material is affected by temperature and humidity.

Papers designed specifically for inkjet printers have a thin coating applied to the paper base that allows for higher ink loads, greater density, and increased color gamut. For this to work properly, the paper must absorb the ink to just the right degree. A cold and dry paper will not absorb ink in the same manner as one that is exposed to hot and humid conditions. Two common effects of low humidity are horizontal banding and rough transitions between neighboring print tonalities. Printing in an environment with too much humidity can cause paper cockling and increase the frequency of print head clogs.

Printer manufacturers list optimum ranges for both temperature and humidity. It's important to ensure that your ambient environment falls within these specifications whenever you get ready to print either images or calibration and profiling targets. If you store paper in a different room from that in which you actually print, make sure to allow the paper time to acclimate to the printing environment before you start to print. This can require some planning if you own a wide format printer and store numerous rolls of paper.

The easiest way to maintain consistent humidity levels in your printing environment is with either a humidifier, shown in Figure 6.32, or a dehumidifier, depending on your seasonal conditions.

Figure 6.32 This humidifier has two large capacity water tanks and keeps moisture circulating throughout the air for hours between refills.

The basic guideline for operating temperature is that if it's uncomfortable for you, it's also bad for printing. Living in New York City means that in my studio I need to run an air conditioner in the summer. In addition to cooling the air, it removes excess moisture at the same time. Two humidifiers—one in the print room, another in the paper storage room—get heavy use in the dry winter months. I use a combination humidity and temperature measuring device, shown in Figure 6.33 to keep track of ambient conditions.

Figure 6.33 A combination hygrometer and thermometer is an inexpensive and widely available tool you can use to keep tabs on the ambient printing conditions.

Pigment Settling

It seems ironic that pigment inks rated for a print life well over 100 years would have an expiration date on their cartridges of 12–18 months from the date of manufacture. The shelf life of pigment inks in their cartridges is a function not of lightfastness, but of the ink's ability to remain in suspension. Pigment particles are ground to microscopically small sizes for use in inkjet printers, but they are still solids. They must be delivered onto the paper via a liquid carrying agent.

Over time, as the pigment particles settle out from the liquid, the ratio of carrier to pigment that is moved from the cartridge to the print head is altered. In this state, a given volume of ink delivered to the print head contains fewer pigment particles. The result is a print with reduced density and muted colors.

Those of you who already own pigment printers are undoubtedly familiar with the instructions to shake new ink cartridges a few times before installing them into the printer. This is especially important with 17, 24, and 44-inch printer models because the ink cartridges remain stationary during printing. Ink is delivered to the print heads via long ink lines, shown in Figure 6.34. This preinstallation agitation ensures that any pigments that may have settled

Figure 6.34 Large format printers, like this Epson 9600, deliver ink to the print heads via long ink lines that run the length of the printer chassis.

out of suspension as the ink sat in storage are mixed back in with the liquid carrying agent. Desktop printers are designed so that the ink cartridges rest directly above the print heads. The ink passes directly from the cartridge to the nozzle. The side-to-side passes as the printer lays down ink serves as automatic ink agitation. Each of the big three printer manufacturers designs inks and high volume cartridges for their large printers with an eye toward keeping pigments evenly dispersed in the ink formulations for as long as possible. Canon, with its PROGRAF line of printers, takes the additional measure of including a mechanical agitation device that keeps the inks moving and the pigment in suspension. The HP Designjet Z Photo Series printers include a self-maintenance routine that periodically agitates inks in the cartridges to prevent pigment settling.

A quick preventative measure to take if your wide format printer has been sitting idle for a few weeks is to remove the cartridges, gently shake them a few times, and then run some test images on cheap paper to move the freshly agitated ink through the length of the ink lines.

Nozzle Checks

Anyone who has used inkjet printers for any length of time is undoubtedly familiar with the havoc that clogged print head nozzles can cause. Sudden color shifts and thin horizontal bands in areas of solid color are telltale signs that ink is not firing as expected.

With previous generations of printers, one of my first tasks before sending a print was to perform a nozzle check, shown in Figure 6.35, and manually verify that no gaps existed in the line pattern. Today's wide format printers can automate this task and, in the case of Canon and HP, take corrective action without user intervention.

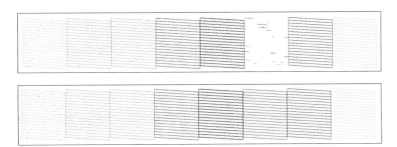

Figure 6.35 The nozzle check on the top shows severe clogging in the cyan print head. After running a head cleaning routine a subsequent check (bottom) shows the nozzles are firing perfectly.

All of Epson's Stylus Pro printers feature nozzle check and cleaning routines that you initiate from either the printer driver or printer control panel. Their printers also run periodic head cleanings based on ink usage. With Canon's imagePROGRAF line of printers, the status of the print head nozzles is checked in accordance with user preferences. The default setting calls for a nozzle check each time the printer is powered on or brought out of sleep mode by an incoming print job. You can change the frequency of the nozzle checks or disable the feature altogether. In the latter case, you would initiate nozzle checks manually from the printer driver or printer control panel when you notice a loss in print quality.

The HP Designjet Z Photo Series printers are actually designed to be powered on around the clock. The printer will periodically rouse itself from its sleep mode and verify that all nozzles are operating properly. One basic advantage of the thermal print head technology used by both Canon and HP is that it allows for a significantly greater number of nozzles per print head, as shown in Table 6.4. Whether a greater number of nozzles outperforms a piezoelectric printer that can utilize variable drop sizes is a debate better left for

Table 6.4 Print Head Density

Piezoelectric print heads employ a mechanical device to vary the dot size on the fly for any given nozzle. In a thermal head design, the dot size is fixed for each nozzle, but a greater density of nozzles can be fabricated onto a print head.

Printer Series	Print Mechanism	Ink Channels	Nozzles per Channel
Canon imagePROGRAF	Thermal	12	2,560
Epson Stylus Pro	Piezoelectric	8	180
HP Designjet Z Photo	Thermal	12	1,056

Head Cleaning and Ink Usage

The user-initiated head cleaning routines attempt to address missing or deflected nozzles by firing ink through the print head at varying intensities. This is usually followed by a physical wiping of the print head in an effort to clear outside debris from the nozzles. The process uses a substantial amount of ink. If you are using a 13-inch or smaller printer, it may only take a few head cleaning cycles to trigger a rash of out-of-ink warnings. So it makes sense to perform a nozzle check first and confirm that nozzles are the culprit for unexpected output. One benefit of HP's Designjet Z Photo Series printers is made possible by its use of six individual print heads, each dedicated to just two colors. In the event that you need to run a head-cleaning routine, you can choose to clean a specific pair of print heads, keeping ink waste to a minimum.

online user forums. But one big advantage of having such a high density of nozzles comes into play should any stubborn nozzles remain clogged even after cleaning attempts. Canon's image-PROGRAF printers and HP's Designjet Z Photo Series printers will simply remap ink firings from the defective nozzles to functioning nozzles. The HP models also offer a user-initiated option of printing with extra print head passes to maintain image quality if a significant number of nozzles become clogged.

Paper Dust

If you work a lot with matte papers, particularly those with a cotton rag base, you've likely noticed stray or loose fibers around your paper cutting area. It is very important to keep this debris from working its way inside the printer. Stray fibers protruding from the paper surface can be transferred to the print head and lead to clogged nozzles. Small specks of loose fibers or coating material laying on the paper surface will absorb ink dots, and when they later fall off of the surface, you're left with distracting specks of paper white where ink should have been laid down.

The easiest way to prevent this is to brush down your paper just before printing. A 12-inch drafting brush, available at any art supply store, is a cheap and effective way to remove dust and loose fibers. Sheets can be gently brushed before they are loaded into the printer. With roll paper, I prefer to unwind the approximate length needed for printing (see Figure 6.36) and brush it down gently. This also gives me a great opportunity to check the paper for any defects before I commit to the print job. After brushing, I simply reroll the paper and feed it into the printer as normal.

Figure 6.36 Paper dust and loose fibers are your enemies in the print room. Before each print on roll paper, I unroll the length to be printed. I use a clamp-on light to check for paper defects and brush any loose fibers off the paper.

Final Steps

The preliminaries are completed, and it's time for the main event. Putting the image onto paper is the culmination of a series of stages designed to send the most appropriate pixels for conversion into dots. We have made our decision regarding print dimensions and pixel resolution. In the next few sections, we will optimize a file for desired print sharpness, configure Photoshop's print dialog for color managed output, and look at printer driver settings for Canon, Epson, and HP inkjet printers. Finally, we'll examine some of the benefits you enjoy when using a RIP. Taken in combination, the issues present here represent the final stage of the workflow. We finally get to click the Print button.

Output Sharpening

In Chapter 4, we discussed the concept of capture sharpening. The idea that a digital capture induces softness that must be compensated for, rings just as true on the output end of the workflow. In other words, ink on paper will always appear less sharp than its on-screen counterpart. The phenomenon of ink being sprayed onto paper involves dot gain. In simplest terms, this refers to the fact that a dot spreads when it hits the paper, becoming slightly larger and more diffuse. In fact, the primary role of the coating on an inkjet paper is to minimize dot gain as much as possible. Figure 6.37 shows a clear example of the effects of an inkjet-optimized coating.

The ability of a coating to hold a tight dot determines both the density and sharpness of a printed image. A coated paper will keep ink from spreading or bleeding to a remarkable degree, but it cannot

Figure 6.37 The typeface on the left was output with an uncoated paper. Notice the pronounced bleed or wicking around the edges of the letter. The print made on coated paper (right) not only holds a tighter dot, but also yields a greater ink density.

eliminate this phenomenon altogether. Couple this with the fact that a pixel must be converted into a physical representation of ink dots, and it is easy to understand why inherent differences in their technologies make it impossible to translate an image on the screen into an exact duplicate on paper. It's true that we can get remarkably close, but nowhere is this effect more noticeable than in the perceived sharpness of an on-screen and printed image. The enhanced sharpness of LCD technology only exacerbates this difference. It is up to you to compensate for the image softening that occurs when ink is laid down on paper.

Just as with the issue of capture sharpening, the PhotoKit Sharpener plug-in from PixelGenius is well suited to automating the task of defining and creating optimally sharpened output. Because post-capture sharpening is a localized contrast adjustment, the plug-in needs information about your print dimensions and image resolution, as well as printer and paper type. Figure 6.38 shows a configuration specifically for inkjet output on a matte paper when the image is sized at 16×24 inches and will be sent at a resolution of 300 ppi.

Taking this information into account, the plug-in will make a global contrast adjustment that is restricted to contrast edges in the image. Since an image that appears sharp on-screen will print a bit soft, the result after sharpening is an image that appears "crunchy" on-screen when viewed at 100 percent. It's never an ideal situation when you must ignore how an image looks on-screen in order to judge output. The easiest workaround is to view your sharpened image at either 25 or 50 percent pixel view for an accurate preview of how it will print.

Images that were captured with a tripod, properly exposed at a relatively noise-free ISO, and contain lots of intricate detail will benefit the most from careful output sharpening. The differences in print output are often too subtle to reproduce in an offset printed

Figure 6.38 The PhotoKit Sharpener plug-in requires an RGB image, so you must temporarily convert images from grayscale to RGB mode. The sharpening effect is tailored to output dimension, image resolution, paper type, and printer technology.

book like this one, but can mean the difference between an image that draws the viewer's eye toward its subject or one that feels lifeless by comparison. Output sharpening is device and size specific. So an image with print dimensions of 16 × 20 destined for an inkjet print loaded with glossy paper will require a different amount of sharpening than one destined for the Web. In Chapter 7, you will look at output sharpening within a broader capture-edit-print workflow.

Photoshop's Print Dialog

Even though it is the most common interface that serious and professional photographers use to send their images to the printer,

Photoshop's Print dialog is not as well understood as it should be. The interface has been redesigned in CS3, as Figure 6.39 shows. The dialog has been rearranged to allow a larger preview window. The pixel resolution of the image is now displayed. There is also a Match Print Colors option that mimics the effect of View>Proof Setup with both Simulate Paper Color and Simulate Black Ink enabled.

Figure 6.39 In CS3, the standard Print command now brings up what used to be called Print with Preview in earlier versions.

The most important thing to understand when you print from Photoshop is that your image file will be processed again by the printer driver. It's important that the instructions you specify in Photoshop do not conflict with those set in the printer driver. The most common mishap occurs when both Photoshop and the printer driver are set to convert the image from its native color space to that of the printer profile. Figures 6.40 through 6.42 highlight the appropriate settings for allowing Photoshop to either handle the color space conversion or hand this responsibility off to the printer driver.

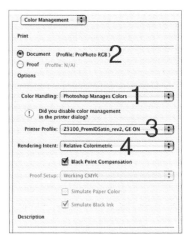

Figure 6.40 When you select Photoshop Manages Colors (1), the image is converted from its assigned color space (2) to the selected printer profile (3). Any out-of-gamut colors are handled according to the rendering intent (4) that you select. All of this takes place *before* the image is handed off to the printer driver.

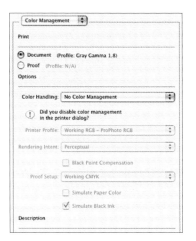

Figure 6.41 Selecting No Color Management prevents any conversion from taking place in Photoshop. Raw pixel data is passed on to the printer driver.

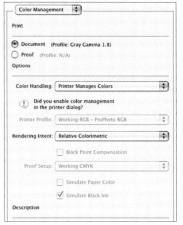

Figure 6.42 When the Printer Manages Colors option is enabled, Photoshop does not convert to a printer profile, but it does pass along the image's assigned profile to the printer driver.

What gets done with the profile information that Photoshop passes along depends on many OS and printer driver variables. The safer choice, by far, when you want to send unmodified pixel data to the printer driver is the option described in Figure 6.41.

Printer Driver Settings

Unless you are using a RIP to process your image data, your image pixels must pass through the manufacturer's printer driver. Both the quality of your image and the likelihood of your choosing the appropriate settings are going to be determined by the interface design and logic of the printer driver. Each specific printer model will have unique features, so even within a single manufacturer, there will be subtle differences in the optimal settings for the finest quality output. Below we'll take a brief look at some of the features offered by the OEM printer drivers.

Canon

Canon offers two separate printer drivers with its imagePROGRAF line of printers. The standard driver accepts both RGB and grayscale image files. Of particular interest to black-and-white photographers is that when you choose to print with the Monochrome Photo setting, shown in Figure 6.43, no color inks are used to generate the image. Only the gray and photo gray plus the appropriate black (matte or glossy) are fired from the print head.

Canon is also the first to provide an OEM printer driver that can process 16-bit image files. Normally, even drivers that accept a high-bit file bump it down to 8 bits on its way to the printer. Canon's printer driver actually processes the image data as 12-bit information. This driver is installed as an export plug-in for Photoshop. Its interface is shown in Figure 6.44. Unfortunately, the driver is only compatible with RGB images. But as a matter of simplifying your workflow, it does allow you to bypass Photoshop's print dialog and make all of your color management settings from a single interface.

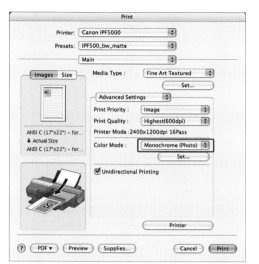

Figure 6.43 Selecting Monochrome (Photo) in the Canon driver eliminates the use of color inks. Three dilutions of black are used exclusively to print the image.

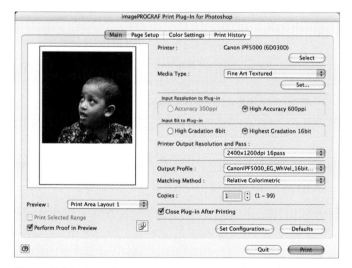

Figure 6.44 Canon's imagePROGRAF Print Plug-In for Photoshop exports 12-bit data to the printer. It is only compatible with RGB images, however, so for black-and-white photographers, this feature only comes into play with images that have been tinted in Photoshop.

Epson

One of the most crucial actions you'll be asked to make in the printer driver is to define the media type with which you are going to print. This may seem like just a list of OEM paper stocks, as shown in Figure 6.45 But each paper calls up specific settings in the printer driver. The media type determines how much ink is laid down, as well as which of the two black ink options—matte or photo—are to be used when printing.

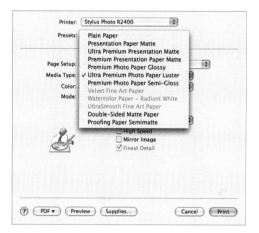

Figure 6.45 The choice of a media type triggers specific inking behaviors for the printer driver, selecting parameters optimized for the OEM paper indicated. Note that with photo black ink installed, Epson's fine art matte papers are grayed out.

The print quality setting (see Figure 6.46) corresponds to a particular set of output resolutions. A higher quality setting places more ink dots per square inch, for finer resolution of detail.

With the release of its UltraChrome K3 ink set, Epson added a new driver algorithm to its printers titled Advanced Black and White mode. Shown in Figure 6.47, this driver was created to produce very linear monochrome output when left at the default settings. But it also offers the ability to globally tint the image from warm to cool. While the UltraChrome K3 ink set comes with three dilutions of black, even a neutral-toned black-and-white image is printed with

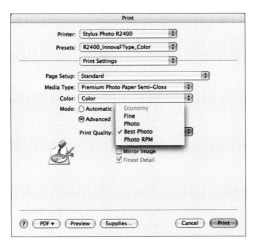

Figure 6.46 The menu of print quality settings in the Epson driver provides greater printer resolution as you move down the list.

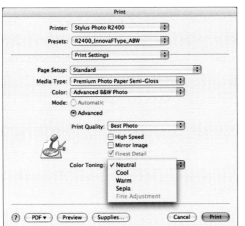

Figure 6.47 The Advanced B&W Photo mode triggers a separate printer driver and offers four built-in toning options. You can also configure custom tints.

a small amount of color inks. The use of color pigments can be further increased in order to achieve a broad range of toning options at print time. The image pixels are not altered, so the image file can remain in grayscale mode. The printer driver takes over color management and shifts the hue of the printed image according to user adjustments.

HP

The printer driver for HP's Designjet Z Photo Series printers offers some unique additions and conveniences to the print workflow. Acknowledging the reality that most photographers prefer to handle profile conversion in the Photoshop print dialog, the HP driver includes an easy way to defer color management to the printing application, as shown in Figure 6.48. The use of four dilutions of black when printing on matte paper makes this series of printers the first OEM solution to offer color-managed quad black printing out of the box.

The implementation of a flexible, yet easy-to-use, split-toning option is remarkable as well. You can define both the tonal range and hue of highlights, midtones, and shadows. (See Figure 6.49.) Your original image remains in grayscale mode so the pixels themselves are not altered. The driver sends instructions to the printer that call up color pigments to tone the image accordingly. As with

Figure 6.48 The driver for HP's Designjet Z Photo Series printers can be set to the Application Managed Colors option. This reflects how the majority of us will actually be handling profile conversions—inside Photoshop.

Figure 6.49 In HP's driver for the Designjet Z3100 printers, you can specify up to three separate tints, assigned to three separate tonal regions. The Zone Definitions sliders allow you to define the start points of each tonal region. If you would rather apply a global tint, simply select the Apply Midtone Adjustment to All check box.

the toning options in the Canon and Epson drivers, making any adjustments to color inside the driver eliminates the possibility of accurate soft proofing, at least without springing for third-party profiling software.

RIP Layout

So what can a RIP offer you that justifies the purchase of additional software to replace the printer driver that came with your printer? A good RIP can offer you significantly more control over both process and production. As I mentioned earlier in this chapter, the more recent advances in OEM printer drivers have led to a significant leap in out-of-the-box print quality. For a majority of inkjet users, simply building RGB profiles on top of the printer driver may be sufficient for all of their printing needs.

I would go so far as to say that if you plan to combine the inks that came with the printer with papers from the same manufacturer, a RIP is decidedly more of an option rather than a requirement for high quality printing.

The further you stray in your ink and media choices, however, the more important a RIP becomes. The better ones allow you to linearize each ink channel, optimizing output for any media you choose to employ. A RIP will also allow you to bypass print length limitations imposed by printer drivers.

Perhaps the most widely relevant feature of a RIP in today's environment is the ability to create custom layouts of multiple images when printing on a large format machine. Instead of having to combine images into a single Photoshop document, a RIP allows you to load multiple images one at a time onto a single sheet. The size of the layout area is determined by the paper that is actually loaded in the printer. When a roll is loaded, you can gang up images for the entire length of the roll if you want. The limit on print length imposed by the OS on standard printer drivers is not a factor with a RIP.

Colorbyte software has introduced some of the most advanced layout features on the market with the version 7 release of its popular ImagePrint RIP software. Figures 6.50 to 6.52 highlight some of the software's layout features.

Figure 6.50 You can crop an image right within the RIP interface and have it centered automatically on the sheet.

Figure 6.52 Built-in templates provide preconfigured frames to hold images of specific print dimensions and orientation. You can take a single image and easily create prints of different sizes. You can also create your own custom templates.

Figure 6.51 The integrated File Browser makes it easy to drag and drop images from any folder directly onto the layout area.

Pixels to Dots: The Printmaker's Craft

With all of the hardware and software wizardry involved with making a print, it is easy to dismiss the whole affair as a sequence of technical decisions that leave no room for interpretive nuance. But the element of craft is very much a part of printing in the digital darkroom. A good printmaker takes a holistic approach to image production, identifying materials and procedures at each stage of the workflow that can enhance the communicative ability of the image before her.

Of course, this approach is built on a thorough understanding of the strengths and limitations of the tools and materials. There are simply too many choices and options available to randomly outfit a studio with equipment best suited to one's personal style and vision. One of the great advantages to working digitally is the ability to apply techniques, tools, and materials that closely align with the intent of the image. The decision to tint or split-tone an image can add a sense of depth and dimensionality that make the image sustain a viewer's attention. The choice of paper tone and texture can play an important role in amplifying the intent of the image.

You can own the most expensive equipment in the world, but there is simply no underestimating the difference that experience makes in producing fine art prints of consistent and high quality. The digital revolution has undeniably given us conveniences, made some stages of production more creative, and yes, opened the floodgates to mediocre work that masquerades as fine art. But digital printmaking is a craft in every sense that wet darkroom printing has always been.

Printmakers intimately familiar with their equipment and materials can leverage their techniques to extract the essential qualities of a collection of pixels and reproduce them onto paper.

In the next chapter, I will take three images through a step-by-step workflow that ties together many of the concepts and techniques we have explored over the past three chapters.

Title Truman, 33rd, 1945-53
Dimensions 36 × 54 3/8 in.
Paper Somerset Velvet Radiant White
Ink Set PiezoTone Selenium Tone
Printer Epson Stylus Pro 9000

Case Study 2: Alex Forman

Artist Bio

Alex Forman is a multifaceted artist. In addition to her fine-art photography work, she has curated exhibits and is the cofounder of "Jubilat," a literary journal. A limited edition book of her series, *Tall, Slim & Erect,* is forthcoming from Kat Ran Press.

⊙ Download an mp3 audio file of this entire interview by visiting the book's companion Web site at www.masteringdigitalbwbook.com.

The Artist Speaks

Amadou Diallo: *Could you talk about the genesis of your project* Tall, Slim & Erect? *How did this idea to document presidents through these toy miniatures come about?*

Alex Forman: Quite honestly, I just found a collection of toys in a junk shop and was attracted to them. I found them in a box. There were 36 of them—each just under two inches tall, and they're cast in plastic. I didn't really understand my attraction but put out some money to buy them. I think I spent $100 on this collection. I brought them home, and they sat on my shelf probably for two years.

Eventually, I started taking them out of the box and photographing them in different ways: in color, in juxtaposition with one another. I would send them on journeys. Essentially, I just started to play. So, that's how it started, I guess.

AD: *One thing that I noticed when you approached me with this project was that you had devoted quite a bit of research into the histories of each president. How did your research inform your compositions?*

AF: Well, I guess part of it was that I had grown up in Brazil. Although I was born in the States, I lived all over the world when I was a kid, and I somehow missed that fourth grade class where they taught us about the American presidents.

I didn't have a sense of how many presidents we had at all. I remember when I was about 12, seeing a magazine layout with little oval images of all of the presidents, and thinking, "My God, I didn't know that there were more than five or six."

So it was educational for me. I was interested in learning more about American history. I was also interested in the obsessiveness and fascination of Louis Marx in creating this set of figures. He glutted the market with these tiny figures that he would give out for free. They are essentially souvenirs. Yet, they're based on very iconic postures, and even at two inches they had a power for me. I started thinking about their entitlement. Like, "How could a two-inch little figure think he could become president?"

I was interested in the idea of the "American Dream"—how every kid grows up thinking that it's possible for them to become president. I became curious about the actual background of each of these men and what made them think that they could become president, so I started doing some research.

I also found a collection of books at the same time… *The American Heritage Book of Presidents and Famous Americans.* I think they were produced in the '60s, and they were for children. But the information in them is so racy, and so sexy, that I got really sort of turned on by it. I thought, "Wow, this is curious, these guys were kind of messed up, at least a lot of them."

Take Rutherford B. Hayes. In these volumes, it is said that he had a relationship with his sister that went over the bounds of sibling affection. This piqued my curiosity! I discovered that three of our presidents were illiterate until their wives taught them how to read. That four of our presidents were considered gay, even at the time of their presidency. And, I just became really curious about who they were as men.

Or even women—we had one female regent. Edith Wilson was president, ostensibly, when Wilson had his heart attack and wasn't able to work. And so I became real interested in that sort of thing. There's a biographical note as well. I was married at the time, and I was thinking a lot about the entitlement that I felt my husband had. And I was interested just in gender: Why men more often than women felt a sense of entitlement?

So I was looking at these very iconic figures of masculinity as well and trying to get at the base of that. My ex-husband was 6' 4" and 185 pounds, which was exactly the physical dimensions of Lincoln, and so I felt like I had an in. I knew what it would be like to stand in front of him and look up to him, or to hold him. It made him very human to me.

AD: *At the time that I became involved with this project, you brought in negatives and some Polaroid proofs. Of course, the final prints are quite different from those early manifestations of the image. When you composed and shot the images, that was a very solitary endeavor. What was it like then going from that experience to working through the digital editing and printing process, in which you had to communicate your ideas to me as a printmaker in order to reach this final vision of your images as a print?*

AF: Magical. I loved it. I think that was where everything sort of came together for me. I did have a very specific vision of how they would look, and I think part of that was from my own background as a gravure printer. My sense of photography or any kind of fine art has always been that it is good if you want to touch it. And I was interested in making a print that was rich and lush, that had the same attraction that the figurines had to me.

Although I should say that the images that I made are completely different than the figures. They really do transform. It's generally astonishing for someone to look at the prints and then to look at the figures, because they really do look very different.

But the process was amazing, because I had an image in my head, and I had tried all sorts of things. I had tried to print them myself. I had tried making gelatin silver prints, and they all lacked luster—they just didn't match with what I had in my mind's eye. I was dealing with the limitations of the medium, too. I knew that I wanted to enlarge them to be roughly six feet tall. It's very hard to find a lab that prints platinum that size. It's also exorbitantly expensive. The prints that I had made, I didn't like the surface quality of them. They reflected light, as opposed to absorbing it. They didn't feel like objects that I wanted to touch. And I had this vision of what a photogravure print could be, and somebody suggested to me that you were an excellent printer that I should check out. I knew really nothing about digital printing.

So I came and talked to you about it, and you were really very open to what I had in mind. The process of communicating that was a delight. I think I pushed you in certain ways, and there was a lot of back and forth in terms of the right kind of paper. I had very specific ideas, and you were exceptionally willing to try out new things.

AD: *I think one of the attractions for me was that you really did have this very clear and strong sense of what you wanted these images to be. I remember at one point you were talking about how the original figures were plastic, but that they had to feel like they were metal. You were very, very specific as to how you wanted these images to transfer on paper. As a printmaker, that was a fun and exciting process to really have a target like that to shoot for.*

One of the things that really strikes me about the Truman image that is reproduced in this book is the sense of humanity that really comes across in this print. Particularly in the original print that is almost six feet tall. We're talking about an inanimate object that really manages to convey a sense of warmth or openness. Talk about your vision for this particular image. What did you want to convey about Truman?

AF: To be fair, I also came to you with directives that were a little oblique, like "I want these guys to breathe." And "I want them to feel like they're alive. Can you translate that into a print?" Truman seems to me like one of the more pivotal images in a way. He's different from the other presidents in his posture and his pose. He's got his arms outstretched. I think we've become visually literate, and we take clues from the images and the visuals as to what they can tell us about the subject. He's standing there with his hands outstretched and his palms turned up. It's like he's holding something in balance. At the same time, it's a gesture of acceptance. And I think that Truman for me represented… I'll just read you a quote that I picked up about him. "Harry Truman's ramrod posture made him recognizable even with his back to the camera." That seems interesting to me. There is something innate about him; and it's true, anybody who sees that picture can recognize Harry Truman.

He was a post-war president and a Cold War president. His presidency began with the explosion of the atomic bomb. Yet, at the same time, he was somebody who was afflicted with extremely poor eyesight from boyhood. He was left-handed, but his parents made him write with his right hand. He was self-taught. He had read every book in the public library, but he never went to college. With hindsight, he did some horrific, horrific things. But he was also a visionary, in that he proposed legislation that wouldn't be enacted until the sixties, like the Civil Rights Act and Medicare.

He was a person who was full of contradictions. And so it seemed to me that he was holding his life in the balance, too. I mean he was the president of the United States, and yet he was married to a woman whom he had met when he was in the fifth grade and was very devoted to. So he was interesting to me in that way.

AD: *I remember at the opening of the exhibit in New York City, Truman was one of the first images that you saw. It just really set the tone to have something life-size, but an inanimate object, yet with such warmth. The historical and biographical detail that informed your vision of what that image was, I think it really made it a remarkable translation of something that could easily have been seen as kitsch. I think it turned it into something much more profound.*

7

The Imaging Workflow

In the preceding chapters, we've taken in-depth looks at equipment choices, color management options, and techniques related to scanning, raw conversion, editing, and printing. Now it's time to tie all of these elements together in the service of producing a finished image. This chapter offers an illustrated guide to evaluating, editing, and preparing an image for output. I will take three separate images through a complete workflow. The first image is destined for an Epson printer outfitted with a third-party monochrome ink set. The second image is to be printed on an HP model using the OEM printer driver's split-toning options. The final image will be prepared for Web output. Each step of the process is illustrated with screenshots, as well as commentary regarding the thought process behind creative decisions.

Raw File: An ACR/Photoshop Split Workflow

Adobe Camera Raw (ACR) comes bundled with Photoshop and provides an impressive array of tools for generating gamma-corrected images from raw files. ACR does not render Photoshop obsolete, however. Localized edits still require a trip to Photoshop. In addition, optimizing files for various output devices can involve changes to file size and bit depth, color space conversion, and image sharpening that must be carried out in Photoshop. In this example, I will demonstrate a workflow that leverages the raw conversion capabilities of ACR with the pixel editing strength of Photoshop. We will end up with a raw file, master file, and a derivative prepared specifically for inkjet output. Figure 7.1 shows the raw file as rendered by ACR's default conversion settings.

Figure 7.1 Before Image: This is a TIFF from the original raw file converted with ACR's default settings.

Capture Notes

This photograph in Figure 7.1 was taken during a boat excursion through a land-locked fjord inland of Newfoundland's western coast. The boat sailed during mid-day, and the cloudless sky made wide-angle compositions impractical due to extreme contrast. I chose the longest lens in my bag and isolated a small area of glacier-carved rock that was shielded from the sun by overhanging cliffs. The challenge involves turning the range of subdued tones of the original color image into a black-and-white composition with a satisfying tonal range, while maintaining important image detail.

- Camera: Canon 20D
- Lens: Canon EF 200mm f/2.8L USM
- Exposure: Handheld, 1/320 sec @f/8
- Location: Western Brook Pond, Gros Morne National Park, Newfoundland

Imaging Goals

One of the most interesting elements of the image for me is the juxtaposition of the S-shaped path of the water against the triangular-shaped and hard-edged cutout in the rock face. The final image will be converted to grayscale. I want it to have more contrast to accentuate the juxtaposition between water and rock and give a greater sense of both weight and scale to the subject.

Image Adjustments

Image editing will begin in ACR version 4 where I will make the conversion to a grayscale image. In Photoshop, I will apply localized edits using the Curves tool and History Brush in combination. I will then apply capturing sharpening using the PhotoKit Sharpener plug-in to arrive at a "master" file.

1. Adjust the white balance (see Figure 7.2).

2. Control highlight clipping with the Recovery slider (see Figures 7.3 and 7.4).

3. Convert to grayscale (see Figures 7.5 to 7.7).

Figure 7.2 I make a slight adjustment to the white balance by clicking in the waterfall (red circle). This step is optional since I'll be converting the image to grayscale, but I prefer to begin with a pleasing color balance.

Figure 7.3 With the white balance set I click the Highlight clipping warning icon (circled). A significant amount of the water (highlighted in red) is blown out.

Figure 7.5 In the HSL/Grayscale tab, I select Convert to Grayscale. This automatically desaturates the image. The default setting for Grayscale Mix desaturates by giving equal weight to all of the hues.

ACR Grayscale Conversions

When you select Convert to Grayscale in ACR, the destination color space automatically changes to a grayscale setting. (Compare the Workflow Options settings in Figure 7.5 with those in Figure 7.4.) This means that any conversion of this raw file will now result in a single channel grayscale image.

Figure 7.4 New to CS3 is the Recovery slider in ACR. Setting it to a value of 22 eliminates the clipping but without darkening the overall image. Compare the far right end of this histogram to the histogram in Figure 7.3.

My goal when desaturating an image is to create as much tonal separation as possible. In Figure 7.6, the Preview box near the top of the ACR window allows me to toggle back and forth between the color and grayscale rendering to get a sense of which hues to adjust. See Figure 7.7 for a before-and-after comparison.

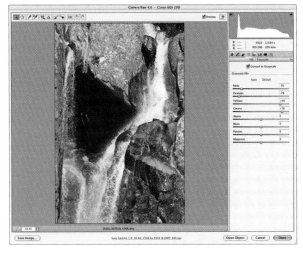

Figure 7.6 Darkening the reds and oranges, while lightening the yellows and greens, provides a bit more separation among rock tones.

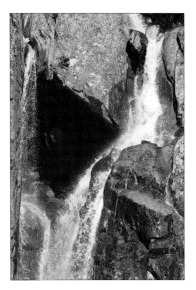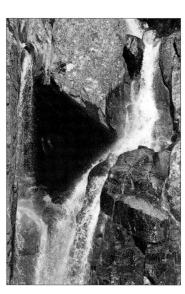

Figure 7.7 At left is the default grayscale conversion. On the right, I have applied the custom settings shown in Figure 7.6.

The differences in Figure 7.7 are subtle and may be hard to distinguish due to the reproduction limitations of this book. But aiming for tonal separation at this stage in the workflow will allow for a wider range of options later in both global and localized contrast adjustments.

4. Adjust the image with the Tone Curve (see Figure 7.8).

5. Save the image to a gamma-corrected TIFF format (see Figure 7.9).

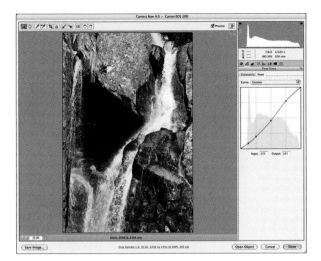

Figure 7.8 With a grayscale rendering of the image, I go to the Tone Curve tab and make adjustments to the Point Curve. I bring down the shadow values and brighten lighter areas of rock to increase contrast. The moves are fairly small, and I have turned on both the Shadows and Highlights clipping previews to avoid losing important image detail.

Figure 7.9 The image is now ready for conversion. Further edits will be made in Photoshop. I click the Save button, select a folder destination, and append "ACRedits" to the file name to reflect the image's status in the workflow.

Essential Shortcuts

To quickly toggle the Preview check box, use the keyboard shortcut P. You can also undo your last settings change in ACR with the shortcut Cmd+Z.

Linear Data Editing

The Curves tool in ACR is working behind the scenes on linear gamma raw data. Even very small moves can result in dramatic changes in contrast. For more refined control of tones, particularly in the shadows, you can use the Curves tool in Photoshop.

6. In Photoshop, set highlight and shadow endpoints and make global contrast adjustments (see Figures 7.10 and 7.11).

7. Make selective, or localized, image edits using the Curves tool and the History Brush (see Figures 7.12 to 7.17).

 The change in Figure 7.15 is subtle and may be hard to distinguish due to the reproduction limitations of this book, but it allows the interior rocks to become more visible. Providing subtle shadow details can often draw a viewer into the image, both literally and figuratively.

8. Apply capture sharpening (see Figure 7.18).

9. Convert the image back to grayscale mode.

10. Save a master image from which all derivatives will be produced (see Figure 7.19).

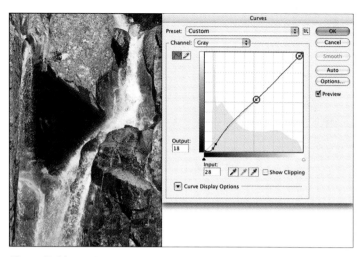

Figure 7.11 In the Curves dialog box, I lock down points at the midtone and highlight regions (circled in red) to maintain current tonal values at those locations. This curve brings the darkest shadows down to a near black. The solid point toward the bottom of the curve further restricts the darkening effect and even brightens pixels in the three-quarter tone range.

Figure 7.12 The first step is to create a snapshot to identify the before state. Here I label it *precurve1*.

Figure 7.10 Use the shadow and highlight clipping preview in the Curves dialog box to identify the darkest (top) and brightest (bottom) pixels in the image. If you're using an earlier version of Photoshop, you can generate the same clipping preview in the Levels dialog by holding the option key while dragging the endpoint sliders.

Figure 7.15 At left is a crop of the area before the edit. At right is the area after painting with the History Brush.

Figure 7.13 This curve opens up some detail in the crevice of the rock face (highlighted in red). The rest of the image is now too bright, but I will restrict this adjustment in the steps that follow by creating a new snapshot called *lighten crevice.*

Figure 7.14 In the History palette, I select *precurve1* as the image state, set *lighten crevice* as the source, and paint with the History Brush over the rocks in the crevice at an opacity of 50 percent.

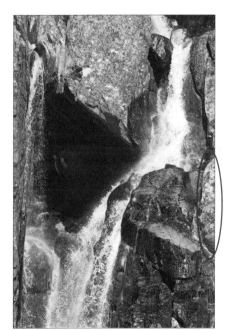

Figure 7.16 To create a sense of directional light that illuminates the scene from the top, I want to darken the rock area circled in red.

Figure 7.17 I create a new snapshot, *stage1* (left). I create and apply a curve that darkens the rock (middle). I save a new snapshot, *darken rock*, set the image state to *stage1* and the history source to the *darken rock* (right). I then paint in the edit over the area highlighted in Figure 7.16.

Figure 7.18 PhotoKit Sharpener requires that images be in RGB mode. The first step is to convert the image (left). Next, I choose the high-resolution sharpener set with a medium-edge sharpening routine (right).

Figure 7.19 The appendage "_cs" to the file name indicates that capture sharpening has been applied.

Epson Inkjet Output with a RIP

Now that I have a master file, it is time to prepare a print-ready derivative file. I will print on an Epson 9600 outfitted with a PiezoTone selenium/sepia blended ink set. I will use StudioPrint RIP to drive the printer. My own testing has determined that files from my Canon 20D can produce high-quality prints, even at a resolution as low as 240 ppi.

1. Set the image resolution (see Figure 7.20).

2. Reduce the image to 8 bits and save the print derivative file (see Figure 7.21).

3. Apply output sharpening (see Figure 7.22).

4. Create an image layout in StudioPrint RIP and print the image (see Figures 7.23 and 7.24).

5. Compare the before and after images (see Figure 7.25).

Figure 7.20 When I set the image resolution to 240 ppi without resampling pixels, I get a print size of 9.733 × 14.6 inches.

Figure 7.22 PhotoKit Sharpener offers settings for specific paper type and file resolution.

Figure 7.21 For a smaller file size and faster print spooling, I reduce the bit depth from 16 to 8 (left). I perform a Save As and name the file to reflect its output destination (right).

Figure 7.23 I can easily lay out multiple copies of the image with print borders of my choosing. The images will then print with trim marks for easy cutting.

Figure 7.24 In StudioPrint, I choose a custom Print Environment. Each one is associated with a specific set of driver settings and ink/paper linearization to maintain precise and consistent output.

Black-and-White Negative: An Adjustment Layer Workflow

The most powerful feature of Photoshop is its ability to allow for precise edits targeted at specific areas in an image. Layer masks play a crucial role in applying localized edits that can be continuously tweaked over many editing sessions. In this example, I will use multiple Curves adjustment layers to reconfigure tonal relationships throughout the image. I will then prepare the image for printing and utilize the well-designed toning options available in the HP Designjet Z3100 printer driver. Figure 7.26 shows the image as captured by the scanner with no contrast adjustments applied.

Capture Notes

This photograph (Figure 7.26) was taken in the early morning after a fresh snowfall. The scene is much busier than ones I am normally drawn to capture. But the curved path of the creek leading to the

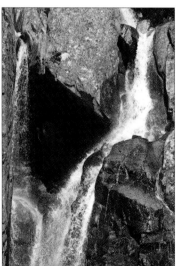

Figure 7.25 The default raw conversion is at left and a reproduction of the final print is on the right.

Figure 7.26 This is the unmodified scan of the film.

boulder is an irresistible compositional element. The challenge here is to make the scene feel less cluttered and draw the viewer's eye along the path of the creek to the boulder.

- Camera: Canon EOS 3
- Lens: Canon EF 20mm f/2.8 USM
- Film: Kodak TMax 100
- Exposure: Tripod, 1/4 sec @f/5.6
- Digital Capture: Drum Scan @4000 ppi
- Location: Prospect Park, Brooklyn, New York

Imaging Goals

The image was scanned flat—with no adjustments in the scanner software. This ensured that all of the tonal range was captured, but it results in a very low contrast image with very little tonal separation. There obviously needs to be a significant contrast adjustment. But I also want to create a sense of depth or dimensionality to the image.

Image Adjustments

The image edits will take place exclusively in Photoshop. I will use the Curves tool in combination with adjustment layers, layer masks, and the Brush tool in order to apply localized contrast adjustments. In Figure 7.27, I have outlined important subject areas in red. In winter snow scenes with an overcast sky, there is often a hazy, low-contrast feel to distant objects. I want to add much more contrast to foreground objects like the reflections in the water (1) than to the distant tree line (3). The snow will need to be brightened (2), and the boulder in the middle of the creek (4) should become a focal point of the image.

1. Build density with a blending mode (see Figure 7.28).

Figure 7.27 I have identified important areas of the image that will require individual attention during the editing stage.

Figure 7.28 An easy way to automatically build density in a low contrast scan is to create an empty adjustment layer and set the blending mode to Multiply. Here, I chose a Curves layer, but any of the other choices will do. This empty adjustment layer does not add to the file size.

2. Set highlight and shadow endpoints and make global contrast adjustments (see Figures 7.29 and 7.30).

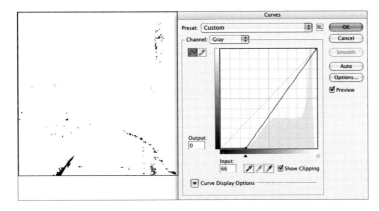

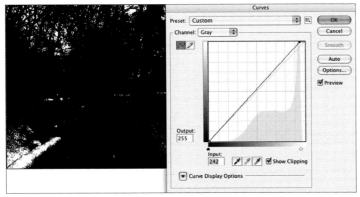

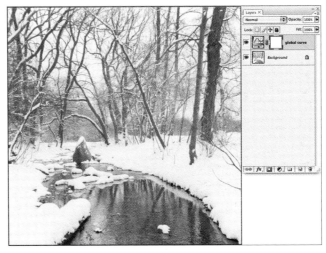

Figure 7.29 I use the shadow and highlight clipping preview in the Curves dialog box to identify the darkest (top) and brightest (bottom) pixels in the image. If you're using an earlier version of Photoshop, you can generate the same clipping preview in the Levels dialog by holding the option key while dragging the endpoint sliders.

Figure 7.30 I use the Curves tool to darken quarter tones and midtones, while keeping the shadows and highlights at their current values. The edit also places midtones at a more pleasing gray value. I name the layer *global curve.*

3. Create localized edits using adjustment layers and the Brush tool (see Figures 7.31 to 7.41).

The curve in Figure 7.31 significantly increases contrast and draws attention to the reflections in the water. The rest of the image obviously receives too much contrast, so this edit must be applied selectively.

In Figure 7.35, I turn my attention to the trees and boulder. The lockdown point near the top of the curve maintains the tonal values of bright highlights.

In Figure 7.39, I want to add some directional lighting to the boulder.

In Figure 7.41, the mask areas painted gray indicate a reduction in brush opacity. Figure 7.42 shows the image with all of the above edits applied.

Figure 7.32 I select the layer mask *foreground water* and go to Image>Adjustments>Invert. This switches the mask from white to black. The effect of the curve is now hidden.

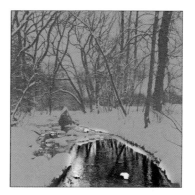

Figure 7.33 With *foreground water* selected, I paint directly on the mask with white to reveal the edit in the desired area. At left is the mask after painting, as seen in Quick Mask mode. The edit is hidden in areas marked red. At right is the mask itself.

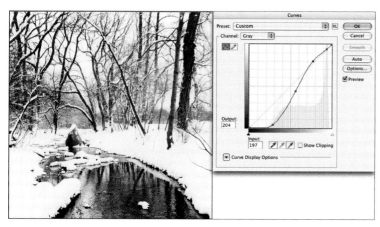

Figure 7.31 I create a new Curves adjustment layer to address the foreground water area. I name the layer *foreground water*.

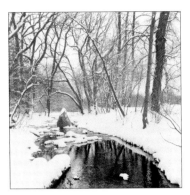

Figure 7.34 Here, you see the image with the localized edit applied.

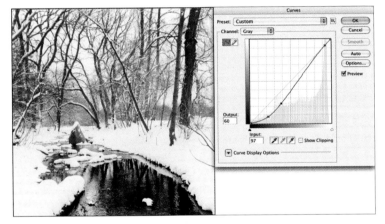

Figure 7.35 This Curves adjustment darkens the shadows, midtones, and to a lesser degree the quarter tones. This edit will be applied selectively. I name the layer *foreground trees*.

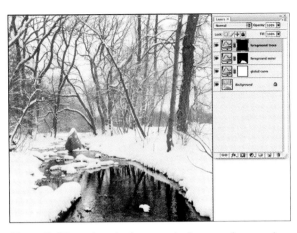

Figure 7.36 I select the layer mask *foreground trees* and go to Image>Adjustments>Invert. This switches the mask from white to black. The effect of the curve is now hidden.

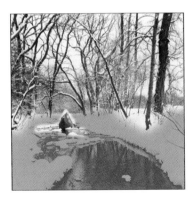

Figure 7.37 With *foreground trees* selected, I paint directly on the mask with white to reveal the edit in the desired area. At left is the mask after painting, as seen in Quick Mask mode. The edit is hidden in areas marked red. At right is the mask itself.

Figure 7.38 Here, you see the image with the localized edit applied.

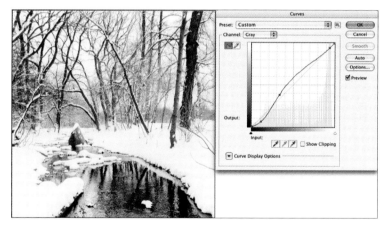

Figure 7.39 This curve darkens the shadow areas on the left side of the boulder, while opening up the three-quarter and midtone areas along the right. This edit will be applied selectively. I name the layer *rock*.

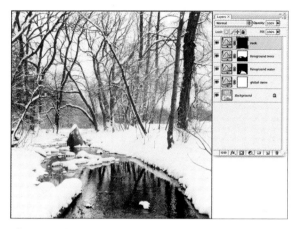

Figure 7.40 I select the layer mask *rock* and go to Image>Adjustments> Invert. This switches the mask from white to black. The effect of the curve is now hidden.

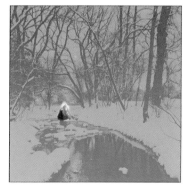

Figure 7.41 With *rock* selected, I paint directly on the mask with white to reveal the edit in the desired area. At left is the mask after painting, as seen in Quick Mask mode. The edit is hidden in areas marked red. At right is the mask itself.

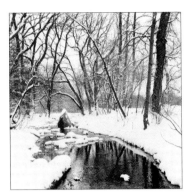

Figure 7.42 The image now has a full range of tones and pleasing contrast.

4. Apply capture sharpening (see Figure 7.43).

5. Convert the image back to grayscale mode.

6. Save a master image from which all derivatives will be produced (see Figure 7.44).

Figure 7.43 PhotoKit Sharpener requires that images be in RGB mode. The first step is to convert the image (left). Next, I choose the 35 Slow Negative Film sharpener set with a Narrow Edge Sharpen routine (right).

Figure 7.44 The appendage "_cs" to the file name indicates that capture sharpening has been applied. Note that layers will be saved with the master file.

HP Inkjet Output

Now that I have a master file, it is time to prepare a print-ready derivative file. I will print to an HP Z3100 using the OEM Vivera inks and printer driver. The file will be printed at an image resolution of 300 ppi.

1. Reduce the bit depth and set the print dimensions (see Figure 7.45).

2. Apply output sharpening (see Figure 7.46).

 I am going to use the printer driver to alter the color of an image. This is a different print condition from the one under which I created the ICC profile. So I must tell Photoshop that the printer is handling color management (see Figure 7.47).

3. Configure the print settings in CS3's Print dialog.

4. Adjust the tint controls in the HP printer driver for a custom split tone (see Figure 7.48).

Figure 7.45 I set the resolution to 300 ppi without resampling pixels (left). This gives me a print size of 8.227 × 8.193 inches. For a smaller file size and faster print spooling, I reduce the bit depth from 16 to 8 (center). I perform a Save As and name the file to reflect its output destination (right).

Figure 7.46 PhotoKit Sharpener offers settings for specific paper type and file resolution.

Figure 7.47 I configured Photoshop to let the printer handle color management.

Figure 7.48 I have chosen a cool tint for the highlights and a warm tone for the shadows. Midtones will retain the natural hue of HP's Vivera black inks.

5. Compare the before-and-after images (see Figure 7.49).

Figure 7.49 The original scan is at left and a reproduction of the final split-toned print is on the right.

3D Scan: A Composite Image

This image begins as a direct flatbed scanner capture. When you use a flatbed scanner to digitize three-dimensional objects, you are turning the scanner into an inexpensive yet extremely high-resolution digital camera. When you scan with the lid open, the short throw of the scanner's light source renders the background as a solid black. Special care must be taken to avoid scratches when placing objects directly on the glass scan bed. But using a scanner to create the photograph is becoming an intriguing option for a number of photographers.

Capture Notes

I cut strips of paper to make simple forms, which I used to arrange the beans directly on the scan bed, as seen in Figure 7.50. After carefully removing the forms, I created a prescan in SilverFast Ai and drew a marquee around the final scan area, as shown in Figure 7.51.

Figure 7.50 The circular forms allow me to easily reposition the beans while maintaining the desired shape.

Figure 7.51 The letter-sized scan area common to most flatbeds offers the potential for very large image files even at moderate scan resolutions. Scanning a 7.4 × 9.5-inch area at just 900 ppi yields a 352MB high-bit RGB file.

When scanning such a large area, I have no shame in going against my rule of scanning at the maximum resolution. With such a large physical area to scan, file size can easy surpass 1GB.

1. Arrange the materials on the scan bed (see Figure 7.50).

2. Determine an appropriate scanning resolution (see Figure 7.51).

■ Digital Capture: Epson Expression 1680 Pro

■ Resolution: 900 ppi

■ Scanning Software: SilverFast AI 6.5

Imaging Goals

The challenge here is to create a composite image. The black background of the original scan will be replaced with a patterned fabric that was scanned at an identical size and resolution. The beans will have to be separated from the original background and blended seamlessly with the fabric. The image will then be optimized for Web output.

Image Adjustments

This image will be scanned and then combined with another image in Photoshop. I will use two new features of CS3. The Black and White command will be used for the monochrome conversion, and the Quick Selection tool will be used to combine two separate images into a seamless composite.

1. Confirm that no image data is being clipped during the scanning process (see Figure 7.52).

2. Save a copy of the unmodified scan for archiving purposes (see Figure 7.53).

3. Locate the highlight and shadow endpoints (see Figure 7.54).

In Figure 7.54, you will notice that the clipping previews show pixel locations in color. Remember that we are working with an RGB image at this point. The darkest pixels show as red, indicating the red channel. The brightest pixels include yellow, which indicates both the red and green channels. In instances where all three channels are clipping, the preview will be white (for the highlights) or black (for the shadows).

Figure 7.52
SilverFast's multichannel histogram view confirms that no data is being clipped in either the shadows or highlights.

Figure 7.53
Immediately after the scan is complete, I perform a Save As and select the Save As a Copy option. The copy becomes my digital negative and is stored on a separate hard drive. The current file remains open.

Figure 7.54 I use the shadow and highlight clipping preview in the Curves dialog box to identify the darkest (left) and brightest (right) pixels in the image. If you're using an earlier version of Photoshop, you can generate the same clipping preview in the Levels dialog by holding the option key while dragging the endpoint sliders.

4. Apply capture sharpening (see Figures 7.55 to 7.58).

 One of the greatest features of PhotoKit Sharpener is the ability to easily modify the strength of the sharpening after it is applied. At its default setting, I felt the sharpening was just a tad overdone.

5. Convert the image to grayscale (see Figures 7.59 to 7.62).

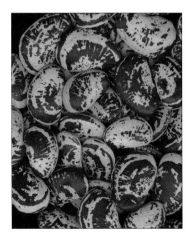

Figure 7.55 For this direct scan capture, the Scanning Back Sharpen option in the PhotoKit Capture Sharpener routine is most appropriate.

Figure 7.56 At left is a crop of the image before capture sharpening. To the right is the result after sharpening. Both are reproduced here at 100 percent screen view.

Figure 7.57 This set of before and after comparisons is shown at 200 percent screen view to make the difference more obvious in this offset printed book. At left is the image before capture sharpening. To the right is the result after sharpening.

Figure 7.58 In the Layers palette, I select the Dark Contour layer created by the sharpening routine and reduce its opacity from 60 percent to 40 percent. This reduces edge contrast specifically by keeping edge pixels from becoming too dark. The image is shown here at 100 percent screen view.

Figure 7.59 The Black and White dialog's default setting converts the color image (top) to monochrome (bottom).

Figure 7.60 I want to increase contrast. Clicking on the dark portion of a bean shows red as the principal color component. I bring that hue down to a much lower luminance. The lighter part of the bean is composed largely of yellow. I brought that area much higher along the brightness scale.

Figure 7.61 To make sure that this contrast increase does not unintentionally clip any part of the tonal range, I use two color samplers. Their values indicate that both shadows and highlights are well protected.

Figure 7.62 Even though the image is desaturated, the file itself is still in RGB mode. After achieving a pleasing monochrome conversion, I convert the image to grayscale mode.

6. Adjust global image contrast (see Figures 7.63 and 7.64).

7. Build the composite image (see Figures 7.65 to 7.70).

Figure 7.63 I create an S-shaped curve for greater contrast.

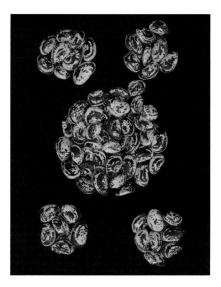

Figure 7.64 Here is the image after the edits and grayscale conversion.

Figure 7.66 I need to create a mask that separates the beans from the scan bed in order to reveal the fabric. With the beans layer selected, I duplicate the gray channel. I will alter the contrast of this duplicate channel to create the mask.

Figure 7.65 I have scanned some fabric to use as the new background for the image. With both document windows open, I use the Move tool (circled in red) to drag the fabric onto the beans image. Holding the Shift key aligns the centers of the two layers.

Figure 7.67 With the duplicate channel selected, I go to Select>Color Range. I click the black background and adjust the Fuzziness slider to select as much of the black as possible.

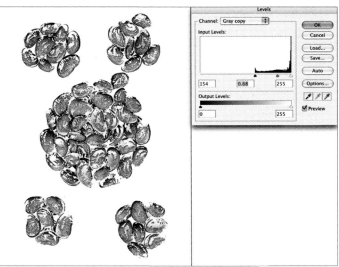

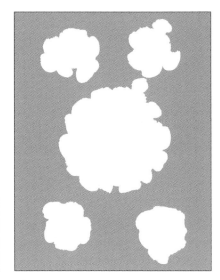

Figure 7.68 With white as the background color in the Tools palette, I press the Delete key to replace the selection with white (left). I then apply a strong Levels adjustment (right). This gives me the greatest amount of contrast along the outermost edges of the beans.

Figure 7.69 I call up the CS3's new Quick Selection tool (W) and paint inside the beans. This creates a fairly precise marquee around the contour of the bean's edges. Here, you can see the resulting selection in Quick Mask mode.

Figure 7.70 I click the Save Selection as Channel button (left) and name the new channel *rough silo* (center). The selection is now saved in the Channels palette (right).

8. Fine-tune the blend of the image layers (see Figures 7.71 to 7.75).

Figure 7.71 With the beans layer highlighted, I click the Add Layer Mask button.

Figure 7.73 I load the selection of the beans mask by Cmd-clicking its icon (left). With the beans mask highlighted in the Channels palette (right), I click the Refine Edge button in the toolbar (bottom).

Figure 7.72 The selection has now become a mask (left), which reveals the fabric layer. A 100 percent view of the image shows areas where the mask edges need improvement (right).

Figure 7.74 In the Refine Edge dialog box, I adjust the Smooth and Feather settings to expand the selection and soften the edge transitions (left). The resulting mask is at right.

Figure 7.75 In Quick Mask mode, I paint in some areas of the mask for a more precise composite. Compare the view here (right) to that in Figure 7.72.

9. Adjust the contrast and composition of the composite image (see Figures 7.76 and 7.77).

10. Save a master image from which all derivatives will be produced (see Figure 7.78).

Figure 7.76 I add separate Curves adjustment layers to the fabric (top) and to the beans (bottom) for a better match in contrast.

Figure 7.77 A tighter crop creates a composition that better emphasizes the juxtaposition of the patterns on the beans and the fabric.

Web Output

Now that I have a master file, it is time to prepare a derivative file suitable for the Web. In addition to resizing the image for optimal viewing in a Web browser, I will change the image's color space to sRGB, the de-facto standard for the Web.

1. Reduce the bit depth, convert the image to sRGB, and reduce the resolution (see Figures 7.79 and 7.80).

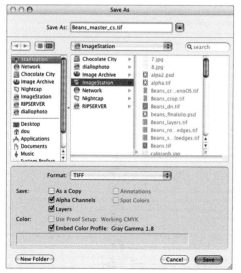

Figure 7.78 The appendage "_cs" to the file name indicates that capture sharpening has been applied. Note that layers and alpha channels will be saved with the master file.

Figure 7.79 To prepare the image for the Web, I will convert it to an 8-bit image (left), change the mode to RGB (right), and convert the color space to sRGB (bottom).

Figure 7.80 I go to Image>Image Size and change the Resolution to 72 pixels/inch and the Width to 1,024 pixels. The Resample Image box is selected.

Figure 7.82 I save the derivative file with the appendage "_web" to indicate its intended output.

2. Apply output sharpening (see Figure 7.81).

3. Save the file in JPEG format (see Figures 7.82 and 7.83).

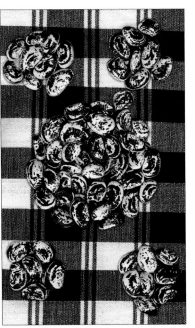

Figure 7.83 Here is a reproduction of the final image.

Figure 7.81 PhotoKit Sharpener offers settings for specific pixel dimensions determined by the width of the image. After sharpening is applied, I flatten the image (right).

8

The Limited Edition

The very idea of selling your photographs can invoke feelings of both pride and apprehension. We'd all like to think that our best work deserves a place on someone else's wall. Yet the confidence we have in our photographic technique and vision does not often translate to the daunting task of preparing our images as commodities for the art market. A number of left-brain decisions need to be made. But none will have consequences as far reaching as the choice to create a limited edition.

A captivating image is special whether it hangs in a gallery or remains on your living room wall. But the perceived value of any piece of art is unquestionably influenced by the context in which it is produced and displayed. Creating a body of work for seasoned collectors involves marketing considerations and places a greater level of responsibility on artists for documenting their output.

In this chapter, I'll weigh the benefits and responsibilities that come with editioning your work, provide some historical background of editions in the visual arts, and discuss the ethical and legal requirements that come into play when you designate a limited edition print. Then we'll take an in-depth look at ways to maximize image longevity, a key consideration for any work designated as a limited edition. This will be followed by an interview with Henry Wilhelm, who talks about the current state of inkjet image permanence.

What Is an Edition?

The term "edition" comes to us from traditional printmaking. It can be defined most simply as multiples of original art produced from a single matrix. This short definition provides very important distinctions based on two key terms. The *matrix* is the structure that contains either the latent or visible image.

It is created by, or under, the direct supervision of the artist. In traditional printmaking, the matrix can be carved wood, painted stone, or engraved copper plate. In Figure 8.1, a sheet of linoleum is used as the ink-receiving surface. It becomes worn with use and at a certain point can no longer produce satisfactory prints. In the wet darkroom, the matrix is the exposed negative. In digital photography, it is the collection of ones and zeros that comprise the image file itself. A distinguishing feature of the photographic process is that the matrix can be reused with no loss in print quality (see Figure 8.2).

Multiple has a very precise meaning and is not to be confused with the term *reproduction*. A multiple is conferred all of the status of an original artwork. Each multiple in an edition derives from the same matrix and is produced using the same medium. Multiples are virtually identical because they are produced by a repeatable

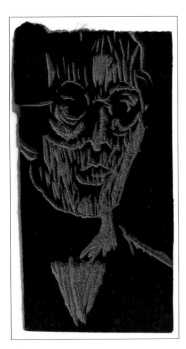

Figure 8.1 This linocut by New York artist Ethan Cornell was created by cutting into the linoleum and then inking the uncut areas of the surface. Transferring the ink directly onto paper creates a print. *Image courtesy of Ethan Cornell*

Figure 8.2 The film negative (top) and digital image file (bottom) are the two most common sources of photographic prints.

mechanical means. Whether running a plate through a press or sending an image file to a printer driver, there is no manual alteration of the matrix. In Figure 8.3, you see examples of two prints created through different mediums. They cannot be considered to be part of the same edition.

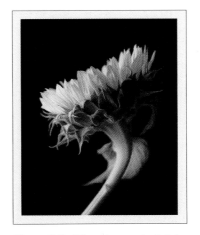
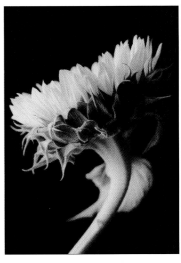

Figure 8.3 The print on the left is a multiple in an edition created using an inkjet printer. At right is the same image, but as a postcard reproduction created with an offset printing press.

It is now easy to see the major distinction between printmaking, which is a serial medium and say, painting, in which a single original is created. But it's worth noting that the rise of digital printing has created an interesting relationship between the two mediums. Consider an artist who paints with oil on canvas. The painting is an original work of art. There is no matrix. The entire work was created in its finished form by the hand of the artist. But she may decide to create a reproduction by digitally capturing the painting with an

eye toward making an inkjet print on canvas. No matter how great the fidelity of the digital capture or how brilliant the colors of the inkjet output, the artist has created a reproduction of the original. The print may be visually indistinguishable from the painting. It may even look "better" than the painting. No matter. The print was produced in a different medium than the painting and cannot be sold as an original artwork. It is designated as a reproduction.

It is true that the artist can decide to produce a limited edition reproduction of the painting, using these prints on canvas. Each print will be a multiple of the reproduction. I'll talk more about the ethical and legal requirements of print editions later in this chapter. But this example shows the importance of understanding the terminology used in the fine art market when producing editions.

There are two broad categories of editions. In an open edition, the number of multiples to be produced remains an open question. An artist can make 10,000 editions from the matrix if demand and materials allow. On each print of an open edition, a number is typically affixed to indicate the chronological order in relation to the entire edition. Much like a serial number, a print with an edition number of 10 will have been produced earlier than a print bearing the number 150.

In a limited edition, the number of multiples is fixed at the time of the edition's creation. Only a set number of prints will ever be produced from the matrix. Once that predetermined limit is reached, there are to be no more originals created from the matrix. A limited edition print is designated with two numbers separated by a slash. The first number identifies a print's chronological order in relation to the entire edition. The second number indicates the total size of the edition. A print marked 3/50 indicates the third print produced in an edition of 50.

The limited edition is much more common than the open edition in today's fine art market and is therefore the primary focus of this chapter. Unless otherwise noted, I will simply use the term "edition" to refer to the practice of a fixed, or limited, production of originals.

I'll be blunt. In photography, the creation of an edition is purely a marketing strategy whose aim is to create scarcity and thus increase the value of each print. I don't mean to suggest anything unsavory about the practice. I count myself among the large number of fine art photographers who sell work in limited editions. I'll look at some of the reasons behind this choice in the very next section. The point I do want to make is that in photography—unlike traditional forms of printmaking where the matrix has a finite lifespan—editioning your work is a choice. The decision to create an edition provides certain benefits but also entails some very real responsibilities.

The Benefits

The most compelling reason to edition your work is the increased monetary value it confers on individual prints. Simply put, many buyers will pay a premium if they can be assured that what they purchase will remain relatively scarce. By agreeing to limit the production of prints from the matrix, you offer the buyer an opportunity to own something rare.

Selling editions is a classic example of the high margin, low volume sales strategy. By setting a high price for a single print, it takes relatively few sales to earn a given amount of money. Do you have more confidence in your ability to sell 10 prints at $500 each than 1,000 prints at $5 each? If so, creating an edition paves the way for you to command this higher print price.

The sales history of an edition also provides an objective, market-driven determinant of print pricing. It is common practice for the price of a print to increase as the edition sells. Print 18/20 will command a higher price than print 1/20, simply because it is one of only three remaining opportunities to purchase the print.

Demand-driven pricing can also encourage buyers to make purchases earlier in the life of the edition. If charging late buyers a higher price than early ones seems unfair, consider that few of us complain when we've bought something at a lower price than is currently available. We are likely to be happy that we got a bargain.

There are many avenues through which you can sell your work. But you should be aware that galleries catering to well-heeled collectors will generally require that photographic prints be editioned. Gallery owners strive to make as much money from each sale as they can. That is a requirement to stay in business. Below a certain selling price, they stand little chance of recouping their overhead and promotional costs in a timely manner.

Collectors who spend large sums on art often do so with an eye toward the work's appreciation in value. A painting and a photograph by artists of equal reputation will always be priced differently. The painting has a greater perceived value because there exists only one original. Yet a photographer can make an unlimited number of identical prints from a single negative or digital file. The only way to bring a photograph closer to a painting with regard to scarcity is to artificially limit its production. The edition is the accepted mechanism for doing just that.

One of the big advantages that digital printing has wrought is the ability to print-on-demand. Inkjet printers in particular (see Figure 8.4) are very efficient at low-volume printing. Unlike commercial presses, an inkjet printer can be set up easily to print just a single image. Should you decide on an edition of 50 prints, you don't need to produce all 50 at once. Instead, you can choose to print only when you generate a sale. You eliminate the need for storage of unsold prints. But the designation of the edition size at the outset guarantees to buyers the maximum number of prints that can ultimately end up in the marketplace.

Figure 8.4 Large format inkjet printers, like the Canon imagePROGRAF IPF8000, are very consistent in their output and have low operating costs. *Image courtesy of Canon USA*

The Responsibilities

Should everyone edition their prints? Even though I'm devoting almost a full chapter to the process, the answer is no. Creating editions is not in every photographer's best interests. And a photographer who chooses not to edition is by no means conceding the inherent quality of her photographic vision or technique. When you create an edition, you accept a significant responsibility for thoroughly documenting your production and materials. The moment you offer an edition for sale, you are bound by accepted ethical standards, and in many states, by specific legal requirements. I'll discuss both of these later in this chapter, but the decision to sell an editioned print is not one that should be taken lightly.

If the thought of pricing your work makes you uneasy, an edition requires that you take the additional step of arbitrarily limiting the image to a fixed number of multiples. Predicting what people will pay for your work and how many pieces will sell is difficult under any circumstances. That's particularly so if you are selling your work for the first time or are moving into a new market where you have no previous history by which to estimate sales. Once you sell to a

buyer based on the premise of a specific edition size, you're stuck with it. No matter how popular an image becomes, you must honor the terms under which the print was sold.

Print documentation becomes very important with editions. Buyers are entitled to information about image dimensions, production date, materials used, the actual printmaker if you did not print it yourself, and additional prints that are already in the market, including artist proofs that have been gifted. Precise and reliable record keeping, including the tracking of print sales, must form the foundation of any attempt at creating an edition in accordance with professional standards.

Providing buyers with the appropriate documentation can help establish trust that you will honor the edition size. But it still falls squarely on your shoulders to protect the integrity of the edition. The ease with which digital image files can be duplicated and transmitted makes this task much more difficult. At a minimum, you should be prepared to take the following steps if you are going to guarantee the size of the edition.

- Limit duplicates of the matrix to backup copies.

- Ensure that the matrix and any duplicates remain in your personal possession or that of the printmaker responsible for the edition.

- If versions of the matrix must be distributed, then alter the size, resolution, or content so that any prints produced from them will be visually distinguishable from the prints in the edition.

- As each print of an edition is produced or sold, update your records to reflect the status of the edition.

- Once an edition is sold out, the matrix and all duplicates should be accounted for.

As you can see, these steps involve no small amount of work on your part. If you sell directly to buyers and have a pricing structure that is both popular and provides you with satisfactory income, then the time spent on devising a strategy for editioning your prints could be better spent on making photographs.

Look Before You Leap

The decision to edition your work is a personal one and can be influenced by many factors. A gallery may demand that you edition before it will even consider showing your work. You may have decided that a low volume high markup sales strategy is more suited to your marketing strengths. Whatever the reason, you'll find that a number of decisions need to be made. Which images should I edition? What should be the edition limit? Should pricing remain constant or increase according to popularity?

Unfortunately, there are no hard and fast answers to these questions. The fine art market is in many respects quite provincial and fluid, adopting practices and standards as trends emerge. So before coming up with arbitrary answers to these questions, it pays to do some research into the choices of those targeting a similar audience through comparable sales channels.

Having said that, however, there are a few common practices you will find as you visit galleries and artist Web sites. Prints of large dimensions are editioned in lower quantities than small or medium-sized prints. Photographers may limit their 30 × 40-inch prints to editions of five, while their 16 × 20-inch prints may be editioned at 50 prints. The thinking here is that fewer buyers will have the space and budget for larger prints.

You will also find that edition numbers are consistent at a given size and print medium for a single artist. If all of your inkjet prints are the same dimensions, you'll want to have them at the same edition

size. Remember that the whole point of limiting an edition is to confer a perceived value. And if some 8 × 10 prints are editioned at 15, while others are editioned at 50, you have created the impression that the latter series of prints is inferior to the former. Judgments of the relative worth of your images are best left to the buyers. They will vote with their dollars. You will also find that edition numbers are relatively small. An edition of 50 may be on the high side for an unknown photographer. Again, it's all about creating scarcity. So unless you're already famous, setting an edition size of 1,500 defeats the whole purpose of editioning. No one will believe the edition has any chance of selling out.

Understand Your Market

When you create an edition to sell, you are in many ways trading your artist's hat for that of a salesman. There's no shame in that, mind you. Successful marketing can be as much art as science. But it takes time and skill. It deserves your full attention. Devising a detailed marketing strategy is well beyond the scope of this book. I will offer some very general advice that can help you begin to work through some of the questions posed when creating an edition.

At the outset, you need to identify the type of buyers you are trying to reach. I've attended gallery openings where a visitor who blanches at spending $300 for a print is immediately followed by one who writes a check for $2,000 without a second thought. If you sell your images at outdoor arts and crafts fairs, $100 may be considered a premium. In this market, creating a limited edition will do nothing but price you out of it. Again, I am not suggesting any intrinsic value difference in a photograph based on where and for how much it is sold. I've seen well-crafted images at flea markets that I considered superior to some selling for thousands of dollars in high-end galleries. But the perceived value of those two images is always based more on context than content.

I should mention a common argument voiced by some photographers against the very concept of editioned prints. They reason that early masters of photography, such as Paul Strand, Alfred Steiglitz, and even later figures like Henri Cartier-Bresson, did not concern themselves with artificially limiting their output. And if they didn't do it, why should we? I would counter this by stating that if they were alive and forced to compete in today's fine art market, they would have no choice but to edition their work. It is simply how the mainstream art market functions today. I would also add that the work of some of these same masters is now available as posthumously-created photogravure editions crafted from the original negatives.

Understanding the needs and means of your intended market allows you to tailor your edition in a way that is both credible and attractive to buyers. In Table 8.1, I list a small sampling of online photography sites that I have visited in my own research into editions. I urge you to devote time on your own to finding galleries and Web sites of individual photographers targeting the fine art market. It's a great way to establish a context for your own decisions regarding the editioning of your work.

Communication Is the Key

Once you have determined the parameters of your edition, it is very important to communicate these terms openly and in a clear manner to both galleries and collectors. Each person who buys an editioned print from you has implicitly put his trust in what you have represented to him regarding the edition.

If you sell directly to buyers, you want to make your exchange, refund, and replacement policy clear and unambiguous. If a gallery represents you, it will convey this to the buyer. But you should be aware of your gallery's established policies to ensure that you're able to comply with them. When paying a premium for your work,

Table 8.1 Online Photography Galleries

This is a short list of photography galleries and limited edition book publishers. The Internet is a great resource for researching pricing, as well as strategies for editioning works.

Organization	Web Site	Editions...
Disfarmer.com	www.disfarmer.com	Contemporary prints made from the original glass negatives of Mike Disfarmer
Blow Up Press	www.blowuppress.com	Lithographs and inkjet prints of famous musicians
Ansel Adams Gallery	www.anseladams.com	Original and contemporary prints from the negatives of Ansel Adams, as well as work of a select group of contemporary landscape photographers
Photo-eye	www.photoeye.com	Prints by established photographers and a juried showcase for emerging talent
Aperture Foundation	www.aperture.org	A large collection of fine art prints from 20th century masters
The Center for Photography At Woodstock	www.cpw.org	Selected works by emerging and mid-career photographers
Blind Spot Magazine	www.blindspot.com	Selected works by established and emerging photographers
Santa Fe Workshops	www.sfworkshop.com	Original prints from their collection of 20th century masters
Lumiere Press	www.lumierepress.com	Handmade limited edition photographic books
powerHouse Books	www.powerhousebooks.com	Limited edition books of contemporary photographers

buyers have a right to know about the longevity of the print. You don't need to bombard them with spreadsheets of print longevity data, but you should briefly note the materials used, their intrinsic stability, and as a courtesy, provide tips on proper display, storage, and handling. I'll discuss longevity in much greater detail later in this chapter.

The distinction between a multiple and a reproduction is likely to be lost on most buyers. It is helpful then to spell out examples of reproductions, such as promotional pieces, posters, or commercial image licensing if that applies to your work. You should also disclose any prints outside the edition, such as artist proofs or work prints. I'll talk about these later in the chapter.

In short, you want to be as open with information as possible so that buyers understand exactly what they are gaining by purchasing an editioned print. You're selling art, not a used car. Later in this chapter, I'll give examples of how a professional printmaking studio documents their editions to clients.

History of the Edition

To understand the role that editions play in the fine art world, it is necessary to explore the fundamental distinction between an original work of art and a reproduction. When an artist creates a drawing or painting, it is understood that the result is a unique and original work created "by the hand" of the artist. Any copy of that work, no matter what the technique or tools employed, is labeled a *reproduction* and is deemed to be of lesser value. There is only one Mona Lisa, for example, and it hangs in the Louvre Museum. It will always command greater value than any of its countless reproductions.

The rise of printmaking—the process of affixing an image onto paper by indirect, rather than direct, means—presented a number of dilemmas with regard to designating the original work of art. If a number of inked impressions can be made from a single matrix created or at least supervised by the artist, what constitutes an original work? What is deemed a mere reproduction?

Confusing matters further is that some printmaking processes, such as lithography and etching, require the participation of a specialized printmaker working in concert with the artist to transfer her sketches or images onto the matrix in a manner that facilitates the transfer of ink onto paper. How does one reconcile the hand of the artist with the indispensable contributions of the printmaker?

Fortunately for us, the art world has long settled upon answers to these very questions. As we'll see in upcoming sections, the arrival of photography, and more recently digital printmaking, has required a renewed look at these issues. But first, we'll examine the traditional distinctions between originals and reproductions, viewed through the printmaking process of lithography.

Lithography

Lithography translates as "writing with stone" and is a direct ancestor to the offset printing so familiar to us today. Developed in the late eighteenth century by Austrian Alois Senefelder, lithography heralded significant innovations in the printmaking process. Unlike earlier printmaking methods, such as woodcut or engraving, lithography allows the artist to draw directly on the surface of the matrix—in this case, a stone. Because lithography revolves around a chemical process on a flat surface, the number of high-quality impressions or prints that can be made from a single matrix is substantially increased.

The Process

The following series of images (see Figures 8.5–8.10) show Master Printer Carolyn Muskat performing the steps in the lithography process. *Images are courtesy of Muskat Studios*

Figure 8.5 The stone is prepared for use by graining the top with grit to ensure a smooth and flat surface.

Figure 8.6 The image is drawn or painted directly on the surface of the prepared stone with oil- or wax-based materials.

Figure 8.7 A mildly acidic gum arabic solution is brushed onto the completed image (left) and then wiped across the surface (bottom) to chemically fix the image to the stone.

Figure 8.8 A roller is charged with oil-based ink (top) and then applied in several passes to the dampened stone (bottom). The image areas accept ink and repel water, while the rest of the stone accepts water and repels ink.

Figure 8.9 The printing paper is placed on the inked stone (left) and covered with newsprint and a greased sheet of plastic. The stone is then passed through the press (bottom) where the pressure transfers the image to the paper.

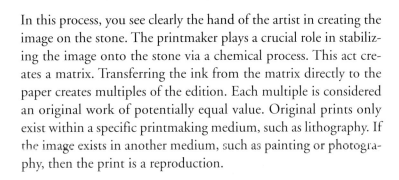

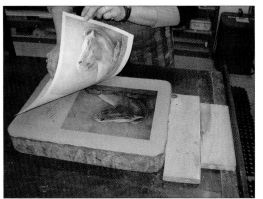

Figure 8.10 After running through the press, the paper is lifted (left), revealing the image. Because this is a direct printing method, the print is a reverse of the stone image (bottom).

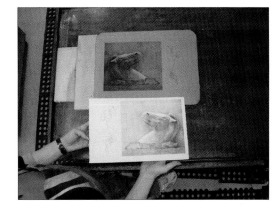

In this process, you see clearly the hand of the artist in creating the image on the stone. The printmaker plays a crucial role in stabilizing the image onto the stone via a chemical process. This act creates a matrix. Transferring the ink from the matrix directly to the paper creates multiples of the edition. Each multiple is considered an original work of potentially equal value. Original prints only exist within a specific printmaking medium, such as lithography. If the image exists in another medium, such as painting or photography, then the print is a reproduction.

Matrix Degradation

The distinction between a multiple and a reproduction is an important one because the matrix can only be used a certain number of times before the physical wearing out of the materials prevents more transfers of the image. Lithography, as I mentioned earlier, has the advantage of producing a very large number of impressions before the matrix degrades. But in practical application, the stones are reused. After an edition is created, the printmaker will efface the stone by literally grinding away the etched

image. In this way, the stone can be reused for other artists and editions. Once the stone is "erased," it is physically impossible to create more prints in the edition.

Analog Photography

Today, photography is universally accepted as a collectible medium. So it is easy to forget that for the first century or so of its existence, photography was derided as a medium uniquely unworthy of a place next to paintings, sculptures, and other traditional forms of visual art. It was not until 1940 that New York's Museum of Modern Art even established a department of photography.

Much of the art world's reluctance can be traced to the notion that as a purely mechanical method of creating an image, the hand of the artist was subordinate to the shutter mechanism and the chemical process required to reveal the latent image. But long after this argument lost steam, there remained a concern over the perceived value of photographic prints.

In some printmaking techniques, the matrix can deteriorate rather quickly. With each successive print, the heavy pressure applied to the plate can cause print quality to suffer. As a result, buyers often prefer and pay premium for early edition numbers. In photography, however, the matrix remains in the same condition throughout the printing process. With a film or even glass plate negative, the 4,000th print can be identical in appearance to the first one. So for the first time, an artist wishing to create an edition was not limited in any mechanical way in terms of the size of the edition.

But as the market for photographs matured, galleries desired to limit their artists' works, in order to increase the value of each print. With no physical degradation of the matrix, there lacked a way to verify the limits placed on the edition outside of trusting the integrity of the artist. In an effort to align photography more closely with printmaking, some photographers took to the extreme habit of

destroying the negative to prevent future prints being made. Brett Weston famously began destroying virtually his entire collection of negatives on the occasion of his 80th birthday. Without the negatives, any future versions of his images must be created from an existing print. The print could be subjected to a traditional printmaking process, like gravure or lithography, or to digital scanning and printing technologies. In either case, the resulting works would be categorized as reproductions for two reasons. They were not made directly from the now-destroyed matrix, and they were produced using a means of production different from the original print.

By all accounts, the overwhelming majority of wet darkroom photographers who edition their work retain the negatives and maintain the integrity of the edition by simply refusing to print from the negative after the edition is closed.

The Digital Era

The digital revolution has brought with it significant consequences with regard to the ability to create editions. Instead of a stone slab, metal plate, or film negative, the digital photographer has as her matrix the collection of ones and zeros that constitute the image file itself. A bit-for-bit replica of the matrix can be created by selecting File>Duplicate in the Finder. This has never been possible before in a printmaking medium and highlights a number of issues regarding the edition.

If exact duplicates of the matrix can exist, the potential for abuse of the editioning process increases dramatically. If a digital photographer were to destroy a hard drive containing his image files, who could verify that duplicates did not survive on DVDs, for instance? Perhaps copies had been previously uploaded to a server. Destroying a negative is simple to document. You can punch a hole in it or cut it in half. The damaged negative becomes proof of its "erasure." This technique has no reliable digital equivalent.

The rapid pace of technology raises more difficult issues. With the same enlarger, paper stock, developer, and exposure time, you can produce a wet darkroom print that matches one produced 30 years ago. By contrast, how many of us are printing with the same software, ink, printer, and paper we used just three years ago? Will every print in an edition printed over a number of years be identical? Should they? When we make edits to the image file, are we creating a new matrix and therefore a new edition? Can a single matrix be used to produce editions of different print dimensions?

These are questions that remain largely unsettled. But when you create an edition for sale, you must come to some conclusions about these issues that can be explained to buyers in a logical, well-reasoned manner. In this next section, I'll look at some of the standard practices that have emerged during this early stage of digital photography and offer some of my own experiences in grappling with theses issues.

Standard Editioning Practices

In many ways, editioning your digital work is uncharted territory. The nature of the tools and technologies pushes against the relevance of traditionally accepted norms of printmaking. However, the photographer who is familiar with aspects of traditional print documentation and ethical editioning practices is much better equipped to devise a set of guidelines that a buyer finds to be fair and reasonable.

Edition Size and Incremental Pricing

We are under no physical constraints with regard to edition size. So naturally a pressing question becomes, "How large should I make my edition?" Remember that the value-added component of limiting an edition only comes into play if there is a reasonable chance

the edition will sell out. Ansel Adams' *Moonrise Over Hernandez* is regarded as one of the most popular images by an American photographer. Original print sales of this photograph are put anywhere between 800 and 1,200. Now if an unknown photographer creates an edition of 2,000, the perceived value does not increase because no one will believe the edition can ever sell out.

When I visit galleries in my native New York City—perhaps the priciest art market in the country—I often see editions as low as five or even three for large images by emerging photographers. Small and medium-sized prints are usually found in editions of well under 30. Generally speaking, the more expensive the gallery, the lower the number of editions. Most exhibiting photographers will consult with their gallery for guidance, but don't forget that a successful edition is one that sells out. If there is a large gulf between how much you can reasonably expect to sell and your edition size, you have two options: get famous (quickly), or lower the edition size.

I mentioned earlier the idea of incremental pricing. From a purely selfish point of view, you want to make sure that you are adequately compensated for a popular image. After the edition sells out, you have lost a significant opportunity to generate income from this image. So it stands to reason that as the demand increases and supply decreases, the price will rise. This also benefits buyers, however, particularly those who bought early in the edition. Consider the following scenario. A collector buys edition 1/10 at $500. One year later, five more prints have sold and edition 7/10 is now selling for $1,500. This early buyer owns a print identical to one selling for three times the price he paid. A new appraisal of his print will reflect the higher price. His investment in the work would yield a financial return should he decide to sell it.

One note of caution is that the edition size represents an agreement between you and the buyer. If you change your mind about the edition size *after* your first sale, you are defrauding the buyer in an

ethical sense certainly and perhaps in a legal sense as well, as I'll explore shortly in "Legal Requirements." So be sure to give long thought to your edition size. There are too many variables for me to suggest a specific edition size, let alone pricing. But I can say that I was aided tremendously in this endeavor by researching other photographers and galleries that had work of similar size, quality, and were targeting a similar demographic and geographic market.

Multiple Editions of a Single Image

A big area of contention among photographers concerns multiple print sizes of a single image. Should you offer an image in more than one size? And if you offer the same image at 24 × 30 inches and 8 × 10 inches, can they be considered separate editions?

If we go back to our earlier definition of an edition as *multiples of original art produced from a single matrix,* two things stand out. A multiple is understood to be virtually identical throughout the edition. This quality is precisely what differentiated printmaking in the first place. With digital photography, the notion of a "single matrix" is an interesting one. What type of adjustment constitutes a new matrix? Does changing the spacing between pixels to increase or decrease print size constitute a new matrix?

Again, I'll refer back to traditional printmaking for guidance. In the woodcut and to a lesser extent the engraving process, additional cuts can be made to the block or plate between impressions. By aligning the same sheet in perfect registration, the combined states of the matrix are applied in a single print. But even with these alterations to the matrix, the physical dimensions of the prints remain unchanged.

So I am inclined to believe that an edition is specified for a single size. If you print the image file at 8 × 10, that constitutes one edition. Changing the print size to 24 × 30 creates a completely new edition that can be limited and priced in a different manner. It doesn't take too much imagination to see the potential for abuse here, however. If an edition sells out more quickly than the photographer anticipated, why not just tweak the print size and start all over again? Think about this from the buyer's perspective, however. No one wants to feel cheated. And having the artist subtlety alter print size after an edition sells out cannot be seen as anything but an attack on the integrity of the edition.

Call me an optimist, but I believe most photographers who spend countless hours crafting an image to their exacting standards are inclined to respect their work *and* their buyers. You'll find that the large majority of photographers will create only a small number of size-differentiated editions from a given image. The difference in print sizes will be great enough to materially alter the image. An 8 × 10 inch print can feel quite different from a 16 × 20. You will not generally encounter size differences of, say, just an inch or two. And best practices would suggest that photographers list these editions at the time the work is first presented for sale. Giving potential buyers all of this information up front, before a purchase is made, goes a long way toward building a relationship of trust.

By and large, you will find size-differentiated editions much more often with photographers who sell their work directly. This allows them to offer admirers of their work more economical ways of collecting their work. Most galleries tend to either limit images to a single size or offer two options at most.

Personally, I favor the approach that it is my responsibility as an artist to determine for each work the size most appropriate for conveying my vision. There are indeed images that can be effective at more than one size, but I've found for my own images that there is usually a "right" size. And that is what I offer to buyers. This is a highly personal decision, and I encourage you to make one that is most comfortable to you.

Work Prints and Artist Proofs

In traditional printmaking, where days or even weeks of work are required just to pull a print for initial evaluation, there is a long history of saving work prints and setting aside a small number of artist proofs outside of the edition. A work print is generally understood as one that is not satisfactory for inclusion into the edition due to a technical flaw or the need for further corrections. Work prints can offer a window into the process of producing the final print, but they are not considered part of the edition and are sometimes even marked specifically as being not for sale.

Due to the highly collaborative nature of the work between artist and printmaker, it was customary for the artist to gift some prints to the printmaker as a gesture of appreciation. These artist proofs (see Figure 8.11) are identical to the editioned prints but do not count against the edition total. The artist may choose to give an artist proof to whomever he pleases. But it is generally recognized that artist proofs should not number much above 10 percent of the edition size. A print edition of 50 with five artist proofs is within the norm, while setting aside 20 artist proofs for this edition would be considered an abuse.

Figure 8.11 An artist proof is generally designated with the initials "AP" followed by roman numerals stating the proof number, as well as the total number of proofs created. This example indicates the first of two artist proofs.

Legal Requirements

Providing complete and thorough documentation for each editioned print you sell goes a long way toward assuring buyers that you intend to honor the size of the edition. But your personal integrity is not the only thing that is on the line. There can actually be legal responsibilities that you incur simply by offering a photograph for sale. Whether you are selling directly to buyers or working with a gallery, you should be aware of both the rights of the buyer and the responsibilities of the seller.

Selling an edition may place additional burdens on you because the potential for fraud is so high when multiples are involved. The regulation of art sales is generally covered by state legislatures. Be aware that the jurisdiction regarding which state's laws apply to the sale may depend on where the transaction was completed.

State Law

A large number of states have legislation to govern the sale of artwork. There are often more specific requirements for the sale of multiples, limited editions, or fine art prints. In many states, these laws specify what you must provide the buyer in the way of documentation. Failure to do so can result in damages well beyond a refund of the purchase price.

Neither my publisher nor I are under any illusion that I am qualified to dispense legal advice. You should check with a lawyer to find out the guidelines for your particular state. But what I *can* offer, in the sidebar, "Legal Definitions," are some key terms as defined by New York State law. Appendix B at the end of this book includes a lengthy excerpt from the actual legislation on the books in my home state. It's in fairly readable English, and taking the time to read through it can bring to light issues of which you should be aware before you sell editioned work. Again, it's important that you research the applicable laws in your particular part of the country.

Legal Definitions

Section 11.01 of New York State's arts and cultural affairs law (see Appendix B) provides definitions for some of the key terms related to the sale of editioned artwork.

- *Multiples* means prints, photographs, positive or negative, sculpture and similar art objects produced in more than one copy and sold, offered for sale or consigned in, into or from this state for an amount in excess of one hundred dollars exclusive of any frame or in the case of sculpture, an amount in excess of fifteen hundred dollars. Pages or sheets taken from books and magazines and offered for sale or sold as visual art objects shall be included, but books and magazines are excluded.

- *Print* in addition to meaning a multiple produced by, but not limited to, such processes as engraving, etching, woodcutting, lithography and serigraphy, also means multiples produced or developed from photographic negatives, or any combination thereof.

- *Proofs* means multiples which are the same as, and which are produced from the same masters as, the multiples in a limited edition, but which, whether so designated or not, are set aside from and are in addition to the limited edition to which they relate.

- *Limited edition* means works of art produced from a master, all of which are the same image and bear numbers or other markings to denote the limited production thereof to a stated maximum number of multiples, or are otherwise held out as limited to a maximum number of multiples.

- *Certificate of authenticity* means a written statement by an art merchant confirming, approving or attesting to the authorship of a work of fine art or multiple, which is capable of being used to the advantage or disadvantage of some person.

Print Documentation

Print documentation is important for both the seller and the buyer. You obviously need to have a way to keep track of prints in an edition so you can accurately communicate to the buyer what you are selling.

Figure 8.12 shows a sample print documentation from a professional printmaking studio. At a minimum, this will give you an idea of what you can expect to receive as an artist when having your edition made by a professional printmaker. It will also show how detailed records about an edition can make the step of creating a certificate of authenticity for your buyers much simpler.

Figure 8.12 At Black Point Editions, the print documentation is included directly on the invoice. A description of both the materials used, print dimensions, and edition size makes it easy for the artist to track production of the edition. *Image courtesy of Black Point Editions*

Certificate of Authenticity

While print documentation helps with in-house accounting of work, a certificate of authenticity is presented to the buyer with each purchase of an editioned work. A certificate assures the buyers that they are receiving an original artwork and provides relevant details about the production of the print. In Figure 8.13, you'll find a sample certificate identical to the one I issue with each print I sell, either directly or through a gallery.

editions@Diallo Photography
347.231.6652 · editions@diallophotography.com · www.diallophotography.com

CERTIFICATION OF AUTHENTICITY

ARTIST Amadou Diallo

TITLE Delineation #1

DATE OF PRINTING March 2007

EDITION 5 of 15

DATE OF EDITION June 2006

IMAGE SIZE 30 x 38.4375 inches

SHEET SIZE 32 x 40.4375 inches

PAPER Innova Cold Press

MATERIALS Pigment Ink on Acid-free paper

PROOFS MADE Artist Proof i/ii

ADDITIONAL INFORMATION Delineation #1 has been printed and framed with archival materials. This print is guaranteed against any signs of image degradation (i.e. fading, discoloration) for a minimum of 100 years when displayed indoors under glass and away from direct sources of sunlight. Should fading or discoloration occur when the print has been displayed in the above conditions a replacement print will be provided at no cost.

This image was printed by editions@Diallo Photography, in New York City, to the highest standards of image quality and permanence. As with all paper-based artwork, proper care and handling will ensure image stability. We recommend displaying prints under glass or acrylic, with limited exposure to UV rays and direct sunlight.

We assert that the supplied information regarding edition size and number of proofs, accurately accounts for all prints produced in our studio.

Amadou Diallo, Printer 3/18/07
 Date

Figure 8.13 This certification of authenticity gives the buyer information regarding materials used in creating the print and the size of the edition. I also include basic recommendations for print handling and display, as well as a longevity guarantee.

Image Permanence

You can never go wrong with the assumption that anyone who pays money for your work expects it to remain in its present form, without visible signs of fading or discoloration for the lifetime of ownership. You can also assume that outside of museum curatorial staffs, the owners of your work will know very little about prolonging the life of the print, and may, in fact, introduce elements conducive to instability. It becomes crucial then that longevity be of the utmost concern from the outset of the print production process and that buyers are educated about basic care for works on paper.

The Archival Myth

One word that you will find conspicuously absent from my discussions of image lifespan is _archival_. While commonly used in marketing materials, this word connotes no actual fade or stability standard. Calling a print "archival" does not mean it will last 100 years. I'll use more meaningful terms such as permanence, longevity, lightfastness, and stability. I encourage you to do the same.

To say that image permanence has been a concern since the arrival of digital prints would be an understatement. Early inkjet output had life spans of just months or even weeks before fading significantly altered the image. Remember that inkjet printing was not originally developed as a photographic medium, but as an inexpensive alternative to laser printing for office and graphics work. Longevity only became a concern for manufacturers after the photography market adopted the inkjet printer. Only a few short years ago, the first response of anyone to an inkjet print was, "How long will it last?" The good news is that all of this focus on longevity has made manufacturers respond with relevant products. Today, it is possible to create an inkjet print with the potential to outlive a large

majority of the photographs made throughout the history of the medium. Without question, the current inkjet printing technology has taken the lead among other digital methods of photographic printing with regard to long-term image stability.

To realize these permanence advantages, however, you must understand, first and foremost, that the stability of any printed image is determined by the interaction of print materials and the ambient environment. For an image to remain stable, its component materials must be free of chemical properties that deteriorate over time. Exposure to pollutants and excessive light levels must also be minimized.

Figure 8.14 The Canon image-PROGRAF IPF5000 uses LUCIA pigment inks, which offer much greater longevity than the dyes inks used in Canon's lower priced consumer-oriented printers. *Image courtesy of Canon USA*

Materials: What to Look for, and Why

An understanding of the longevity characteristics of the materials that comprise the image is the first step toward ensuring long-term stability of an image. Any single inkjet image is composed of a particular ink on a particular paper. Once printed, this ink-on-paper combination is presented for display via some method of mounting and (usually) framing. In the following sections, we'll look at the selection of materials with an eye toward maximizing permanence.

Ink

You can easily determine the target audience for a printer by the type of ink included. Consumer-level snapshot printers contain dye inks. Models geared toward artists and professionals employ pigment-based inks, as shown in Figure 8.14. There is a good reason for this. Pigments are much more stable than dyes. They are more resistant not only to light, but also to airborne pollutants.

Not all pigments are created equal. Some are inherently more lightfast than others. The undisputed leader in this regard is the carbon pigment. In its natural state, a carbon pigment appears rather warm, approaching a sepia tone. While black-and-white photographers do

not require a wide color gamut of saturated hues, the use of carbon pigment in its natural state presents a problem if you desire something other than a warm-toned monochrome print.

There are two commonly understood methods of deriving different hues from a carbon-based pigment. You can subject the carbon particles to a milling or shaping process in order to change the way it reflects light. Alternatively, you can achieve a much wider range of hues by adding small amounts of color pigments to a carbon-based ink set.

Until fairly recently, the approach of the major printer manufacturers was to use color pigments exclusively when producing monochrome prints. In theory, it would seem fairly straightforward to produce neutral grayscale output from CMY-based ink sets. But issues of color casts, metamerism, and long-term stability quickly came to the forefront.

Simply getting the right mix of color pigments to produce a consistent grayscale throughout the tonal range proved to be difficult task for both OEM printer drivers and third-party RIPs. For one thing, the ink receptive coating on a paper can greatly influence image color. A color pigment combination that appears warm on

one manufacturer's paper can produce a significantly cooler tint on another paper. Even more unsettling is the propensity for pigments of different hues to react differently with the paper coating. You may have highlights and shadows each with their own color cast—an unintended split tone, if you will.

And even if you strike the right balance for a given paper, the propensity of pigments to shift color under various light sources rears its head. "Metamerism," or more precisely metameric failure, became an unfortunate part of most printmakers' vocabulary with the release of first generation color pigments. The term describes the phenomenon in which identical colorants produce different colors under different lighting conditions. While this is problematic for color output, it is an absolute deal-breaker for monochrome prints. The color of a black-and-white print can shift dramatically, from a magenta hue under tungsten light to a sickly green when viewed under daylight conditions.

Photographers interested in long-term image stability also had to contend with the potential for differential fading. I noted briefly that some colors are inherently more lightfast than others. Yellow pigment, in particular, tends to fade much more quickly than, say, cyan, which is relatively stable. Imagine a print where equal amounts of cyan, magenta, and yellow pigment produce a neutral gray. Well, if the yellow pigment fades more quickly than the cyan and magenta, you no longer have a neutral gray. The color balance is altered, and instead of simply becoming less brilliant or lacking in contrast, the print exhibits a color cast.

In the face of these issues, Canon, Epson, and HP have all included multiple dilutions of black inks in their current pigment-based printers. By reducing the dependence on color pigments to produce gray, issues of color casts, metameric failure, and differential fading are significantly reduced. HP has gone a step further, taking its cue from the third-party monochrome ink sets and providing up to four dilutions of black. For black-and-white photographers, this represents the first OEM ink set that uses no color inks to print visually dotless black-and-white images—a significant milestone in longevity.

Paper

The permanence and stability of the paper with which you choose to print obviously plays a key role in determining the longevity of the image. The story of modern papermaking dates back nearly 2,000 years. So unlike much of the cutting edge technology we rely upon in the digital darkroom, paper has a long performance history from which to determine desirable characteristics with regard to longevity.

The American National Standards Institute (ANSI) has established a comprehensive set of criteria that a paper should meet to provide the greatest degree of permanence. In its specification ANSI/NISO Z39.48-1992 (R2002), it defines permanence as, "The ability of paper to last at least several hundred years without significant deterioration under normal use and storage conditions in libraries and archives."

In order to meet this definition of permanence, a paper must first and foremost be free of acidic content. The most common example of the damage that acids can cause is the rapid yellowing and brittle aging of common newsprint. Left to its own devices, the paper will destroy itself over time. The most commonly cited spec by makers of fine art papers is that their products are acid-free, as shown in Figure 8.15. The ANSI standard requires that a permanent paper contain a pH value between 7 and 10. A value of 7 is pH neutral, while a higher number indicates an alkaline content. In a perfect storage environment, a pH of 7 may suffice, but it is accepted practice to manufacture a paper base with a slightly alkaline presence to counteract the introduction of acids by the display and storage environment.

Figure 8.15 Hahnemühle makes some of the most widely used digital inkjet papers and adheres to industry standards with regard to paper permanence.

Base Material

The majority of fine art inkjet papers are composed of cotton plant fibers. These 100 percent Cotton Rag papers have long been desirable because cotton is a virtually lignin-free material. Lignins are the "glue" that hold cellular fibers together and are highly prevalent in wood pulp. As they break down over time, lignins become acidic, with the previously noted negative consequences for paper longevity. Aside from being naturally acid-free, cotton's strong fibers provide a durable surface with a high tear-resistance to weight ratio. Cotton is also extremely flexible. When you handle large sheets, cotton papers can be less prone to accidental kinks or dents than more rigid substrates. Rolling large prints into tubes for maximum protection in shipping is also much easier with cotton papers.

One downside to cotton is that it is a very expensive base material for paper production. More recent advances in papermaking have allowed for the chemical processing of wood pulp that removes lignins and other acidic agents. Commonly referred to as "alpha cellulose," this material is showing up as the base component of a growing number of papers. They meet permanence standards and are less costly to produce. Alpha cellulose papers can have very high tear resistance at heavier weights but will generally be less supple in the hand than pure cotton substrates. Some manufacturers offer papers that are blends of cotton and alpha cellulose, leveraging the most desirable properties of each material.

Inkjet-Receptive Coatings

Perhaps the biggest distinction among competing paper manufacturers is the formulation of the coatings they apply to their paper base. As you saw in Chapter 6, the coating on an inkjet paper can have a profound effect on the paper's ability to absorb ink and maintain image sharpness. The perfect paper would allow you to lay down a high ink load for maximum density, yet hold a very tight

dot so that image detail is sharply rendered. But in the search for maximum performance, you must not neglect the factor of image permanence.

While paper manufacturers are understandably reluctant to share information about their coating formulas, we can identify two broad distinctions when it comes to coating paper for inkjet output. Swellable polymer coatings are nonporous agents that actually expand to encapsulate the ink they receive. This type of coating provides a physical barrier between atmospheric elements and the ink. The major disadvantage is that inks are typically very slow to dry when printed on this type of coating. The coating is also quite susceptible to moisture levels in the ambient air. Conditions of high humidity can cause the coating to react in such a way that the ink dots actually spread apart, blurring the image. The slow drying of ink and reactions to humidity changes present challenges with regard to print handling and display. The long drydown period also impacts color and density stabilization when you are measuring profiling targets. Even more importantly, for our concerns, is the fact that these swellable coatings are generally incompatible with pigment-based inks.

Microporous coatings, on the other hand, allow the ink to "fall into" the paper surface. This approach promotes very fast drying times with none of the potential for ink smearing. These coatings are also much more stable over a wide range of humidity levels. What is lost is the protective layer surrounding the ink itself. The inks are therefore exposed to atmospheric pollutants like ozone. This is not as bad as it sounds if you use pigment-based inks. Pigment particles are intrinsically more immune to atmospheric contaminants than dye-based inks. A paper with a microporous coating will generally behave in a more stable fashion over a wider range of ambient conditions. Used in combination with pigment-based ink sets, this coating offers a greater degree of overall image stability.

I should point out that the very attribute that makes a coating attractive—the ability to receive ink—means that great care must be taken to ensure that harmful liquids or residues are not received by the coating. In an upcoming section, I will talk about the importance of acid-free products when considering materials that come into physical contact with the finished print.

Optical Brighteners

You may have noticed that some paper vendors offer their products in both a natural white and bright white version. This brings to light the sometimes contentious issue of optical brightening agents, or OBAs. Cotton and alpha cellulose fibers are somewhat yellow in their natural state and have a relatively low brightness rating when compared to papers designed for office laser printers or card stocks, for example. These brighter papers have been pumped with OBAs—essentially ultraviolet dyes—that reflect blue and violet wavelengths and thus make a paper appear "whiter."

The concern for conservators and archivists revolves around the longevity of the OBAs themselves. As they break down, the paper will yellow, reverting to its natural color. Should this occur at different rates within a single sheet, you'll end up with an irregular paper color that may significantly affect the color balance of an image. The long-term implications of OBAs are not well established. There is the concern that they may contribute damaging acidic content over time.

Makers of fine art inkjet papers that do use OBAs go to great pains to stress that they use relatively small amounts. It's nothing like what you see in office paper, for example. OBAs are sometimes used in very small amounts simply to maintain consistent surface color from batch to batch. How much is enough to be concerned about? We simply don't know yet. Keep in mind that there are much greater and more immediate threats to image longevity than the breakdown of OBAs. Improper handling and storage can produce

negative results fairly quickly. But if you want to adhere to the highest standards of image permanence, there is no shortage of OBA-free papers from which to choose.

Framing

Most of us think of framing primarily as protection from sunlight. But there are many other hazards to account for when considering the longevity of images on display. The choice of framing materials is crucial simply because of their proximity to the printed image. Great care must be taken with any material that comes into physical contact with the print. Acids and other contaminants can migrate quickly from one surface to another. Conservation-grade framing can provide significant protection against airborne and environmental pollutants. Let's look at the individual materials of a well-framed print.

Aluminum frames are attractively priced, easy to assemble, and come in a wide range of extrusions, colors, and dimensions. Even more importantly, they are an extremely stable material. They are chemically inert, do not warp, and resist the seasonal expansion and contraction that affects wood frames. They are the preferred choice for long-term display of photographic prints.

The choice of glazing material comes down primarily to glass or an Acrylic plastic, such as Plexiglas. While plastics scratch more easily than glass, their reduced weight and superior shatter resistance make them a popular choice. Both glass and plastics can achieve similar UV blocking characteristics and thus reduce the effect of UV light on the printed image. No matter which material you choose, it is important that the print does not come into direct contact with the glazing.

Any material that does come into direct contact with the print must be acid and lignin-free. Mats and backing boards are readily available in conservation-grade quality, which can minimize the transfer of acids and other pollutants. Figure 8.16 shows an acid-free backing board. Although they can be rather expensive, high-quality mats and mount boards serve as an expendable barrier that protects the print. With this in mind, museums will always mount prints in a manner that is reversible rather than permanent. If the mat or mount board is ever damaged, you want to be able to transfer the print to another mount or backing without damaging the image.

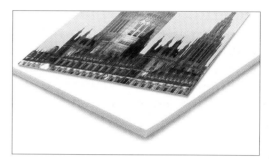

Figure 8.16 The ArtCare cotton rag backing board provides an additional barrier of protection by trapping pollutants and neutralizing acids before they pass through to the print surface. *Image courtesy of Light Impressions*

Putting It All Together

A print inherits the longevity characteristics of the aggregate of its components. You simply can't separate ink stability from paper permanence when assessing the lifespan of a printed image. In addition, the care and handling of the print after it exits the printer can have just as great an impact on longevity as the materials themselves. A print housed in climate-controlled dark storage is likely to outperform one that is displayed unframed in the light path of a south-facing window. Seeking out existing longevity data for your materials, implementing sensible display and storage conditions, and practicing proper image handling can often make the difference between works that remain intact and those that noticeably degrade.

Print Permanence Data

One of the more overlooked changes wrought by the digital revolution has been the shift of industry power to companies with computer technology, rather than photographic backgrounds. When you think back to the days of film-based photography, companies like Kodak, Fuji, Canon, and Nikon were the undisputed giants. Today, you cannot conceive of photography without names like Adobe and Epson, to name but two. Some may bemoan the fact that product development can seem driven more by engineering feats rather than photographic needs. But the very culture of Silicon Valley, with its emphasis on rapid innovation and information sharing over wizard-behind-the-curtain secrecy, has meant that as consumers, we have access to more and better information about the products we use than ever before. Perhaps nowhere is this more evident than in longevity data.

Granted, you sometimes need a keen ear to separate facts from marketing hype, but there are methods for comparing the relative stability of competitors' products. A Google search will turn up much more information about the longevity of Epson's UltraChrome inks and fine art papers than a Kodak developer/paper combination, for instance.

A large part of the credit for providing accessible permanence data goes to Wilhelm Imaging Research, an image stability and permanence testing company founded by Henry Wilhelm and Carol Brewer. It has become an invaluable resource for direct comparisons between competing companies' offerings with regard to image permanence. Its findings are widely accepted as industry standards and are usually referred to directly by the companies whose products have been tested. The public availability of independently tested image permanence ratings has given companies a real incentive to improve their products in this regard.

Test Criteria and Methodology

But before you can draw relevant and meaningful conclusions about image permanence from anyone's tests, it is important to understand very clearly both the endpoint criteria and environmental testing conditions. Figure 8.17 shows the permanence data from Wilhelm Imaging Research for Epson's Stylus Pro 3800 when using the Advanced Black-and-White Print Mode. The full document is available for download from Wilhelm Imaging Research's Web site: www.wilhelm-research.com.

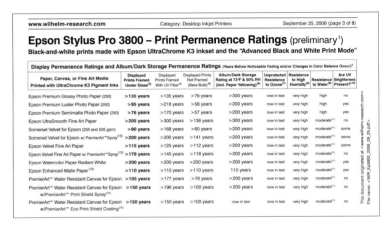

Figure 8.17 Data provided courtesy of Wilhelm Imaging Research.

When you download the full document, a careful reading of the test notes provides even more useful information. The first thing you must understand is the fade criteria used to generate the permanence ratings themselves. Footnote 2 from the test notes (see Figure 8.18) shows that testing is conducted at a stable temperature and humidity of 24°C and 60% RH respectively. The luminance conditions are set to simulate a display condition of 450 lux for 12 hours a day. In addition, the Visually-Weighted Endpoint Criteria

2) Display Permanence Ratings (DPR) are based on accelerated light stability tests conducted at 35 klux with glass-filtered cool white fluorescent illumination with the sample plane air temperature maintained at 24°C and 60% relative humidity. Data were extrapolated to a display condition of 450 lux for 12 hours per day using the Wilhelm Imaging Research, Inc. "Visually-Weighted Endpoint Criteria Set v3.0." and represent the years of display for easily noticeable fading, changes in color balance, and/or staining to occur.

Figure 8.18 Data provided courtesy of Wilhelm Imaging Research.

Set v3.0 defines just how much density loss constitutes fading. The definitions of these endpoints are available online at www.wilhelm-research.com/ist/ist_2002_2.html.

Taken as a whole, this information tells us specifically the performance we can expect under a very precise set of display conditions. The further your real world conditions vary from this, the less reliable the permanence rating may be for you.

Display Conditions

Reading the permanence data in Figure 8.17, you will notice the sometimes dramatic increase in permanence rating when the light reaching the print is blocked with a UV filter. The Epson Premium Luster Photo Paper more than doubles its rating, from 95 to 218 years, when UV filtering is employed. By the same token, notice the decrease in permanence rating that occurs when a print is exposed to light unframed. The same paper and ink combination drops to 58 years in the bare-bulb test.

These numbers alone make a convincing argument for the advantages of keeping a print behind a glazing material. But airborne pollutants can pose an even greater threat than exposure to light, even indoors. Residue from gas stoves, cooking products, oil-based paints, and other products can pose a threat to image permanence. A frame with glazing, hung away from the source of these pollutants, is the most cost-effective solution to minimizing these dangers.

Storage and Handling

If you have a large number of prints that need to be stored for any length of time, framing is obviously not a practical solution. Flat files, cabinets, and shelves made of metal offer the best chance at avoiding the migration or leeching of harmful acids. Relatively inexpensive but longevity-minded storage boxes, like the one shown in Figure 8.19, are also very popular. Wood products are uniquely unsuited in this regard. As I noted earlier, the lignins present in untreated wood pulp can destroy paper over time. These lignins, along with synthetic adhesives used in the construction of the cabinets or veneers used for the finish, can create an environment conducive to paper instability. Products derived from untreated wood pulp, like cardboard, also present similar hazards and should be avoided.

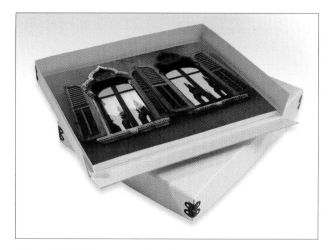

Figure 8.19 The TruCore drop front storage box from Light Impressions offers long-term protection for prints and is available in a wide range of sizes. The box has an alpha cellulose base material and is buffered to protect against acidic breakdown. *Image courtesy of Light Impressions*

When you do store prints, laying them flat avoids paper curl and bowing. Care should be taken to interleave stacked prints with acid-free sheets or tissue to avoid scuffing or flaking of the print surface. If the prints are not mounted and must be handled directly by the paper edges, inexpensive cotton gloves can prevent the oils from your skin from coming into contact with the print. If gloves are not available, one trick that works for smaller prints in particular is to grasp the edges with the inside of your knuckles rather than your fingertips. This technique is shown in Figure 8.20 and can help keep dirt and oils from reaching the paper surface.

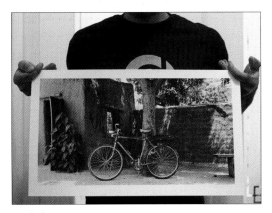

Figure 8.20
Holding a print with the inside of your fingers can minimize the oils transferred from your skin to the paper surface.

Image Permanence: A Shared Responsibility

As we've seen, image permanence is the result of the interaction of many materials and environmental conditions. Printing with carbon pigment ink on an unstable paper does little to ensure print longevity. And even the most lightfast of materials requires proper attention for display, storage, and handling in order to prolong the life of the print.

Image permanence strives for much more than simply preventing the physical disintegration of a print. The aim of all those concerned with preserving a work must be to maintain its original appearance over time. The work should be allowed to communicate its full range of tones and contrast to future generations. This is a daunting task, but today we have at our disposal a greater range of longevity-centric printing materials than at any point in the history of photography.

As soon as a print leaves your possession, the responsibility for its long-term care and preservation becomes a shared one. In the best of all possible worlds, your work would head straight into an important museum or private collections where a professional staff of conservators would care for its longevity. Barring such good fortune, however, it is up to each of us to educate buyers about proper handling, display, and storage practices.

The logistics and cost of shipping do not always allow for delivery of framed prints to buyers, particularly for large prints. It is important then to provide them with guidance. The cost of high-quality framing can be a shock to first-time print buyers. In fact, for heavily discounted artwork, it is not uncommon for the price of framing to exceed that of the print. Our responsibility is to make the buyer aware of the long-term benefits provided by an investment in appropriate framing materials.

Even if a gallery represents your work, there may be issues specific to inkjet prints with which it may be unfamiliar—both in terms of print handling and communicating longevity to buyers. It's a good practice to share your knowledge of the materials used in creating the print. Fine art quality inkjet printing is still a relatively new process, and you are likely to be the most educated resource for your gallery about the tools and techniques involved in the process.

Henry Wilhelm

For over three decades, Henry Wilhelm has been a leading authority on the stability and longevity of photographic materials. He has served as a consultant to some of the most influential museum and private collections of photographic images, but he is perhaps best known among digital photographers as cofounder of Wilhelm Imaging Research, a company that conducts extensive independent stability and fade tests for major vendors in the inkjet industry.

✪ Download an mp3 audio file of this entire interview by visiting the book's companion Web site at www.masteringdigitalbwbook.com.

Amadou Diallo: When did you first become concerned professionally with image permanence?

Henry Wilhelm: We had our beginnings way back in the late 1960s in the days of fiber-based, silver halide, black-and-white photography. Our work proceeded through that era and into the chromogenic color era. That is where much of the testing technology was developed with respect to light stability.

We came to the realization over time that the intrinsic permanence of print materials established a window in time during which the photograph remains in good enough condition to arrive in a museum collection. Usually, there is considerable time involved as the print passes from photographer to collector to museum. We became very aware that with color photography, this window of opportunity was actually very, very short.

And, unfortunately, there was a tradition in the photographic industry to withhold image permanence data from the consumer. Photographers themselves had no way to assess products or choose between them. Furthermore, this secrecy removed the incentive for manufacturers to improve products

in this regard. It certainly eliminated the possibility of competition between the companies to make longer lasting material. In the digital age, one of the things that's really been gratifying to see is that this has changed completely.

AD: *Concern about longevity is very much at the forefront in the industry.*

HW: Yes, and really for the first time. Photography has a very long history—all the way back to the 1840s. But it's really been only in the digital era that permanence has been talked about at the outset of a new technology, primarily because the companies coming into this field were new to photography. Most of them came out of the computer technology field, where discussions and evaluation of product, benchmarking, and a highly competitive environment have been the rule rather than the exception.

One of the things I find very fascinating is that these companies developed inkjet technology as a low cost way to make plain paper output in color. The initial goal was not photography at all. But as the resolution got better and better in terms of sharpness and visible dot structure, these companies sort of found themselves in the photography industry.

I consider the first photo capable desktop inkjet to be the Epson Stylus Color 720dpi printer that was introduced in 1994. I remember when I first saw it at a trade show, the sales people in the booth didn't have a clue about photography. One of the sales people held up the print, and he pointed to the text below the picture and said, "Now look at this; this is almost as sharp as laser." And I thought, "I could care less about the text. Look at that gorgeous picture." That was my cathartic moment. I knew that the entire field had changed.

Because of this evolution out of plain paper office printing, image permanence was not even on the radar. There was no concern about it. That was also true of the IRIS Graphics

printer. Those were designed for digital proofing and CAD applications, not photography.

AD: *So they had short-term life spans.*

HW: Yes. It just wasn't a concern. Unbelievable progress has been made in the industry since then. There's never been a period in the history of photography when things have moved so rapidly from a permanence point of view. From the extremely poor stability of early products to the modern inkjet printers form Canon, HP, and Epson.

AD: *Are we standing on the cusp of better longevity than we've ever had in the history of photography?*

HW: For color, absolutely. For black and white, I look at the classic Ansel Adams print—the archivally processed, silver gelatin, black-and-white fiber-based print. This is a very real benchmark of permanence. The image itself is composed essentially of pure metallic silver. It's a very finely divided filamentary structure that absorbs light. That's why it looks black. But in and of itself, the silver image is not subject to light fading. It is exceedingly stable.

The problems associated with black-and-white prints have generally been poor processing—fixing and washing—or contamination from poor quality mounting materials. The silver is quite sensitive to oxidation and discoloration by sulfur in the atmosphere or in other materials, but in a fairly dry environment, the protection offered by the gels and emulsion is really quite extraordinary. These prints, particularly if they were selenium toned to protect them from atmospheric contamination, like the later period of Ansel Adams, are extraordinarily stable both on display and in the dark, as long as the humidity isn't above 65–70% for a prolonged period of time.

So that classic Ansel Adams print—I do consider it the benchmark of permanence, even in terms of our discussion today.

Its permanence is exceedingly good. Keep in mind, this type of print can be found only in a very small segment of the total volume of prints out there. But it represents the optimal condition, which is very stable.

Today, with these multilevel black or gray inks, like the Epson K3, HP Vivera , and the Canon, Lucia inks carbon is the backbone of these pigmented ink sets. You could think of this in a modern guise, as a return to carbon printing. And carbon itself is not affected by light, so it has a real parallel with silver gelatin prints. So the permanence of a black-and-white print, made with modern pigmented inkjet printers, is, in most cases, going to be limited by the paper more than the ink set itself.

Now there are color pigments used to tint and control the hue of the image, and you can shift the image warmer or cooler. But for a basically neutral print, the majority of the image is formed with carbon black, and again, exceedingly stable.

AD: *We have moved from dyes to pigments, and within pigments, the carbon pigment is preferred for image stability. What makes one type of ink more lightfast than another?*

HW: Well, carbon black is a pigment. It has long been used in India ink and in pigmented paints, in part because it can be ground to exceedingly small particles. It is chemically inert and also exceedingly stable when exposed to pollutants and light. You can think of carbon black as the ideal pigment. It is even fairly inexpensive to manufacture on an industrial scale.

With color pigments, there are exceedingly stable color pigments, and some of the more stable ones have been used with outdoor signage printers, especially solvent based inks, generally with a significant sacrifice of color gamut. Epson's original UltraChrome ink set was really the first pigmented ink set focused on image quality and color gamut, with the realization that it would be used indoors.

But there's the inherent conflict between image permanence, color gamut, and Dmax. In fact, if people were not concerned about permanence at all, then I don't think pigmented inks would even have appeared in the market. We would have extremely high saturation dye-based inks. Everything would look great. The problem is it would not look great for very long.

Here's one interesting way to look at permanence and how much fading is acceptable. Say that you are making a fine print. You are doing test prints, making minor adjustments and localized edits in Photoshop. If you look at your final print, the one where you say "Ah…. this is it!" and compare it to the one that you made just before it that was almost, but not quite there, that is where permanence starts to become very important. You want to keep that subtle difference alive throughout the life of that final print. That subtle difference mattered when you made it and will continue to matter not only to yourself, but also to everyone else viewing the picture years going forward.

AD: *Speak a little about the interrelated nature of the individual materials that make up a print. A stable ink on a fugitive paper, for example, won't gain you much long-term benefit.*

HW: That is a very good point. To take an extreme example, you could use the Vivera Pigment inks found in HP's Z3100 and print on newsprint. You would have an exceedingly stable image and an exceedingly unstable photograph because of the base material itself. As the ink sets themselves have become more stable from a permanence point of view, there have been more demands on the paper, to not shortchange that stability.

One of the real benefits that inkjet has provided, which was not initially apparent, is really twofold: Inkjet can use almost any colorant, be it pigment or dye, and can be manufactured in huge chemical factories unlike, say, silver halide, which has

the colors synthesized right in the color development step. At its most basic level, the inkjet printer is simply moving its colorant from point A to B, so it has by far the widest flexibility of colorant in the history of photography. The second is what we call media independence. Inkjet printing is the first photographic technology that can print on almost anything.

AD: *You can print on aluminum, paper…*

HW: …even fabric or canvas. There was never a silver halide canvas. And this all happens to be extremely scalable, that is, really easy to make a big print. From a manufacturing standpoint, all you have to do is extend the print head rails to travel the required distance. Can you imagine a 40-inch wide dye-sublimation printer? The complexity and cost would be staggering. Inkjet has really lent itself to making big printers that are amazingly cheap and compact.

AD: *What about optical brighteners?*

HW: That's a whole separate subject. But, particularly with pigmented ink, if the paper has optical brighteners, that is the weak link from a permanence point of view. Optical brighteners are rather unstable with exposure to light, and even in the dark. They fade, or rather they lose their brightening effect, and can do so rather quickly compared to the intrinsic stability of the base papers and the inks. The result of that is, say, if we have a print that is overmatted and exposed to light for a couple of years, if you lift the matte, the image, particularly the lighter areas of the image, may appear to have yellowed somewhat, compared to where the image is protected by the overmatte, and that is because of the loss of brightener.

Another problem with brighteners is that a print will look subtly different in terms of the paper brightness, depending on the illumination used to view the print. It's a good idea to frame the print under a UV-absorbing glass or acrylic sheet. Now optical brighteners are activated by long-wave UV light, but

the UV filtering framing of the material will eliminate those wavelengths. In short, the brightener doesn't brighten. If you have two prints of the same image, one framed under ordinary glass and one framed under museum quality UV glass, the museum quality framing will make the paper appear slightly dull by comparison. I should note that any museum will filter UV from the light sources themselves or the individual print through careful framing. So if your print ends up hanging on the museum wall, the optical brighteners are not providing any benefit.

AD: When you look ahead, what are some of the things that you would like to see happen in the inkjet industry?

HW: One is higher Dmax. It's really the black that establishes the dynamic range of a print. It establishes the whole sense of brilliance in an image, both in color and black and white. Another would be improvement in the physical durability of matte papers—increases to things like scratch or scuffing resistance of the prints.

AD: Right. That's a big issue, just the handling of the print. Now that people can make prints so easily, they get handled and moved around a lot.

HW: Particularly in the high ink density areas. If you just run your fingernail across it, you wreck the print with the matte papers. Certainly once they are framed, they are quite safe, but I think everyone would welcome improvements in this area.

AD: For improved Dmax, is the solution to be found in improvements to inks or to substrates or coatings?

HW: Well, I think both. I think it's a combination of the two. One of the things that the major manufacturers—HP, Canon, Epson—have had in their favor is being able to design inks and media in concert. You can see it particularly in the Epson

premium luster paper. It was developed as a match to the K3 UltraChrome ink set, not just in color, but with regard to the differential gloss issues as well. This is really crucial from a permanence point of view. Dye-based inks could be increasingly destabilized by mismatched ink media combinations. Pigments are much less interactive that way.

We've never had such a wide range of papers available in photography. But from a permanence point of view, photographers should be very cautious about using papers for which there is no permanence information available. That's particularly important in terms of the yellowing of substrates. If you're using pigment inks, the image itself is probably going to be quite stable on almost all papers. But the yellowing problem is something you can't see because it takes place over time, even in the dark. In some cases, ironically, the yellowing problem is greater on prints stored in the dark than those on display because the yellowing stain component, in some cases, is very light sensitive itself.

AD: What is your take on the third-party monochrome inks?

HW: For the Piezography inks, I think Jon Cone did quite a wonderful job. Initially, it was very hard to make a good black-and-white print with the OEM color ink sets. Maintaining an exact neutral balance throughout the tonal scale was sort of a major issue. I think Jon recognized this quite early, and the monochrome ink sets he developed were really filling a market interest that major manufacturers were not. He did a real service to the industry.

Case Study 3: Jeanne Greco

Artist Bio

Jeanne Greco has enjoyed a successful career as a graphic designer and letterer with a focus on logos and packaging. She has designed wine labels for Francis Ford Coppola. Her photograms are an expression of her life through light and the organic forms of nature. These images are in public and private collections around the world and have been used for perfume and food package identities.

✪ Download an mp3 audio file of this entire interview by visiting the book's companion Web site at www.masteringdigitalbwbook.com.

The Artist Speaks

Amadou Diallo: *One of the things that struck me when I first saw your images was the strong sense of form and structure that they possess. Could you talk a little bit about your design background and how that has translated to your photography-based work?*

Jeanne Greco: A big part of my work is about composition and how the subject of the piece relates to the edge of the page, and that does come from years of being a graphic designer. I'm very conscious of how elements are placed in a space to give the biggest impact. I actually worked for several years doing very small designs: logos and monograms, wine labels, and right now I'm working on a project for the U.S. Postal Service. In small design, the composition is very important. I'm very conscious of detail as well. Line weights and color intensity, the spaces between letters—these are some of the things I look for and work with. I look at life from the standpoint of being a graphic designer. So when something turns me on visually, I remember to use it in a design later on. It could be a typeface, or it could be a shadow, or it could be a soda can smashed on the curb.

But in the end, my designs all tend to look similarly—somewhat sophisticated but simple. That's how I would describe these photograms as well.

AD: *I'd like to talk a little bit about this series of photograms. How did this project evolve? What was the genesis of the idea behind this series of work?*

JG: Well, the story begins when I moved to Napa Valley years ago. I had almost always lived in New York City, so it was a big change going to Napa. I moved out there alone with just my design portfolio, and I was looking for work in the wine industry. It was funny because probably the first thing that strikes anyone about Napa Valley is all the nature, the abundance of nature everywhere. And the second thing that strikes you is the abundance of sun. It rarely rains from July to November.

My reaction to these two conditions was probably a little different from another artist who might have pulled out a paintbrush and painted the colorful landscapes. Instead, I was inspired to create these photograms of ghostly black-and-white images that utilize the organic forms around me.

The image is formed by first applying a photographic emulsion directly onto the paper. I would lay a flower or a vine or an insect upon it, and that's how I was able to create these designs. I attribute much of my success with this to nature, because nature is so lovely and

Title Sunflower
Dimensions 21 5/8 × 30 in.
Paper Hahnemühle William Turner
Ink Set PiezoTone Selenium Tone
Printer Epson Stylus Pro 9600

the sun painted the picture so beautifully. What was also great was the sun created a negative shape around the form, but it also enveloped it or sometimes traveled through it. Sometimes, the wind blew the subject and created some more interest. And that's how I created these photograms. I was having a blast just relying on the beauty of nature to create the photos. A photogram is really the simplest form of photography. It's making photos without a camera—it's just exposure to light.

AD: *It's such an organically derived process. You're really using elements of nature in a very direct way.*

JG: Yeah, absolutely. One more thing about the relationship between these photograms and my previous design work was that I'm very well known for my lettering design. One of my most famous logos is the Barbie logo lettering. When I compose these letter forms, I'm thinking about black space verses white space. And I'm thinking about the finesse of the line, the curve, and the spaces they create. I am thinking about creating or portraying the correct character. I am thinking about the fact that these compositions are self-contained. They are marks unto themselves.

With these photograms, I have the same kinds of concerns. The difference is that the letter forms of my design work are replaced by these organic forms. These photograms are negative forms, which may be different from my lettering. But, essentially I think they are very, very similar.

AD: *With this sunflower image, in particular, one of the things that is very striking about it is the sense of tone, where you have got highlights spread across the face of the flower and darker tones in the stems. And all of this is juxtaposed against a black background. I am wondering, for this image—I understand it is an organic process—but did you visualize or preconceive of this exactly as it ended up? Or was it sponta-neous? Did you make sketches beforehand and say, "These are the kind of shapes and forms that I am interested in?"*

JG: All of these photograms are somewhat spontaneous. I did not do any sketches in advance, which is very different from my design work. I did probably have a preconceived notion of what I wanted to do that day, but I did not design it as I would in my graphic work. It was somewhat of a freeing experience, because I let the subject dictate to me what should happen on the page.

AD: *When we were talking about printing an edition of this, we spent quite a bit of time on paper selection—just going over different sheets, talking about different paper grain and texture and how that would relate to contrast adjustments we could make on the print. And for me, as a printmaker, part of the great joy of this project was that you and your work both reacted well to very, very subtle changes in contrast, tone, and paper.*

I wondered if you could talk a little bit about what the experience was like for you, from transplanting these small palladium prints to these much larger inkjet prints we made, which were probably four times the size of the originals. What were some of the similarities or differences you felt? Do you feel that the inkjet print speaks in a different way compared to the originals?

JG: Well, let us get back to the paper aspect of it. I have always been interested in a piece of paper. Paper is very important to me. I worked very early on with printmaking, and, of course, my calligraphy. Both of these mediums require that you know a lot about paper. In fact, good paper has always been an addiction of mine. I have drawers filled with handmade papers. And, when you suggested the William Turner paper for the project, I was quite happy, because it was a great paper. It was mould-made, had a lot of rag, and was

acid-free. It was not dissimilar to the types of paper I used for the original photograms. I painted the palladium emulsion onto a paper that was similar. It was soft but sturdy, and had a slight tooth to the surface.

The decision to translate my original palladium prints to a much larger inkjet output seemed to be sort of a natural progression because, unlike photographs, my negatives are my original prints, and the logical way to produce an edition of prints was to use a method of this high-quality archival inkjet printing. That is where you came in. I fell in love with the blacks that you produced with the carbon pigment, and I felt that they were so rich that you could almost blow them off the page. In fact, I think we had to tone back the richness.

AD: *Right. We wanted to pull it back at one point because it was a little bit overwhelming for the image.*

JG: The originals had a lot of subtlety and did not hit those blacks. But actually my originals were sepia-toned, because that is the nature of palladium print. I guess the other thing about working together had to do with the fact that I was a printmaker and a calligrapher, and both of these mediums require that you love the process of producing the art. It is not so much about the end product as it is about doing it. So that was the way it was with the palladium prints and working with you in the creation of this digital edition. You just have to trust that in the end, the product will be equal to the experience. And in the case of this edition, it was. I loved the size. I loved the richness. They worked very well together.

9

The Portfolio

In the preceding chapters, we've looked at the concepts, tools, and techniques required to carry your photographic vision through the entire digital imaging and printing process. A portfolio enables you to present that vision to others. It can take many forms and involve relatively simple or elaborate presentation materials. But the importance of the portfolio is hard to overstate. It introduces your work to new audiences, most often without your presence. In this final chapter, we will examine options related to the research, planning, and presentation of a successful portfolio. Also included in these pages are four unique perspectives from a select group of experts regarding basic curatorial, marketing, and design issues.

Research

Creating a portfolio is a surprisingly involved process. It includes much more than just gathering up your favorite images and dropping them off at FedEx. There are a number of questions that need to be addressed before you even approach the task of image selection. Who is the audience? To what kinds of work are they attracted? How many images do they need to see? Do they prefer the portfolio in print or electronic form? Will it be returned? What supporting materials need to accompany the images?

Next, you must consider what you hope to accomplish with the portfolio. Is it a vehicle to stimulate sales or Web traffic? Are you seeking to fund a personal or commercial project? Should the portfolio lead to a meeting or studio visit?

The answers to these questions go a long way toward defining just what kind of portfolio you should produce. Among other things, they provide a hint as to the shelf life of the portfolio and how many copies will need to be distributed. But these questions cannot be answered in a vacuum. They require careful research of both your audience and purpose. The aim is always to get your work seen by the person who can provide what you are looking to achieve. Portfolios are purpose-specific. A good one doesn't have to do everything under the sun. It does have to do a small number of things remarkably well in order to be considered a success.

Who's Your Audience?

A successful portfolio is one that engages its viewer. A major step in planning a portfolio is determining your audience and what they respond to in a photographic image. A portfolio should be tailored to elicit a specific response from a specific audience. To have any reasonable chance of accomplishing this, you must do your homework.

First and foremost, make sure that you understand and follow all of the submission requirements. Two of the most common portfolio destinations are galleries and competitions. And they usually have specific guidelines that allow them to sift through large submissions of images in an efficient manner. Some specify the number of images you can include. When prints are called for, there is almost always a limit to their physical dimensions. Even if the guidelines seem minor and arbitrary, understand that your portfolio is just one of what may be hundreds, or perhaps thousands, of submissions. If the guidelines request JPEGs at 800 pixels wide, don't send them 50MB files just because you don't feel your work can be fully appreciated in the required size or format.

The most time consuming part of your research may be determining the type of work your target audience is most interested in seeing. The world's most talented photographer will not make much of an impression on the photo editor of muscle car magazine with a portfolio of flowers, for example. Become as familiar as possible with the tastes and preferences of your audience. For competitions, you can look at the work of previous winners. Even though the jurors may change annually, this can give you a sense of the quality of work that they reward.

Before you approach a local gallery, attend a number of shows to get a feel for the type of work that they exhibit (see Figure 9.1), and ideally, that their clients purchase. Opening receptions can be a good time to visit. You may have the opportunity to talk with the exhibiting artist. At the very least, you can gauge people's reactions to the work. But visits during the week without the crowds can be helpful as well. Here in New York City's posh Chelsea art district, even the most expensive galleries are often staffed by recent graduates, who are only too happy to break the monotony of answering e-mails and stuffing envelopes to talk about the work on the walls and the gallery itself.

Figure 9.1 The SF Camerawork gallery presents six to eight exhibits each year featuring photography and related media. *Image courtesy of SF Camerawork*

If the gallery is not exclusively devoted to photography, you may want to know how often their shows feature photographers. Ask about seasonal group shows. Many galleries that seek out new and emerging talent will introduce their work during a summer group show. This provides less experienced artists time to build up an extensive body of work and generate a strong following before the gallery commits to a solo show.

Curious about the marketing muscle that a gallery puts into its artists? Sign up for the mailing list. If you receive invitations to openings, frequent updates about artists' upcoming projects, and press clippings, this shows a healthy commitment on the gallery's part to the development of its artists.

Seize opportunities to present your work for one-on-one critiques, whether through a portfolio review, shown in Figure 9.2, or an appointment with a curator. Direct and detailed feedback is priceless. It can provide insights into your work that is impossible to gain in any other way. You take away much more information from even a negative critique than simply hearing, "nice work" over and over again.

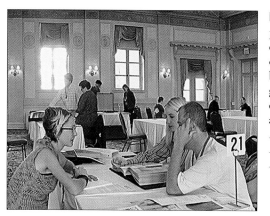

Figure 9.2 The portfolio review offers individual critique of your work by art consultants, gallery directors, curators, publishers, and photo editors. *Image courtesy of Photolucida/Dave Potter*

A constructive critique lets you see how others view your work. Perhaps your portfolio contains a few great images but a lot of mediocre ones. You may be on the right path and just need more time to build a solid body of work. Maybe your range of eclectic images could benefit from the discipline of focusing your creative energies on a single style or subject. The vast majority of photographers who submit portfolios will have them rejected, without any explanation. Take advantage of any chance for feedback, positive or negative.

Perspectives: Gallery President

Larry Davis is a fine art photographer and president of the Soho Photo Gallery. This cooperative gallery was established in 1971 as a means for serious photographers to show their work, exchange ideas, and grow as artists. The gallery holds monthly portfolio reviews and also runs three national photography competitions. Larry shares with us his thoughts on a variety of topics that come into play when submitting work for review.

On portfolio submissions…

A portfolio should be a cohesive body of work representing a single theme or an ongoing project. In other words, it should have a single voice and a single look. The strength of the portfolio is in the consistency. One or two strong images don't really tell us whether the photographer is going in the right direction. Are these beautiful pieces by chance? Or were they intentional?

In our gallery, the portfolio should contain 12 to 15 images that illustrate your skill as a photographer, the ability to edit your work, and your care in preparing prints for exhibition.

We ask that prints be unframed, but in all other respects ready for exhibition. Frames are a little too cumbersome to deal with during a portfolio review, but it's important for us to see the mattes if they will be exhibited matted and framed. We evaluate not only photographic skill, but also presentation ability. The submission of books, or slides, or disks cannot be considered.

On portfolio selection…

We have a portfolio review committee of 10 to 12 members, which is wonderful because each member sees things from a different perspective. This makes for an extremely healthy give-and-take, and the work being considered is really getting a thorough review.

On the ability to self-edit one's work…

We find that people who've previously gone through the portfolio process are able to edit their work much better than somebody doing it for the first time.

Someone without experience might just pick out their favorite images, which generally turns out to be a little bit of this and a little bit of that. There's nothing cohesive for us to evaluate. The common theme to them is that they chose their favorite pictures, but that's not what makes a portfolio.

On portfolio critique…

When prospective members come in and are rejected for membership, the beauty of the process in our gallery is that we will discuss the portfolio with them when the review is over. We'll tell them what they can do to their portfolio to enhance it, to make it a more cohesive portfolio. We spend time with them, and it's very valuable feedback. We have actually been thanked by people we've rejected because it's such a constructive criticism.

Take a situation where we see someone's work and it's clear that they know what they're doing. But when it comes to actually putting their portfolio together, they may not be able to distinguish their strongest pieces from those that truly don't belong in the series.

We would point out to them the ones that we felt were the strongest, and the ones that were weaker, and tell them why. We would ask them to go to more galleries, see what's around, study a show as though it were a portfolio. Then shoot some more, and come back with another portfolio. This happens quite often.

On photography competitions…

As a photographer, I enter competitions myself. In one instance, I felt that my style of photography was right up the juror's alley, but my work was not accepted. I later went to a lecture by the juror where he explained why he chose what he did. He actually said that he decided to go in the exact opposite direction of what he usually is attracted to. So you really never know.

In our own competitions, we've actually gotten calls and e-mails asking questions about the type of work the juror likes to see. I give the same answer: There's no way to know what he or she will be selecting. There's no way of getting inside a juror's head.

On a member-run gallery…

The benefit of being in a membership gallery is that it's a cooperative where everybody has an equal share in the place. We don't hire anybody to do anything. Everything is done on a volunteer basis. Of course, with any organization of this type, you have to address the fact that not everybody likes to volunteer. But the gallery's been in existence since 1971. It's never folded, and it's always been run by volunteer efforts.

On digital versus traditional techniques…

Digital appears to be winning the race. A lot of our members, who were truly wonderful wet printers, were very, very resistant to the digital change for a very long time. Then when they decided to get their feet wet, they turned out to be just as good in the digital darkroom as they were in the wet darkroom.

What we see happening digitally is that there are so many things Photoshop allows you to do, that you would not ever think of doing in the darkroom. There's this new crop of photographers now that have never been in the darkroom and are just going wild with all the filters and all the other features in Photoshop just to try and turn snapshots into fine art photography. It's quite disconcerting. Fortunately, we're able to weed out these examples from the work of people who are obviously putting their blood, sweat, and tears into creating images.

Setting Goals

What do you want your portfolio to accomplish? The question may seem superfluous, but it is an important one to answer. The very purpose of your portfolio determines many key elements of its content and presentation. A portfolio meant to create sales of your work should certainly include information about final print size and preferably some postcard sized reproductions, as shown in Figure 9.3, that prospective buyers can keep as they decide on an image. If the aim is to secure gallery representation, the images should reflect a genre appropriate for that gallery.

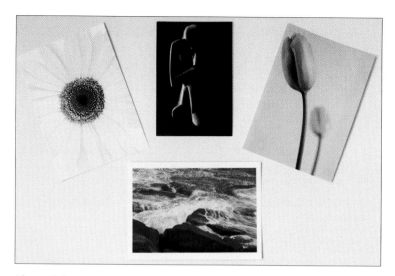

Figure 9.3 A collection of your images reproduced as postcards offers an economical yet effective "leave behind" for potential buyers.

Most important, though, setting a desired outcome is the best way to determine whether the portfolio is successful. If your aims are not being met, perhaps it is time to revise the portfolio into something more effective. Often, the best way to find out what works and what doesn't is simply to ask. No one loves to hear negative feedback. It can be discouraging. But as I alluded to earlier, it actually helps you correct your mistakes. And a negative reaction doesn't always mean your work is sub par. Perhaps you're simply approaching the wrong audience for your type of work. Only when you're made aware of this can you make the necessary adjustments.

Goals will differ with each photographer, but the overriding aim of any portfolio should be to establish a relationship with your audience. Selling your work, getting into a gallery, or landing a licensing deal are not things that usually happen overnight. When introducing your work to someone, you should try to do two things above all else.

First, create a positive, professional impression of both you and your work. Remember that the portfolio must stand on its own. In most cases, you will not be there to explain away any shortcomings, either in content or presentation. The portfolio is a direct reflection on the respect with which you regard your craft and the audience's time. All else being equal, most people prefer to work with someone who makes their job easier, not more difficult. When you adhere to submission guidelines and present your work in a manner that allows for easy handling and safe return, you signal that you are someone who is familiar with the review process, takes your work seriously, and is easy to work with. Couple these attributes with a strong body of work, and that's about as good a first impression as you can hope to create.

In addition, the portfolio should facilitate future contact and communication. Curators, for example, may follow the careers of emerging artists, taking note of their progress, for years before committing to a show or acquisition of their work. In this regard, the portfolio is a beginning rather than a final step. Make sure that your contact information is readily accessible. If you are presented with personal feedback, ask the reviewer(s) if you may keep them informed of your progress and upcoming exhibitions. Then add them to your mailing list. A memorable portfolio can spark someone's interest. Regular follow-up can help sustain this interest. Over time, a relationship that pays tangible dividends can develop. The dividend can be an obvious one like a gallery exhibit or a museum acquisition. But it can also come in the form of access to an industry insider who can provide introductions, career guidance, or simply objective feedback.

Your goals will certainly change over time. By giving thought to them early in the portfolio process, you can ensure that the selection and presentation of your work change accordingly.

Finding Inspiration

It has often been said that artists make the best thieves and liars because they constantly take ideas from others and present them as their own. While this may be a little glib, the truth is that each of us draws inspiration from someone or something. In this vein, it makes sense to look at how other photographers present their work.

The greatest benefit in looking at other artists' work is…well, looking at other artists' work. Whether through galleries, fine art books, or Web sites, I often gain new perspectives about my own work by viewing the images of others. This extends beyond content into image selection and presentation, the hallmarks of the portfolio. It is always interesting to see how photographers and institutions choose to curate and display their work.

In a gallery, consider the prints on the wall as a life-sized portfolio. Ask yourself some questions as you browse through the exhibit. Why does this image begin the show? Why does that image end the show? Why are the images arranged in this particular layout? How does the order of images create a sense of narrative? How do the print dimensions enhance the viewing experience? The answers can give you insights into the very same issues you face when creating your own portfolio. Figures 9.4 and 9.5 show two gallery installations.

Fine art photography books, like those in Figure 9.6, have even more obvious parallels to your portfolio. The images are sized more closely to those you would find in most portfolios. And the issues related to horizontal or vertical format are quite similar, as either orientation must fit within the fixed dimensions of the book. As you look through some of your favorite photography books, consider how this collection of individual images fits into a broader unifying theme. Even if the book is a retrospective spanning a long career, chances are that the images are grouped in such a way that there are similarities in style, mood, or tone between adjacent images.

Figure 9.4 The Yossi Milo gallery in New York City has a roster of emerging and mid-career photographers. The exhibit, *History Images,* by Sze Tsung Leong chronicles the rapid urban development in China. *Images © Sze Tsung Leong, courtesy of Yossi Milo Gallery*

Figure 9.5 The neat and orderly double-hung layout of Chris Jordan's show, *In Katrina's Wake: Portraits of an Unnatural Disaster,* can be read as a comment on the random chaos and destruction that the images depict. *Image courtesy of Chris Jordan*

Figure 9.6 Fine art books by past and contemporary photographers can be a great source of inspiration, as well as suggest practical approaches to creating your portfolio.

One great piece of advice that I was given when I started in photography was to go to the bookstore and collect my favorite images, whether from photography books, calendars, travel guides, or magazines. Then compare these images side-by-side with what I considered to be examples of my best work. If the exercise had stopped there, it would have been nothing more than a lesson in humility. But the next step was to try to identify precisely what these well-known images had that my own did not.

The challenge of judging my work against photographers whom I admired gave me a fresh perspective on what I was attempting to achieve. Just as importantly, it allowed me to see my work as an experienced viewer might perceive it. Assume that everyone who is going to see your portfolio is literate in at least some aspect of the photography tradition. They will be comparing your current work not against your previous efforts, but against the best photography they have witnessed. The more time you spend looking at other photographers' work—both newcomers and established masters—the more literate you will become about the aesthetics and craft of powerful and moving images.

Planning

Once you've identified a specific audience, it's time to start pulling together images in an effort to select those most appropriate for the portfolio. This is admittedly a difficult task. We are often so close to our work that all but the most basic of selections becomes problematic. We often confuse our best images with those that were the most difficult to create. But the reality is that no one but us cares that we spent hours fussing over layer masks, contrast adjustments, or raw conversion settings. Your audience cares only about the final image. Technical information like megapixels, exposure settings, and printer resolution are of interest only to other photographers, if at all. So resist the temptation to include images because they show off your fancy new equipment. Make sure that the content alone is capable of grabbing a viewer's attention and maintaining his interest.

When presenting your work to someone for the first time, the natural inclination may be to show him every style, genre, or subject matter with which you've ever worked. It's much more effective, however, to show images that revolve around a unifying theme or element, as described in Figure 9.7. This shows that you have accumulated a body of work over time that is driven by a single purpose.

Figure 9.7 This image of a terracotta figurine is just one image in my Delineations series, which examines man-made expressions of the human form in premodern cultures.

For all its intricacies, photography is not rocket science. Anyone with a basic understanding of how a camera works can get lucky and take a great picture. They might just be in the right place at the right time. But a collection of images purposefully planned and executed over a period of time requires discipline and a commitment to a specific vision. It is this commitment of purpose and the ability to become fully engaged with both your subject matter and medium of expression that commands attention in the art market.

In short, people want to know that you have something to say. The images you select for the portfolio must represent your way of seeing the world.

Making the Cut

I recommend that you break the image selection process down into manageable chunks. I liken this to sports teams that have a long training camp during which they make a series of cuts as they whittle down to their final roster. The first big cut should be determined by the theme of your portfolio. A theme is usually subject driven and can be quite broad or very specific. One photographer may focus on mountain imagery, while another may document a specific corner of her neighborhood at the same time every day for a whole year. But whatever your theme, it serves as the primary requisite for which images are included in this first round of cuts. This is a fairly dispassionate round of selections. Either an image fits into a theme, or it doesn't. But the act of choosing a theme can give you insights into the way you see with the camera.

Perhaps you shoot a lot of trees but few rivers, lots of architecture but no people. There are usually things that hold inherent attraction for us as photographers, whether we are conscious of them or not. One of the great benefits of creating a portfolio is the time it affords us to simply examine our body of work and identify just what we're drawn to record.

With the most basic of selections made, we can start to weed out images based on technical and aesthetic merit. Do you find that some images display a surer hand, either in composition and editing, than others? Are all of the images free of defects that distract the viewer from establishing a dialogue? If your work spans a number of years, you are likely to see, if not outright flaws, then regrets over opportunities you did not realize to their full potential.

Don't be discouraged if the previous questions eliminate a large chunk of images. This is exactly what editing is supposed to accomplish. You want to present the best of the best. This allows you to collect a group of images that all relate to a unifying theme and exhibit the same high level of image quality. Now comes the hard part.

Perspectives: Museum Curator

Sarah Hermanson Meister is an associate curator in the Department of Photography at The Museum of Modern Art (MoMA), New York. She has numerous publications and writing credits and is a recipient of the Lee Tenenbaum Award for outstanding scholarship and research. Ms. Meister recently organized a reinstallation of the Edward Steichen Photography Galleries that offers a history of photography from the 1840s through the 1980s. In an exclusive conversation, she offers her perspective on several topics.

On MoMA's history of collecting digitally printed photographs…

We've been collecting and exhibiting digital prints since the early 1990s. The first digitally manipulated prints to come into the collection were by Peter Campus, the video artist. One of these was included in *More Than One Photography*, organized by Peter Galassi in the summer of 1992. Part of the premise of that show was that it is no longer possible to define achievement in photography in any one way.

On the acceptance of digital photography…

Technological innovations have repeatedly transformed the medium of photography throughout its history, from Daguerreotypes, to wet collodion on glass plates, to flexible film in handheld cameras. Anyone who has studied the history of photography understands that it is always changing. Each metamorphosis of the medium is something we pay attention to very carefully.

Photographers from the earliest days of the medium have been interested in new methods of taking pictures, of manipulating those

pictures, and printing them, whether it be [Oscar] Reijlander, [Henry Peach] Robinson, or any number of now anonymous practitioners. That photographers would be exploring the potentials of digital manipulation and printing and capturing isn't surprising. We pay attention to it just like we pay attention to photographers who take pictures with a 35mm camera. Our efforts are to try to be as attentive as possible to the full range of what photographers are doing now. We're not trying to define what they do before they do it.

On the acquisition process…

The process for acquisition most often begins with the interest of a curator in a particular photographer. It often takes place over many years. We'll see a photographer's work that we're interested in, and we'll ask them to keep in touch and let us know what other things they're doing. If we feel that a particular work is suitable for the collection, we will present the work to our Committee on Photography. Ultimately, it is the committee that approves or rejects the acquisitions that the curators propose, but the proposals most often start with the curators. There are currently five curators who meet regularly to discuss new work, old work, all kinds of work.

On reviewing portfolios…

Certainly, the ability for photographers to look at their own work and pick good examples of that work to send to us is a hallmark of a good portfolio. At the same time, we often work with photographers to help them edit their work, whether it is for exhibitions or acquisition or just a project that they might be working on independent of the museum. We all have relationships with photographers.

It is not always easy to have the distance or the perspective on your own work to be able to edit it successfully. When we're most excited is when we see a portfolio with lots of great pictures in it, and we're least excited when we see a portfolio without any interesting pictures in it. If a photographer has made one great picture and they send it to us, we want to see more about where that accomplishment is

coming from. Is it part of a sustained exploration, or is it that they just got lucky and created a really great picture?

We have a limit to the number of pictures we'll look at in any given day because of the volume of portfolios we receive. We have to request that portfolios not include more than 50 pictures. We're accustomed to looking at work in a variety of different ways. We can look at work prints, we can look at digital printouts, we can look at finished prints, and we can look at Web sites. We no longer accept DVDs as part of portfolio review because it was logistically difficult to discuss the work together with colleagues, and the volume was overwhelming us.

We really value our relationships with photographers, and so if someone is young and they're showing promise, individual achievement, uniqueness of vision and success of execution, this is someone we want to work with whether or not they know how to edit their work. There are a lot of times when we'll see a strong portfolio, and we'll say to the photographer, "That's a really great portfolio. Keep us posted; let us know what you do next." We don't do that to be discouraging; it is often a long process.

As we're pursuing a relationship with someone, we don't want to know just did they capture a great image, but how do they like to present this image? Portfolio review is often the first step in establishing a relationship with the artist.

On current trends in photography…

There are so many ways in which photography is being used in contemporary art—there are artists who are very conscious of being a part of a photographic tradition, and other photographers who are inspired by a broader tradition that extends back to artists such as Warhol and Rauschenberg. There's huge variety in what is being made that can be called photographic, and part of our challenge is to be attentive to all of it. In both our photography galleries and across the Museum as a whole, we try to display these two traditions in a way that enriches our understanding of both.

Telling a Story

At its core, the portfolio tells a story to your audience. Like all satisfying stories, this narrative should have an arc that compels the viewer to turn the page. Now that a selection of images has been made, it's time to look at how they fit together to create a unified whole.

Visual narrative is most easily expressed in how the images flow from one to the next. Are there similarities in subject, mood, tonality, orientation, or perspective that make for obvious pairings of images? Is there a sense of completeness to the portfolio? What overall impression will a viewer have of your vision as an artist?

The collection of images in the opening chapter of this book is, in all respects, a portfolio of my own work over the past few years. I'll talk briefly about my approach to the selection and presentation of these images.

Unlike a portfolio destined for a gallery, critique, or competition, the audience for this book is relatively broad. Perhaps the only trait shared by each reader is an interest in fine art black-and-white photography. That's a large genre, but right off the bat, it eliminates my assignment work and, of course, color images.

The layout of the book you're reading dictates that the images appear on facing pages: two images side-by-side. So the relationship of the image on the left-hand page to that on the right-hand page becomes crucial. I approached each turn of the page as if it were a new scene in the same movie. I wanted to convey distinctions between pairs of images, but in a way that maintained a connective thread within the overall collection. In Figures 9.8 through 9.13, I'll show specific examples of how I created a unified collection, while maintaining a broad range of subject matter to appeal to as much of my audience as possible.

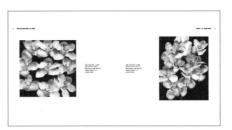

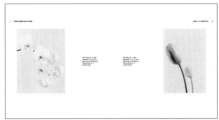

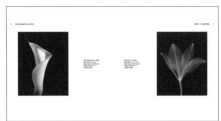

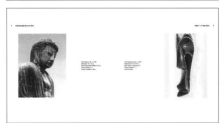

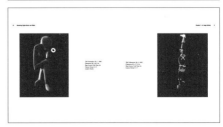

Figure 9.8 I arranged the images so that each of the first five spreads alternates between dark and light backgrounds.

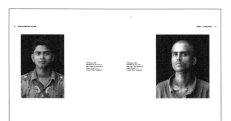

Figure 9.9 The last spread in Figure 9.8 segues from portraits of two wooden statues into the portraits of actual people shown here.

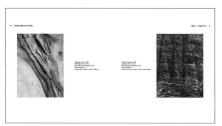

Figure 9.11 Spreads 10 and 11 take the dark/light idea referenced in Figure 9.8, but constrain the juxtapositions within each spread.

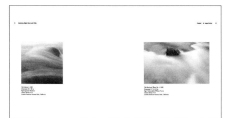

Figure 9.10 Spreads seven through nine all feature moving water as primary subjects.

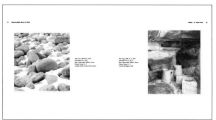

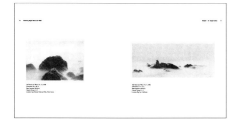

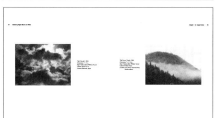

Figure 9.12 Spreads 12 and 13 present images with significant dark and light areas in the same image. This culminates with spread 14, which for all intents and purposes contains just shadows and highlights.

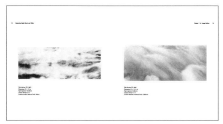

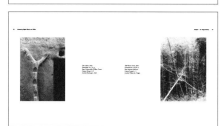

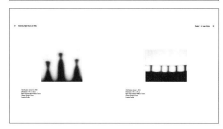

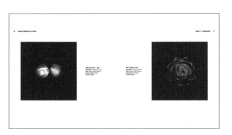

Figure 9.13 The final two images recall the opening spread, with their prominent black backgrounds. This conveys a sense of a closure to the journey.

The Artist Statement

The artist statement represents an opportunity for you to put your portfolio into a broader context. A great artist statement doesn't make up for a poor portfolio, but it can offer insights into how you perceive your work and engage with both your subject and materials. It doesn't need to be epic in length or contain phrases like, "postmodern deconstruction of the self." But it should talk more about the *why* of your images than the *what*. Viewers can see that you shot images of say, desert landscapes, but they may very well want to know what has drawn you to this subject and what you hope to convey with these images.

The key is to be direct, sincere, and give the viewer a sense of why the work is important to you. This is, by definition, a highly personal endeavor, and one of the great benefits of writing an artist statement is that it forces you to ask yourself why you are compelled to capture the images you do. The artist statement can also serve as a final check with regard to your selection of images. If you find that some images do not actually convey what it is you've put into words about your work, they really don't belong in this particular portfolio.

We'll take a look at two well-crafted artist statements by photographers whose work I admire and see how their words provide a more meaningful understanding of their work.

Chris Jordan, a fine art photographer based in Seattle, attracted widespread attention with his series, *Intolerable Beauty: Portraits of American Mass Consumerism*. In his artist statement, he gives insight into the personal significance of this work. Reading this gives us a much richer context in which to place the image in Figure 9.14.

Exploring around our country's shipping ports and industrial yards, where the accumulated detritus of our consumption is exposed to view like eroded layers in the Grand Canyon, I find evidence of a slow-motion apocalypse in progress. I am appalled by these scenes, and yet also drawn into them with awe and fascination. The immense scale of our consumption can appear desolate, macabre, oddly comical and ironic, and even darkly beautiful; for me its consistent feature is a staggering complexity.

The pervasiveness of our consumerism holds a seductive kind of mob mentality. Collectively we are committing a vast and unsustainable act of taking, but we each are anonymous and no one is in charge or accountable for the consequences. I fear that in this process we are doing irreparable harm to our planet and to our individual spirits.

As an American consumer myself, I am in no position to finger wag; but I do know that when we reflect on a difficult question in the absence of an answer, our attention can turn inward, and in that space may exist the possibility of some evolution of thought or action. So my hope is that these photographs can serve as portals to a kind of cultural self-inquiry. It may not be the most comfortable terrain, but I have heard it said that in risking self-awareness, at least we know that we are awake.

Figure 9.14 We read the image, *Crushed Cars#2,* quite differently when it is put in the context of mass consumerism. *Image courtesy of Chris Jordan*

Chester Higgins is one of America's most important photographers with a career that includes numerous books, magazine assignments, and over 30 years as a staff photographer for the *New York Times.* His introduction to his 2000 book, *Elder Grace: The Nobility of Aging,* serves as a powerful testament to the passion and profound respect he has for his subjects. Figure 9.15 shows one image from this collection of photographs.

> Elder Grace is a love song to the nobility of aging. The process of aging for some elder people can translate into a mysterious reservoir of wisdom—people who miraculously blossom, seasoned by years of living. We, as a society, do not honor our elders, and as a result, very few of us are emotionally comfortable in our older bodies. Today, individuals who blossom and season well are on their own special paths. They are beacons, in my mind—perhaps even

national treasures, which we as a society need not only to appreciate and applaud, but to study and emulate. Refusing to give in to the societal pressures of ageism, these people are proud survivors who have relied on their inner selves and instincts.

Figure 9.15 The phrase, "nobility of aging," from the book's introduction emphasizes the subject's strength and wisdom, rather than simply evoking feelings of pity for the aged. *Image courtesy of Chester Higgins*

Presentation

There are any number of ways to present your portfolio, from a custom, hand-bound book to a slideshow on DVD. Which method is best? Well, it's quite likely that you'll prepare portfolios in various formats tailored to meet the needs of clients, funders, review committees, and the like. In this final section, we will take a look at some of the opportunities that exist to present your work in the fine art market. We will then look at some of the options available when it's time to actually assemble the portfolio.

Opportunities

The art gallery is probably the first thing that comes to mind when photographers dream about critical or commercial success. But it is just one opportunity out of many that exist for getting your work in front of the public. And when you stop and think about the sheer number of still images you see in your daily life, it is not hard to imagine other possibilities.

Most every work of fiction you see in your local bookstore is graced with a photographic image on its cover. If you're in the housing market, you may have noticed that the walls of the model units are often lined with framed photographs. My local bank has mural-sized photographs of the surrounding neighborhood behind the teller windows. All of these images came from somewhere and had to be purchased or commissioned.

Detailed advice on exploring markets for your work is beyond the scope of this book. But the range of potential uses for fine art photographs is broad. So it becomes very important to choose a presentation most appropriate for your audience and the content of your work.

Perspectives: Marketing Consultant

Mary Virginia Swanson uses her expertise in marketing and licensing fine art to help photographers identify receptive audiences for their images. She is a sought after portfolio reviewer at events such as Review Santa Fe, Fotofest, and PhotoLucida. She gives frequent workshops and lectures on the subject of marketing opportunities and awareness. She serves on the Board of Directors of Center, formerly the Santa Fe Center for Photography, and the American Society of Media Photographers (ASMP) Foundation. She is the author of her self-published *The Business of Photography: Principles and Practices (2007),* available at www.mvswanson.com. She shares her thoughts on presenting work to the fine art market.

On the traits of success…

Successful photographers exhibit a strong focus in their work. They are clear about their intentions, continuously learning about the industry, and always striving to improve their art. Successful photographers are able to take rejection in stride and not quit. If they enter a juried competition and are not selected, they re-enter the following year. They are committed to their creation being the best reflection of their voice. They see the bigger picture of the life of an artist and tackle their career as a whole.

On researching your audience…

It's important that you research your audience. For example, you wouldn't take your work to a gallery that only represents 19th century work. Too few artists think about the audience for the gallery, museum, or magazine that they are approaching to place their work.

The Web is an invaluable research tool, but there are also publications like *Art in America Magazine's* annual guide that lists all of the upcoming gallery and museum shows. *Photo-Eye Booklist* magazine is devoted exclusively to fine art photography.

On what makes a successful portfolio…

Less is more. Don't strive to fill that box with 20 images if the last five are a distraction from the strong thread through the others. Continuity of the presentation is essential. All the prints should be the same size, have the same border, and be printed on the same paper. The biggest mistake people make when showing work is to depict everything they can do. They include still lifes, portraiture, and landscape images. Art professionals prefer a single idea pushed as far as you can take it. Of course, if you're exploring process rather than just subject or genre, you want to show a range of what you can do within that process. It's more likely, however, that you should be presenting one style, one genre, one subject throughout.

Your visual presentation reflects the seriousness with which you are involved with your work. When there's a box that's falling apart, damaged prints, or poorly packed work, it gives the impression that you don't respect your work. It may be the best work anyone has seen, but a curator viewing a poorly packaged portfolio will question how professional the experience would be working with you.

On editing your work…

Artists are, generally speaking, not the best editors of their work. It's difficult to be objective when you're that close to the material or subject. I absolutely encourage people to seek an outside view, and that's one way in which professional portfolio review events are a great help.

In addition, many cities have terrific small, informal salons or non-profit organizations that offer the opportunity for dialogue among local photographers. The Minnesota Center for Photography, the Print Center in Philadelphia, Atlanta Celebrates Photography, and Photographic Resource Center in Boston are some examples. Many other organizations have portfolio reviews on a regular basis where people come in and share their work.

On portfolio reviews…

I'm a big fan of portfolio reviews. I participate in as many of them as I can. At a single event, you might see five or ten professionals and, without question, you'll come out of that with a clear sense of which work is the strongest. In my case, I offer either a critique of the work or marketing advice, as the situation warrants. I often have photographers sit at my table who have never before shown their work. They know it's not ready for galleries or publication, but want feedback on identifying their strengths and discussing their printing interpretation. They want to know if they are clear in communicating their intent. We will have a discussion about the work itself.

However, if someone sits down with a body of work that is finished and conveys completely and thoroughly what they intend, we'll talk about who and where to present it, who the right publishers might be, what gallerists and museum curators will be most likely to respond to the work.

That's what goes on at my review table; experiences with other reviewers will vary. Galleries have a certain audience that they must satisfy, while museum curators have a public that's diverse, and as a result, have a broader range of what they can deal with and bring to the public.

Another benefit of participating in a portfolio review is meeting your peer group and beginning a dialogue and making friends. People forge great friendships that continue, and they often become each other's editors. It's fantastic to build your own community through these events.

There's a chapter in my book where I talk about making the most of your portfolio review investment—and it is an investment—before, during, and after the event. You can make terrific industry connections. But if you don't follow up, it's a missed investment and a wasted experience in terms of moving your career forward. You may have learned more about your work and met your peer group, but you will not have taken the opportunity as far as you could. I look at the meetings with the reviewers as the beginning of a relationship. It is up to you to continue this relationship. The photographers I see are really investing in portfolio reviews; those conscientiously taking notes, continuing the dialogue with gallerists, museum curators, publishers, magazine editors, and others are among the most successful photographers today.

Here's an example. I met Dave Anderson at FotoFest '04, and he was taking such copious notes that finally I said, "Dave, what are you doing?" He turned around his clipboard. He had printed out every reviewer's bio on a single sheet for a quick reference and made detailed notes to himself about how each presentation went. And most importantly, he had printed thumbnails of the images in his portfolio and circled the ones reviewers were responding to and even added their

comments. After the event, he sent individual thank you notes to reviewers, illustrated with the specific images to which they responded.

A few years later, his first book, *Rough Beauty,* came out. Dewi Lewis, who he met at a portfolio review, published it. Dave recently had his first solo show in New York and another in San Francisco. Ken Rosenthal is another artist who has done incredibly effective follow-up from portfolio reviews, and has nine galleries representing his work now.

When you're out of school and don't have a peer group seeing each others' work regularly, you are a bit more isolated. If you don't have the advantage of living in a major city like New York with so many fabulous non-profits—from En Foco, to Positive Focus, to the Camera Club of New York, to Professional Women Photographers—the opportunity for dialogue is not present. The portfolio review is really essential to get feedback and meet people.

On marketing opportunities…

One of the reasons I started my blog was to keep people informed about new opportunities. You see fine-art photography being reproduced as illustration in every issue of *The New Yorker* magazine. You cannot walk into a bookstore without seeing amazing work on the cover of recent fiction. Even biographies today tend to avoid photos of the subject, opting instead for images that reflect that era or the subject's particular expertise—a more metaphorical approach. *Esquire* has a summer reading issue every year, which has multiple opportunities. Publishers like *Harpers*, *Orion*, and *Audubon* have been showcasing fabulous work.

I was at an ICP lecture recently, in conjunction with their *Ecotopia* series. The panel included a photographer, a scientist, and the science editor of *The New York Times*. One of the points that really struck me was expressed by the scientist who asserted that the scientific community needs to collaborate with artists to envision the challenges that are facing us in terms of the environment. We can look at data and graphs forever; the public responds to images. So

the question to artists, for example is, "How can you envision extinction?"

The range of use of our medium as a vocabulary is exploding. I see opportunity for great photography in so many places. Some of my favorite exhibitions have been in airports. There are amazing opportunities in public art for photographers, given that the fabrication techniques are expanding. Photography can be reproduced on ceramic tiles, sandblasted into glass, you name it. I want artists to recognize that they have so many more opportunities than the gallery wall. Galleries are a wonderful goal, but they're probably the smallest audience for your work.

On making your work stand out…

First impressions are based on continuity, professionalism, craft, and your seriousness about interpreting the work. You want to demonstrate a strong thread through the work that shows you are exploring a subject or issue all the way through.

Speak with passion about your work. When people say, "My work can speak for itself," that's a cop-out. You really do need to describe your work to engage an audience. The way in which you speak about your work tells us how serious you are about it.

Eric Miles, from Photo-Eye, talked at a lecture during Photo L.A. about the artist's statement. He encouraged photographers to place their work in context, not just with the subject, but within the history of the medium, and to talk directly about influences. That helps others understand your work. Relatively few artists take risks with process or explore a subject deeply enough. This is a challenge, but one that makes you a better artist, a better communicator, a better person.

On the role of the Internet…

The Internet is an opportunity for us to be able to dialogue internationally. I see too few artists using the Internet to their advantage. Today, a Web site is essential, but a bad Web site can harm you more

than no Web site. The most common mistakes I see are simply too much work. I respect photographers who put the work that they're *now* most excited about on their Web sites. You can have an archive section to link to other work if you wish. But when you overwhelm people at the home page with imagery, it begins to look like a stock-photography site, and there's no way a visitor can focus on anything.

Few artists are clear about what they want their viewer to do. Few sites state clearly why someone should contact you. Do you want people to buy prints? Can you be commissioned? Would you discuss the possibility of licensing some of these images? Do you have work that's ready for exhibition? When you neglect to say this on your site, it's another missed opportunity. A Web site should do more than show your pictures. It should effectively move your career forward.

If get a promotional piece in the mail that intrigues me, I'll go to the Web site. But often the promo piece and the Web site look completely different. Creating a consistent graphic identity is important. If you're mailing a promo piece, you should put the image that you featured right on your home page or near to it. Don't force me to make five clicks to get to the picture that led me to you in the first place. Focus your work and purpose.

On licensing…

Licensing your images for use as illustration for fiction is a fantastic way to broaden your audience for print sales. Who reads *The New Yorker*? People who appreciate and are likely to collect art. It's a vast generalization, but I can tell you when I had my agency SWAN-STOCK, when we granted licensing rights for an image to be used as an illustration for a piece of fiction in *The New Yorker*, people would often call to buy prints. A wonderful by-product from appropriate licensing placement!

Slide Portfolio

Putting together a portfolio of slides is a relatively straightforward affair. The most difficult aspect in today's digital environment may simply be transferring your digital images to a film format. If you've still got a film camera, the most inexpensive approach is simply to photograph finished prints with slide film. Careful attention must be given to lighting to avoid distracting shadows and color casts. The print must lay flat to ensure sharp focus across the entire image. And composition becomes important. With the small size of 35mm film, you want to fill up the frame with as much of the image as possible, while making sure it is centered and level. A copy stand, shown in Figure 9.16, makes this all very easy.

Figure 9.16 The Copymate II copy stand lets you capture evenly lit shots of flat artwork. *Image courtesy of Bencher, Inc.*

An even better option, though, is to have your digital file converted to a slide. A film recorder, like the one shown in Figure 9.17, works by exposing the digital file through a CRT tube so that it can be photographed by a film camera. While the technology fell out of favor with the proliferation of digital capture, there are still service providers like Gamma Tech, based in New Mexico, that can produce slides in a number of film formats.

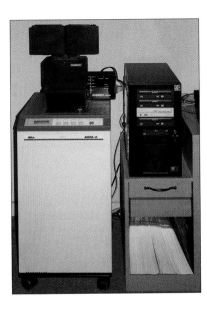

Figure 9.17 The Agfa Alto 16K film recorder allows for direct film capture of 35mm film slides. *Image courtesy of Gamma Tech*

Once you have the slides, the best way to store and transport them is in clear polypropylene slide pages like those from Print File, shown in Figure 9.18. There are a variety of sizes available, and they allow for quick visual inspection of slides without removing them from their sleeves.

Figure 9.18 Polypropylene sleeves offer durable and safe protection for film slides.

It is also important to include any required image or contact information on the slide mounts. I've found that adhesive return address labels are the perfect size for applying to slide mounts. Microsoft Word comes with built-in label templates that allow me to quickly and easily print out exactly the information that I need on a full sheet of labels, as shown in Figure 9.19. The use of plastic, removable slide mounts, shown in Figure 9.20, offers advantages over the standard cardboard packaging. Some submissions guidelines call for contact and image details to be affixed directly on the mount. Others have a blind selection process where no personal information is to be seen by the jurors. The plastic mounts are inexpensive and make it easy to reuse the same slide and prepare the new mount accordingly.

Figure 9.19 Microsoft Word includes built-in templates for standard printing labels (left). If you need to include the same information on each label, you can type it once in the Address field. Otherwise, you can manually type directly into the document (right), with the boundary of each label clearly indicated.

Figure 9.20 Plastic slide mounts come with a simple mounting tool (in black) that allows for easy opening of the mount.

Print Portfolio

A print portfolio is perhaps the best way to present your aesthetic and technical abilities. Though reduced in size, it takes the same form as the finished print. Subtle nuances of ink tone, paper texture, as well as a sense of depth or dimensionality can be conveyed even in a small print. So great care should be taken with the actual production of the portfolio prints. They should not be inferior work prints with flaws or less than ideal printing characteristics. When you approach the print portfolio as you would a mini-exhibition, you can convey to your audience a strong sense of how the finished prints will communicate.

There are a number of options with regard to the actual physical presentation of the prints. You obviously want the viewers to have easy access to each print, but you also want to minimize the risk of damage, either in shipping or handling. Your very first task should be to ensure that the images stay together. Your prints will likely

change hands many times on the way to the reviewers' table. Stuffing loose prints in a padded envelope will almost guarantee that something will get lost or damaged along the way.

A clamshell case design, like the ones shown in Figures 9.21 and 9.22, offers a sturdy and secure way to present your prints. They are available in a number of styles and sizes. A reviewer can simply open the case and flip from one image to the next. The case also makes it convenient to include supplemental materials such as a bio, press clippings, or promotional postcards.

Figure 9.21 A clamshell box, like the Limited Edition Portfolio from Light Impressions, combines stylish presentation with durable and acid-free print storage. *Image courtesy of Light Impressions*

Figure 9.22 This custom design clamshell box provides an elegant and personalized presentation. *Images courtesy of Jean Miele*

For larger or especially delicate prints, it is a good idea to affix them to a rigid backing. This makes the print easier to handle without damage. One of my own portfolios showcased a project in which the images were printed on a thin Japanese paper. The paper adds significantly to the content of the image, but it is much too delicate to be handled without creating kinks in the paper surface. The solution, shown in Figure 9.23, was to place each print in a clear polypropylene sleeve with an acid-free, chipboard backing. Reviewers get a strong sense of image detail and paper texture, but in a stiff package that is easily handled and passed around a table.

An increasingly popular option for presenting prints is to make a book of the images. More and more inkjet paper manufacturers are selling not only precut sheets with coating on both sides, but actual books and albums that you can assemble in minutes, as shown in Figures 9.24 and 9.25. The greatest benefit is that you can produce

a self-contained portfolio that is easy to ship and handle, contains a large number of images, and is printed on a high-quality, acid-free fine art paper.

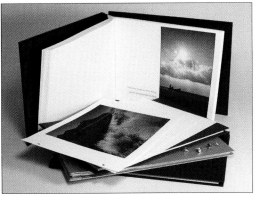

Figure 9.24 Hahnemühle offers a line of Digital FineArt photo albums. Each album can be self-assembled and comes with sheets that are prescored, hole-punched, and coated for printing on both sides. *Image courtesy of Hahnemühle USA*

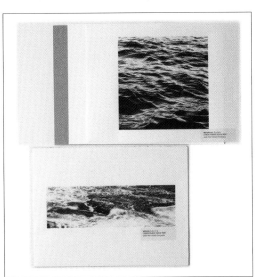

Figure 9.23 To protect the delicate paper surface, I mounted this very thin Japanese paper on top of a cotton rag backing paper and acid-free chipboard. The print was then presented inside a clear plastic sleeve for viewing and handling.

Figure 9.25 The Chinle Digital Book v2 combines a leather-bound cover and sturdy slipcase, which makes it an ideal portfolio for shipping. Prescored and predrilled pages are available in cotton, alpha cellulose, and RC surfaces that are coated for printing on both sides. *Image courtesy of Moab by Legion Paper*

Online Portfolio

Your Web site is in many ways the ultimate portfolio. It can reach a worldwide audience, can be continuously updated with new work, and provides easy access to your contact information and any promotional materials you want to publicize. In today's age of instant communication, anyone even remotely interested in your work is going to expect to see at least a small selection of your images online.

Very few photographers have the time or inclination to become fluent in HTML programming. So you are likely to need the services of a professional to plan, design, and build a Web site. But if you just need to get a relatively small group of images on the Internet for clients, buyers, or reviewers that are interested in your work, you may already have all the tools you need. Many of today's imaging and digital asset management applications offer built-in ability to create simple Web pages without your having to write a single line of code. In Figures 9.26, 9.27, and 9.28, you can take a quick peek at the Web gallery feature in Aperture, Photoshop, and Portfolio.

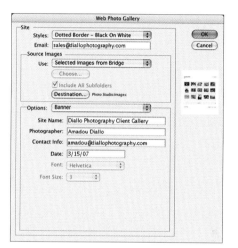

Figure 9.27 With images selected in Bridge, you can go to Tools>Photoshop> Web Photo Gallery and choose from a list of prebuilt Web page styles (left). The result is a Web gallery with a thumbnail overview (bottom left) and a detailed image view (bottom right).

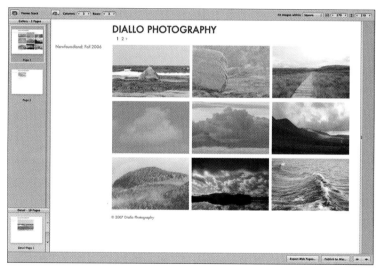

Figure 9.26 Aperture's Web gallery feature allows you to lay out your images using prebuilt templates and exports the collection into an HTML-generated Web gallery.

Figure 9.28 In Portfolio 8 from Extensis, you can choose from a series of prebuilt Web page styles for both thumbnail gallery views (top) and larger detail views (bottom). You can specify separate information to be displayed in each image view.

Perspectives: Web Designer

Sue Jenkins is a Web designer and author of *Dreamweaver 8 All-in-One Desk Reference For Dummies* and *Web Design: The L Line, The Express Line to Learning.* She offers these tips for creating a collection of images on the Web.

On image selection and orientation…

Your online portfolio need not showcase your entire oeuvre, but if you have a few different styles or themes you'd like to display, select six to ten images maximum per category to give visitors a good overview of your work without overwhelming them with too many images.

If at all possible, try to keep your images either all portrait or all landscape to help create a visual unity to your portfolio. If that's not possible, try to keep image details about each image in the same place on every Web page.

On site navigation…

How visitors navigate from image to image in your online portfolio depends on the marriage between your aesthetics and technology. Talk with your Web designer about whether you'd like to use thumbnails of your images for navigation buttons to view close-ups of those images or use text or graphic buttons to advance from one larger image to the next without using thumbnails.

On image details…

Will you be adding image details, such as what camera, lens, and exposure settings, to your portfolio? If so, let your Web designer know this, so he or she can build that data into the design layout.

On image layout, dimensions, and file size…

You have no control over the monitor resolution of your site visitors' computers. So pick a layout for your portfolio that will look good on any computer. That means keeping the layout size to 760 pixels wide

or less. As for height, put the most important information like navigation buttons and close-ups in the top 420 or so pixels. This will keep visitors from having to scroll vertically to view your images.

Having your images large enough to view detail is important, but not at the expense of file size and quality. Thumbnails can be square or rectangular in shape and should be between 20 × 20 and 150 × 150 pixels in size. For close-ups, depending on their orientation, make landscape images no larger than 400 pixels in width, and portrait images should be no taller than 300 pixels.

Because your portfolio images are photographic, to be viewable on the Web, they'll need to be optimized at 72 pixels per inch and saved into the JPEG file format. For the Web, you want to create the highest quality image with the lowest possible file size. If you'll be optimizing the images yourself, try to keep images under 30K, but shoot for around 10–20K if at all possible to help improve page loading times in a browser.

On programming language…

There are a lot of different ways to present your works online, so how do you select the technology that will drive the presentation of your e-portfolio? Your designer should be proficient enough in the various technologies to explain the drawbacks and benefits of each, including costs and whether or not you'll be able to manage the images yourself after your portfolio goes online.

On editability…

Will you want to be able to manage your portfolio images yourself, or will you always be hiring your designer to make updates for you? If you'll want to be in control of updating your own files, let your Web designer know before they begin the design. A custom contact management system (CMS) may need to be built if the site will be using a programming language like PHP to manage the images. Alternately, you may be able to edit the site yourself post-launch using Adobe's Contribute software.

On copyright protection…

As the artist, you retain the full rights to your works, unless or until you transfer those rights to another person or entity. But on the Internet, once your work is out there, it's out there, which means that people who don't understand copyright law will likely borrow your images without compensation to you. Before putting any of your images online, register them through the US Copyright office. Then, when you do put your images online, add an artist's copyright disclaimer (such as, "All images and content are © 2007 YOUR-NAME and may not be distributed, used, or sold without permission.") to any pages displaying your works. You might also want to ask your Web designer to add JavaScript to your site that blocks visitors from right-clicking (PC) or control-clicking (Mac) on your images to save or copy them.

Final Thought

Creating a portfolio is in many ways a culmination of the entire capture, evaluation, edit, and print workflow. For the photographer seeking to expose her work to a wider audience, it becomes a crucial element in the successful presentation of her photographic vision. You've been presented with a lot of detailed, and sometimes technical, information in this book that ultimately serves a single purpose: to bring forth your work in a manner that reflects how you experience the world around you, rather than the limitations of equipment or technique. We are all very fortunate to live in an age where such possibilities for self-expression exist. It is my hope that the experiences and insights shared between these pages have helped guide you along in this endeavor.

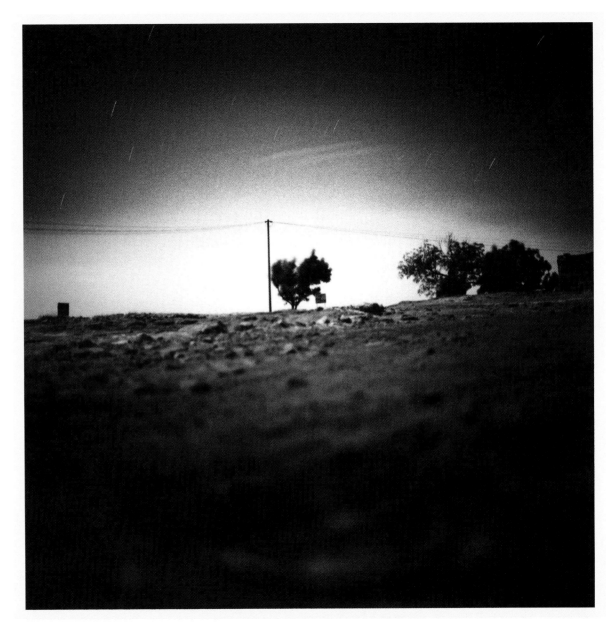

Title Mali 2005

Dimensions 20 × 20 in.

Paper Innova Soft Textured Natural White

Ink Set PiezoTone Carbon Sepia/Selenium Tone blend

Printer Epson Stylus Pro 9600

Case Study 5: Philippe Dollo

Artist Bio

Philippe Dollo is a freelance photographer who has enjoyed a career in editorial portraiture that began in his native France. Since moving to New York City 16 years ago, he has been immersed in several long-term photographic explorations of his adopted city, as well as the ancient Dogon culture of Mali. He is also regularly commissioned for his documentary-style black-and-white wedding photography.

✪ Download an mp3 audio file of this entire interview by visiting the book's companion Web site at www.masteringdigitalbwbook.com.

The Artist Speaks

Amadou Diallo: *You've mentioned that cinema has played a big role in how you conceive of still images. What aspects of it resonate with you as a photographer?*

Philippe Dollo: I guess cinema and movies have been my earliest influences. I didn't have so much access to culture when I was a kid, and movies had a special place. I would read a book because there was a movie about it.

At least once a week, I was going to see a movie. That was the period of those Jim Jarmusch movies—those black-and-white art films in the '80s. I think what started to influence me were those urban movies with long frames that look like a picture, with nothing really happening except ambiance with music. All these really had an influence on me when I started to take pictures in cities. The first photos I started to take were in Paris when I moved there.

And then, when I started to do the weddings, critics said that I had a cinematographic vision. I was like, "Wow! Really?" I never consciously realized it. It's true that I use a panoramic camera a lot for weddings, and it gives a cinematographic aspect to the photos.

AD: *One thing that's always struck me is that for your fine art work, you really cover a wide range of subjects. You have the* Fragile City *portfolio, which is really an ode to your adopted city of New York.* American Wedding *explores what's usually an extravagant ritual. But then you also have a portfolio where you examine the ancient Dogon culture in Mali. So I'm wondering, what are the common threads you see in these bodies of work? How do these types of images relate to your artistic vision? What do you find in common between these subject matters?*

PD: I guess I consider it more like a puzzle. Each portfolio is like a piece of a puzzle. When you put them together, it makes a global picture—my global vision of photography. Photography is very important for me. It's not a job. It's a philosophy, a way of living. I always carry a camera. I almost sleep with my camera. Well, I'm not sleeping with my camera.

AD: *[laughing] That's good to hear.*

PD: I'm not that crazy, but I always carry a camera, even when I go to the deli. So I'm constantly thinking about photography. I'm attracted by a lot of different things or layers, and they are all linked somewhere. The weddings are an intimate approach with people.

They are very important to me. Photography is a great way to approach people, especially in the intimacy of the wedding day. It's perfect for that. These are complementary with the work on New York where the people become only silhouettes. The two projects are linked.

For Africa and Mali, it's another story. It's one of many of my dreams that came true. I have a Dogon name—Dollo is a Dogon name. I learned that when I was younger, and I always said, "One day I will go there to the village of the Dollo." In 2002, I was invited to show the Wedding photos in Ivory Coast. Mali is a nearby country, and I decided to extend my stay and realize the dream.

I decided to visit the village. I didn't know what I was going to do, but thought I would bring the camera to do some portraits. Now this is an aspect of photography that scares me. In fact, I think portraiture is probably one of the most difficult disciplines. It's a big challenge. It's the original art. From the beginning—in caves—people started to do portraits. Painters like Rembrandt study light all their lives in order to create portraits. So when you do it with photography, it's very challenging. But for me, Mali had to be a portrait project. Of course, I also took pictures of the village and the amazing landscape there.

AD: *The Bandiagara cliffs are a pretty amazing part of the world.*

PD: It's wild and terribly difficult to live in.

AD: *Can you talk specifically about the Mali 2005 image that we reproduced for the book? You first printed this image in the darkroom as a silver print. What was it that attracted you to this image?*

PD: This image is part of a series that I improvised when I was there. I was going around by night, and there was this full moon. There was not so much electricity, like in New York, and by night the moon had this amazing texture. There was only the light from the stars and the moon.

This photo was taken at two o'clock in the morning in a completely deserted village. Everyone was sleeping. There were only wild donkeys around. And I completely improvised, as I always do. I didn't bring a tripod, and I estimated the exposure because I had no way to measure the light. I put the camera on the floor, so the foreground is completely unfocused. The camera was focused at infinity. The stars were moving, and you see those in the shot.

Technically, I had problems printing it because I love high contrast pictures. Generally, I love grain and high contrast with a warm toning. Again, this picture was very difficult to print in the darkroom because it was not exposed properly. So it was interesting to have it printed digitally to see the results.

AD: *We looked at various ink tones. We looked at a lot of paper options, but I think we probably spent the most time fine-tuning the localized contrast in various regions of this image. I wonder if you could talk about the experience of reinterpreting the image from a silver gelatin print to a digital one? Do you think the inkjet print has created a new interpretation of the image or simply enhanced the properties that you were envisioning while you were making the silver print in the darkroom?*

PD: It's completely different. And that's why it's very interesting for me. It's starting to quiet down, but there is a war going on between people who are only talking about digital and guys like myself who are still printing in the darkroom. I think the techniques are different, and somewhat complementary. The first thing here, and that was one of the factors for me in deciding to do it, was that these prints are not on photo paper but on a watercolor-type surface. It's not a painting, of course; it's not an etching. But somewhere it's getting a little bit outside of traditional photography and veering towards this area of etching.

AD: *The inkjet brings a combination of photography and print making together.*

PD: I think that's the first thing that is interesting for me. I think it fits pretty well to the photograph.

A

Resource Guide

On the following pages, you will find information for select individuals, products, services, and online resources that are either referenced in this book, or played a useful role during the research stage.

Hardware and Software Vendors

Adobe Systems Inc. www.adobe.com
Photoshop, Lightroom, and DNG Converter software

Aztek Incorporated www.aztek.com
Drum scanners, DPL scanning software, and wet mount consumables

Better Light, Inc. www.betterlight.com
High-resolution scanning backs

Canon USA www.usa.canon.com
DSLRs, pigment inkjet printers, media, and consumables

Chromix www.chromix.com
ColorThink Pro analysis software, custom profiling service, and reseller of color management hardware and software

ColorByte Software www.colorbytesoftware.com
ImagePrint RIP with drivers for Epson and HP large format printers

ColorVision www.colorvision.com
PrintFIX Pro hardware and software bundle for creating custom printer profiles

Compatible Systems Engineering www.colorburstrip.com
ColorBurst RIP with drivers for Epson large format printers

Crucial www.crucial.com
High-quality computer memory for Mac and Windows systems with a lifetime warranty

Eizo Nanao Corporation www.eizo.com
High-performance LCD monitors with calibration/profiling bundles

Epson America, Inc. www.epson.com
Pigment inkjet printers, media, consumables, and flatbed scanners

Ergosoft US www.ergosoftus.com
StudioPrint RIP with drivers for Canon, Epson, and HP large format printers

Granite Digital www.granitedigital.com
High-performance data cables and storage devices

GTI Graphic Technology, Inc. www.gtilite.com
Color-corrected viewing stations and lamps

Hamrick Software www.hamrick.com/vsm.html
VueScan scanning software

Harrington Photography www.quadtonerip.com
Quad Tone RIP software optimized for black-and-white printing
with Epson printers

Hasselblad USA Inc. www. hasselblad.com
Medium-format cameras, backs, and film scanners

Hewlett-Packard USA www.designjet.com
Pigment inkjet printers, media, and consumables

Integrated Color Corporation www.integrated-color.com
ColorEyes Display Pro monitor calibration and profiling software

LaCie www.lacie.com
External storage and LCD monitors with calibration/profiling
bundles

LaserSoft Imaging www.silverfast.com
SilverFast scanning software

Mac Gurus www.macgurus.com
External storage systems, memory, and PCI cards for the Mac and
an extensive tech forum

NEC Corporation of America www.necus.com
LCD monitors with calibration/profiling bundles

Nikon USA www.nikonusa.com
DSLRs and film scanners

Pixel Genius www. pixelgenius.com
PhotoKit Sharpener plug-in

Shirt Pocket www.shirt-pocket.com
SuperDuper! automated backup utility

Wacom Technology Corporation www.wacom.com
Graphics tablets and the Cintiq interactive pen display monitor

Western Digital www. westerndigital.com
Hard drives for desktop and laptop computers

X-Rite, Inc. www.xritephoto.com
Color calibration and profiling solutions, including the
GretagMacbeth product line

Supplies and Consumables

AllSquare Computer Technologies www.allsquare.com
Large-format inkjet printers and consumables

Hiromi Paper International, Inc. www.hiromipaper.com
Wide selection of Japanese papers suitable for inkjet printing

Inkjet Art Solutions www.inkjetart.com
Inkjet printers and consumables

InkJet Mall www.inkjetmall.com
Third-party black-and-white ink sets, fine art papers, color man-
agement products, and digital photography workshops

Light Impressions www.lightimpressionsdirect.com
Archival storage, display, and framing supplies

MIS Associates Inc. www.inksupply.com
Third-party black-and-white ink sets

Shades of Paper www.shadesofpaper.com
Fine art papers and Canon inkjet printers

Photographers

Alex Forman	www.tallslimerect.com
Chester Higgins	www.chesterhiggins.com
Chris Jordan	www.chrisjordan.com
Jean Miele	www.jeanmiele.com
Jeanne Greco	www.caffegrecodesign.com
Philippe Dollo	www. philippedollo.com
Sze Tsung Leong	homepage.mac.com/szetsungleong

Galleries and Portfolio Review Opportunities

MoMA **www.moma.org**
New York, NY
Founded in 1929, arguably the foremost public collection of modern art in the world

Photolucida **www.photolucida.org**
Portland, OR
Hosts an international portfolio review every other spring

SF Camerawork **www.sfcamerawork.org**
San Francisco, CA
Nonprofit organization promoting photography through exhibits, publications, and educational programs

Soho Photo Gallery **www.sohophoto.com**
New York, NY
Member-run gallery with monthly portfolio reviews and national photo competitions

Yossi Milo Gallery **www.yossimilogallery.com**
New York, NY
Commercial gallery in New York's Chelsea art district

Professional Services

Black Point Editions **www.blackpointeditions.com**
Fine art digital printmaking studio in Chicago, IL

Custom Digital **www. custom-digital.com**
Fine art digital printmaking studio in Seattle, WA

Dean Imaging **www. deanimaging.com**
Fine art digital printmaking studio in Atlanta, GA

Diallo Photography **www.diallophotography.com**
Fine art digital printmaking studio and digital imaging workshops in New York City

Gamma Tech **www.gammatech.com**
Conversion of digital files to 35mm, 120, and LF film formats

Luckychair **www. luckychair.com**
Web and logo design

Mary Virginia Swanson **www.mvswanson.com**
Marketing consultant for fine art photographers based in Tuscon, AZ

Muskat Studios **www.muskatstudios.com**
Fine art lithography studio in Somerville, MA

Online Forums and Resources

www.adobe.com/support/forums/main.html
Official user forums for all Adobe products

www.color.org
Official International Color Consortium (ICC) Web site with technical information and white papers on the use of ICC profiles in a color-managed workflow

www.dpreview.com
Frequent and exhaustive reviews of a wide range of digital cameras

www.luminous-landscape.com
Articles, reviews, and technical discussions relevant to landscape, nature, and documentary photography

marketingphotos. wordpress.com
A blog run by marketing expert Mary Virginia Swanson, which includes a regularly updated list of competition, portfolio review, and grant deadlines

www.masteringdigitalbwbook.com
The companion Web site for this book with additional content and an online discussion group

www.photo.net/community/forums
Online community with forums for a wide range of photographic interests, including photo critiques and equipment discussions

www.photoshopnews.com
Offers Photoshop-related news, articles, and discussions

tech.groups.yahoo.com/group/DigitalBlackandWhiteThePrint
A user group dedicated to technical and aesthetic issues related to black-and-white digital output

www.wilhelm-research.com
Provides public access to print permanence data for products from the major inkjet printer manufacturers

Suggested Readings

Adobe Photoshop CS3 for Photographers by Martin Evening, Focal Press, 2007
Image editing and retouching techniques for photography-based images

Mastering Digital Printing, Second Edition by Harald Johnson, Course Technology PTR, 2005
A thorough examination of the genesis and evolution of digital printing technology

Photoshop Masking & Compositing by Katrin Eismann, New Riders Press, 2004
A trove of techniques for creating selections and masks for localized image adjustments and composite images

Real World Color Management, 2nd Edition by Bruce Fraser, Chris Murphy, Fred Bunting, Peachpit Press, 2004
An exhaustive yet relatively accessible look at the concepts, tools, and applications involved in maintaining color fidelity in a digital workflow

Real World Image Sharpening with Adobe Photoshop CS2 by Bruce Fraser, Peachpit Press, 2006
The definitive guide to understanding and implementing optimal sharpening of digital images

B

New York State Law

Article fifteen of the New York arts and cultural affairs law provides for disclosure in writing of certain information concerning multiples of prints and photographs when sold for more than one hundred dollars ($100) each, exclusive of any frame, prior to effecting a sale of them.

Section 15.01. Full disclosure in the sale of certain visual art objects produced in multiples.

An art merchant shall not sell or consign a multiple in, into or from this state unless a written instrument is furnished to the purchaser or consignee, at his request, or in any event prior to a sale or consignment, which sets forth as to each multiple the descriptive information required by this article for the appropriate time period. If a prospective purchaser so requests, the information shall be transmitted to him prior to the payment or placing of an order for a multiple. If payment is made by a purchaser prior to delivery of such an art multiple, this information shall be supplied at the time of or prior to delivery.

Section 15.03. Information required.

The following information shall be supplied, as indicated, as to each multiple produced on or after January first, nineteen hundred eighty-two:

1. Artist. State the name of the artist.

2. Signature. If the artist's name appears on the multiple, state whether the multiple was signed by the artist. If not signed by the artist then state the source of the artist's name on the multiple, such as whether the artist placed his signature on the master, whether his name was stamped or estate stamped on the multiple, or was from some other source or in some other manner placed on the multiple.

3. Medium or process.

 (a) Describe the medium or process, and where pertinent to photographic processes the material, used in producing the multiple, such as whether the multiple was produced through etching, engraving, lithographic, serigraphic or a particular method and/or material used in the photographic developing processes. If an established term, in

accordance with the usage of the trade, cannot be employed accurately to describe the medium or process, a brief, clear description shall be made.

(b) If the purported artist was deceased at the time the master was made which produced the multiple, this shall be stated.

(c) If the multiple or the image on or in the master constitutes a mechanical, photomechanical, hand-made or photographic type of reproduction, or is a reproduction, of an image produced in a different medium, for a purpose other than the creation of the multiple being described, this information and the respective mediums shall be stated.

(d) If paragraph (c) of this subdivision is applicable, and the multiple is not signed, state whether the artist authorized or approved in writing the multiple or the edition of which the multiple being described is one.

4. Use of master.

(a) If the multiple is a "posthumous" multiple, that is, if the master was created during the life of the artist but the multiple was produced after the artist's death, this shall be stated.

(b) If the multiple was made from a master which produced a prior limited edition, or from a master which constitutes or was made from a reproduction of a prior multiple or of a master which produced prior multiples, this shall be stated.

5. Time produced. As to multiples produced after nineteen hundred forty-nine, state the year or approximate year the multiple was produced. As to multiples produced prior to nineteen hundred fifty, state the year, approximate year or period when the master was made which produced the multiple and/or when the particular multiple being described was produced. The requirements of this subdivision shall be satisfied when the year stated is approximately accurate.

6. Size of the edition.

(a) If the multiple being described is offered as one of a limited edition, this shall be so stated, as well as the number of multiples in the edition, and whether and how the multiple is numbered.

(b) Unless otherwise disclosed, the number of multiples stated pursuant to paragraph (a) of this subdivision shall constitute an express warranty, as defined in section 13.01 of this title, that no additional numbered multiples of the same image, exclusive of proofs, have been produced.

(c) The number of multiples stated pursuant to paragraph (a) of this subdivision shall also constitute an express warranty, as defined in section 13.01 of this title, that no additional multiples of the same image, whether designated "proofs" other than trial proofs, numbered or otherwise, have been produced in an amount which exceeds the number in the limited edition by twenty or twenty percent, whichever is greater.

(d) If the number of multiples exceeds the number in the stated limited edition as provided in paragraph (c) of this subdivision, then state the number of proofs other than trial proofs, or other numbered or unnumbered multiples, in the same or other prior editions, produced from the same master as described in paragraph (b) of subdivision four of this section, and whether and how they are signed and numbered.

Section 15.13. Construction.

Whenever an artist sells or consigns a multiple of his own creation, the artist shall incur the obligations prescribed by this article for an art merchant, but an artist shall not otherwise be regarded as an art merchant.

Section 15.15. Remedies and enforcement.

1. An art merchant, including a merchant consignee, who offers or sells a multiple in, into or from this state without providing the information required by this article for the appropriate time period, or who provides required information which is mistaken, erroneous or untrue, except for harmless errors such as typographical errors, shall be liable to the purchaser to whom the multiple was sold. The merchant's liability shall consist of the consideration paid by the purchaser with interest from the time of payment at the rate prescribed by section five thousand four of the civil practice law and rules or any successor provisions thereto, upon the return of the multiple in substantially the same condition in which received by the purchaser. This remedy shall not bar or be deemed inconsistent with a claim for damages or with the exercise of additional remedies otherwise available to the purchaser.

2. In any proceeding in which an art merchant relies upon a disclaimer of knowledge as to any relevant information required by this article for the appropriate time period, such disclaimer shall be effective only if it complies with the provisions of section 13.05 of this title, unless the claimant is able to establish that the merchant failed to make reasonable inquiries, according to the custom and usage of the trade, to ascertain the relevant information or that such relevant information would have been ascertained as a result of such reasonable inquiries.

3. (a) The purchaser of such a multiple may recover from the art merchant an amount equal to three times the amount recoverable under subdivision one of this section if an art merchant offers, consigns or sells a multiple and:

 (i) willfully fails to provide the information required by this article for the appropriate time period;

 (ii) knowingly provides false information; or

 (iii) the purchaser can establish that the merchant willfully and falsely disclaimed knowledge as to any required information.

 (b) Pursuant to subparagraphs (i) and (iii) of paragraph (a) of this subdivision, a merchant may introduce evidence of the relevant usage and custom of the trade in any proceeding in which such treble damages are sought. This subdivision shall not be deemed to negate the applicability of article thirteen of this chapter as to authenticity and article thirteen is applicable, as to authenticity, to the multiples covered by the provisions of this article.

Index